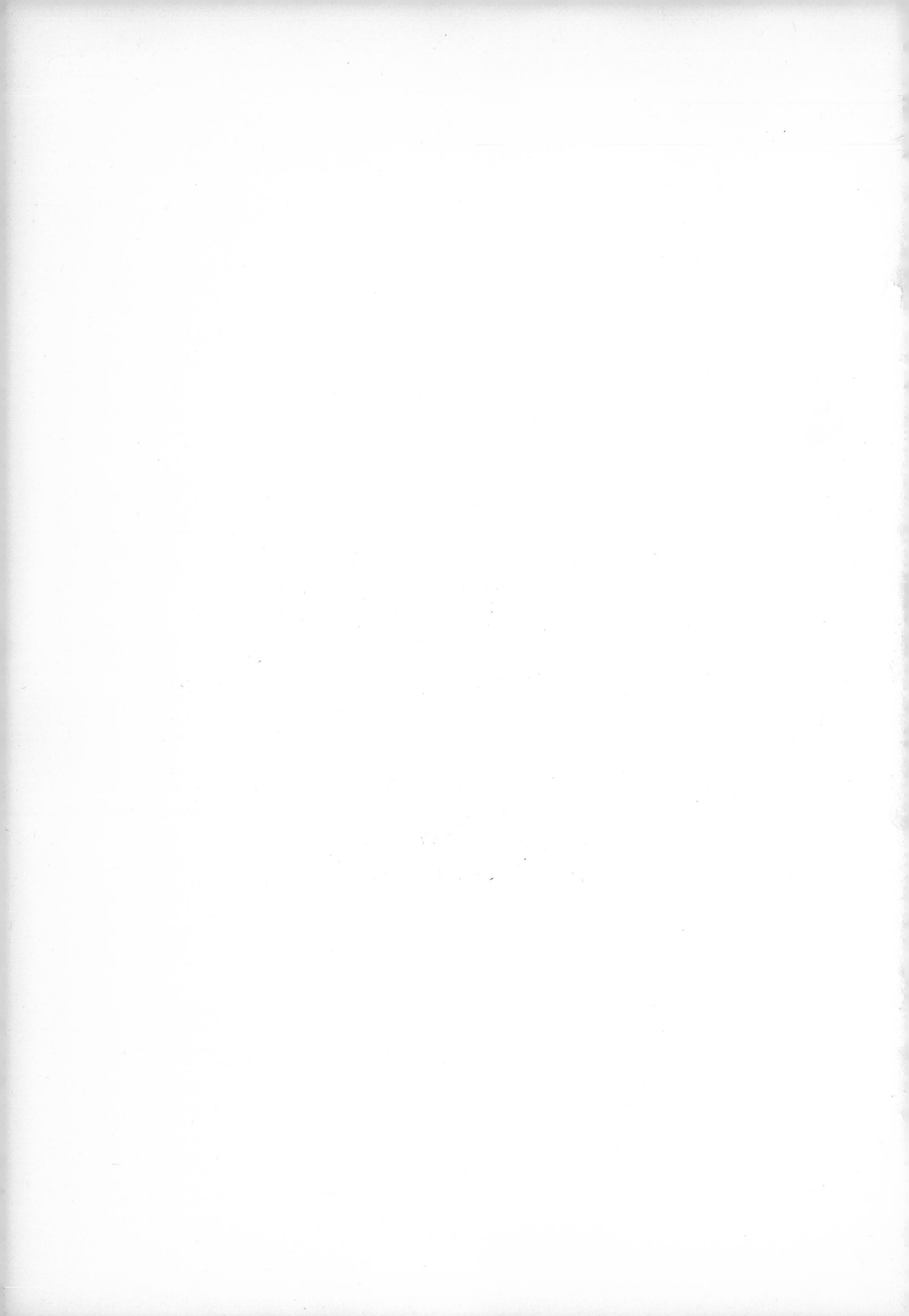

❧ THE AUTOBIOGRAPHY OF ❦
BENVENUTO CELLINI

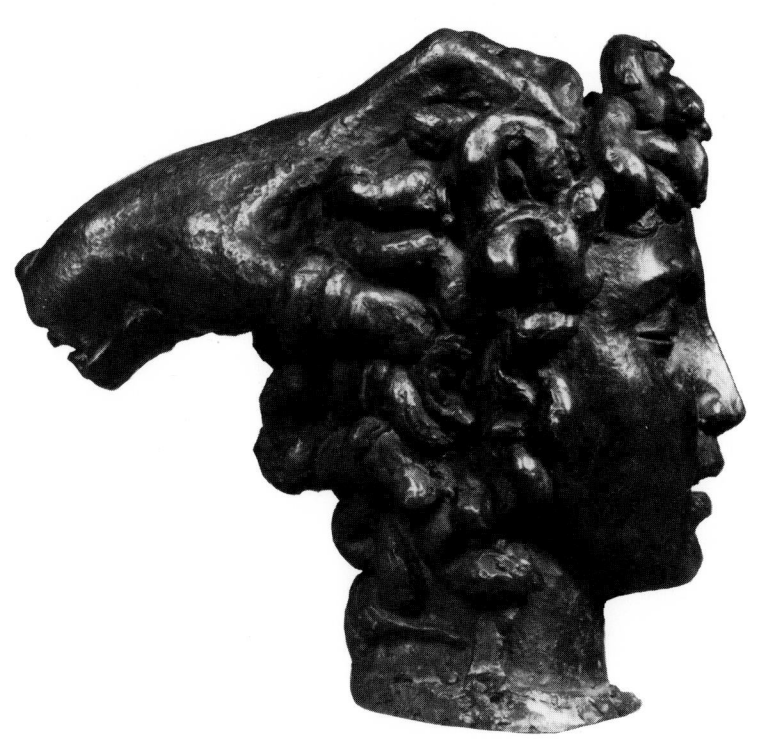

THE AUTOBIOGRAPHY OF
BENVENUTO CELLINI

edited and abridged by Charles Hope
and Alessandro Nova

from the translation by
John Addington Symonds

Phaidon · Oxford

This illustrated edition first published in 1983 by
Phaidon Press Limited
Littlegate House, St Ebbe's Street, Oxford OX1 1SQ

Introduction and notes © 1983 John Calmann and Cooper Ltd

British Library Cataloguing in Publication Data
Cellini, Benvenuto
 The autobiography of Benvenuto Cellini.
 1. Cellini, Benvenuto 2. Sculptors—
Italy—Biography
 I. Title II. Hope, Charles
 III. Nova, Alessandro
 370'.92'4 NB623

ISBN 0 7148 2297 3

This book was designed and produced by
John Calmann and Cooper Ltd,
71 Great Russell Street,
London WC1B 3BN
Designer: Gail Engert

Filmset in Great Britain by BAS Printers Ltd,
Over Wallop, Hampshire
Printed in Singapore by Toppan Printing Co.

1 HALF-TITLE Bronze model of the head of the Medusa
from the *Perseus*. Victoria and Albert Museum
(*see also plates 76, 77*)

2 FRONTISPIECE *Cosimo I*, bronze bust by Cellini,
1545–8. Florence, Bargello (*see page 164*)

3 OPPOSITE *Pegasus* from the medal for Cardinal Bembo
(*plate 43*)

CONTENTS

Acknowledgements

The editors and John Calmann and Cooper Ltd would like to thank those who have kindly provided photographs for this edition. The photographic sources are mentioned in the captions; additional information is given below. A special word of thanks is due to Mr Ian Woodner and Mr Charles Davis.

Plate 10 is © Coke Estates Ltd, Norfolk

Plates 5, 47, 72, 74, 80, 81, 84, 85, 91, 93–99, 101, 102: photos Alinari, Florence, and Mansell, London

Plate 67: photo Jörg P. Anders, Berlin

Plate 14: photo Giulio Gavioli, Modena

Plates 22, 23: photos Giovetti, Mantua

Plate 53: photo Giraudon, Paris

Plates 52, 56–63: Réunion des Musées Nationaux, Paris

Plates 12, 13, 16, 29, 30, 35, 49, 71: Scala, Florence

Plates 24, 33, 69, 70, 73, 82, 83, 86–9, 90: Gabinetto Fotografico Soprintendenza Beni Artistici e Storici di Firenze.

INTRODUCTION

THE autobiography of the goldsmith and sculptor Benvenuto Cellini is now probably more widely read than any other book written in Italy during the Renaissance. The text, the bulk of which was dictated to a young assistant, Michele di Goro, was composed in Florence mostly between 1558 and 1562, but it remained unpublished until 1728. Over the next century Cellini's work, which was translated into English, German and French, acquired the status of a classic. Much of its appeal to the generation of the Romantics lay in the fact that Cellini himself seemed to embody all their preconceptions about the Renaissance. He was brave, impetuous, violent, promiscuous and totally committed to his art; and his life included an astonishing variety of dramatic incidents, such as murders, battles and daring escapes. The autobiography, indeed, often reads like the most lurid adventure story; but it is much more than that, for Cellini happened to be an outstanding artist as well as a natural writer. To anyone interested in the art of the period he remains an indispensable source, not merely for his comments on painters and sculptors, but even more for the accounts of his dealings with his patrons, who included some of the most famous and powerful men of his day. His cast of characters, however, also includes many less exalted people – minor craftsmen, tradesmen, petty officials, criminals and prostitutes, in short a cross-section of an entire society. With astonishing frankness and in a language which retains the vigour and flexibility of spoken speech, Cellini gives us the most complete, vivid and memorable picture of one man's life, personality and preoccupations to have survived from the sixteenth century.

He was born in Florence on 3 November 1500. It is entirely characteristic that he should have claimed in the autobiography that his family was among the most ancient in the city, even that Florence was named after one of his ancestors. This, of course, was pure invention. His father Giovanni was a musician and artisan whose work sometimes brought him into contact with professional artists; in 1505, for example, he was responsible for making the scaffold used by Leonardo da Vinci when he was painting his mural of the *Battle of Anghiari* in the Palazzo Vecchio. It was Giovanni's ambition that his son should take up music, but Benvenuto was always drawn to the visual arts and from the age of thirteen began to work as a goldsmith. In Florence many distinguished painters and sculptors had started their careers in this way, among them Ghiberti, Brunelleschi, Donatello and Antonio Pollaiuolo. From the first Cellini revealed a restless, quarrelsome temperament. Forced to leave the city for a time in 1516 after a brawl, he moved to Siena, then continued his training in Bologna and Pisa before arriving in Rome in 1519. This was to be the centre of his activities until 1540.

When Cellini first came to Rome it was already the artistic capital of Italy, thanks largely to the achievements of Bramante, Michelangelo and Raphael. At that time the reigning Pope was Leo X, a member of the Medici family, so Florentines were especially welcome in the city. Leo died in 1521, but two years later his cousin was elected to the papacy with the title of Clement VII. In these years the opportunities for a goldsmith in Rome could hardly have been better,

since the papal court included many potential patrons with vast financial resources and a taste for luxury objects. Moreover, there can be no doubt that Cellini was an outstandingly skilful craftsman. The brilliance of his technique, which he emphasizes both in the autobiography and in the *Trattato dell'Oreficeria*, his treatise on goldsmith-work, is confirmed both by his surviving work and by the testimony of his contemporary Giorgio Vasari, the author of the *Lives of the painters, sculptors and architects*. It is therefore not surprising that he soon began to attract major commissions, not only from members of the Curia, but also from Clement himself.

This does not mean that Cellini's career in Rome was uneventful or without its setbacks. In 1527 the city was sacked by troops of the Emperor Charles V, and the Pope was forced to take refuge with his supporters in Castel Sant'Angelo. Cellini's account of the Sack and the subsequent siege of the castle is among the most famous sections of the autobiography, even if it is probably one of the least trustworthy, since he claimed to have been personally responsible for the deaths of both the Imperial generals. Most of his problems in Rome, however, seem to have been at least partly of his own making. During this period, as indeed throughout his life, Cellini persistently quarrelled with his fellow artists, and his fiery temper and loose tongue made him powerful enemies at court. Added to this was his habit of resolving disputes by violence, which on two occasions in Rome led him to commit murder. The low point in Cellini's fortunes came in 1538, when Pope Paul III and his son Pier Luigi Farnese had him imprisoned in Castel Sant'Angelo on a charge of stealing jewels entrusted to him by Clement during the Sack. He soon managed to escape, but was free for only a few weeks; and it was not until the end of 1539 that he was finally released, thanks to the intercession of Cardinal Ippolito d'Este. Shortly afterwards, again sponsored by Ippolito, Cellini entered the service of the King of France, Francis I.

Very little of the work executed by Cellini before 1540 has come down to us, but this is hardly surprising. Of all artistic products jewellery and other objects in gold and silver are among the most ephemeral, since they are always liable to be melted down, whether by thieves or by the owners themselves, anxious to recover the gems and precious metals. Fortunately there exist water-colour drawings of one of Cellini's major creations from these years, the morse or pectoral of Clement VII, which dates from about 1531 (plates 18–20). Original impressions also survive of two of the seals which he made for prominent cardinals, the first for Ercole Gonzaga in 1528 (plate 22), the second for Ippolito d'Este in 1540. Finally, there are a number of examples of his coins and medals from this period, notably those for Clement and for Alessandro de' Medici, the ruler of Florence who employed him for a few months in 1535 (plates 25, 27, 33, 39, 40). It is clear from the *Trattato dell'Oreficeria* that Cellini was particularly proud of the technical innovations which he introduced in the manufacture of such objects, enabling him to produce unusually sharp and uniform images.

From the first he evidently regarded himself as not merely a supremely skilled craftsman, but also as a creative artist to be judged by much the same standards as painters and sculptors. Several times in the autobiography he emphasized that he was himself consistently responsible for the designs that he used, whether for figures or decoration. In other words he was claiming to be competent in the field of *disegno*, which Florentines of the period regarded as the foundation of all the visual arts and the one indispensable gift of the artist. In terms of style, too, Cellini showed himself responsive to contemporary ideals. It has been observed that the works produced up to about 1530, that is to say the seal of Ercole Gonzaga and the morse, reflect most strongly the art of the mature Raphael, whose pupils exerted a dominant influence in Rome at least until the Sack, but in the following decade Michelangelo, then at work on the *Last Judgement*, became a more important source of inspiration.

The best evidence that we have of Cellini's ability as a goldsmith is provided by the famous salt-cellar in Vienna. He himself regarded it as the most important object in precious metals that he ever made, and it is still universally recognized as one of the supreme examples of the goldsmith's art (plates 54, 55). The original commission came from Cardinal d'Este, but was

taken over by Francis I. Cellini's own account of the genesis of the salt-cellar is highly revealing. When the project was first discussed two of the Cardinal's literary friends suggested alternative schemes. One proposed the theme of Neptune and Amphitrite, the other Venus – presumably rising from the sea – surrounded by cupids. Both of these ideas were based on the conventional and inevitable association of salt with the sea, but neither, as Cellini pointed out, could have been turned into a satisfactory work of art. Their inadequacy is shown up by his own solution, which took as its starting point a contrasting pair of nude figures, Neptune with the salt and Tellus, the goddess of the earth, with the pepper. This simple invention, whose essential symmetry was ideally suited to a free-standing object, allowed ample scope for further elaboration, for example in the creatures of the earth and sea who surround the two deities, and in figures representing the times of day and the winds which decorate the oval base.

The salt-cellar was a work which demanded to be judged by the most rigorous aesthetic standards. The basic invention immediately recalls the slightly later request to Vasari for a painting from a prominent member of the Roman literary establishment, Annibale Caro, who began by saying 'Provided there are two nude figures, a man and a woman, which are the greatest themes of your art, choose whatever subject and whatever poses you think best'. As one would expect, for his visual sources Cellini went to the most admired model, Michelangelo, whose allegories in the Medici Chapel are clearly recalled both in the central figures and in the Times of Day. But Cellini's ideal of female beauty was different from Michelangelo's; the elongated body and small head of Tellus are closer instead to the work of two artists in the service of Francis I, Rosso and Primaticcio. This certainly does not mean that he was slavishly derivative. His work is stylistically coherent and reveals in every detail the richness of formal and iconographic invention then considered indispensable in a great work of art. In these respects, as well as in its prodigious technical virtuosity, the salt-cellar can justly be considered as one of the finest and most characteristic achievements of its period in any medium.

It was also ideally suited to the taste of Francis I. The king was then engaged in an ambitious attempt to import the latest in Italian art into France, particularly to his palace at Fontainebleau. The two main founders of the School of Fontainebleau, as it has come to be called, were the Florentine painter Rosso and the Bolognese Primaticcio (a pupil of Giulio Romano), who was both a painter and a supreme sculptor in stucco. Together they developed a distinctive, highly decorative form of Mannerism, characterized above all by the use of elongated figures in elegant poses. Neither of these men was likely to regard potential rivals with any enthusiasm. Indeed, when Cellini had paid a brief visit to France in 1537 Rosso had made it clear that he was unwelcome. Now in 1540, the year of Rosso's death, Primaticcio was equally hostile. He had every reason to be, for Cellini saw in the patronage of Francis I an opportunity to produce works on a much larger scale than anything he had attempted up to that time.

Cellini's stay in France, which he was later to regard as the most fortunate and productive period of his life, lasted until 1545. Of the various projects which he undertook for the king only one, apart from the salt-cellar, has survived even in part. This is the *Nymph of Fontainebleau* (plate 58), a bronze relief more than thirteen feet wide. It was commissioned in 1542 as an element of a larger decorative ensemble for a monumental doorway, which was also to include two bronze caryatid figures of satyrs, each more than twice life-size, and two smaller reliefs showing winged Victories holding torches (plates 59, 60). The imagery was directly related to the intended setting. The nymph, of course, is the deity of the fountain which gave Fontainebleau its name; the prominent stag whom she protectively embraces represents the king himself, who used this animal as his device; the dogs and game allude to the hunting that took place in the neighbourhood; finally, the satyrs were probably meant simply as inhabitants of the surrounding forest, while the Victories, a common enough decorative motif in the architecture of the period, may have had no particular iconographic significance.

As a work of art the *Nymph* is generally regarded as something of a failure, a misguided attempt to deploy the techniques of goldsmith-work on a monumental scale. Certainly the

elaborate surfaces and proliferation of detail in the subsidiary elements, notably the animals, are reminiscent of the salt-cellar, but these features are undeniably effective. If the same perhaps cannot be said of the water beneath the figure, this is at least in part due to the intervention of assistants after Cellini's departure. But the real problem arises with the nymph herself; the pose is curiously slack and much of the modelling, for example in the legs, perfunctory and unconvincing. These shortcomings cannot be explained simply by the fact that here Cellini was consciously adopting the style of the School of Fontainebleau, but they seem less glaring if the work is considered in its intended setting, more than twelve feet above the ground, with the satyrs below. Some idea of what these would have looked like is provided by a drawing (plate 64) and a bronze which reproduces one of the figures on a reduced scale. It is clear from this evidence that the satyrs were to be virtually free-standing, strongly modelled and exceedingly formidable. The whole ensemble, in fact, depended for its effect on a series of contrasts. The simplified form of the nymph was set off by the richly textured background, and she in turn was meant to be very different from the satyrs. How coherent the scheme would have been in practice is another matter; but it was certainly ambitious.

This was also a feature of the other two major commissions which Francis gave Cellini. The first dated from shortly after his arrival in France, and was for twelve candelabra, each of which was to be a life-size silver statue of a god or goddess on an elaborate bronze base. Only one of these, representing Jupiter, was actually completed, in 1544. It no longer exists, but there is a drawing for the statue of Juno (plate 52), showing a figure similar in style to the Nymph and the goddess on the salt-cellar. Even more than in these other works, Cellini was here able to indulge his taste for the bizarre and fantastic, as is made abundantly clear by his account of the way in which Jupiter was first displayed to the king, slowly pushed forward on concealed castors and lit only by a flaming torch. Equally spectacular was the project for a gigantic fountain at Fontainebleau; in the centre of the basin was to be a bronze figure of Mars about fifty feet high, representing Francis, and around the rim of the basin personifications of philosophy, design, music and liberality. By 1544 Cellini had even made a full-scale model of the central figure, but his departure in the following year prevented him from continuing with the scheme.

In the autobiography he implies that he was planning to return to France after a short visit to Italy, but he also describes in some detail his growing disenchantment with his situation there, predictably attributing his problems to the fickleness of his patron, the jealousy of his professional colleagues and the machinations of courtiers. Whatever Cellini's original intention, however, he very soon resolved to stay in Florence, for almost immediately after his arrival the ruler of the city, the young Duke Cosimo de'Medici, offered him a commission too tempting to refuse. This was for a bronze statue of Perseus to be set up in the Piazza della Signoria. Cellini could not have asked for a better opportunity to demonstrate his prowess as a sculptor and thus fulfil his deepest ambition, since here his work would be displayed with two of the most celebrated masterpieces of Florentine art, Donatello's *Judith* and Michelangelo's *David*. Faced with this challenge, he produced his masterpiece.

The *Perseus* (plates 1, 76–7, 84–90) occupied Cellini intermittently for nine years. His original scheme is preserved in a wax model (plate 69). At this stage he was evidently still thinking very much in terms of the ideals of the School of Fontainebleau. The figure of Perseus was extremely slender, almost effeminate, and set in a gently twisting pose which was designed to be equally effective from several different viewpoints, a characteristic further emphasized by the rather insubstantial base. The final design was much more suited both to the nature of the site, under the centre of one of the arches of the Loggia dei Lanzi, and to the scale of the statue, which even excluding the support is more than ten feet high. Thus the pose of Perseus is much firmer, the body more robust, and the frontal viewpoint is emphasized not only in the figure itself but also in the plinth.

Cellini's statue had no real precedent in recent Florentine sculpture. The closest parallels, indeed, were to be found in Donatello's two famous free-standing bronzes, the *David* and the

Judith, each produced about a century earlier. In the sixteenth century the favourite medium of the local sculptors, following the lead of Michelangelo, was marble; but the impact of the *Perseus* was directly related to the use of bronze. This allowed Cellini to give his figure an exceptional lightness and grace by means of open forms and slender supporting elements, and also to provide it with unusually elaborate and fine decorative embellishment. Only his vast experience of working in metal enabled him to carry out the scheme, for the casting of the principal figure presented him with unprecedented technical problems, which are described in detail both in his treatise on sculpture and in some of the most dramatic pages of the autobiography.

While he was engaged on the *Perseus* Cellini also undertook various other tasks, mostly at the instigation of Cosimo de' Medici. The first of these was a bust of the Duke, begun in 1545, which the sculptor said he made primarily to gain experience of bronze casting (plate 2). The exceptional richness of the decoration and the precise delineation of every feature clearly reflect Cellini's experience as a goldsmith, but the head itself has a forcefulness of characterization which is quite unexpected. This does not seem to have been altogether to Cosimo's liking, for in 1557 he sent the bust to a fortress on Elba, presumably because it did not conform to his chosen public image of a calm, essentially benign ruler. Cellini's only other portrait bust, of the banker Bindo Altoviti (plate 92), which dates from about 1550, is conceived in much more sculptural terms; appropriately enough, it even aroused the admiration of Michelangelo. It was made very soon after Cellini's first experience of working in marble, in his statues of *Ganymede*, *Apollo and Hyacinth* and *Narcissus* (plates 80, 82, 83). The *Ganymede* was a restoration of an antique torso, but the other two, both of which have suffered greatly from long exposure to the weather, were original compositions. None of these works can be considered a total success; and it seems that in attempting here to come to terms with the principles of Hellenistic sculpture Cellini to some degree failed to impose the stamp of his own distinctive style. These statues, however, clearly show the lengths to which he was prepared to go after his return to Florence in his efforts to compete on equal terms with the established sculptors of the city.

Far more significant both to Cellini himself and as a work of art was his other major statue in marble, the *Crucifix* (plates 103–4). The idea for this originated as early as 1539, when in a moment of delirium during his imprisonment he saw a vision of the crucified Christ with the Virgin and St Peter. At that time he made a wax model of the figure of Christ, and in several wills drawn up in the 1550s he referred to this image. At first he wanted it to be reproduced in marble by a sculptor trained in the medium, but in about 1556 he began work on the *Crucifix* himself, completing it six years later. In this curious and disturbing figure, with its large head and relatively immature body, Cellini was evidently not consciously trying to fulfil any specific stylistic ideals, but simply to represent what he had seen. None the less, the distortions of the anatomy and the highly elegant rhythm of the outlines of the body, now sadly compromised by a drapery covering the genitals, place it firmly within the context of Florentine Mannerism. Apparent too, especially in the carving of the hair and beard and in the very delicate surface, is Cellini's experience of working in bronze.

He began work on the *Crucifix* at a time of increasing setbacks in his career. The account of his years in the service of Cosimo is filled with a series of complaints which by now have a familiar ring: the Duke was temperamental, and mean when it came to paying; the Duchess was initially a supporter of Cellini, but then turned against him; the officials at court were resentful and duplicitous; and he was faced with the jealousy of other artists, notably the sculptor Baccio Bandinelli, who is consistently portrayed in the autobiography as a comic figure. Regardless of the truth or otherwise of these claims, it is clear that Cellini had the misfortune to be temperamentally unsuited to the career of a court artist, however much he needed the patronage of wealthy rulers like Cosimo if he were to fulfil his ambitions as a sculptor. It is not surprising that he should several times have sought to return to France, but on each occasion the Duke refused to give his permission. Even the immense and merited acclaim

which greeted the *Perseus* did little to improve Cellini's situation, since it did not lead to other significant commissions. In 1556 and again in the following year, indeed, he found himself once more in prison, first for attacking another goldsmith and then on the much more serious charge of sodomy. A further misfortune occurred in 1559, when he expected to win a very important commission for a gigantic statue of Neptune to decorate a fountain in the Piazza della Signoria. Cellini certainly realized that this was his one chance of establishing his fame as a sculptor in marble, but the job went instead to the younger Bartolomeo Ammannati (plate 102). At about the same period he was disappointed in his hopes of producing reliefs for the cathedral.

It was in these years that Cellini turned to the composition of the autobiography. One of his main reasons for doing so was certainly the desire to record for posterity the achievements which he felt had been unjustly neglected by his contemporaries, especially in Florence. But this was not his only motive. It is evident that Cellini quite rightly felt that he had led an extraordinary life, that he was an exceptional man. The most obvious evidence of this, of course, was the vision he experienced in prison, which he later recorded in the *Crucifix*. This is described exactly in the middle of the autobiography, at the very end of the first book; and in this passage he went so far as to claim that since that time 'an aureole of glory (marvellous to relate) has rested on my head. This is visible to every sort of men to whom I have chosen to point it out; but those have been very few'. It was this conviction of divine favour that led Cellini to describe not merely his work as an artist, nor even just the most dramatic events in his life, such as the escape from Castel Sant'Angelo, but everything of note that had ever happened to him. Added to this, he was clearly a man who liked nothing better than to tell stories, particularly about himself. Thus one anecdote leads to another, and each is recounted with astonishing vividness, including long passages of dialogue. Sometimes Cellini's obsessions get the better of him. He can never forget a quarrel or forgive an injury; and his tortuous accounts of minor disputes, his complaints about imagined slights or plots, can tax the patience of the reader. But even these passages contribute to our understanding of the way in which Cellini saw his life.

In the very first sentence of the autobiography Cellini said that everyone who had achieved something of note ought to describe their own life, but not before they had reached the age of forty. The book he then produced is very different from anything written in Florence up to that time, but it is unlikely that he would have undertaken the task unless he had been aware of certain precedents. The most important of these was the Florentine tradition of *ricordanze*, manuscripts compiled by private individuals for themselves and their descendants in which they recorded the principal events in their lives, usually concentrating on business affairs and the births, marriages and deaths of relatives. Some of these were quite elaborate, but none had the scope or character of the autobiography. In Florence, too, there was a specific interest in the lives of artists. In the middle of the fifteenth century the goldsmith and sculptor Ghiberti had composed a series of very short biographical studies of fourteenth-century artists, ending with a brief account of his own career. Much nearer Cellini's own time there was of course also Vasari, another born writer, whose *Lives* was published in 1550. He did not confine himself strictly to the professional careers of artists, but also included a mass of anecdotal material, and in the case of Michelangelo produced a remarkably detailed biography. Yet another life of Michelangelo, by Ascanio Condivi, appeared in 1553. Other Florentine artists contemporary with Cellini are likewise known to have written accounts of their own lives, not all of which have survived. Cellini's book can therefore to some extent be seen as part of a local tradition, even though it is not closely based on any specific model.

It is most unlikely that the autobiography circulated at all widely in Cellini's lifetime. Some of the comments about Cosimo de' Medici would have made that impossible. But a certain amount of the material about his most important projects reappeared in the two treatises, on goldsmith-work and sculpture, which he composed between 1565 and 1567. To a degree, therefore, these were a substitute for the autobiography. In other respects they are entirely

practical in character, and this distinguishes them very markedly from most of the other writing on art produced in Italy at this period, whether by artists or critics. Cellini's method was to use his own work to illustrate the technical points he wanted to make. But even in this context he could not resist a good story, even if it was scarcely relevant to his argument. Significantly, at one point he claimed to have destroyed some pages which he had written containing disloyal remarks about the Duke. This is clearly a reference to the autobiography, the manuscript of which still survives intact. (It is in the Laurentian Library in Florence, Codex Mediceo-Palatino 234[2].) The implication is that dangerous rumours about its contents were then current in Florence.

After the completion of the *Crucifix* Cellini did not produce any further significant works of sculpture, presumably because it was physically too demanding. In his old age he seems to have sought a measure of domestic tranquillity, for in 1565 he finally married, having had a series of children by various women over the previous two decades. But his relationship with the Duke remained uneasy. In 1565 he sold him the *Crucifix*, but was forced to accept less than half the price he had originally asked; and final settlement of his fee for the bronze bust of Cosimo was reached only in 1570. Cellini also continued to quarrel with his fellow artists, notably in 1564 when he was given a major role in the preparations for the funeral of Michelangelo. Angered by a decision to give more prominence to a representation of painting than to a personification of sculpture, he declined to attend the ceremony. It seems entirely in character, therefore, that much of his energy in these last years was devoted to litigation, an activity in which he took an intense interest. Rather unexpectedly, many of his disputes were concerned with a popular Florentine form of gambling, involving wagers on the sex of unborn children. Cellini died on 13 February 1571, having bequeathed the contents of his studio to Cosimo's successor Francesco.

In certain respects Cellini's career was by no means untypical in the sixteenth century. Many of the major artists travelled widely in search of employment, and many too found problems in adjusting to the requirements of their patrons. Even Cellini's habitual recourse to violence has its parallels, notably in the case of the sculptor Leone Leoni. What made him exceptional among the Florentine artists of his day was his ambition to achieve the status of a great sculptor in the field of metalwork rather than marble carving. It is characteristic of his polemical attitude that in his design for the seal of the Florentine Accademia del Disegno, dating from about 1563, he should have added to the normal threefold division of the visual arts – painting, sculpture and architecture – a fourth category of goldsmith-work. It has been his misfortune that he has often been regarded primarily as a goldsmith, whose genius lay above all in the creation of small and exquisite objects. This does less than justice to the *Crucifix* and, above all, to the *Perseus*. For in this work especially he produced the most masterly and representative statement in sculpture of the ideals of Florentine Mannerism. In reading the autobiography it is important always to remember that Cellini's claims about his own ability were by no means unwarranted. He was unquestionably the greatest Italian goldsmith of the sixteenth century, and one of the major sculptors. His most fitting epitaph is provided by Vasari: 'in all his things he has been bold, proud, vigorous, very resolute and awesome, and he is a person who has only too well known how to speak his mind to princes, no less than to employ his skill and talent in works of art'.

<div style="text-align: right">CHARLES HOPE</div>

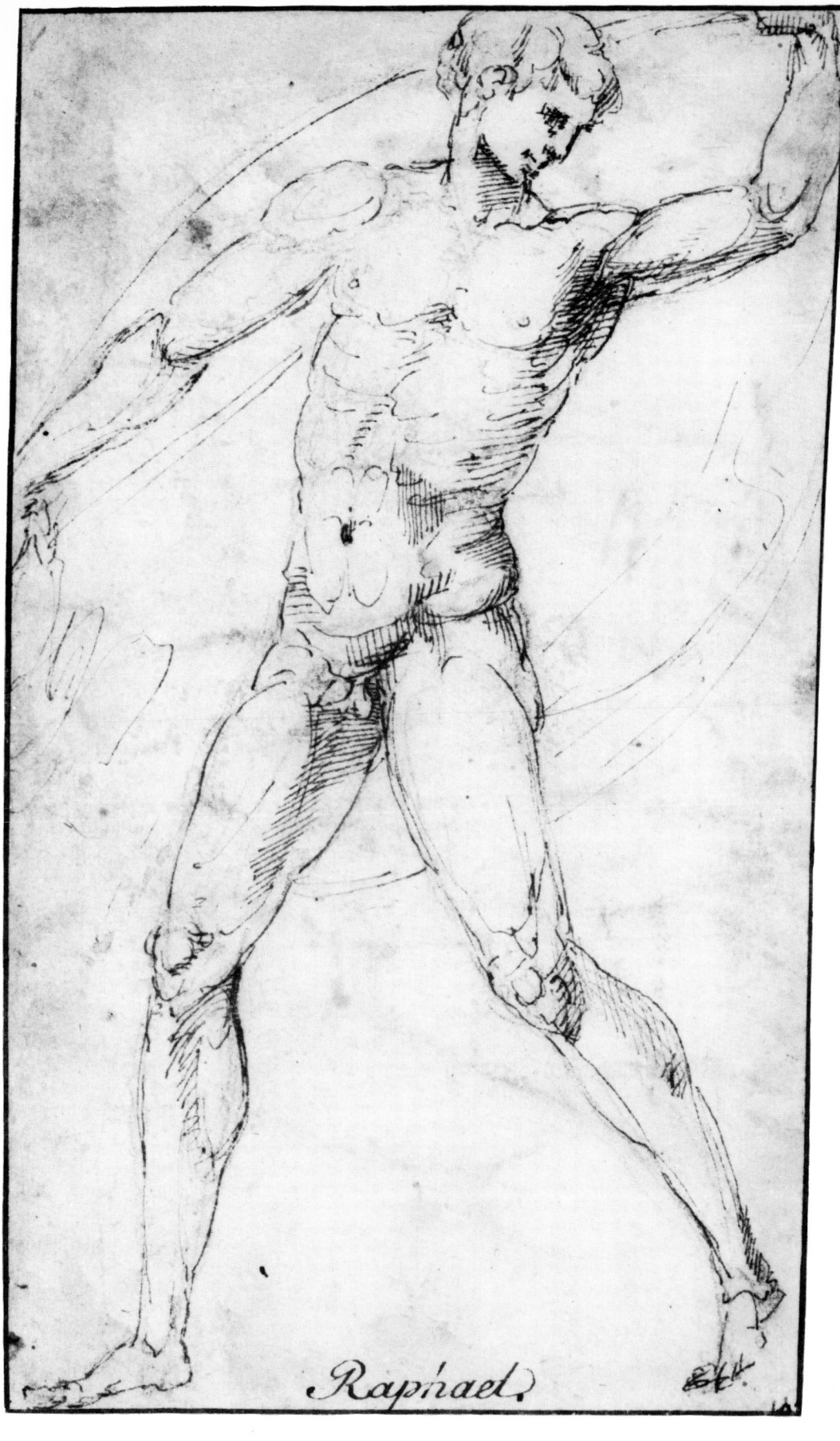

Raphael

THE LIFE OF BENVENUTO
THE SON OF GIOVANNI CELLINI
WRITTEN BY HIMSELF IN FLORENCE

ALL MEN of whatsoever quality they be, who have done anything of excellence, or which may properly resemble excellence, ought, if they are persons of truth and honesty, to describe their life with their own hand; but they ought not to attempt so fine an enterprise till they have passed the age of forty. This duty occurs to my own mind, now that I am travelling beyond the term of fifty-eight years, and am in Florence, the city of my birth. Many untoward things can I remember, such as happen to all who live upon our earth; and from those adversities I am now more free than at any previous period of my career—nay, it seems to me that I enjoy greater content of soul and health of body than ever I did in bygone years. I can also bring to mind some pleasant goods and some inestimable evils, which, when I turn my thoughts backward, strike terror in me, and astonishment that I should have reached this age of fifty-eight, wherein, thanks be to God, I am still travelling prosperously forward.

1

❦ ❧

In a work like this there will always be found occasion for natural bragging, which is of divers kinds, and the first is that a man should let others know he draws his lineage from persons of worth and most ancient origin.

2

I am called Benvenuto Cellini, son of Maestro Giovanni, son of Andrea, son of Cristofano Cellini; my mother was Madonna Elisabetta, daughter to Stefano Granacci; both parents citizens of Florence. It is found written in chronicles made by our ancestors of Florence, men of old time and of credibility, even as Giovanni Villani writes, that the city of Florence was evidently built in imitation of the fair city of Rome; and certain remnants of the Colosseum and the Baths can yet be traced. These things are near Santa Croce. The Capitol was where is now the Old Market. The Rotonda is entire, which was made for the temple of Mars, and is now dedicated to our Saint John. That thus it was, can very well be seen, and cannot be denied, but the said buildings are much smaller than those of Rome. He who caused them to be built, they say, was Julius Cæsar, in concert with some noble Romans, who, when Fiesole had been stormed and taken, raised a city in this place, and each of them took in hand to erect one of these notable edifices.

3

4

Julius Cæsar had among his captains a man of highest rank and valour, who was called Fiorino of Cellino, which is a village about two miles distant from Monte Fiascone. Now this Fiorino took up his quarters under the hill of Fiesole, on the ground where Florence now stands, in order to be near the river Arno, and for the convenience of the troops. All those

5

4 *Male nude*, drawing by Cellini *c.* 1560. Pen and brown ink. Berlin (West), Staatliche Museen Preussischer Kulturbesitz (Kupferstichkabinett)

soldiers and others who had to do with the said captain, used then to say: 'Let us go to Fiorenze'; as well because the said captain was called Fiorino, as also because the place he had chosen for his quarters was by nature very rich in flowers. Upon the foundation of the city, therefore, since this name struck Julius Cæsar as being fair and apt, and given by circumstance, and seeing furthermore that flowers themselves bring good augury, he appointed the name of Florence for the town.

I take much more pride in having been born humble and having laid some honourable foundation for my family, than if I had been born of great lineage and had stained or overclouded that by my base qualities. So then I will make a beginning by saying how it pleased God I should be born.

<p style="text-align:center">❧ ☙</p>

6 My ancestors dwelt in Val d'Ambra, where they owned large estates, and lived like little lords, in retirement, however, on account of the then contending factions. They were all men devoted to arms and of notable bravery. In that time one of their sons, the younger, who was called Cristofano, roused a great feud with certain of their friends and neighbours. Now the heads of the families on both sides took part in it, and the fire kindled seemed to them so threatening that their houses were like to perish utterly; the elders upon this consideration, in concert with my own ancestors, removed Cristofano; and the other youth with whom the quarrel began was also sent away. They sent their young man to Siena. Our folk sent
7 Cristofano to Florence; and there they bought for him a little house in Via Chiara. The house with some other trifles fell to the share of one of the said sons, who had the name of Andrea. He also took wife, and had four male children. The first was called Girolamo, the second Bartolommeo, the third Giovanni, who was afterwards my father, and the fourth Francesco.
8 This Andrea Cellini was very well versed in architecture, as it was then practised, and lived by it as his trade. Giovanni, who was my father, paid more attention to it than any of the other
9 brothers. And since Vitruvius says, amongst other things, that one who wishes to practise that art well must have something of music and good drawing, Giovanni, when he had mastered
10 drawing, began to turn his mind to music, and together with the theory learned to play most excellently on the viol and the flute; and being a person of studious habits, he left his home but seldom.

They had for neighbour in the next house a man called Stefano Granacci, who had several daughters, all of them of remarkable beauty. As it pleased God, Giovanni noticed one of these
11 girls who was named Elisabetta; and she found such favour with him that he asked her in marriage. They enjoyed their youth and wedded love through eighteen years, always greatly desiring to be blessed with children. At the end of this time Giovanni's wife miscarried of two boys through the unskilfulness of the doctors. Later on she was again with child, and gave birth to a girl, whom they called Cosa, after the mother of my father. At the end of two years she was once more with child; and inasmuch as those longings to which pregnant women are subject, and to which they pay much attention, were now exactly the same as those of her former pregnancy, they made their minds up that she would give birth to a female as before, and agreed to call the child Reparata, after the mother of my mother. It happened that she was
12 delivered on a night of All Saints, following the feast-day, at half-past four precisely, in the year 1500. The midwife, who knew that they were expecting a girl, after she had washed the baby and wrapped it in the fairest white linen, came softly to my father Giovanni and said: 'I am bringing you a fine present, such as you did not anticipate.' My father, who was a true philosopher, was walking up and down, and answered: 'What God gives me is always dear to me'; and when he opened the swaddling clothes, he saw with his own eyes the unexpected male child. Joining together the palms of his old hands, he raised them with his eyes to God, and said: 'Lord, I thank Thee with my whole heart; this gift is very dear to me; let him be Welcome.' All the persons who were there asked him joyfully what name the child should

bear. Giovanni would make no other answer than 'Let him be Welcome – Benvenuto'; and so they resolved, and this name was given me at Holy Baptism, and by it I still am living with the grace of God.

Andrea Cellini was yet alive when I was about three years old, and he had passed his hundredth. One day they had been altering a certain conduit pertaining to a cistern, and there issued from it a great scorpion unperceived by them, which crept down from the cistern to the ground, and slank away beneath a bench. I saw it, and ran up to it, and laid my hands upon it. It was so big that when I had it in my little hands, it put out its tail on one side, and on the other thrust forth both its claws. They relate that I ran in high joy to my grandfather, crying out: 'Look, grandpapa, at my pretty little crab.' When he recognized that the creature was a scorpion, he was on the point of falling dead for the great fear he had and anxiety about me. He coaxed and entreated me to give it him; but the more he begged, the tighter I clasped it, crying and saying I would not give it to any one. My father, who was also in the house, ran up when he heard my screams, and in his stupefaction could not think how to prevent the venomous animal from killing me. Just then his eyes chanced to fall upon a pair of scissors; and so, while soothing and caressing me, he cut its tail and claws off. Afterwards, when the great peril had been thus averted, he took the occurrence for a good augury.

When I was about five years old my father happened to be in a basement-chamber of our house, where they had been washing, and where a good fire of oak-logs was still burning; he had a viol in his hand, and was playing and singing alone beside the fire. The weather was very cold. Happening to look into the fire, he spied in the middle of those most burning flames a little creature like a lizard, which was sporting in the core of the intensest coals. Becoming instantly aware of what the thing was, he had my sister and me called, and pointing it out to us children, gave me a great box on the ears, which caused me to howl and weep with all my might. Then he pacified me good-humouredly, and spoke as follows: 'My dear little boy, I am not striking you for any wrong that you have done, but only to make you remember that that lizard which you see in the fire is a salamander, a creature which has never been seen before by any one of whom we have credible information.' So saying, he kissed me and gave me some pieces of money.

My father began teaching me to play upon the flute and sing by note; but notwithstanding I was of that tender age when little children are wont to take pastime in whistles and such toys, I had an inexpressible dislike for it, and played and sang only to obey him. My father in those times fashioned wonderful organs with pipes of wood, spinets the fairest and most excellent which then could be seen, viols and lutes and harps of the most beautiful and perfect construction. He was an engineer, and had marvellous skill in making instruments for lowering bridges and for working mills, and other machines of that sort. In ivory he was the first who wrought really well. But after he had fallen in love with the woman who was destined to become my mother – perhaps what brought them together was that little flute, to which indeed he paid more attention than was proper – he was entreated by the fifers of the Signory to play in their company.

My father was the devoted servant and attached friend of the house of Medici; and when Piero was banished, he entrusted him with many affairs of the greatest possible importance. Afterwards, when the magnificent Piero Soderini was elected, and my father continued in his office of musician, Soderini, perceiving his wonderful talent, began to employ him in many matters of great importance as an engineer.

Thus some time passed, until the Medici returned. When they arrived, the Cardinal, who afterwards became Pope Leo, received my father very kindly. During their exile the scutcheons which were on the palace of the Medici had had their balls erased, and a great red cross painted over them, which was the bearing of the Commune. Accordingly, as soon as they returned, the red cross was scratched out, and on the scutcheon the red balls and the golden field were painted in again, and finished with great beauty. My father, who possessed a simple vein of poetry, instilled in him by nature, together with a certain touch of prophecy, which

13
14

15

16

17

was doubtless a divine gift in him, wrote these four verses under the said arms of the Medici, when they were uncovered to the view:

> These arms, which have so long from sight been laid
> Beneath the holy cross, that symbol meek,
> Now lift their glorious glad face, and seek
> With Peter's sacred cloak to be arrayed.

18 This epigram was read by all Florence. A few days afterwards Pope Julius II died. The Cardinal de' Medici went to Rome, and was elected Pope against the expectation of everybody. He reigned as Leo X, that generous and great soul. My father sent him his four prophetic verses. The Pope sent to tell him to come to Rome; for this would be to his advantage. But he had no will to go; and so, in lieu of reward, his place in the palace was taken from him by Jacopo
19 Salviati, upon that man's election as Gonfalonier. This was the reason why I commenced goldsmith; after which I spent part of my time in learning that art, and part in playing, much against my will.

My good father placed me in the workshop of Cavaliere Bandinello's father, who was called Michel Agnolo, a goldsmith from Pinzi di Monte, and a master excellent in that craft. He had no distinction of birth whatever, but was the son of a charcoal-seller. This is no blame to
20 Bandinello, who has founded the honour of the family – if only he had done so honestly!
21 At that time I had a brother, younger by two years, a youth of extreme boldness and fierce temper. He afterwards became one of the great soldiers in the school of that marvellous general
22 Giovannino de' Medici, father of Duke Cosimo. The boy was about fourteen, and I two years older. One Sunday evening, just before nightfall, he happened to find himself between the gate
23 San Gallo and the Porta a Pinti; in this quarter he came to duel with a young fellow of twenty or thereabouts. They both had swords; and my brother dealt so valiantly that, after having badly wounded him, he was upon the point of following up his advantage. There was a great crowd of people present, among whom were many of the adversary's kinsfolk. Seeing that the thing was going ill for their own man, they put hand to their slings, a stone from one of which hit my poor brother in the head. He fell to the ground at once in a dead faint. I ran up at once, seized his sword, and stood in front of him, bearing the brunt of several rapiers and a shower of stones. I never left his side until some brave soldiers came from the gate San Gallo and rescued me from the crowd; they marvelled much, the while, to find such valour in so young a boy.
 Then I carried my brother home for dead, and it was only with great difficulty that he came
24 to himself again. When he was cured, the Eight, who had already condemned our adversaries and banished them for a term of years, sent us also into exile for six months at a distance of ten
25 miles from Florence. I went to Siena, wishing to look up a certain worthy man called Maestro Francesco Castoro. Francesco, when I reached him, recognized me at once, and gave me work to do. While thus occupied, he placed a house at my disposal for the whole time of my sojourn in Siena. Into this I moved, together with my brother, and applied myself to labour for the space of several months.
26 The Cardinal de' Medici, who afterwards became Pope Clement VII, had us recalled to Florence at the entreaty of my father. A certain pupil of my father's, moved by his own bad nature, suggested to the Cardinal that he ought to send me to Bologna, in order to learn to play well from a great master there. The Cardinal said to my father that, if he sent me there, he would give me letters of recommendation and support. My father, dying with joy at such an opportunity, sent me off; and I being eager to see the world, went with good grace.
 When I reached Bologna, I put myself under a certain Maestro Ercole del Piffero, and began to earn something by my trade. In the meantime I used to go every day to take my music-lesson, and in a few weeks made considerable progress in that accursed art. However, I made

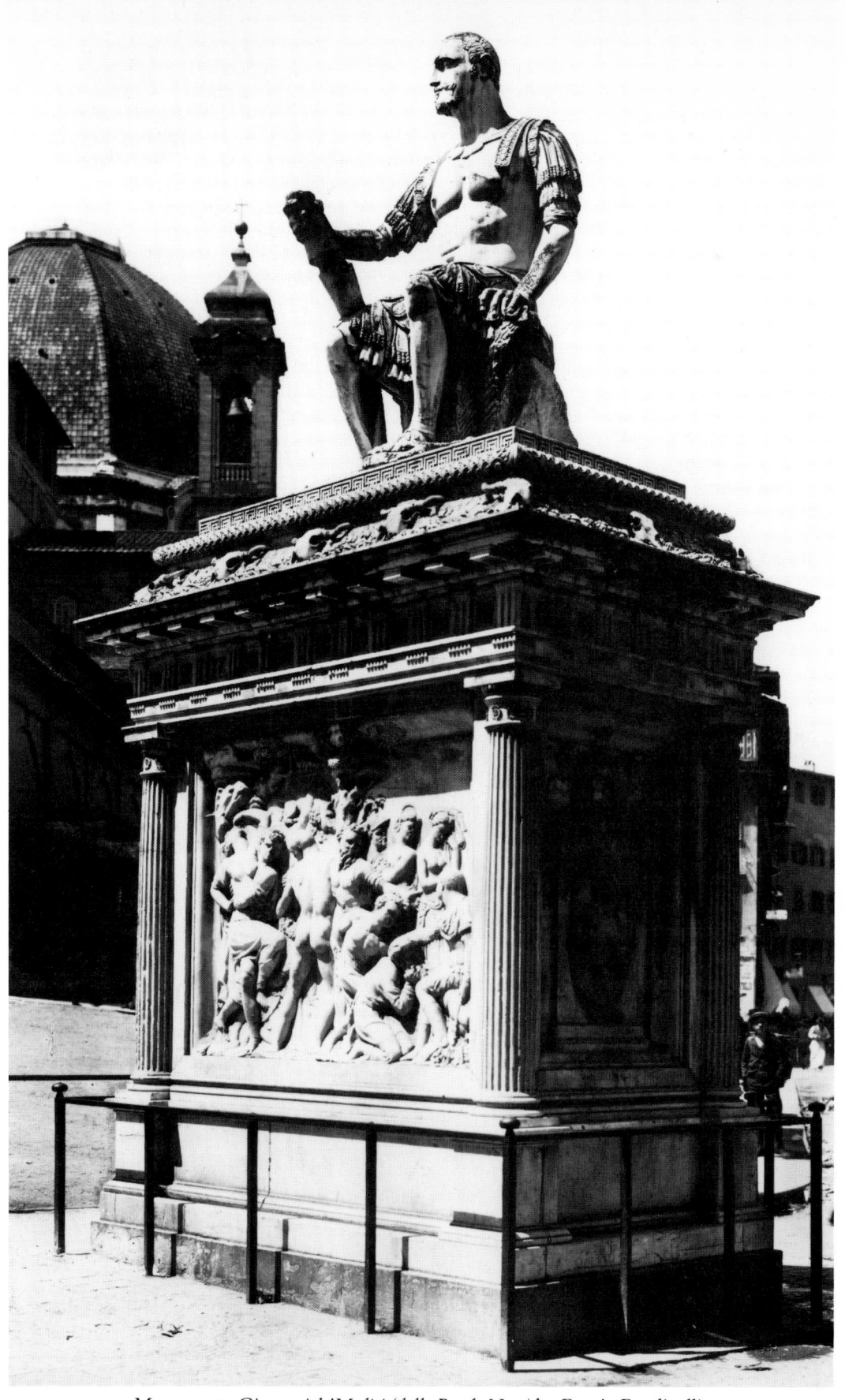

5 *Monument to Giovanni de'Medici (dalle Bande Nere)* by Baccio Bandinelli,
1540. Florence, Piazza S. Lorenzo

still greater in my trade of goldsmith; for the Cardinal having given me no assistance, I went to
live with a Bolognese illuminator who was called Scipione Cavalletti (his house was in the
street of our Lady del Baraccan); and while there I devoted myself to drawing and working for
one Graziadio, a Jew, with whom I earned considerably. At the end of six months I returned to
Florence.

My brother Cecchino, being still quite a lad, was returning from his first lesson in the school
of the stupendous Giovannino de' Medici. On the day when he reached home, I happened to
be absent; and he, being in want of proper clothes, sought out our sisters, who, unknown to
my father, gave him a cloak and doublet of mine, both new and of good quality. I ought to say
that, beside the aid I gave my father and my excellent and honest sisters, I had bought those
handsome clothes out of my own savings. When I found I had been cheated, and my clothes
taken from me, and my brother from whom I should have recovered them was gone, I asked
my father why he suffered so great a wrong to be done me, seeing that I was always ready to
assist him. He replied that I was his good son, but that the other, whom he thought to have lost,
had been found again; also that it was a duty, nay, a precept from God Himself, that he who
hath should give to him who hath not; and that for his sake I ought to bear this injustice, for God
would increase me in all good things. I, like a youth without experience, retorted on my poor
afflicted parent; and taking the miserable remnants of my clothes and money, went toward a
gate of the city. As I did not know which gate would start me on the road to Rome, I arrived at
Lucca, and from Lucca reached Pisa.

When I came to Pisa (I was about sixteen years of age at the time), I stopped near the middle
bridge, by what is called the Fish-stone, at the shop of a goldsmith, and began attentively to
watch what the master was about. He asked me who I was, and what was my profession. I told
him that I worked a little in the same trade as his own. This worthy man bade me come into his
shop, and at once gave me work to do, and spoke as follows: 'Your good appearance makes me
believe you are a decent honest youth.' Then he told me out gold, silver, and gems; and when
the first day's work was finished, he took me in the evening to his house, where he dwelt
respectably with his handsome wife and children.

While I stayed at Pisa, I went to see the Campo Santo, and there I found many beautiful
fragments of antiquity, that is to say, marble sarcophagi. In other parts of Pisa also I saw many
antique objects, which I diligently studied whenever I had days or hours free from the labour of
the workshop. My master, who took pleasure in coming to visit me in the little room which he
had allotted me, observing that I spent all my time in studious occupations, began to love me
like a father. I made great progress in the one year that I stayed there, and completed several
fine and valuable things in gold and silver, which inspired me with a resolute ambition to
advance in my art.

At the end of the year my master Ulivieri had occasion to go to Florence, in order to sell
certain gold and silver sweepings which he had; and inasmuch as the bad air of Pisa had given
me a touch of fever, I went with the fever hanging still about me, in my master's company,
back to Florence. There my father received him most affectionately, and lovingly prayed him,
unknown by me, not to insist on taking me again to Pisa.

About that time there came to Florence a sculptor named Piero Torrigiani; he arrived from
England, where he had resided many years. When he saw my drawings and the things which I
was making, he said: 'I have come to Florence to enlist as many young men as I can; for I have
undertaken to execute a great work for my king, and want some of my own Florentines to help
me. Now your method of working and your designs are worthy rather of a sculptor than a
goldsmith; and since I have to turn out a great piece of bronze, I will at the same time turn you
into a rich and able artist.' This man had a splendid person and a most arrogant spirit, with the
air of a great soldier more than of a sculptor, especially in regard to his vehement gestures and
his resonant voice, together with a habit he had of knitting his brows, enough to frighten any
man of courage. He kept talking every day about his gallant feats among those beasts of
Englishmen.

In course of conversation he happened to mention Michel Agnolo Buonarroti, led thereto
by a drawing I had made from a cartoon of that divinest painter. This cartoon was the first
masterpiece which Michel Agnolo exhibited, in proof of his stupendous talents. He produced it
in competition with another painter, Leonardo da Vinci, who also made a cartoon; and both
were intended for the council-hall in the palace of the Signory. They represented the taking of *31*
Pisa by the Florentines; and our admirable Leonardo had chosen to depict a battle of horses, *32*
with the capture of some standards, in as divine a style as could possibly be imagined. Michel
Agnolo in his cartoon portrayed a number of foot-soldiers, who, the season being summer, had
gone to bathe in Arno. He drew them at the very moment the alarm is sounded, and the men all
naked run to arms; so splendid in their action that nothing survives of ancient or of modern art
which touches the same lofty point of excellence; and as I have already said, the design of the
great Leonardo was itself most admirably beautiful. These two cartoons stood, one in the
palace of the Medici, the other in the hall of the Pope. So long as they remained intact, they *33*
were the school of the world. Though the divine Michel Agnolo in later life finished that great *34*
chapel of Pope Julius, he never rose half-way to the same pitch of power; his genius never *35*
afterwards attained to the force of those first studies.

Now let us return to Piero Torrigiani, who, with my drawing in his hand, spoke as follows:
'This Buonarroti and I used, when we were boys, to go into the Church of the Carmine, to
learn drawing from the chapel of Masaccio. It was Buonarroti's habit to banter all who were *36*
drawing there; and one day, among others, when he was annoying me, I got more angry than
usual, and clenching my fist, gave him such a blow on the nose, that I felt bone and cartilage go
down like biscuit beneath my knuckles; and this mark of mine he will carry with him to the
grave.' These words begat in me such hatred of the man, since I was always gazing at the
masterpieces of the divine Michel Agnolo, that although I felt a wish to go with him to
England, I now could never bear the sight of him.

All the while I was at Florence, I studied the noble manner of Michel Agnolo, and from this I *37*
have never deviated. About that time I contracted a close and familiar friendship with an
amiable lad of my own age, who was also in the goldsmith's trade. He was called Francesco, *38*
son of Filippo, and grandson of Fra Lippo Lippi, that most excellent painter. Through
intercourse together, such love grew up between us that, day or night, we never stayed apart.
The house where he lived was still full of the fine studies which his father had made, bound up
in several books of drawings by his hand, and taken from the best antiquities of Rome. The *39*
sight of these things filled me with passionate enthusiasm; and for two years or thereabouts
we lived in intimacy.

There was one Giovan Battista, surnamed Il Tasso, a woodcarver, precisely of my own age, *40*
who one day said to me that if I was willing to go to Rome, he should be glad to join me. Now
we had this conversation together immediately after dinner; and I being angry with my father
for the same old reason of the music, said to Tasso: 'You are a fellow of words, not deeds.' He
answered: 'I too have come to anger with my mother; and if I had cash enough to take me to
Rome, I would not turn back to lock the door of that wretched little workshop I call mine.' To
these words I replied that if that was all that kept him in Florence I had money enough in my
pockets to bring us both to Rome. Talking thus and walking onwards, we found ourselves at
the gate San Piero Gattolini without noticing that we had got there; whereupon I said: 'Friend *41*
Tasso, this is God's doing that we have reached this gate without either you or me noticing that
we were there; and now that I am here, it seems to me that I have finished half the journey.'
And so, being of one accord, we pursued our way together, saying, 'Oh, what will our old
folks say this evening?' We then made an agreement not to think more about them till we
reached Rome. So we tied our aprons behind our backs, and trudged almost in silence to Siena.
When we arrived at Siena, Tasso said (for he had hurt his feet) that he would not go farther,
and asked me to lend him money to get back. I made answer: 'I should not have enough left to
go forward; you ought indeed to have thought of this on leaving Florence; and if it is because
of your feet that you shirk the journey, we will find a return horse for Rome, which will

deprive you of the excuse.' Accordingly I hired a horse; and seeing that he did not answer, I took my way toward the gate of Rome. When he knew that I was firmly resolved to go, muttering between his teeth, and limping as well as he could, he came on behind me very slowly and at a great distance. On reaching the gate, I felt pity for my comrade, and waited for him, and took him on the crupper, saying: 'What would our friends speak of us to-morrow, if, having left for Rome, we had not pluck to get beyond Siena?' Then the good Tasso said I spoke the truth; and as he was a pleasant fellow, he began to laugh and sing; and in this way, always singing and laughing, we travelled the whole way to Rome. I had just nineteen years then, and so had the century.

42 When we reached Rome, I put myself under a master who was known as Il Firenzuola. His name was Giovanni, and he came from Firenzuola in Lombardy, a most able craftsman in large vases and big plate of that kind. I showed him part of the model for the clasp which I had made in Florence. It pleased him exceedingly; and turning to one of his journeymen, a Florentine *43* called Giannotto Giannotti, who had been several years with him, he spoke as follows: 'This fellow is one of the Florentines who know something, and you are one of those who know nothing.'

He gave me a very fine piece of silver plate to work on for a cardinal. It was a little oblong box, *44* copied from the porphyry sarcophagus before the door of the Rotonda. Beside what I copied, I enriched it with so many elegant masks of my invention, that my master went about showing it through the art, and boasting that so good a piece of work had been turned out from his shop. It was about half a cubit in size, and was so constructed as to serve for a salt-cellar at table. This was the first earning that I touched at Rome, and part of it I sent to assist my good father; the rest I kept for my own use, living upon it while I went about studying the antiquities of Rome, until my money failed, and I had to return to the shop for work. Battista del Tasso, my comrade, did not stay long in Rome, but went back to Florence.

After undertaking some new commissions, I took it into my head, as soon as I had finished them, to change my master; I had indeed been worried into doing so by a certain Milanese, *45* called Pagolo Arsago. My first master, Firenzuola, had a great quarrel about this with Arsago, and abused him in my presence; whereupon I took up speech in defence of my new master. I said that I was born free, and free I meant to live, and that there was no reason to complain of him, far less of me, since some few crowns of wages were still due to me; also that I chose to go, like a free journeyman, where it pleased me, knowing I did wrong to no man. Firenzuola cried: 'Don't show yourself again upon my premises.' I reminded him of the money he owed me. He laughed me in the face; on which I said that if I knew how to use my tools in handicraft as well as he had seen, I could be quite as clever with my sword in claiming the just payment of my labour. While we were exchanging these words, an old man happened to come up, called *46* Maestro Antonio, of San Marino. He was the chief among the Roman goldsmiths, and had been Firenzuola's master. Hearing what I had to say, which I took good care that he should understand, he immediately espoused my cause, and bade Firenzuola pay me. The dispute waxed warm, because Firenzuola was an admirable swordsman, far better than he was a goldsmith. Yet reason made itself heard; and I backed my cause with the same spirit, till I got myself paid. In course of time Firenzuola and I became friends, and at his request I stood godfather to one of his children.

I went on working with Pagolo Arsago, and earned a good deal of money, the greater part of which I always sent to my good father. At the end of two years, upon my father's entreaty, I returned to Florence. At that time I fashioned a silver heart's-key (*chiavaquore*), as it was then called. This was a girdle three inches broad, which used to be made for brides, and was executed in half relief with some small figures in the round. It was a commission from a man called Raffaello Lapaccini. I was very badly paid; but the honour which it brought me was worth far more than the gain I might have justly made by it.

I finished several pretty pieces, and made good gains, and was able to give my family much help. This roused the jealousy of the bad men among my former masters, who were called

Salvadore and Michele Guasconti. In the guild of the goldsmiths they had three big shops, and 47
drove a thriving trade. It chanced one day that I was leaning against a shop of one of these men,
who called out to me, and began partly reproaching, partly bullying. I answered that had they
done their duty by me, I should have spoken of them what one speaks of good and worthy
men; but as they had done the contrary, they ought to complain of themselves and not of me.
While I was standing there and talking, one of them, named Gherardo Guasconti, their cousin,
having perhaps been put up to it by them, lay in wait till a beast of burden went by. It was a
load of bricks. When the load reached me, Gherardo pushed it so violently on my body that I
was very much hurt. Turning suddenly round and seeing him laughing, I struck him such a
blow on the temple that he fell down, stunned, like one dead. Then I faced round to his cousins,
and said: 'That's the way to treat cowardly thieves of your sort'; and when they wanted to
make a move upon me, trusting to their numbers, I, whose blood was now well up, laid hands
to a little knife I had, and cried: 'If one of you comes out of the shop, let the other run for the
confessor, because the doctor will have nothing to do here.' These words so frightened them
that not one stirred to help their cousin. As soon as I had gone, the fathers and sons ran to the
Eight, and declared that I had assaulted them in their shops with sword in hand, a thing which
had never yet been seen in Florence. The magistrates had me summoned. I appeared before
them; and they began to upbraid and cry out upon me.

I waited till the magistrates had gone to dinner; and when I was alone, and observed that
none of their officers were watching me, in the fire of my anger, I left the palace, ran to my
shop, seized a dagger, and rushed to the house of my enemies, who were at home and shop
together. I found them at table; and Gherardo, who had been the cause of the quarrel, flung
himself upon me. I stabbed him in the breast, piercing doublet and jerkin through and through
to the shirt, without however grazing his flesh or doing him the least harm in the world. When 48
I felt my hand go in, and heard the clothes tear, I thought that I had killed him; and seeing him
fall terror-struck to earth, I cried: 'Traitors, this day is the day on which I mean to murder you
all.' Father, mother, and sisters, thinking the last day had come, threw themselves upon their
knees, screaming out for mercy with all their might; but I perceiving that they offered no
resistance, and that he was stretched for dead upon the ground, thought it too base a thing to
touch them. I ran storming down the staircase; and when I reached the street, I found all the
rest of the household, more than twelve persons; one of them had seized an iron shovel,
another a thick iron pipe, one had an anvil, some of them hammers, and some cudgels. When I
got among them, raging like a mad bull, I flung four or five to the earth, and fell down with
them myself, continually aiming my dagger now at one and now at another. Those who
remained upright plied both hands with all their force, giving it me with hammers, cudgels,
and anvil; but inasmuch as God does sometimes mercifully intervene, He so ordered that
neither they nor I did any harm to one another. I only lost my cap, on which my adversaries
seized, though they had run away from it before, and struck at it with all their weapons.
Afterwards, they searched among their dead and wounded, and saw that not a single man was
injured.

I went off in the direction of Santa Maria Novella, and stumbling up against Fra Alessio 49
Strozzi, whom by the way I did not know, I entreated this good friar for the love of God to
save my life, since I had committed a great fault. He told me to have no fear; for had I done
every sin in the world, I was yet in perfect safety in his little cell.

Frate Alessio disguised me like a friar and gave me a lay brother to go with me. Quitting the
convent, and issuing from the city by the gate of Prato, I went along the walls as far as the 50
Piazza di San Gallo. Then I ascended the slope of Montui, and in one of the first houses there I
found a man called Il Grassuccio, own brother to Messer Benedetto da Monte Varchi. I flung 51
off my monk's clothes, and became once more a man. Then we mounted two horses, which
were waiting there for us, and went by night to Siena. Grassuccio returned to Florence, sought
out my father, and gave him the news of my safe escape. At Siena I waited for the mail to
Rome, which I afterwards joined; and when we passed the Paglia, we met a courier carrying

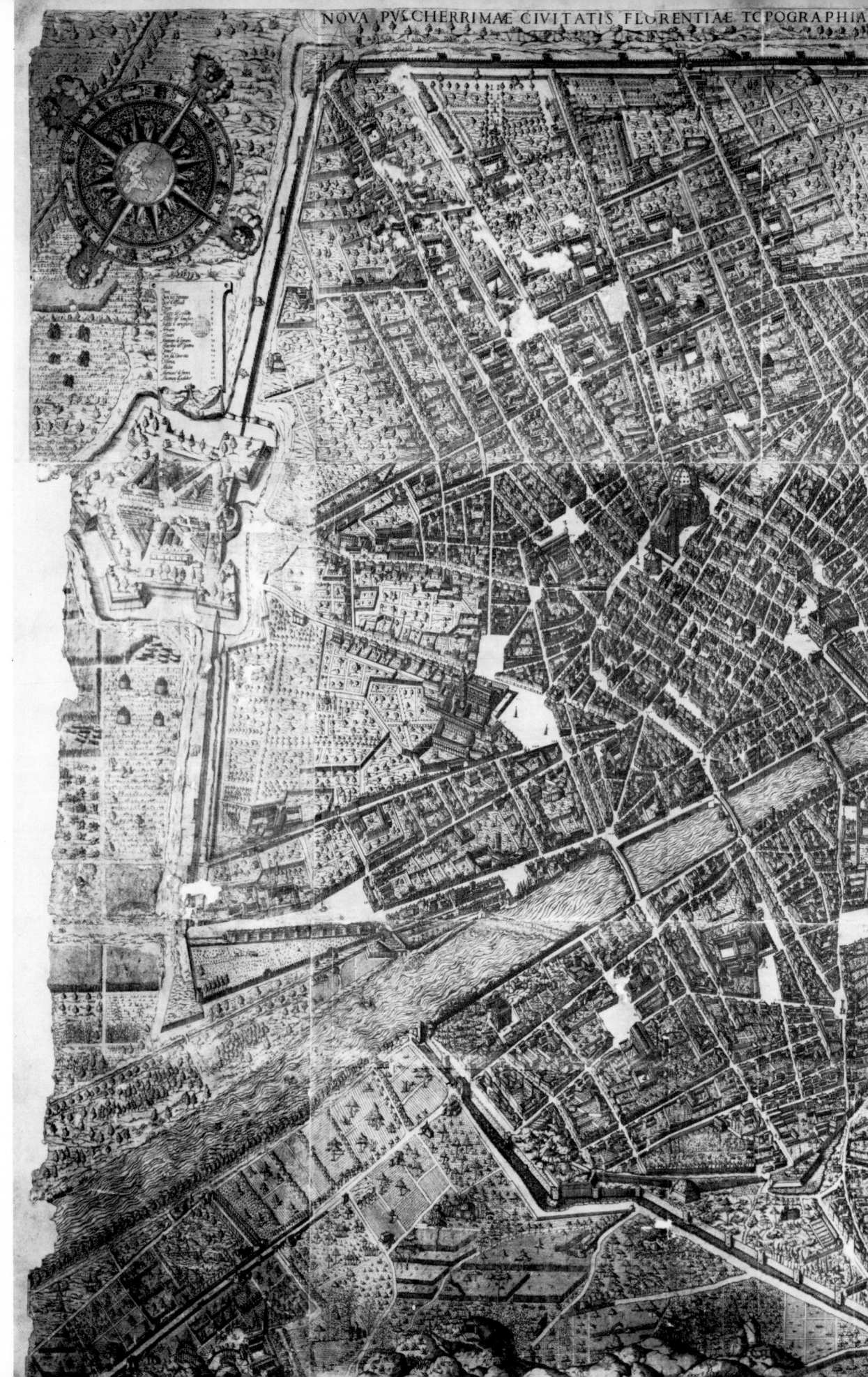

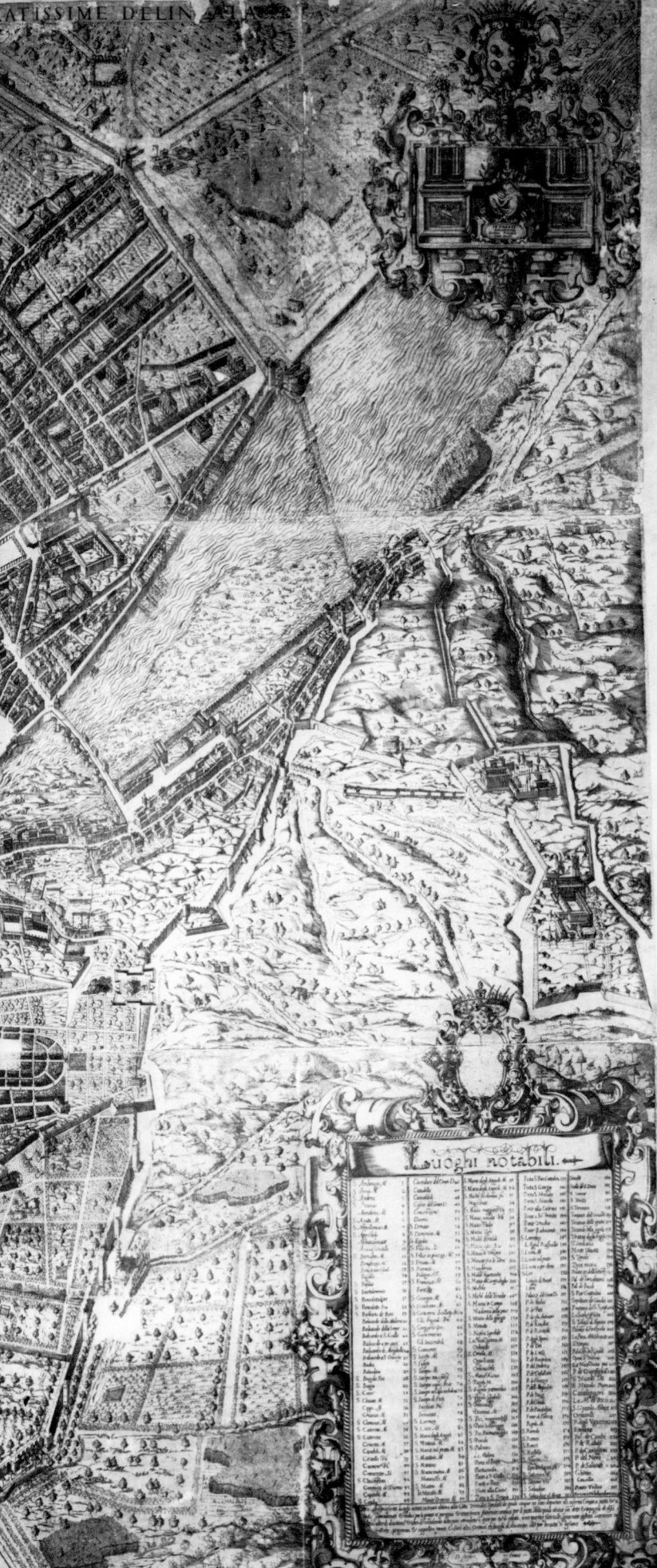

6 Map of Florence by
Buonsignori, 1594. British
Library (23480/21)

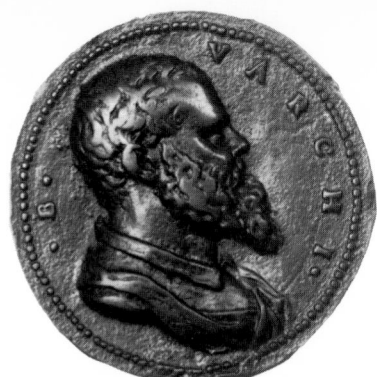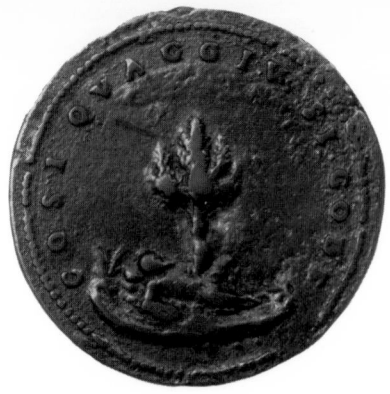

7 Medal by Domenico Poggini (1520–90). Obverse, *Benedetto Varchi*;
reverse, *Man lying beneath a laurel-tree*. Washington DC, National Gallery
(Samuel H. Kress Coll.)

⁵² news of the new Pope, Clement VII. Upon my arrival in Rome, I went to work in the shop of
⁵³ the master-goldsmith Santi. He was dead; but a son of his carried on the business. He did not
⁵⁴ work himself, but entrusted all his commissions to a young man named Lucagnolo from Iesi, a
country fellow, who while yet a child had come into Santi's service. This man was short but
well porportioned, and was a more skilful craftsman than any one whom I had met with up to
that time; remarkable for facility and excellent in design. He executed large plate only; that is
to say, vases of the utmost beauty, basons, and such pieces. Having put myself to work there, I
⁵⁵ began to make some candelabra for the Bishop of Salamanca, a Spaniard. They were richly
chased, so far as that sort of work admits. A pupil of Raffaello da Urbino called Gian Francesco,
⁵⁶ and commonly known as Il Fattore, was a painter of great ability; and being on terms of
friendship with the Bishop, he introduced me to his favour, so that I obtained many
commissions from that prelate, and earned considerable sums of money.

⁵⁷ During that time I went to draw, sometimes in Michel Agnolo's chapel, and sometimes in
the house of Agostino Chigi of Siena, which contained many incomparable paintings by the
⁵⁸ hand of that great master Raffaello. This I did on feast-days, because the house was then
⁵⁹ inhabited by Messer Gismondo, Agostino's brother. They plumed themselves exceedingly
⁶⁰ when they saw young men of my sort coming to study in their palaces. Gismondo's wife,
noticing my frequent presence in that house – she was a lady as courteous as could be, and of
surpassing beauty – came up to me one day, looked at my drawings, and asked me if I was a
sculptor or a painter; to whom I said I was a goldsmith. She remarked that I drew too well for a
⁶¹ goldsmith; and having made one of her waiting-maids bring a lily of the finest diamonds set in
gold, she showed it to me, and bade me value it. I valued it at 800 crowns. Then she said that I
had very nearly hit the mark, and asked me whether I felt capable of setting the stones really
well. I said that I should much like to do so, and began before her eyes to make a little sketch for
it, working all the better because of the pleasure I took in conversing with so lovely and
agreeable a gentlewoman. When the sketch was finished, another Roman lady of great
beauty joined us; she had been above, and now descending to the ground-floor, asked
⁶² Madonna Porzia what she was doing there. She answered with a smile: 'I am amusing myself
by watching this worthy young man at his drawing; he is as good as he is handsome.' I had by
this time acquired a trifle of assurance, mixed, however, with some honest bashfulness; so I
blushed and said: 'Such as I am, lady, I shall ever be most ready to serve you.' The
gentlewoman, also slightly blushing, said: 'You know well that I want you to serve me'; and
reaching me the lily, told me to take it away; and gave me besides twenty golden crowns
which she had in her bag, and added: 'Set me the jewel after the fashion you have sketched, and
keep for me the old gold in which it is now set.' I stayed on a short while at the drawing I was
making, which was a copy of a Jove by Raffaello. When I had finished it and left the house, I set
myself to making a little model of wax, in order to show how the jewel would look when it

was completed. This I took to Madonna Porzia, whom I found with the same Roman lady. Both of them were highly satisfied with my work, and treated me so kindly that, being somewhat emboldened, I promised the jewel should be twice as good as the model. Accordingly I set hand to it, and in twelve days I finished it in the form of a fleur-de-lys, as I have said above, ornamenting it with little masks, children, and animals, exquisitely enamelled, whereby the diamonds which formed the lily were more than doubled in effect.

While I was working at this piece, Lucagnolo showed considerable discontent, telling me over and over again that I might acquire far more profit and honour by helping him to execute large plate, as I had done at first. I made him answer that, whenever I chose, I should always be capable of working at great silver pieces; but that things like that on which I was now engaged were not commissioned every day; and beside their bringing no less honour than large silver plate, there was also more profit to be made by them. He laughed me in the face, and said: 'Wait and see, Benvenuto; for by the time that you have finished that work of yours, I will make haste to have finished this vase, which I took in hand when you did the jewel; and then experience shall teach you what profit I shall get from my vase, and what you will get from your ornament.' I answered that I was very glad indeed to enter into such a competition with so good a craftsman as he was, because the end would show which of us was mistaken. Accordingly both the one and the other of us, with a scornful smile upon our lips, bent our heads in grim earnest to the work, which both were now desirous of accomplishing; so that after about ten days, each had finished his undertaking with great delicacy and artistic skill. 63

Lucagnolo's was a huge silver piece, used at the table of Pope Clement, into which he flung away bits of bone and the rind of divers fruits, while eating; an object of ostentation rather than necessity. The vase was adorned with two fine handles, together with many masks, both small and great, and masses of lovely foliage, in as exquisite a style of elegance as could be imagined; on seeing which I said it was the most beautiful vase that ever I set eyes on. Thinking he had convinced me, Lucagnolo replied: 'Your work seems to me no less beautiful, but we shall soon perceive the difference between the two.' So he took his vase and carried it to the Pope, who was very well pleased with it, and ordered at once that he should be paid at the ordinary rate of such large plate. Meanwhile I carried mine to Madonna Porzia, who looked at it with astonishment, and told me I had far surpassed my promise. Then she bade me ask for my reward whatever I liked; for it seemed to her my desert was so great that if I craved a castle she could hardly recompense me; but since that was not in her hands to bestow, she added laughing that I must beg what lay within her power. I answered that the greatest reward I could desire for my labour was to have satisfied her ladyship. Then, smiling in my turn, and bowing to her, I took my leave, saying I wanted no reward but that.

When I came back to the shop, Lucagnolo had the money for his vase in a paper packet; and on my arrival he cried out: 'Come and compare the price of your jewel with the price of my plate.' I said that he must leave things as they were till the next day, because I hoped that even as my work in its kind was not less excellent than his, so I should be able to show him quite an equal price for it.

On the day following, Madonna Porzia sent a major-domo of hers to my shop, who called me out, and putting into my hands a paper packet full of money from his lady, told me that she did not choose the devil should have his whole laugh out. Lucagnolo, who was burning to compare his packet with mine, burst into the shop; then in the presence of twelve journeymen and some neighbours, eager to behold the result of this competition, he seized his packet, scornfully exclaiming 'O! ou!' three or four times, while he poured his money on the counter with a great noise. They were twenty-five crowns in giulios; and he fancied that mine would be four or five crowns di moneta. I for my part, stunned and stifled by his cries, and by the looks and smiles of the bystanders, first peeped into my packet; then, after seeing that it contained nothing but gold, I retired to one end of the counter, and, keeping my eyes lowered and making no noise at all, I lifted it with both hands suddenly above my head, and emptied it like a mill hopper. My coin was twice as much as his; which caused the onlookers, who had fixed

their eyes on me with some derision, to turn round suddenly to him and say: 'Lucagnolo, Benvenuto's pieces, being all of gold and twice as many as yours, make a far finer effect.' I thought for certain that, what with jealousy and what with shame, Lucagnolo would have fallen dead upon the spot; and though he took the third part of my gain, since I was a journeyman (for such is the custom of the trade, two-thirds fall to the workman and one-third to the masters of the shop), yet inconsiderate envy had more power in him than avarice: it ought indeed to have worked quite the other way, he being a peasant's son from Iesi. He cursed his art and those who taught it him, vowing that thenceforth he would never work at large plate, but give his whole attention to those whoreson gewgaws, since they were so well paid. Equally enraged on my side, I answered that every bird sang its own note; that he talked after the fashion of the hovels he came from; but that I dared swear that I should succeed with ease in making his lubberly lumber, while he would never be successful in my whoreson gewgaws. Thus I flung off in a passion, telling him that I would soon show him that I spoke truth.

Meanwhile, I contrived, by means of a pupil of Raffaello da Urbino, to get an order from the Bishop of Salamanca for one of those great water-vessels called *acquereccia*, which are used for ornaments to place on sideboards. He wanted a pair made of equal size; and one of them he intrusted to Lucagnolo, the other to me. Giovan Francesco, the painter I have mentioned, gave us the design.

64 It happened at that time that one Giangiacomo of Cesena, a musician in the Pope's band, and a very excellent performer, sent word through Lorenzo, the trumpeter of Lucca, who is now in
65 our Duke's service, to inquire whether I was inclined to help them at the Pope's Ferragosto, playing soprano with my cornet in some motets of great beauty selected by them for that occasion. Although I had the greatest desire to finish the vase I had begun, yet, since music has a wondrous charm of its own, and also because I wished to please my old father, I consented to join them. During eight days before the festival we practised two hours a day together; then on
66 the first of August we went to the Belvedere, and while Pope Clement was at table, we played those carefully studied motets so well that his Holiness protested he had never heard music more sweetly executed or with better harmony of parts. He sent for Giangiacomo, and asked him where and how he had procured so excellent a cornet for soprano, and inquired particularly who I was. Giangiacomo told him my name in full. Whereupon the Pope said: 'So, then, he is the son of Maestro Giovanni?' On being assured I was, the Pope expressed his wish to have me in his service with the other bandsmen. Giangiacomo replied: 'Most blessed Father, I cannot pretend for certain that you will get him, for his profession, to which he devotes himself assiduously, is that of a goldsmith.' To this the Pope added: 'I am the better inclined to him now that I find him possessor of a talent more than I expected. See that he obtains the same salary as the rest of you; and tell him from me to join my service, and that I will find work enough by the day for him to do in his other trade.' Then stretching out his hand, he gave him a hundred golden crowns of the Camera in a handkerchief, and said: 'Divide these so that he may take his share.'

When Giangiacomo left the Pope, he came to us, and related in detail all that the Pope had said; and after dividing the money between the eight of us, and giving me my share, he said to me: 'Now I am going to have you inscribed among our company.' I replied: 'Let the day pass; to-morrow I will give my answer.' When I left them, I went meditating whether I ought to accept the invitation, inasmuch as I could not but suffer if I abandoned the noble studies of my
67 art. The following night my father appeared to me in a dream, and begged me with tears of tenderest affection, for God's love and his, to enter upon this engagement. Methought I answered that nothing would induce me to do so. In an instant he assumed so horrible an aspect as to frighten me out of my wits, and cried: 'If you do not, you will have a father's curse; but if you do, may you be ever blessed by me!' When I woke, I ran, for very fright, to have myself inscribed. Then I wrote to my old father, telling him the news, which so affected him with extreme joy that a sudden fit of illness took him, and well-nigh brought him to death's door. In his answer to my letter, he told me that he too had dreamed nearly the same as I had.

Knowing now that I had gratified my father's honest wish, I began to think that everything would prosper with me to a glorious and honourable end. Accordingly, I set myself with indefatigable industry to the completion of the vase I had begun for Salamanca. That prelate was a very extraordinary man, extremely rich, but difficult to please. He sent daily to learn what I was doing; and when his messenger did not find me at home, he broke into fury, saying that he would take the work out of my hands and give it to others to finish. This came of my slavery to that accursed music. Still I laboured diligently night and day, until, when I had brought my work to a point when it could be exhibited, I submitted it to the inspection of the Bishop. This so increased his desire to see it finished, that I was sorry I had shown it. At the end of three months I had it ready, with little animals and foliage and masks, as beautiful as one could hope to see. No sooner was it done than I sent it by the hand of my workman, Paulino, to show that able artist Lucagnolo, of whom I have spoken above. Paulino, with the grace and beauty which belonged to him, spoke as follows: 'Messer Lucagnolo, Benvenuto bids me say that he has sent to show you his promises and your lumber, expecting in return to see from you his gewgaws.' This message given, Lucagnolo took up the vase, and carefully examined it; then he said to Paulino: 'Fair boy, tell your master that he is a great and able artist, and that I beg him to be willing to have me for a friend, and not to engage in aught else.' The mission of that virtuous and marvellous lad caused me the greatest joy; and then the vase was carried to Salamanca, who ordered it to be valued. Lucagnolo took part in the valuation, estimating and praising it far above my own opinion. Salamanca, lifting up the vase, cried like a true Spaniard: 'I swear by God that I will take as long in paying him as he has lagged in making it.' When I heard this, I was exceedingly put out, and fell to cursing all Spain and every one who wished well to it.

Amongst other beautiful ornaments, this vase had a handle, made all of one piece, with most delicate mechanism, which, when a spring was touched, stood upright above the mouth of it. While the prelate was one day ostentatiously exhibiting my vase to certain Spanish gentlemen of his suit, it chanced that one of them, upon Monsignor's quitting the room, began roughly to work the handle, and as the gentle spring which moved it could not bear this loutish violence, it broke in his hand. Aware what mischief he had done, he begged the butler who had charge of the bishop's plate to take it to the master who had made it, for him to mend, and promised to pay what price he asked, provided it was set to rights at once. So the vase came once more into my hands, and I promised to put it forthwith in order, which indeed I did. It was brought to me before dinner; and at twenty-two o'clock the man who brought it returned, all in a sweat, for he had run the whole way, Monsignor having again asked for it to show to certain other gentlemen. The butler, then, without giving me time to utter a word, cried: 'Quick, quick, bring the vase.' I, who wanted to act at leisure and not to give it up to him, said that I did not mean to be so quick. The serving-man got into such a rage that he made as though he would put one hand to his sword, while with the other he threatened to break the shop open. To this I put a stop at once with my own weapon, using therewith spirited language, and saying: 'I am not going to give it to you! Go and tell Monsignor, your master, that I want the money for my work before I let it leave this shop.' When the fellow saw he could not obtain it by swaggering, he fell to praying me, as one prays to the Cross, declaring that if I would only give it up, he would take care I should be paid. These words did not make me swerve from my purpose; but I kept on saying the same thing. At last, despairing of success, he swore to come with Spaniards enough to cut me to pieces. Then he took to his heels; while I, who inclined to believe partly in their murderous attack, resolved that I would defend myself with courage. So I got an admirable little gun ready, which I used for shooting game, and muttered to myself: 'He who robs me of my property and labour may take my life too, and welcome.' While I was carrying on this debate in my own mind, a crowd of Spaniards arrived, led by the major-domo, who, with the headstrong rashness of his race, bade them go in and take the vase and give me a good beating. Hearing these words, I showed them the muzzle of my gun, and prepared to fire, and cried in a loud voice: 'Renegade Jews, traitors, is it thus that one breaks

into houses and shops in our city of Rome? Come as many of you thieves as you like, an inch nearer to this wicket, and I'll blow all their brains out with my gun.' Then I turned the muzzle on their major-domo, and making as though I would discharge it, called out: 'And you big thief, who are egging them on, I mean to kill you first.' He clapped spurs to the jennet he was riding, and took flight headlong. The commotion we were making stirred up all the neighbours, who came crowding round, together with some Roman gentlemen who chanced to pass, and cried: 'Do but kill the renegades, and we will stand by you.' These words had the effect of frightening the Spaniards in good earnest. They withdrew, and were compelled by the circumstances to relate the whole affair to Monsignor. Being a man of inordinate haughtiness, he rated the members of his household, both because they had engaged in such an act of violence, and also because, having begun, they had not gone through with it. At this juncture the painter, who had been concerned in the whole matter, came in, and the Bishop bade him go and tell me that if I did not bring the vase at once, he would made mincemeat of me; but if I brought it, he would pay its price down. These threats were so far from terrifying me, that I sent him word I was going immediately to lay my case before the Pope.

In the meantime, his anger and my fear subsided; whereupon, being guaranteed by some Roman noblemen of high degree that the prelate would not harm me, and having assurance that I should be paid, I armed myself with a large poniard and my good coat of mail, and betook myself to his palace, where he had drawn up all his household. I entered, and Paulino followed with the silver vase. It was just like passing through the Zodiac, neither more nor less; for one of them had the face of the lion, another of the scorpion, a third of the crab. However, we passed onward to the presence of the rascally priest, who spouted out a torrent of such language as only priests and Spaniards have at their command. In return I never raised my eyes to look at him, nor answered word for word. That seemed to augment the fury of his anger; and causing paper to be put before me, he commanded me to write an acknowledgment to the effect that I had been amply satisfied and paid in full. Then I raised my head, and said I should be very glad to do so when I had received the money. The Bishop's rage continued to rise; threats and recriminations were flung about; but at last the money was paid, and I wrote the receipt. Then I departed, glad at heart and in high spirits.

When Pope Clement heard the story – he had seen the vase before, but it was not shown him as my work – he expressed much pleasure and spoke warmly in my praise, publicly saying that he felt very favourably toward me. This caused Monsignor Salamanca to repent that he had hectored over me; and in order to make up our quarrel, he sent the same painter to inform me that he meant to give me large commissions. I replied that I was willing to undertake them, but that I should require to be paid in advance. This speech too came to Pope Clement's ears, and made him laugh heartily.

Madonna Porzia now advised me to open a shop of my own. This I did; and I never stopped working for that excellent and gentle lady, who paid me exceedingly well, and by whose means perhaps it was that I came to make a figure in the world.

I contracted close friendship with Signor Gabbriello Ceserino, at that time Gonfalonier of Rome, and executed many pieces for him. One, among the rest, is worthy of mention. It was a
68 large golden medal to wear in the hat. I engraved upon it Leda with her swan; and being very well pleased with the workmanship, he said he should like to have it valued, in order that I might be properly paid. Now, since the medal was executed with consummate skill, the valuers of the trade set a far higher price on it than he had thought of. I therefore kept the medal, and got nothing for my pains.

69 There was at that time in Rome a very able artist of Perugia named Lautizio, who worked only in one department, where he was sole and unrivalled throughout the world. You must know that at Rome every cardinal has a seal, upon which his title is engraved, and these seals are made just as large as a child's hand of about twelve years of age; and, as I have already said, the cardinal's title is engraved upon the seal together with a great many ornamental figures. A well-made article of the kind fetches a hundred, or more than a hundred crowns. This excellent

8 Drawing by Francesco Bartoli of the tiara made by Caradosso for Pope Julius II. British Museum (*See note 70*)

workman, like Lucagnolo, roused in me some honest rivalry, although the art he practised is far remote from the other branches of gold-smithery, and consequently Lautizio was not skilled in making anything but seals. I gave my mind to acquiring his craft also, although I found it very difficult; and, unrepelled by the trouble which it gave me, I went on zealously upon the path of profit and improvement.

There was in Rome another most excellent craftsman of ability, who was a Milanese named Messer Caradosso. He dealt in nothing but little chiselled medals, made of plates of metal, and such-like things. I have seen of his some paxes in half relief, and some Christs a palm in length wrought of the thinnest golden plates, so exquisitely done that I esteemed him the greatest

70

master in that kind I had ever seen, and envied him more than all the rest together. There were also other masters who worked at medals carved in steel, which may be called the models and true guides for those who aim at striking coins in the most perfect style. All these divers arts I set myself with unflagging industry to learn.

<div align="center">❦ ❧</div>

At that time, while I was still a young man of about twenty-three, there raged a plague of such extraordinary violence that many thousands died of it every day in Rome. Somewhat terrified at this calamity, I began to take certain amusements, as my mind suggested, and for a reason which I will presently relate. I had formed a habit of going on feast-days to the ancient buildings, and copying parts of them in wax or with the pencil; and since these buildings are all ruins, and the ruins house innumerable pigeons, it came into my head to use my gun against these birds. So then, avoiding all commerce with people, in my terror of the plague, I used to put a fowling-piece on my boy Pagolino's shoulder, and he and I went out alone into the ruins; and oftentimes we came home laden with a cargo of the fattest pigeons. My natural temperament was melancholy, and while I was taking these amusements, my heart leapt up with joy, and I found that I could work better and with far greater mastery than when I spent my whole time in study and manual labour. In this way my gun, at the end of the game, stood me more in profit than in loss.

It was also the cause of my making acquaintance with certain hunters after curiosities, who followed in the track of those Lombard peasants who used to come to Rome to till the vineyards at the proper season. While digging the ground, they frequently turned up antique medals, agates, chrysoprases, cornelians, and cameos; also sometimes jewels, as, for instance, emeralds, sapphires, diamonds, and rubies. The peasants used to sell things of this sort to the traders for a mere trifle; and I very often, when I met them, paid the latter several times as many golden crowns as they had given giulios for some object. Independently of the profit I made by this traffic, which was at least tenfold, it brought me also into agreeable relations with nearly all the cardinals of Rome. I will only touch upon a few of the most notable and rarest of these curiosities. There came into my hands, among many other fragments, the head of a dolphin about as big as a good-sized ballot-bean. Not only was the style of this head extremely beautiful, but nature had here far surpassed art; the stone was an emerald of such good colour, that the man who bought it from me for tens of crowns sold it again for hundreds after setting it as a finger-ring. I will mention another kind of gem; this was a magnificent topaz; and here art equalled nature; it was as large as a big hazel-nut, with the head of Minerva in a style of inconceivable beauty. I remember yet another precious stone, different from these; it was a cameo, engraved with Hercules binding Cerberus of the triple throat; such was its beauty and the skill of its workmanship, that our great Michel Agnolo protested he had never seen anything so wonderful. Among many bronze medals, I obtained one upon which was a head of Jupiter. It was the largest that had ever been seen; the head of the most perfect execution; and it had on the reverse side a very fine design of some little figures in the same style.

As I have said above, the plague had broken out. There arrived in Rome a surgeon of the highest renown, who was called Maestro Giacomo da Carpi. This able man, in the course of his other practice, undertook the most desperate cases of the so-called French disease. In Rome this kind of illness is very partial to the priests, and especially to the richest of them. When, therefore, Maestro Giacomo had made his talents known, he professed to work miracles in the treatment of such cases by means of certain fumigations; but he only undertook a cure after stipulating for his fees, which he reckoned not by tens, but by hundreds of crowns. He was a

9 Apollo with the Python, drawing by Cellini for the seal of the Academy of Florence, 1563. Chalk, pen and ink, wash, $7 \times 5\frac{1}{2}$ ins (18.4 × 14.2 cm). Munich, Staatliche Graphische Sammlung

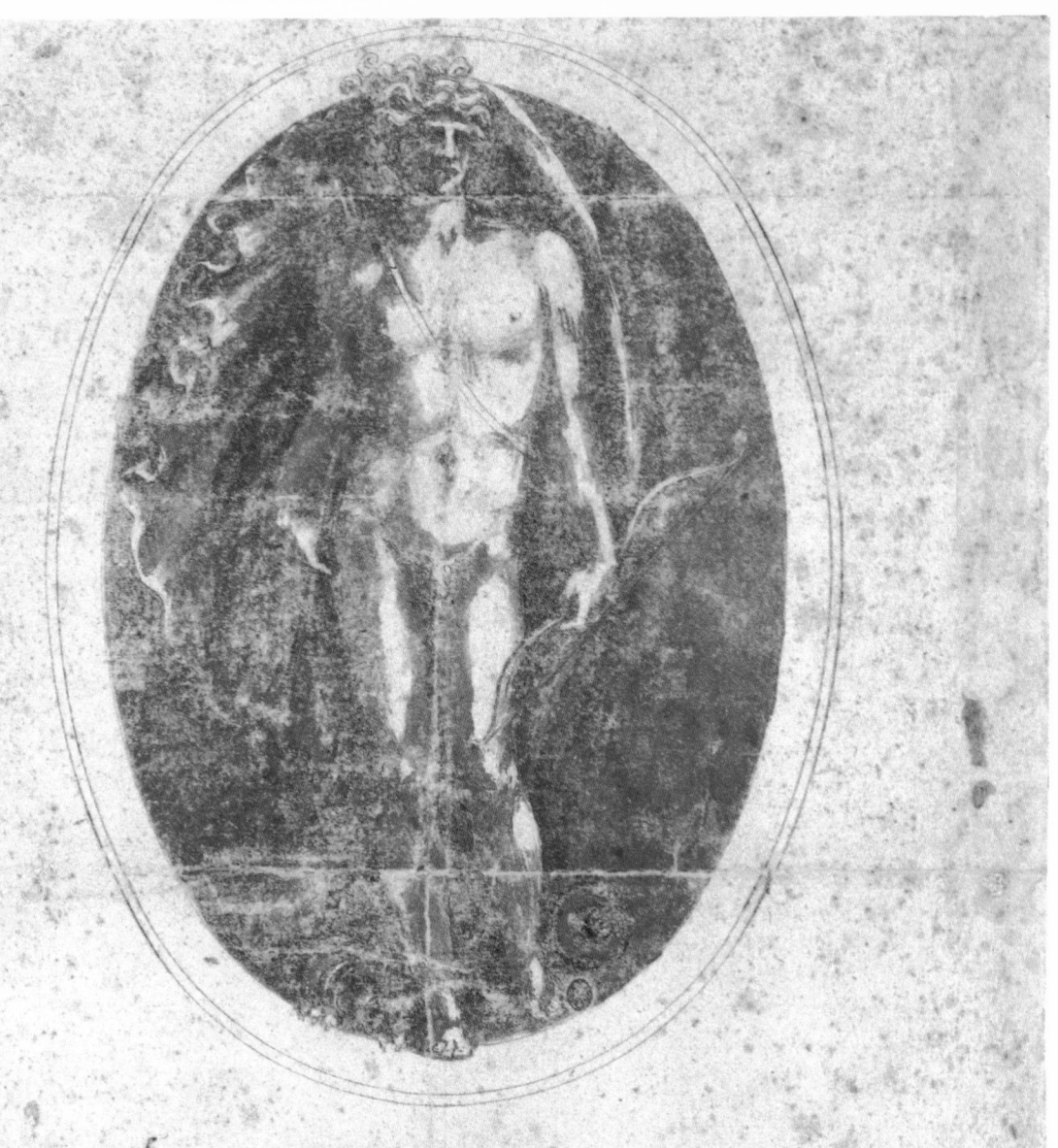

La inscrizione d'intorno al sigillo è questa.

Apollo è sol la Luc'

Cosmo è principio à la gran Scuola, è Duce. ii. F. e's.

Il gran Pianeta del Sole, questo è sol la Lucerna dell'universo, e gli Antichi e maggior nostri lo figurarano, e dimostrarano per la figura d'Apo. e perchè doppo quel gran diluvio, che ricoperse tutta la Terra, essendo ritornate tutte l'Acque à i lor luoghi, era restata una nebbia folta, che non lasciava germinare la Terra; ma il Sole con la virtù de non cuoro feri la nebbia che la risolse; Onde gli Antichi figurarano con l'arco, et le saette con le quali feri Phitone serpente, che così fu

45. 377.

great connoisseur in the arts of design. Chancing to pass one day before my shop, he saw a lot of drawings which I had laid upon the counter, and among these were several designs for little vases in a capricious style, which I had sketched for my amusement. These vases were in quite a different fashion from any which had been seen up to that date. He was anxious that I should finish one or two of them for him in silver; and this I did with the fullest satisfaction, seeing they exactly suited my own fancy. The clever surgeon paid me very well, and yet the honour which the vases brought me was worth a hundred times as much; for the best craftsmen in the goldsmith's trade declared they had never seen anything more beautiful or better executed.

No sooner had I finished them than he showed them to the Pope; and the next day following he betook himself away from Rome. He was a man of much learning, who used to discourse wonderfully about medicine. The Pope would fain have had him in his service, but he replied that he would not take service with anybody in the world, and that whoso had need of him might come to seek him out. He was a person of great sagacity, and did wisely to get out of Rome; for not many months afterwards, all the patients he had treated grew so ill that they were a hundred times worse off than before he came. He would certainly have been murdered if he had stopped. He showed my little vases to several persons of quality; amongst others, to 76 the most excellent Duke of Ferrara, and pretended that he had got them from a great lord in Rome, by telling this nobleman that if he wanted to be cured, he must give him those two vases; and that the lord had answered that they were antique, and besought him to ask for anything else which it might be convenient for him to give, provided only he would leave him those; but, according to his own account, Maestro Giacomo made as though he would not undertake the cure, and so he got them.

77 I was told this by Messer Alberto Bendedio in Ferrara, who with great ostentation showed me some earthenware copies he possessed of them. Thereupon I laughed, and as I said nothing, Messer Alberto Bendedio, who was a haughty man, flew into a rage and said: 'You are laughing at them, are you? And I tell you that during the last thousand years there has not been born a man capable of so much as copying them.' I then, not caring to deprive them of so eminent a reputation, kept silence, and admired them with mute stupefaction. It was said to me in Rome by many great lords, some of whom were my friends, that the work of which I have been speaking was, in their opinion, of marvellous excellence and genuine antiquity; whereupon, emboldened by their praises, I revealed that I had made them. As they would not believe it, and as I wished to prove that I had spoken truth, I was obliged to bring evidence and to make new drawings of the vases; for my word alone was not enough, inasmuch as Maestro Giacomo had cunningly insisted upon carrying off the old drawings with him. By this little job I earned a fair amount of money.

The plague went dragging on for many months, but I had as yet managed to keep it at bay; for though several of my comrades were dead, I survived in health and freedom. Now it chanced one evening that an intimate comrade of mine brought home to supper a Bolognese prostitute named Faustina. She was a very fine woman, but about thirty years of age; and she had with her a little serving-girl of thirteen or fourteen. Faustina belonging to my friend, I would not have touched her for all the gold in the world; and though she declared she was madly in love with me, I remained steadfast in my loyalty. But after they had gone to bed, I stole away the little serving-girl, who was quite a fresh maid, and woe to her if her mistress had known of it! The result was that I enjoyed a very pleasant night, far more to my satisfaction than if I had passed it with Faustina. I rose upon the hour of breaking fast, and felt tired, for I had travelled many miles that night, and was wanting to take food, when a crushing headache seized me; several boils appeared on my left arm, together with a carbuncle which showed itself just beyond the palm of the left hand where it joins the wrist. Everybody in the house was in a panic; my friend, the cow and the calf, all fled. Left alone there with my poor little prentice, who refused to abandon me, I felt stifled at the heart, and made up my mind for certain I was a dead man.

Just then the father of the lad went by, who was physician to the Cardinal Iacoacci, and lived

as member of that prelate's household. The boy called out: 'Come, father, and see Benvenuto; he is in bed with some trifling indisposition.' Without thinking what my complaint might be, the doctor came up at once, and when he had felt my pulse, he saw and felt what was very contrary to his own wishes. Turning round to his son, he said: 'O traitor of a child, you've ruined me; how can I venture now into the Cardinal's presence?' His son made answer: 'Why, father, this man my master is worth far more than all the cardinals in Rome.' Then the doctor turned to me and said: 'Since I am here, I will consent to treat you. But of one thing only I warn you, that if you have enjoyed a woman, you are doomed.' To this I replied: 'I did so this very night.' He answered: 'With whom, and to what extent?' I said: 'Last night, and with a girl in her earliest maturity.' Upon this, perceiving that he had spoken foolishly, he made haste to add: 'Well, considering the sores are so new, and have not yet begun to stink, and that the remedies will be taken in time, you need not be too much afraid, for I have good hopes of curing you.' Soon the admirable remedies which I had used began to work a great improvement, and I came out of that dreadful sickness.

The sore was still open, with a plug of lint inside it and a plaster above, when I went out riding on a little wild pony. He was covered with hair four fingers long, and was exactly as big as a well-grown bear; indeed he looked just like a bear. I rode out on him to visit the painter Rosso, who was then living in the country, toward Città Vecchia, at a place of Count Anguillara's, called Cervetera. I found my friend, and he was very glad to see me; whereupon I said: 'I am come to do to you that which you did to me so many months ago.' He burst out laughing, embraced and kissed me, and begged me for the Count's sake to keep quiet. I stayed in that place about a month, with much content and gladness, enjoying good wines and excellent food, and treated with the greatest kindness by the Count.

On the last day (for after this I went there no more) I was attacked by a band of men, who had disguised themselves, and disembarked from a Moorish privateer. When they thought that they had run me into a certain passage, where it seemed impossible that I should escape from their hands, I suddenly mounted my pony, resolved to be roasted or boiled alive at that pass perilous, seeing I had little hope to evade one or the other of these fates; but, as God willed, my pony, who was the same I have described above, took an incredibly wide jump, and brought me off in safety, for which I heartily thanked God. I told the story to the Count; he ran to arms; but we saw the galleys setting out to sea. The next day following I went back sound and with good cheer to Rome.

The plague had by this time almost died out, so that the survivors, when they met together alive, rejoiced with much delight in one another's company. This led to the formation of a club of painters, sculptors, and goldsmiths, the best that were in Rome; and the founder of it was a sculptor with the name of Michel Agnolo. He was a Sienese and a man of great ability, who could hold his own against any other workman in that art; but, above all, he was the most amusing comrade and the heartiest good fellow in the universe. Of all the members of the club, he was the eldest, and yet the youngest from the strength and vigour of his body. We often came together; at the very least twice a week. I must not omit to mention that our society counted Giulio Romano, the painter, and Gian Francesco, both of them celebrated pupils of the mighty Raffaello da Urbino.

After many and many merry meetings, it seemed good to our worthy president that for the following Sunday we should repair to supper in his house, and that each one of us should be obliged to bring with him his crow (such was the nickname Michel Agnolo gave to women in the club), and that whoso did not bring one should be sconced by paying a supper to the whole company. Those of us who had no familiarity with women of the town, were forced to purvey themselves at no small trouble and expense, in order to appear without disgrace at that distinguished feast of artists. I had reckoned upon being well provided with a young woman of considerable beauty, called Pantasilea, who was very much in love with me; but I was obliged to give her up to one of my dearest friends, called Il Bachiacca, who on his side had been, and still was, over head and ears in love with her. This exchange excited a certain amount of lover's

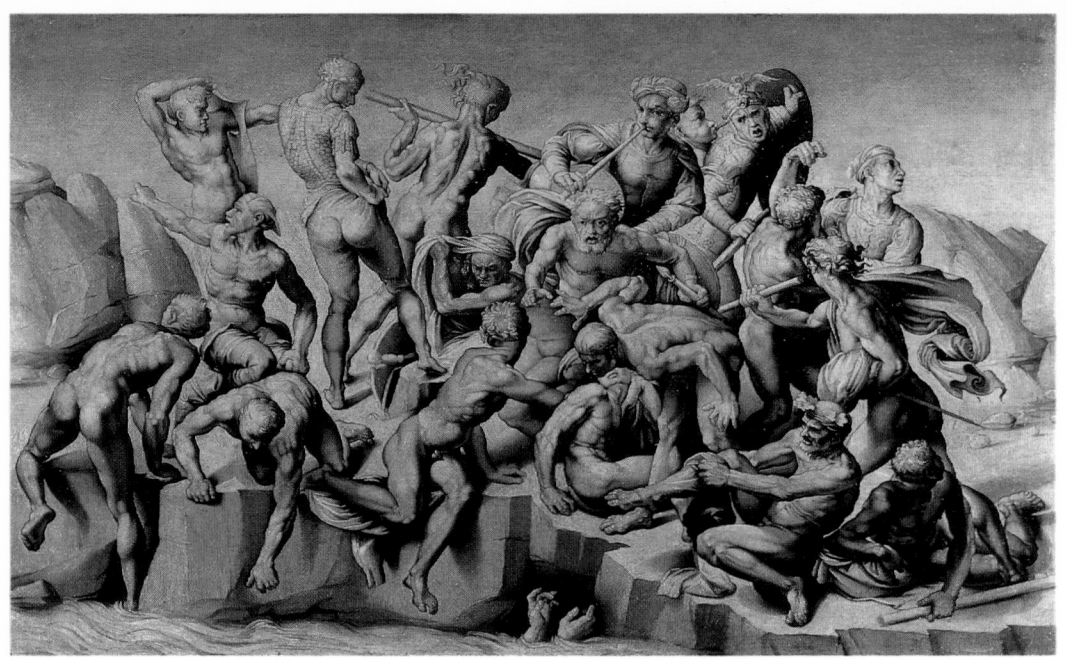

10 TOP *The Battle of Cascina*, copy by Aristotele da Sangallo after Michelangelo, 1542 (?) Panel, 30 × 51 ins (76.5 × 130 cm). Norfolk, Holkham Hall (courtesy of Viscount Coke DL) (*See note 31*)

11 ABOVE Palazzo del Te at Mantua, designed by Giulio Romano. Drawing by Ippolito Andreasi of three façades. Düsseldorf, Kunstmuseum (Graphische Sammlung) (*See note 105*)

12 RIGHT *A Goldsmith's Shop* by Alessandro Fei. Florence, Studiolo of Francesco I, Palazzo Vecchio

anger, because the lady, seeing I had abandoned her at Bachiacca's first entreaty, imagined that I held in slight esteem the great affection which she bore me.

Well, then, the hour was drawing nigh when we had to present ourselves before that company of men of genius, each with his own crow; and I was still unprovided; and yet I thought it would be stupid to fail of such a madcap bagatelle; but what particularly weighed upon my mind was that I did not choose to lend the light of my countenance in that illustrious sphere to some miserable plume-plucked scarecrow. All these considerations made me devise a pleasant trick, for the increase of merriment and the diffusion of mirth in our society.

Having taken this resolve, I sent for a stripling of sixteen years, who lived in the next house to mine; he was the son of a Spanish coppersmith. This young man gave his time to Latin studies, and was very diligent in their pursuit. He bore the name of Diego, had a handsome figure, and a complexion of marvellous brilliancy; the outlines of his head and face were far more beautiful than those of the antique Antinous: I had often copied them, gaining thereby much honour from the works in which I used them. The youth had no acquaintances, and was therefore quite unknown; dressed very ill and negligently; all his affections being set upon those wonderful studies of his. After bringing him to my house, I begged him to let me array him in the woman's clothes which I had caused to be laid out. He readily complied, and put them on at once, while I added new beauties to the beauty of his face by the elaborate and studied way in which I dressed his hair. In his ears I placed two little rings, set with two large and fair pearls; the rings were broken; they only clipped his ears, which looked as though they had been pierced. Afterwards I wreathed his throat with chains of gold and rich jewels, and ornamented his fair hands with rings. Then I took him in a pleasant manner by one ear, and drew him before a great looking-glass. The lad, when he beheld himself, cried out with a burst of enthusiasm: 'Heavens! is that Diego?' I said: 'That is Diego, from whom until this day I never asked for any kind of favour; but now I only beseech Diego to do me pleasure in one harmless thing; and it is this – I want him to come in those very clothes to supper with the company of artists whereof he has often heard me speak.' The young man, who was honest, virtuous, and wise, checked his enthusiasm, bent his eyes to the ground, and stood for a short while in silence. Then with a sudden move he lifted up his face and said: 'With Benvenuto I will go; now let us start.'

I wrapped his head in a large kind of napkin, which is called in Rome a summer-cloth; and when we reached the place of meeting, the company had already assembled, and everybody came forward to greet me. Michel Agnolo had placed himself between Giulio and Giovan Francesco. I lifted the veil from the head of my beauty; and then Michel Agnolo, who, as I have already said, was the most humorous and amusing fellow in the world, laid his two hands, the one on Giulio's and the other on Gian Francesco's shoulders, and pulling them with all his force, made them bow down, while he, on his knees upon the floor, cried out for mercy, and called to all the folk in words like these: 'Behold ye of what sort are the angels of paradise! for though they are called angels, here shall ye see that they are not all of the male gender.' Then with a loud voice he added:

> Angel beauteous, angel best,
> Save me thou, make thou me blest.

Upon this my charming creature laughed, and lifted the right hand and gave him a papal benediction, with many pleasant words to boot. So Michel Agnolo stood up, and said it was the custom to kiss the feet of the Pope and the cheeks of angels; and having done the latter to Diego, the boy blushed deeply, which immensely enhanced his beauty.

When the banquet was served and ready, and we were going to sit down to table, Giulio asked leave to be allowed to place us. This being granted, he took the women by the hand, and arranged them all upon the inner side, with my fair in the centre; then he placed all the men on the outside and me in the middle, saying there was no honour too great for my deserts. The supper was followed by a short concert of delightful music, voices joining in harmony with

instruments; and forasmuch as they were singing and playing from the book, my beauty begged to be allowed to sing his part. He performed the music better than almost all the rest, which so astonished the company that Giulio and Michel Agnolo dropped their earlier tone of banter, exchanging it for well-weighed terms of sober heartfelt admiration.

After the music was over, a certain Aurelio Ascolano, remarkable for his gift as an improvisatory poet, began to extol the women in choice phrases of exquisite compliment. While he was chanting, the two girls who had my beauty between them never left off chattering. One of them related how she had gone wrong; the other asked mine how it had happened with her, and who were her friends, and how long she had been settled in Rome, and many other questions of the kind. It is true that, if I chose to describe such laughable episodes, I could relate several odd things which then occurred through Pantasilea's jealousy on my account; but since they form no part of my design, I pass them briefly over. At last the conversation of those loose women vexed my beauty, whom we had christened Pomona for the nonce; and Pomona, wanting to escape from their silly talk, turned restlessly upon her chair, first to one side and then to the other. The female brought by Giulio asked whether she felt indisposed. Pomona answered, yes, she thought she was a month or so with child; this gave them the opportunity of feeling her body and discovering the real sex of the supposed woman. Thereupon they quickly withdrew their hands and rose from table, uttering such gibing words as are commonly addressed to young men of eminent beauty. The whole room rang with laughter and astonishment, in the midst of which Michel Agnolo, assuming a fierce aspect, called out for leave to inflict on me the penance he thought fit. When this was granted, he lifted me aloft amid the clamour of the company, crying: 'Long live the gentleman! long live the gentleman!' and added that this was the punishment I deserved for having played so fine a trick. Thus ended that most agreeable supper-party, and each of us returned to his own dwelling at the close of day.

Michel Agnolo was at that time making the monument of the late Pope Adrian. Giulio Romano went to paint for the Marquis of Mantua. The other members of the club betook themselves in different directions, each to his own business; so that our company of artists was well-nigh altogether broken up.

About this time there fell into my hands some little Turkish poniards; the handle as well as the blade of these daggers was made of iron, and so too was the sheath. They were engraved by means of iron implements with foliage in the most exquisite Turkish style, very neatly filled in with gold. The sight of them stirred in me a great desire to try my own skill in that branch, so different from the others which I practised; and finding that I succeeded to my satisfaction, I executed several pieces. Mine were far more beautiful and more durable than the Turkish, and this for divers reasons. One was that I cut my grooves much deeper and with wider trenches in the steel; for this is not usual in Turkish work. Another was that the Turkish arabesques are only composed of arum leaves with a few small sunflowers; and though these have a certain grace, they do not yield so lasting a pleasure as the patterns which we use. It is true that in Italy we have several different ways of designing foliage; the Lombards, for example, construct very beautiful patterns by copying the leaves of briony and ivy in exquisite curves, which are extremely agreeable to the eye; the Tuscans and the Romans make a better choice, because they imitate the leaves of the acanthus, commonly called bear's-foot, with its stalks and flowers, curling in divers wavy lines; and into these arabesques one may excellently well insert the figures of little birds and different animals, by which the good taste of the artist is displayed. Some hints for creatures of this sort can be observed in nature among the wild flowers, as, for instance, in snap-dragons and some few other plants, which must be combined and developed with the help of fanciful imaginings by clever draughtsmen. Such arabesques are called grotesques by the ignorant. They have obtained this name of grotesques among the moderns through being found in certain subterranean caverns in Rome by students of antiquity; which caverns were formerly chambers, hot-baths, cabinets for study, halls, and apartments of like nature. The curious discovering them in such places (since the level of the ground has gradually

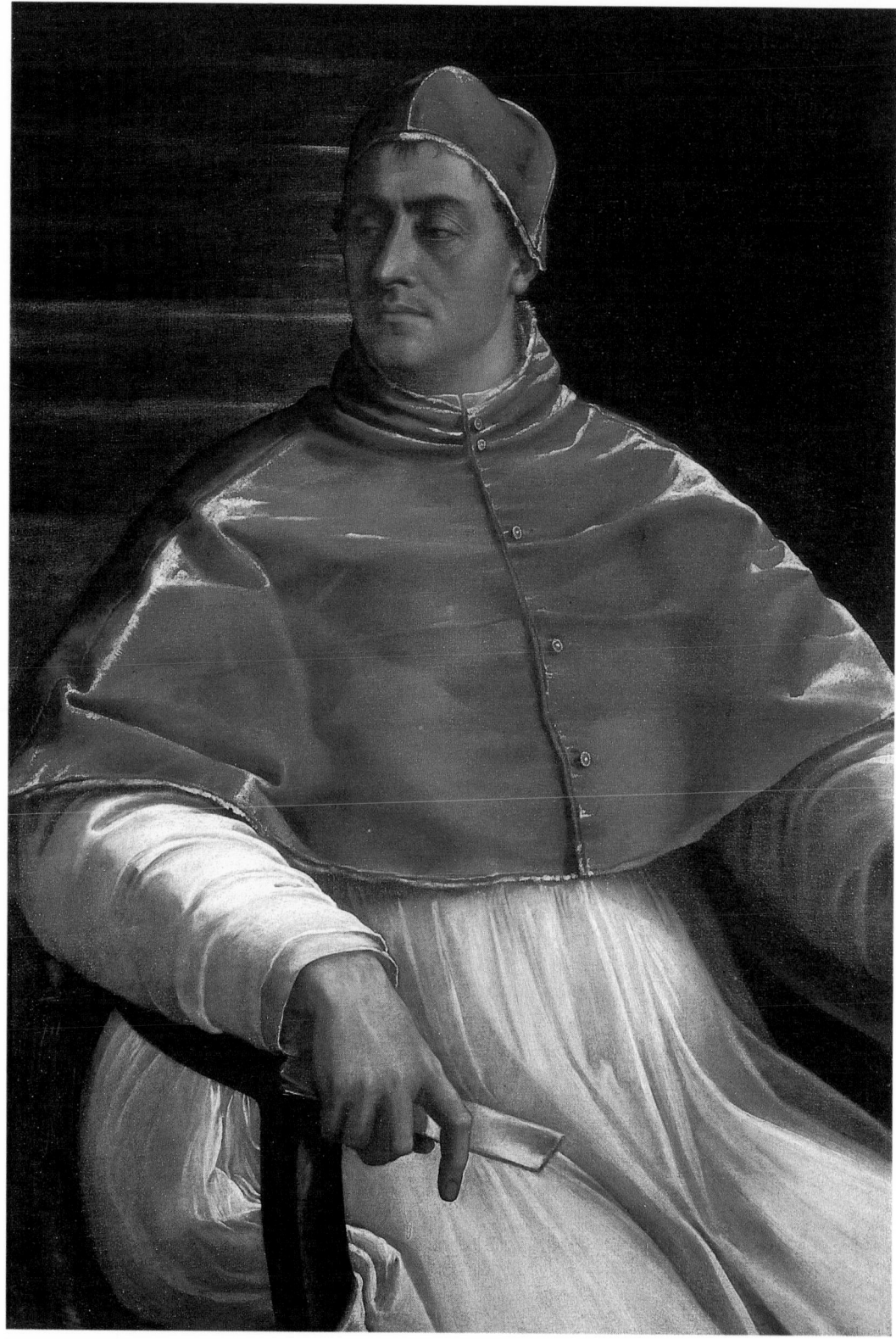

13 ABOVE *Portrait of Pope Clement VII* by Sebastiano del Piombo, *c.* 1526.
Naples, Gallerie Nazionali di Capodimonte

14 RIGHT *Portrait of Alfonso I d'Este* by Dosso and Battista Dossi. Modena,
Galleria Estense

been raised while they have remained below, and since in Rome these vaulted rooms are commonly called grottoes), it has followed that the word grotesque is applied to the patterns I have mentioned. But this is not the right term for them, inasmuch as the ancients, who delighted in composing monsters out of goats, cows, and horses, called these chimerical hybrids by the name of monsters; and the modern artificers of whom I spoke, fashioned from the foliage which they copied monsters of like nature; for these the proper name is therefore monsters, and not grotesques. Well, then, I designed patterns of this kind, and filled them in with gold, as I have mentioned; and they were far more pleasing to the eye than the Turkish.

It was the custom at that epoch to wear little golden medals, upon which every nobleman or man of quality had some device or fancy of his own engraved; and these were worn in the cap. Of such pieces I made very many, and found them extremely difficult to work. I have already mentioned the admirable craftsman Caradosso, who used to make such ornaments; and as there were more than one figure on each piece, he asked at least a hundred gold crowns for his fee. This being so – not, however, because his prices were so high, but because he worked so 88 slowly – I began to be employed by certain noblemen, for whom, among other things, I made a medal in competition with that great artist, and it had four figures, upon which I had expended an infinity of labour. These men of quality, when they compared my piece with that of the famous Caradosso, declared that mine was by far the better executed and more beautiful, and bade me ask what I liked as the reward of my trouble; for since I had given them such perfect satisfaction, they wished to do the like by me. I replied that my greatest reward and what I most desired was to have rivalled the masterpieces of so eminent an artist; and that if their lordships thought I had, I acknowledged myself to be most amply rewarded. With this I took my leave, and they immediately sent me such a very liberal present, that I was well content.

The whole world was now in warfare. Pope Clement had sent to get some troops from 89 Giovanni de' Medici, and when they came, they made such disturbances in Rome, that it was ill living in open shops. On this account I retired to a good snug house behind the Banchi, where I worked for all the friends I had acquired. Since I produced few things of much importance at that period, I need not waste time in talking about them. I took much pleasure in music and amusements of the kind. On the death of Giovanni de' Medici in Lombardy, the Pope, at the advice of Messer Jacopo Salviati, dismissed the five bands he had engaged; and when the 90 Constable of Bourbon knew there were no troops in Rome, he pushed his army with the utmost energy up to the city. The whole of Rome upon this flew to arms. I happened to be intimate with Alessandro, the son of Piero del Bene, who, at the time when the Colonnesi 91 entered Rome, had requested me to guard his palace. On this more serious occasion, therefore, he prayed me to enlist fifty comrades for the protection of the said house, appointing me their captain, as I had been when the Colonnesi came. So I collected fifty young men of the highest courage, and we took up our quarters in his palace, with good pay and excellent appointments.

Bourbon's army had now arrived before the walls of Rome, and Alessandro begged me to go with him to reconnoitre. So we went with one of the stoutest fellows in our company; and on the way a youth called Cecchino della Casa joined himself to us. On reaching the walls by 92 the Campo Santo, we could see that famous army, which was making every effort to enter the town. Upon the ramparts where we took our station, several young men were lying killed by the besiegers; the battle raged there desperately, and there was the densest fog imaginable. I turned to Alessandro and said: 'Let us go home as soon as we can, for there is nothing to be done here; you see the enemies are mounting, and our men are in flight.' Alessandro, in a panic, cried: 'Would God that we had never come here!' and turned in maddest haste to fly. I took him up somewhat sharply with these words: 'Since you have brought me here, I must perform some action worthy of a man'; and directing my arquebuse where I saw the thickest and most serried troop of fighting men, I aimed exactly at one whom I remarked to be higher than the rest: the fog prevented me from being certain whether he was on horseback or on foot. Then I turned to Alessandro and Cecchino, and bade them discharge their arquebuses, showing them

how to avoid being hit by the besiegers. When we had fired two rounds apiece, I crept cautiously up to the wall, and observing among the enemy a most extraordinary confusion, I discovered afterwards that one of our shots had killed the Constable of Bourbon; and from what I had subsequently learned, he was the man whom I had first noticed above the heads of the rest.

Quitting our position on the ramparts, we crossed the Campo Santo, and entered the city by St. Peter's; then coming out exactly at the church of Santo Agnolo, we got with the greatest difficulty to the great gate of the castle; for the generals Renzo di Ceri and Orazio Baglioni were wounding and slaughtering everybody who abandoned the defence of the walls. By the time we had reached the great gate, part of the foemen had already entered Rome, and we had them in our rear. The castellan had ordered the portcullis to be lowered, in order to do which they cleared a little space, and this enabled us four to get inside. On the instant that I entered, the captain Pallone de' Medici claimed me as being of the Papal household, and forced me to abandon Alessandro, which I had to do, much against my will. I ascended to the keep, and at the same instant Pope Clement came in through the corridors into the castle; he had refused to leave the palace of St. Peter earlier, being unable to believe that his enemies would effect their entrance into Rome. Having got into the castle in this way, I attached myself to certain pieces of artillery, which were under the command of a bombardier called Giuliano Fiorentino. Leaning there against the battlements, the unhappy man could see his poor house being sacked, and his wife and children outraged; fearing to strike his own folk, he dared not discharge the cannon, and flinging the burning fuse upon the ground, he wept as though his heart would break, and tore his cheeks with both his hands. Some of the other bombardiers were behaving in

15 *The Death of the Constable of Bourbon*, engraving by Hieronymus Cock after a drawing by Marten van Heemskerck, 1556. British Museum

16 *The Siege of Florence* by Giorgio Vasari. Florence, Palazzo Vecchio
(*See note 113*)

like manner; seeing which, I took one of the matches, and got the assistance of a few men who were not overcome by their emotions. I aimed some swivels and falconets at points where I saw it would be useful, and killed with them a good number of the enemy. Had it not been for this, the troops who poured into Rome that morning, and were marching straight upon the castle, might possibly have entered it with ease, because the artillery was doing them no damage. I went on firing under the eyes of several cardinals and lords, who kept blessing me and giving me the heartiest encouragement. In my enthusiasm I strove to achieve the impossible; let it suffice that it was I who saved the castle that morning, and brought the other bombardiers back to their duty. I worked hard the whole of that day; and when the evening came, while the army was marching into Rome through the Trastevere, Pope Clement appointed a great

94 Roman nobleman named Antonio Santacroce to be captain of all the gunners. The first thing this man did was to come to me, and having greeted me with the utmost kindness, he stationed me with five fine pieces of artillery on the highest point of the castle, to which the name of the

95 Angel specially belongs. This circular eminence goes round the castle, and surveys both Prati and the town of Rome. The captain put under my orders enough men to help in managing my guns, and having seen me paid in advance, he gave me rations of bread and a little wine, and begged me to go forward as I had begun. I was perhaps more inclined by nature to the profession of arms than to the one I had adopted, and I took such pleasure in its duties that I

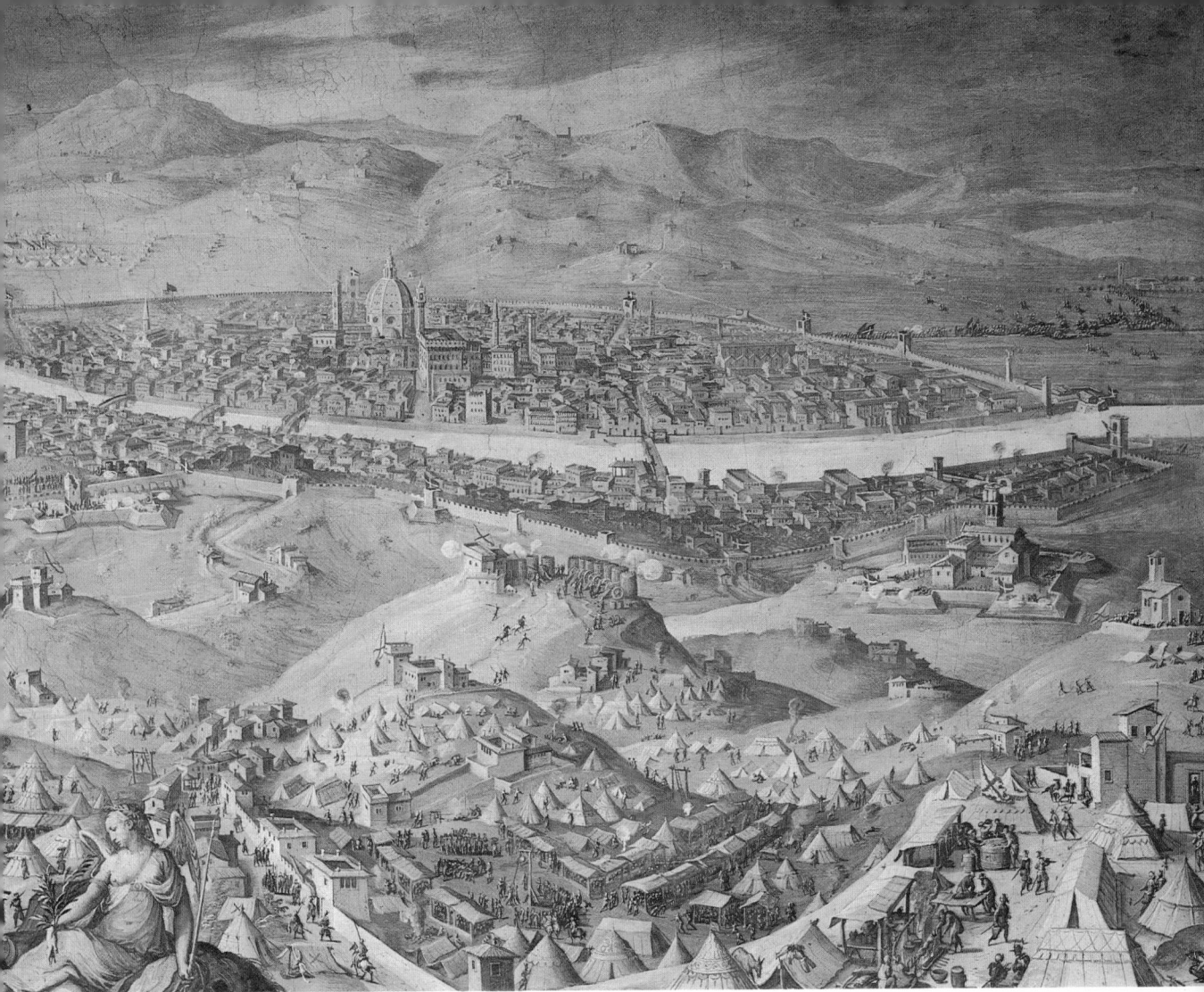

discharged them better than those of my own art. Night came, the enemy had entered Rome, and we who were in the castle (especially myself, who have always taken pleasure in extraordinary sights) stayed gazing on the indescribable scene of tumult and conflagration in the streets below. People who were anywhere else but where we were, could not have formed the least imagination of what it was.

While I was at work upon that diabolical task of mine, there came from time to time to watch me some of the cardinals who were invested in the castle; and most frequently the Cardinal of Ravenna and the Cardinal de' Gaddi. I often told them not to show themselves, since their nasty red caps gave a fair mark to our enemies. From neighbouring buildings, such as the Torre de' Bini, we ran great peril when they were there; and at last I had them locked off, and gained thereby their deep ill-will. I frequently received visits also from the general, Orazio Baglioni, who was very well affected toward me. One day while he was talking with me, he noticed something going forward in a drinking-place outside the Porta di Castello, which bore the name of Baccanello. This tavern had for a sign a sun painted between two windows, of a bright red colour. The windows being closed, Signor Orazio concluded that a band of soldiers were carousing at table just between them and behind the sun. So he said to me: 'Benvenuto, if you think that you could hit that wall an ell's breadth from the sun with your demi-cannon here, I believe you would be doing a good stroke of business, for there is a great commotion

there, and men of much importance must probably be inside the house.' I answered that I felt quite capable of hitting the sun in its centre, but that a barrel full of stones, which was standing close to the muzzle of the gun, might be knocked down by the shock of the discharge and the blast of the artillery. He rejoined: 'Don't waste time, Benvenuto. In the first place, it is not possible, where it is standing, that the cannon's blast should bring it down; and even if it were to fall, and the Pope himself was underneath, the mischief would not be so great as you imagine. Fire, then, only fire!' Taking no more thought about it, I struck the sun in the centre, exactly as I said I should. The cask was dislodged, as I predicted, and fell precisely between

97 Cardinal Farnese and Messer Jacopo Salviati. It might very well have dashed out the brains of both of them, except that just at that very moment Farnese was reproaching Salviati with having caused the sack of Rome, and while they stood apart from one another to exchange opprobrious remarks, my gabion fell without destroying them. When he heard the uproar in the court below, good Signor Orazio dashed off in a hurry; and I, thrusting my neck forward where the cask had fallen, heard some people saying: 'It would not be a bad job to kill that gunner!' Upon this I turned two falconets toward the staircase, with mind resolved to let blaze on the first man who attempted to come up. The household of Cardinal Farnese must have received orders to go and do me some injury; accordingly I prepared to receive them, with a lighted match in hand. Recognizing some who were approaching, I called out: 'You lazy lubbers, if you don't pack off from there, and if but a man's child among you dares to touch the staircase, I have got two cannon loaded, which will blow you into powder. Go and tell the Cardinal that I was acting at the order of superior officers, and that what we have done and are doing is in defence of their priests, and not to hurt them.' They made away; and then came

17 *The Siege of the Castel Sant' Angelo*, engraving by Hieronymus Cock
after a drawing by Marten van Heemskerck, 1556. British Museum

Signor Orazio Baglioni, running. I bade him stand back, else I'd murder him; for I knew very well who he was. He drew back a little, not without a certain show of fear, and called out: 'Benvenuto, I am your friend!' To this I answered: 'Sir, come up, but come alone, and then come as you like.' The general, who was a man of mighty pride, stood still a moment, and then said angrily: 'I have a good mind not to come up again, and to do quite the opposite of that which I intended toward you.' I replied that just as I was put there to defend my neighbours, I was equally well able to defend myself too. He said that he was coming alone; and when he arrived at the top of the stairs, his features were more discomposed than I thought reasonable. So I kept my hand upon my sword, and stood eyeing him askance. Upon this he began to laugh, and the colour coming back into his face, he said to me with the most pleasant manner: 'Friend Benvenuto, I bear you as great love as I have it in my heart to give; and in God's good time I will render you proof of this. Would to God that you had killed those two rascals; for one of them is the cause of all this trouble, and the day perchance will come when the other will be found the cause of something even worse.' He then begged me, if I should be asked, not to say that he was with me when I fired the gun; and for the rest bade me be of good cheer.

I shall skip over some intervening circumstances, and tell how Pope Clement, wishing to save the tiaras and the whole collection of the great jewels of the Apostolic Camera, had me called, and shut himself up together with me and the Cavalierino in a room alone. This Cavalierino *98* had been a groom in the stable of Filippo Strozzi; he was French, and a person of the lowest *99* birth; but being a most faithful servant, the Pope had made him very rich, and confided in him like himself. So the Pope, the Cavaliere, and I, being shut up together, they laid before me the tiaras and jewels of the regalia; and his Holiness ordered me to take all the gems out of their gold settings. This I accordingly did; afterwards I wrapt them separately up in bits of paper, and we sewed them into the linings of the Pope's and the Cavaliere's clothes. Then they gave me all the gold, which weighed about two hundred pounds, and bade me melt it down as secretly as I was able. I went up to the Angel, where I had my lodging, and could lock the door so as to be free from interruption. There I built a little draught-furnace of bricks, with a largish pot, shaped like an open dish, at the bottom of it; and throwing the gold upon the coals, it gradually sank through and dropped into the pan. While the furnace was working, I never left off watching how to annoy our enemies; and as their trenches were less than a stone's-throw right below us, I was able to inflict considerable damage on them with some useless missiles, of which there were several piles, forming the old munition of the castle. I chose a swivel and a falconet, which were both a little damaged in the muzzle, and filled them with the projectiles I have mentioned. When I fired my guns, they hurtled down like mad, occasioning all sorts of unexpected mischief in the trenches. Accordingly I kept these pieces always going at the same time that the gold was being melted down; and a little before vespers I noticed some one coming along the margin of the trench on mule-back. The mule was trotting very quickly, and the man was talking to the soldiers in the trenches. I took the precaution of discharging my artillery just before he came immediately opposite; and so, making a good calculation, I hit my mark. One of the fragments struck him in the face; the rest were scattered on the mule, which fell dead. A tremendous uproar rose up from the trench; I opened fire with my other piece, doing them great hurt. The man turned out to be the Prince of Orange, who was carried *100* through the trenches to a certain tavern in the neighbourhood, whither in a short while all the chief folk of the army came together.

When Pope Clement heard what I had done, he sent at once to call for me, and inquired into the circumstance. I related the whole, and added that the man must have been of the greatest consequence, because the inn to which they carried him had been immediately filled by all the chiefs of the army, so far at least as I could judge. The Pope, with a shrewd instinct, sent for Messer Antonio Santacroce, the nobleman who, as I have said, was chief and commander of the

gunners. He bade him order all us bombardiers to point our pieces, which were very numerous, in one mass upon the house, and to discharge them all together upon the signal of an arquebuse being fired. He judged that if we killed the generals, the army, which was already almost on the point of breaking up, would take to flight. God perhaps had heard the prayers they kept continually making, and meant to rid them in this manner of those impious scoundrels.

We put our cannon in order at the command of Santacroce, and waited for the signal. But when Cardinal Orsini became aware of what was going forward, he began to expostulate with the Pope, protesting that the thing by no means ought to happen, seeing they were on the point of concluding an accommodation, and that if the generals were killed, the rabble of the troops without a leader would storm the castle and complete their utter ruin. Consequently they could by no means allow the Pope's plan to be carried out. The poor Pope, in despair, seeing himself assassinated both inside the castle and without, said that he left them to arrange it. On this, our orders were countermanded; but I, who chafed against the leash, when I knew that they were coming round to bid me stop from firing, let blaze one of my demi-cannons, and struck a pillar in the courtyard of the house, around which I saw a crowd of people clustering. This shot did such damage to the enemy that it was like to have made them evacuate the house. Cardinal Orsini was absolutely for having me hanged or put to death; but the Pope took up my cause with spirit. The high words that passed between them, though I well know what they were, I will not here relate, because I make no profession of writing history. It is enough for me to occupy myself with my own affairs.

After I had melted down the gold, I took it to the Pope who thanked me cordially for what I had done, and ordered the Cavalierino to give me twenty-five crowns, apologizing to me for his inability to give me more. A few days afterwards the articles of peace were signed.

In course of time I came to Florence in the company of several comrades. The plague was raging with indescribable fury. When I reached home, I found my good father, who thought either that I must have been killed in the sack of Rome, or else that I should come back to him a beggar. However, I entirely defeated both these expectations; for I was alive, with plenty of money, a fellow to wait on me, and a good horse. My joy on greeting the old man was so intense, that, while he embraced and kissed me, I thought that I must die upon the spot. He spoke to me as follows: 'Oh, my dear son, the plague in this town is raging with immitigable violence, and I am always fancying you will come home infected with it. I remember, when I was a young man, that I went to Mantua, where I was very kindly received, and stayed there several years. I pray and command you, for the love of me, to pack off and go thither; and I would have you do this to-day rather than to-morrow.'

I had always taken pleasure in seeing the world; and having never been in Mantua, I went there very willingly. Of the money I had brought to Florence, I left the greater part with my good father, promising to help him wherever I might be, and confiding him to the care of my elder sister. Her name was Cosa; and since she never cared to marry, she was admitted as a nun in Santa Orsola; but she put off taking the veil, in order to keep house for our old father, and to look after my younger sister, who was married to one Bartolommeo, a surgeon. So then, leaving home with my father's blessing, I mounted my good horse, and rode off on it to Mantua. *102*

When I got there I looked about for work to do, which I obtained from a Maestro Niccolo of Milan, goldsmith to the Duke of Mantua. Having thus settled down to work, I went after two days to visit Messer Giulio Romano, that most excellent painter, of whom I have already spoken, and my very good friend. He received me with the tenderest caresses, and took it very ill that I had not dismounted at his house. He was living like a lord, and executing a great work for the Duke outside the city gates, in a place called Del Te. It was a vast and prodigious undertaking, as may still, I suppose, be seen by those who go there. *103 104 105*

18–20 The morse or cope button for Pope Clement VII, 1530–1 (since melted down): front, back and side views. Drawings by Francesco Bartoli for John Talman, 1729. British Museum

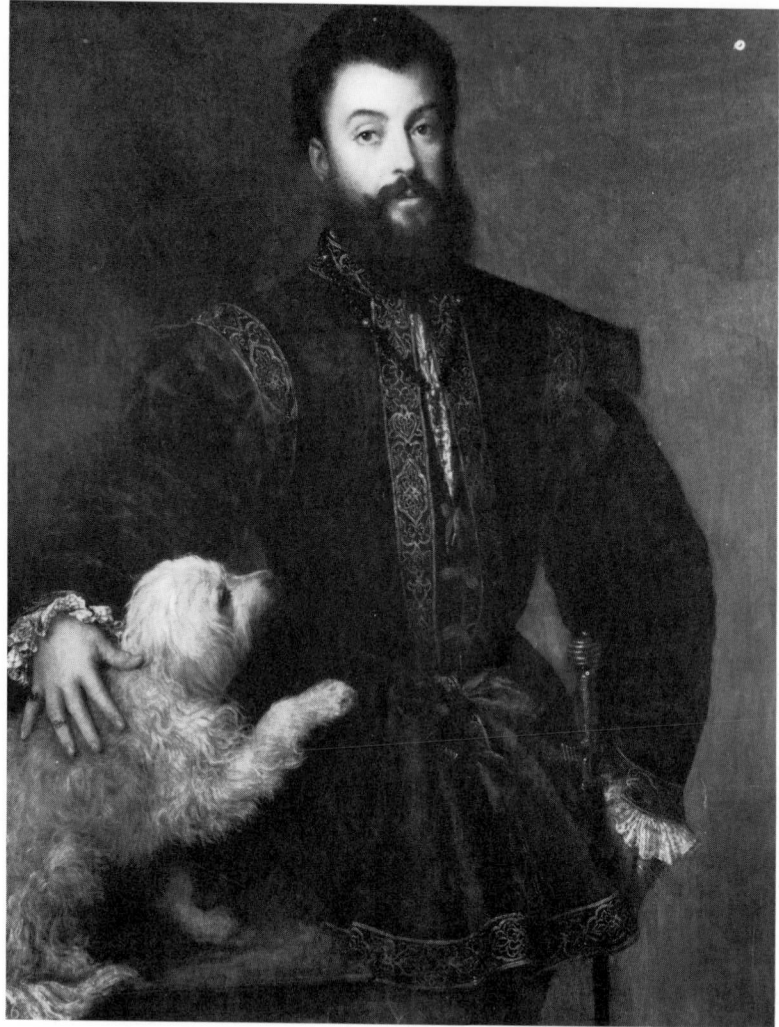

21 ABOVE *Federico II Gonzaga*, painted before he became Duke of Mantua
by Titian, *c.* 1529. 49¼ × 39¼ ins (125 × 99.5 cm). Madrid, Prado

22 RIGHT Impression of the seal of Cardinal Ercole Gonzaga by Cellini,
1528. Mantua, Curia Vescovile

Messer Giulio lost no time in speaking of me to the Duke in terms of the warmest praise.
That Prince commissioned me to make a model for a reliquary, to hold the blood of Christ,
which they have there, and say was brought them by Longinus. Then he turned to Giulio,
bidding him supply me with a design for it. To this Giulio replied: 'My lord, Benvenuto is a
man who does not need other people's sketches, as your Excellency will be very well able to
judge when you shall see his model.' I set hand to the work, and made a drawing for the
reliquary, well adapted to contain the sacred phial. Then I made a little waxen model of the
cover. This was a seated Christ, supporting his great cross aloft with the left hand, while he
seemed to lean against it, and with the fingers of his right hand he appeared to be opening the
wound in his side. When it was finished, it pleased the Duke so much that he heaped favours on
me, and gave me to understand that he would keep me in his service with such appointments
as should enable me to live in affluence.

106 Meanwhile, I had paid my duty to the Cardinal his brother, who begged the Duke to allow
me to make the pontifical seal of his most reverend lordship. This I began; but while I was

23 *Ercole Gonzaga* by an unknown artist, 16th century. Mantua, Cathedral

working at it I caught a quartan fever. During each access of this fever I was thrown into delirium, when I cursed Mantua and its master and whoever stayed there at his own liking. These words were reported to the Duke by the Milanese goldsmith, who had not omitted to notice that the Duke wanted to employ me. When the Prince heard the ravings of my sickness, he flew into a passion against me; and I being out of temper with Mantua, our bad feeling was reciprocal. The seal was finished after four months, together with several other little pieces I made for the Duke under the name of the Cardinal. His Reverence paid me well, and bade me return to Rome, to that marvellous city where we had made acquaintance.

I quitted Mantua with a good sum of crowns, and arrived at Florence, where I learned that my father and all the people in the house had died of the plague. On the entreaty of my brother and sister, I remained at Florence, though my own inclination led me to return to Rome. The dear friend, also, who had helped me in some of my earlier troubles (I mean Piero, son of Giovanni Landi) – he too advised me to make some stay in Florence; for the Medici were in exile, that is to say, Signor Ippolito and Signor Alessandro, afterwards respectively Cardinal and Duke of Florence; he judged it would be well for me to wait and see what happened.

At that time there arrived in Florence a Sienese, called Girolamo Marretti, who had lived

24 *Michelangelo*, bust by Daniele da Volterra, 1564–6. Florence, Bargello

long in Turkey and was a man of lively intellect. He came to my shop, and commissioned me to make a golden medal to be worn in the hat. The subject was to be Hercules wrenching the lion's mouth. While I was working at this piece, Michel Agnolo Buonarroti came oftentimes to see it. I had spent infinite pains upon the design, so that the attitude of the figure and the fierce passion of the beast were executed in quite a different style from that of any craftsman who had hitherto attempted such groups. This, together with the fact that the special branch of art was totally unknown to Michel Agnolo, made the divine master give such praises to my work that I felt incredibly inspired for further effort.

Just then I met with Federigo Ginori, a young man of a very lofty spirit. He had lived some years in Naples, and being endowed with great charms of person and presence, had been the lover of a Neapolitan princess. He wanted to have a medal made, with Atlas bearing the world upon his shoulders, and applied to Michel Agnolo for a design. Michel Agnolo made this answer: 'Go and find out a young goldsmith named Benvenuto; he will serve you admirably, and certainly he does not stand in need of sketches by me. However, to prevent your thinking that I want to save myself the trouble of so slight a matter, I will gladly sketch you something; but meanwhile speak to Benvenuto, and let him also make a model; he can then execute the

better of the two designs.' Federigo Ginori came to me, and told me what he wanted, adding thereto how Michel Agnolo had praised me, and how he had suggested I should make a waxen model while he undertook to supply a sketch. The words of that great man so heartened me, that I set myself to work at once with eagerness upon the model; and when I had finished it, a painter who was intimate with Michel Agnolo, called Giuliano Bugiardini, brought me the drawing of Atlas. On the same occasion I showed Giuliano my little model in wax, which was very different from Michel Agnolo's drawing; and Federigo, in concert with Bugiardini, agreed that I should work upon my model. So I took it in hand, and when Michel Agnolo saw it, he praised me to the skies. This was a figure, as I have said, chiselled on a plate of gold; Atlas had the heaven upon his back, made out of a crystal ball, engraved with the zodiac upon a field of lapis-lazuli. The whole composition produced an indescribably fine effect; and under it ran the legend *Summa tulisse juvat.* Federigo was so thoroughly well pleased that he paid me very liberally. Aluigi Alamanni was at that time in Florence. Federigo Ginori, who enjoyed his friendship, brought him often to my workshop, and through this introduction we became very intimate together.

I left Florence for Rome, and there I again presented myself before his Holiness Pope Clement VII. He received me even better than before, and said: 'If you had come a little earlier to Rome, I should have commissioned you to restore my two tiaras, which were pulled to pieces in the castle. These, however, with the exception of the gems, are objects of little artistic interest; so I will employ you on a piece of the very greatest consequence, where you will be able to exhibit all your talents. It is a button for my priest's cope, which has to be made round like a trencher, and as big as a little trencher, one-third of a cubit wide. Upon this I want you to represent a God the Father in half-relief, and in the middle to set that magnificent big diamond, which you remember, together with several other gems of the greatest value. Caradosso began to make me one, but did not finish it; I want yours to be finished quickly, so that I may enjoy the use of it a little while. Go, then, and make me a fine model.' He had all the jewels shown me, and then I went off like a shot to set myself to work.

During the time when Florence was besieged, Federigo Ginori, for whom I made that medal of Atlas, died of consumption, and the medal came into the hands of Messer Luigi Alamanni, who, after a little while, took it to present in person to Francis, King of France, accompanied by some of his own finest compositions. The King was exceedingly delighted with the gift; whereupon Messer Luigi told his Majesty so much about my personal qualities, as well as my art, and spoke so favourably, that the King expressed a wish to know me.

Meanwhile I pushed my model for the button forward with all the diligence I could, constructing it exactly of the size which the jewel itself was meant to have. In the trade of the goldsmiths it roused considerable jealousy among those who thought that they were capable of matching it. A certain Micheletto had just come to Rome; he was very clever at engraving cornelians, and was, moreover, a most intelligent jeweller, an old man and of great celebrity. He had been employed upon the Pope's tiaras; and while I was working at my model, he wondered much that I had not applied to him, being as he was a man of intelligence and of large credit with the Pope. At last, when he saw that I was not coming to him, he came to me, and asked me what I was about. 'What the Pope has ordered me,' I answered. Then he said: 'The Pope has commissioned me to superintend everything which is being made for his Holiness.' I only replied that I would ask the Pope, and then should know what answer I ought to give him. He told me that I should repent, and departing in anger, had an interview with all the masters of the art; they deliberated on the matter, and charged Michele with the conduct of the whole affair. As was to be expected from a person of his talents, he ordered more than thirty drawings to be made, all differing in their details, for the piece the Pope had commissioned.

Having already access to his Holiness's ear, he took into his counsel another jeweller, named Pompeo, a Milanese, who was in favour with the Pope, and related to Messer Traiano, the first chamberlain of the court; these two together, then, began to insinuate that they had seen my model, and did not think me up to a work of such extraordinary import.

After a few days I finished my model, and took it to the Pope one morning, when Messer Traiano made me wait till he had sent for Micheletto and Pompeo, bidding them make haste and bring their drawings. On their arrival we were introduced, and Micheletto and Pompeo immediately unrolled their papers, which the Pope inspected. The draughtsmen who had been employed were not in the jeweller's trade, and therefore knew nothing about giving their right place to precious stones; and the jewellers, on their side, had not shown them how; for I ought to say that a jeweller, when he had to work with figures, must of necessity understand design, else he cannot produce anything worth looking at: and so it turned out that all of them had stuck that famous diamond in the middle of the breast of God the Father. The Pope, who was an excellent connoisseur, observing this mistake, approved of none of them; and when he had looked at about ten, he flung the rest down, and said to me, who was standing at a distance: 'Now show me your model, Benvenuto, so that I may see if you have made the same mistake as those fellows.' I came forward, and opened a little round box; whereupon one would have thought that a light from heaven had struck the Pope's eyes. He cried aloud: 'If you had been in my own body, you could not have done it better, as this proves. Those men there have found the right way to bring shame upon themselves!' A crowd of great lords pressing round, the Pope pointed out the difference between my model and the drawings. When he had sufficiently commended it, the others standing terrified and stupid before him, he turned to me and said: 'I am only afraid of one thing, and that is of the utmost consequence. Friend Benvenuto, wax is easy to work in; the real difficulty is to execute this in gold.' To those words I answered without a moment's hesitation: 'Most blessed Father, if I do not work it ten times better than the model, let it be agreed beforehand that you pay me nothing.' When they heard this, the noblemen made a great stir, crying out that I was promising too much. Among them was an eminent philosopher, who spoke out in my favour: 'From the fine physiognomy and bodily symmetry which I observe in this young man, I predict that he will accomplish what he says, and think that he will even go beyond it.' The Pope put in: 'And this is my opinion also.' Then he called his chamberlain, Messer Traiano, and bade him bring five hundred golden ducats of the Camera.

While we were waiting for the money, the Pope turned once more to gaze at leisure on the dexterous device I had employed for combining the diamond with the figure of God the Father. I had put the diamond exactly in the centre of the piece; and above it God the Father was shown seated, leaning nobly in a sideways attitude, which made a perfect composition, and did not interfere with the stone's effect. Lifting his right hand, he was in the act of giving the benediction. Below the diamond I had placed three children, who, with their arms upraised, were supporting the jewel. One of them, in the middle, was in full relief, the other two in half-relief. All round I set a crowd of cherubs, in divers attitudes, adapted to the other gems. A mantle undulated to the wind around the figure of the Father, from the folds of which cherubs peeped out; and there were other ornaments besides which made a very beautiful effect. The work was executed in white stucco on a black stone. When the money came, the Pope gave it me with his own hand, and begged me in the most winning terms to let him have it finished in his own days, adding that this should be to my advantage.

I took the money and the model home, and was in the utmost impatience to begin my work. When I came into the presence, I lost no time in exhibiting the golden plate, upon which I had as yet carved nothing but my figure of God the Father; but this, though only in the rough, displayed a grander style than that of the waxen model. The Pope regarded it with stupefaction, and exclaimed: 'From this moment forward I will believe everything you say.' Then loading me with marks of favour, he added: 'It is my intention to give you another commission, which, if you feel competent to execute it, I shall have no less at heart than this, or more.' He proceeded to tell me that he wished to make dies for the coinage of his realm, and asked me if I had ever tried my hand at such things, and if I had the courage to attempt them. I answered that of courage for the task I had no lack, and that I had seen how dies were made, but that I had not ever made any. There was in the presence a certain Messer Tommaso, of Prato,

his Holiness's Datary; and this man, being a friend of my enemies, put in: 'Most blessed Father, the favours you are showering upon this young man (and he by nature so extremely overbold) are enough to make him promise you a new world. You have already given him one great task, and now, by adding a greater, you are like to make them clash together.' The Pope, in a rage, turned round on him, and told him to mind his own business. Then he commanded me to make the model for a broad doubloon of gold, upon which he wanted a naked Christ with his hands tied, and the inscription *Ecce Homo*; the reverse was to have a Pope and Emperor in the act together of propping up a cross which seemed to fall, and this legend: *Unus spiritus et una fides erat in eis.*

After the Pope had ordered this handsome coin, Bandinello the sculptor came up; he had not yet been made a knight; and, with his wonted presumption muffled up in ignorance, said: 'For these goldsmiths one must make drawings for such fine things as that.' I turned round upon him in a moment, and cried out that I did not want his drawings for my art, but that I hoped before very long to give his art some trouble by my drawings. The Pope expressed high satisfaction at these words, and turning to me said: 'Go then, my Benvenuto, and devote yourself with spirit to my service, and do not lend an ear to the chattering of these silly fellows.'

So I went off, and very quickly made two dies of steel; then I stamped a coin in gold, and one Sunday after dinner took the coin and the dies to the Pope, who, when he saw the piece, was astonished and greatly gratified, not only because my work pleased him excessively, but also because of the rapidity with which I had performed it. For the further satisfaction and amazement of his Holiness, I had brought with me all the old coins which in former times had been made by those able men who served Popes Giulio and Leo; and when I noticed that mine pleased him far better, I drew forth from my bosom a patent, in which I prayed for the post of stamp-master in the Mint. This place was worth six golden crowns a month, in addition to the dies, which were paid at the rate of a ducat for three by the Master of the Mint. The Pope took my patent and handed it to the Datary, telling him to lose no time in dispatching the business. The Datary began to put it in his pocket, saying: 'Most blessed Father, your Holiness ought not to go so fast; these are matters which deserve some reflection.' To this the Pope replied: 'I have heard what you have got to say; give me here that patent.' He took it, and signed it at once with his own hand; then, giving it back, added: 'Now, you have no answer left; see that you dispatch it at once, for this is my pleasure; and Benvenuto's shoes are worth more than the eyes of all those other blockheads.' So, having thanked his Holiness, I went back, rejoicing above measure, to my work.

I was on terms of the closest intimacy with one Messer Giovanni Gaddi, who was a clerk of the Camera, and a great connoisseur of the arts, although he had no practical acquaintance with any. In his household were a certain Messer Giovanni, a Greek of eminent learning, Messer Lodovico of Fano, no less distinguished as a man of letters, Messer Antonio Allegretti, and Messer Annibale Caro, at that time in his early manhood. Messer Bastiano of Venice, a most excellent painter, and I were admitted to their society; and almost every day we met together in Messer Giovanni's company.

Meanwhile, I laboured assiduously at the work I was doing for the Pope, and also in the service of the Mint; for his Holiness had ordered another coin, of the value of two carlins, on which his own portrait was stamped, while the reverse bore a figure of Christ upon the waters, holding his hand to St. Peter, with this inscription *Quare dubitasti?* My design won such applause that a certain secretary of the Pope, a man of the greatest talent, called Il Sanga, was moved to this remark: 'Your Holiness can boast of having a currency superior to any of the ancients in all their glory.' The Pope replied: 'Benvenuto, for his part, can boast of serving an emperor like me, who is able to discern his merit.' I went on at my great piece in gold, showing it frequently to the Pope, who was very eager to see it, and each time expressed greater admiration.

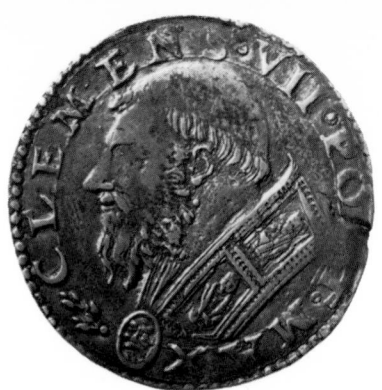

25 Coin worth two *carlini* by Cellini for Pope Clement VII, 1529–30.
Obverse, *Clement VII*; reverse, *Christ walking on the water and saving St
Peter*. British Museum

My brother, at this period, was also in Rome, serving Duke Alessandro, on whom the Pope
had recently conferred the Duchy of Penna. This prince kept in his service a multitude of
soldiers, worthy fellows, brought up to valour in the school of that famous general Giovanni
de' Medici; and among these was my brother, whom the Duke esteemed as highly as the
bravest of them. One day my brother went after dinner to the shop of a man called Baccino
della Croce in the Banchi, which all those men-at-arms frequented. He had flung himself upon
a settee, and was sleeping. Just then the guard of the Bargello passed by; they were taking to
prison a certain Captain Cisti, a Lombard, who had also been a member of Giovanni's troop,
but was not in the service of the Duke. The captain, Cattivanza degli Strozzi, chanced to be in
the same shop; and when Cisti caught sight of him, he whispered: 'I was bringing you those
crowns I owed; if you want them, come for them before they go with me to prison.' Now
Cattivanza had a way of putting his neighbours to the push, not caring to hazard his own
person. So, finding there around him several young fellows of the highest daring, more eager
than apt for so serious an enterprise, he bade them catch up Captain Cisti and get the money
from him, and if the guard resisted, overpower the men, provided they had pluck enough to
do so.

The young men were but four, and all four of them without a beard. The first was called
Bertino Aldobrandi, another Anguillotto of Lucca; I cannot recall the names of the rest.
Bertino had been trained like a pupil by my brother; and my brother felt the most unbounded
love for him. So then, off dashed the four brave lads, and came up with the guard of the
Bargello – upwards of fifty constables, counting pikes, arquebuses, and two-handed swords.
After a few words they drew their weapons, and the four boys so harried the guard, that if
Captain Cattivanza had but shown his face, without so much as drawing, they would certainly
have put the whole pack to flight. But delay spoiled all; for Bertino received some ugly
wounds and fell; at the same time, Anguillotto was also hit in the right arm, and being unable
to use his sword, got out of the fray as well as he was able. The others did the same. Bertino
Aldobrandi was lifted from the ground seriously injured.

While these things were happening, we were all at table; for that morning we had dined
more than an hour later than usual. On hearing the commotion, one of the old man's sons, the
elder, rose from table to go and look at the scuffle. He was called Giovanni; and I said to him:
'For Heaven's sake, don't go! In such matters one is always certain to lose, while there is
nothing to be gained.' His father spoke to like purpose: 'Pray, my son, don't go!' But the lad,
without heeding any one, ran down the stairs. Reaching the Banchi, where the great
scrimmage was, and seeing Bertino lifted from the ground, he ran towards home, and met my
brother Cecchino on the way, who asked what was the matter. Though some of the bystanders
signed to Giovanni not to tell Cecchino, he cried out like a madman how it was that Bertino
Aldobrandi had been killed by the guard. My poor brother gave vent to a bellow which might

122
123
124
125

have been heard ten miles away. Then he turned to Giovanni: 'Ah me! but could you tell me which of those men killed him for me?' Giovanni said, yes, that it was a man who had a big two-handed sword, with a blue feather in his bonnet. My poor brother rushed ahead, and having recognized the homicide by those signs, he threw himself with all his dash and spirit into the middle of the band, and before his man could turn on guard, ran him right through the guts, and with the sword's hilt thrust him to the ground. Then he turned upon the rest with such energy and daring, that his one arm was on the point of putting the whole band to flight, had it not been that, while wheeling round to strike an arquebusier, this man fired in self-defence, and hit the brave unfortunate young fellow above the knee of his right leg. While he lay stretched upon the ground, the constables scrambled off in disorder as fast as they were able, lest a pair to my brother should arrive upon the scene.

126 Noticing that the tumult was not subsiding, I too rose from table, and girding on my sword – for everybody wore one then – I went to the bridge of Sant' Agnolo, where I saw a group of several men assembled. On my coming up and being recognized by some of them, they gave way before me, and showed me what I least of all things wished to see, albeit I made haste to view the sight. On the instant I did not know Cecchino, since he was wearing a different suit of clothes from that in which I had lately seen him. Accordingly, he recognized me first, and said: 'Dearest brother, do not be upset by my grave accident; it is only what might be expected in my profession: get me removed from here at once, for I have but few hours to live.' They had acquainted me with the whole event while he was speaking, in brief words befitting such occasion. So I answered: 'Brother, this is the greatest sorrow and the greatest trial that could happen to me in the whole course of my life. But be of good cheer; for before you lose sight of him who did the mischief, you shall see yourself revenged by my hand.' Our words on both sides were to the purport, but of the shortest.

127 The guard was now about fifty paces from us; for Maffio, their officer, had made some of them turn back to take up the corporal my brother killed. Accordingly, I quickly traversed that short space, wrapped in my cape, which I had tightened round me, and came up with Maffio, whom I should most certainly have murdered, for there were plenty of people round, and I had wound my way among them. With the rapidity of lightning, I had half drawn my sword from

128 the sheath, when Berlinghier Berlinghieri, a young man of the greatest daring and my good friend, threw himself from behind upon my arms; he had four other fellows of like kidney with him, who cried out to Maffio: 'Away with you, for this man here alone was killing you!' He asked: 'Who is he?' and they answered: 'Own brother to the man you see there.' Without

129 waiting to hear more, he made haste for Torre di Nona; and they said: 'Benvenuto, we prevented you against your will, but did it for your good; now let us go to succour him who must die shortly.' Accordingly, we turned and went back to my brother, whom I had at once conveyed into a house. The doctors who were called in consultation, treated him with medicaments, but could not decide to amputate the leg, which might perhaps have saved him.

 As soon as his wound had been dressed, Duke Alessandro appeared and most affectionately greeted him. My brother had not as yet lost consciousness; so he said to the Duke: 'My lord, this only grieves me, that your Excellency is losing a servant than whom you may perchance find men more valiant in the profession of arms, but none more lovingly and loyally devoted

130 to your service than I have been.' The Duke bade him do all he could to keep alive; for the rest, he well knew him to be a man of worth and courage. He then turned to his attendants, ordering them to see that the brave young fellow wanted for nothing.

 When he was gone, my brother lost blood so copiously, for nothing could be done to stop it, that he went off his head, and kept raving all the following night, with the exception that once, when they wanted to give him the communion, he said: 'You would have done well to confess me before; now it is impossible that I should receive the divine sacrament in this already ruined frame; it will be enough if I partake of it by the divine virtue of the eyesight, whereby it shall be transmitted into my immortal soul, which only prays to Him for mercy and forgiveness.' Having spoken thus, the host was elevated; but he straightway relapsed into the

same delirious ravings as before, pouring forth a torrent of the most terrible frenzies and horrible imprecations that the mind of man could imagine; nor did he cease once all that night until the day broke.

When the sun appeared above our horizon, he turned to me and said: 'Brother, I do not wish to stay here longer, for these fellows will end by making me do something tremendous, which may cause them to repent of the annoyance they have given me.' Then he kicked out both his legs – the injured limb we had enclosed in a very heavy box – and made as though he would fling it across a horse's back. Turning his face round to me, he called out thrice – 'Farewell, farewell!' and with the last word that most valiant spirit passed away.

At the proper hour, toward nightfall, I had him buried with due ceremony in the church of the Florentines; and afterwards I erected to his memory a very handsome monument of marble, upon which I caused trophies and banners to be carved. I must not omit to mention that one of his friends had asked him who the man was that had killed him, and if he could recognize him; to which he answered that he could, and gave his description. My brother, indeed, attempted to prevent this coming to my ears; but I got it very well impressed upon my mind, as will appear in the sequel.

Returning to the monument, I should relate that certain famous men of letters, who knew my brother, composed for me an epitaph, telling me that the noble young man deserved it. The inscription ran thus:

Francisco Cellino Florentino, qui quod in teneris annis ad Ioannem Medicem ducem plures victorias retulit et signifer fuit, facile documentum dedit quantæ fortitudinis et consilii vir futurus erat, ni crudelis fati archibuso transfossus, quinto ætatis lustro jaceret, Benvenutus frater posuit. Obiit die XXVII *Maii* MD.XXIX.

He was twenty-five years of age; and since the soldiers called him Cecchino del Piffero, his real name being Giovanfrancesco Cellini, I wanted to engrave the former, by which he was commonly known, under the armorial bearings of our family. This name then I had cut in fine antique characters, all of which were broken save the first and last. I was asked by the learned men who had composed that beautiful epitaph, wherefore I used these broken letters; and my answer was, because the marvellous framework of his body was spoiled and dead; and the reason why the first and last remained entire was, that the first should symbolize the great gift God had given him, namely, of a human soul, inflamed with his divinity, the which hath never broken, while the second represented the glorious renown of his brave actions. The thought gave satisfaction, and several persons have since availed themselves of my device. Close to the name I had the coat of us Cellini carved upon the stone, altering it in some particulars. In Ravenna, which is a most ancient city, there exist Cellini of our name in the quality of very honourable gentry, who bear a lion rampant or upon a field of azure, holding a lily gules in his dexter paw, with a label in chief and three lilies or. These are the true arms of the Cellini. My father showed me a shield as ours which had the paw only, together with the other bearings; but I should prefer to follow those of the Cellini of Ravenna, which I have described above. Now to return to what I caused to be engraved upon my brother's tomb: it was the lion's paw, but instead of a lily, I made the lion hold an axe, with the field of the scutcheon quartered; and I put the axe in solely that I might not be unmindful to revenge him.

I continued working at the jewel and the dies for the Mint; but I also took to watching the arquebusier who shot my brother, as though he had been a girl I was in love with. The fellow lived in a house near a place called Torre Sanguigua, next door to the lodging of one of the most fashionable courtesans in Rome, named Signora Antea. It had just struck twenty-four, and he was standing at the house-door, with his sword in hand, having risen from supper. With great address I stole up to him, holding a large Pistojan dagger, and dealt him a back-handed stroke, with which I meant to cut his head clean off; but as he turned round very suddenly, the blow fell upon the point of his left shoulder and broke the bone. He sprang up, dropped his sword, half-stunned with the great pain, and took to flight. I followed after, and in four steps

131

QVI NVQVAM IN CVRIS CONSVMPSIT
INANIBVS AEVVM
FRANGISCVS NERVS CLAVDITVR HOC

26 *Francesco del Nero*, bust by Giulio Mazzoni. Rome, S. Maria sopra Minerva

caught him up, when I lifted my dagger above his head, which he was holding very low, and hit him in the back exactly at the juncture of the nape-bone and the neck. The poniard entered this point so deep into the bone, that, though I used all my strength to pull it out, I was not able. For just at that moment four soldiers with drawn swords sprang out from Antea's lodging, and obliged me to set hand to my own sword to defend my life. Leaving the poniard then, I made 132 off, and fearing I might be recognized, took refuge in the palace of Duke Alessandro, which was between Piazza Navona and the Rotunda. On my arrival, I asked to see the Duke; who told me that, if I was alone, I need only keep quiet and have no further anxiety, but go on working at the jewel which the Pope had set his heart on. Immediately upon this, I opened a very fine shop in the Banchi, and there I finished the jewel after the lapse of a few months.

It had already been said to Pope Clement by one of his most trusted servants, and by others, 133 that is, by Francesco del Nero, Zana de' Biliotti his accountant, the Bishop of Vasona, and

several such men: 'Why, most blessed Father, do you confide gems of that vast value to a young fellow, who is all fire, more passionate for arms than for his art, and not yet thirty years of age?' The Pope asked in answer if any one of them knew that I had done aught to justify such suspicions. Whereto Francesco del Nero, his treasurer, replied: 'No, most blessed Father, because he has not as yet had an opportunity.' Whereto the Pope rejoined: 'I regard him as a thoroughly honest man; and if I saw with my own eyes some crime he had committed, I should not believe it.'

I went on working assiduously at the button, and at the same time laboured for the Mint, when certain pieces of false money got abroad in Rome, stamped with my own dies. They were brought at once to the Pope, who, hearing things against me, said to Giacopo Balducci, *134* the Master of the Mint, 'Take every means in your power to find the criminal; for we are sure that Benvenuto is an honest fellow.' That traitor of a master, being in fact my enemy, replied: 'Would God, most blessed Father, that it may turn out as you say; for we have some proofs against him.' Upon this the Pope turned to the Governor of Rome, and bade him see he found the malefactor. The officials who received these orders were certain clerks of the Camera, who made the proper search, as was their duty, and soon found the rogue. He was a stamper in the service of the Mint, named Cesare Macherone, and a Roman citizen. Together with this man they detected a metal-founder of the Mint. A few days afterwards, Cesare Macherone, the false coiner, was hanged in the Banchi opposite the Mint; his accomplice was sent to the galleys. *135*

When I had nearly finished my piece, there happened that terrible inundation which flooded the whole of Rome. I waited to see what would happen; the day was well-nigh spent, for the *136* clocks struck twenty-two, and the water went on rising formidably. Now the front of my house and shop faced the Banchi, but the back was several yards higher, because it turned toward Monte Giordano; accordingly, bethinking me first of my own safety and in the next place of my honour, I filled my pockets with the jewels, and gave the gold-piece into the custody of my workmen, and then descended barefoot from the back-windows, and waded as well as I could until I reached Monte Cavallo. There I sought out Messer Giovanni Gaddi, clerk *137* of the Camera, and Bastiano Veneziano, the painter. To the former I confided the precious stones, to keep in safety: he had the same regard for me as though I had been his brother. A few days later, when the rage of the river was spent, I returned to my workshop, and finished the piece with such good fortune, through God's grace and my own great industry, that it was held to be the finest masterpiece which had been ever seen in Rome. When then I took it to the Pope, he was insatiable in praising me.

I continued to work for the Pope, executing now one trifle and now another, when he commissioned me to design a chalice of exceeding richness. So I made both drawing and model *138*

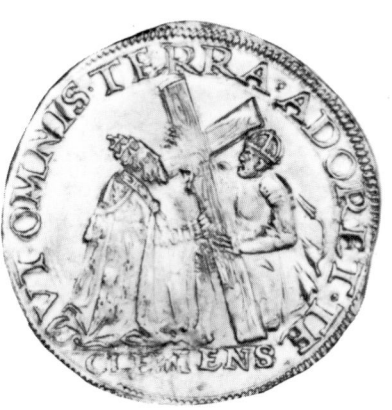

27 Doubloon by Cellini for Pope Clement VII, 1529–30. Obverse, *A Pope and an Emperor*; reverse, *Sts Peter and Paul*. Diameter 1⅛ in (19 mm). Vienna, Kunsthistorisches Museum

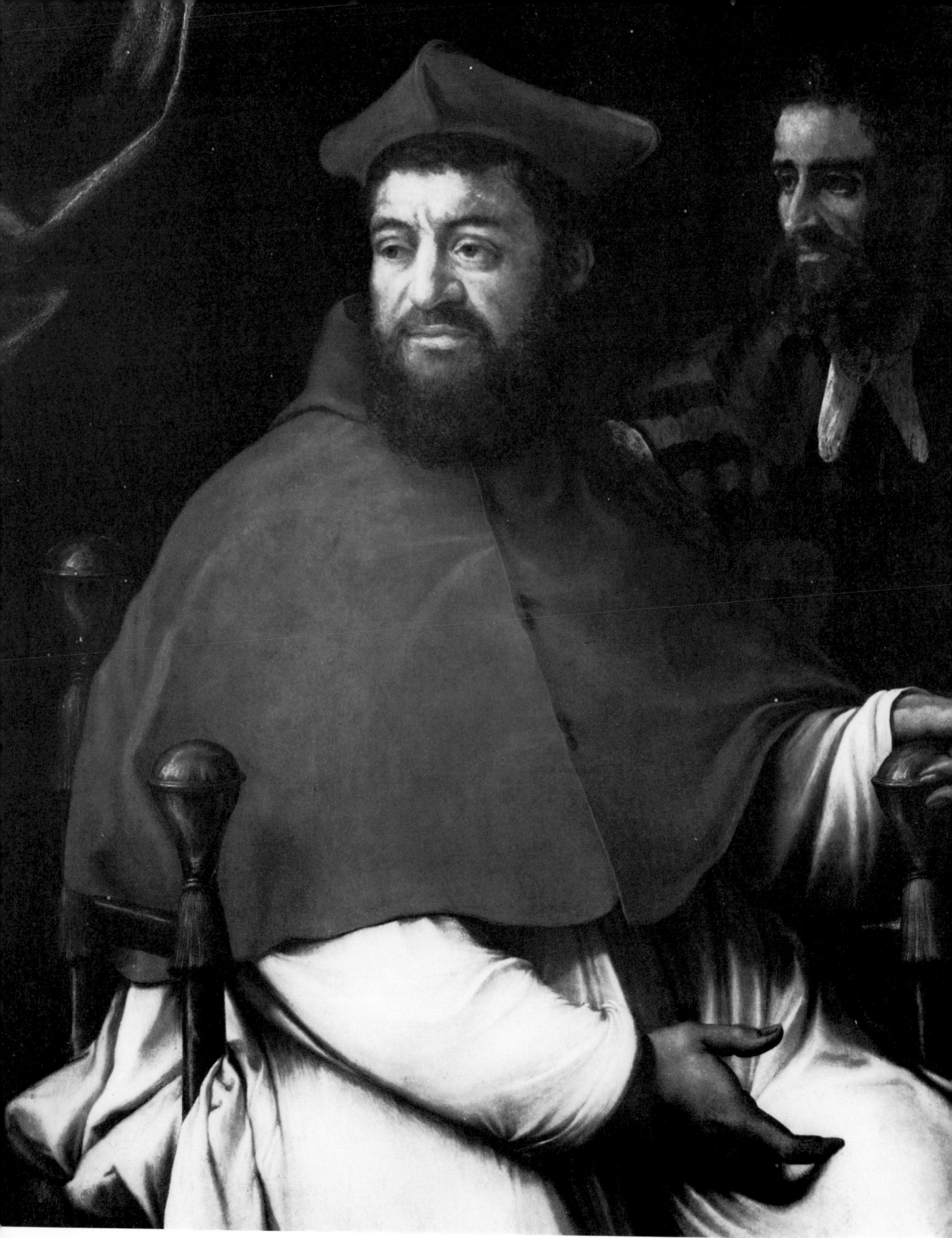

28 *Cardinal Giovanni Salviati* by Sebastiano del Piombo, *c.* 1530/1. Panel,
42 × 35½ ins (107 × 90.5 cm). Sarasota, Fla., John and Mable Ringling
Museum of Art

for the piece. The latter was constructed of wood and wax. Instead of the usual top, I fashioned three figures of a fair size in the round; they represented Faith, Hope, and Charity. Corresponding to these, at the base of the cup, were three circular histories in bas-relief. One was the Nativity of Christ, the second the Resurrection, and the third St Peter crucified head downwards; for thus I had received commission. While I had this work in hand, the Pope was often pleased to look at it; wherefore, observing that his Holiness had never thought again of giving me anything, and knowing that a post in the Piombo was vacant, I asked for this one evening. The good Pope, quite oblivious of his extravagances at the termination of the last piece, said to me: 'That post in the Piombo is worth more than 800 crowns a year, so that if I gave it you, you would spend your time in scratching your paunch, and your magnificent handicraft would be lost, and I should bear the blame.' I replied at once as thus: 'Cats of a good breed mouse better when they are fat than starving; and likewise honest men who possess some talent, exercise it to far nobler purport when they have the wherewithal to live abundantly; wherefore princes who provide such folk with competences, let your Holiness take notice, are watering the roots of genius; for genius and talent, at their birth, come into this world lean and scabby; and your Holiness should also know that I never asked for the place with the hope of getting it. Only too happy I to have that miserable post of mace bearer. On the other I built but castles in the air. Your Holiness will do well, since you do not care to give it me, to bestow it on a man of talent who deserves it, and not upon some fat ignoramus who will spend his time scratching his paunch, if I may quote your Holiness's own words. Follow the example of Pope Giulio's illustrious memory, who conferred an office of the same kind upon Bramante, that most admirable architect.'

Immediately on finishing this speech, I made my bow, and went off in a fury. Then Bastiano Veneziano the painter approached, and said: 'Most blessed Father, may your Holiness be willing to grant it to one who works assiduously in the exercise of some talent; and as your Holiness knows that I am diligent in my art, I beg that I may be thought worthy of it.' The Pope replied: 'That devil Benvenuto will not brook rebuke. I was inclined to give it him, but it is not right to be so haughty with a Pope. Therefore I do not well know what I am to do.' The Bishop of Vasona then came up, and put a word for Bastiano, saying: 'Most blessed Father, Benvenuto is but young; and a sword becomes him better than a friar's frock. Let your Holiness give the place to this ingenious person Bastiano. Some time or other you will be able to bestow on Benvenuto a good thing, perhaps more suitable to him than this would be.' Then the Pope, turning to Messer Bartolommeo Valori, told him: 'When next you meet Benvenuto, let him know from me that it was he who got that office in the Piombo for Bastiano the painter, and add that he may reckon on obtaining the next considerable place that falls; meanwhile let him look to his behaviour, and finish my commissions.'

His Holiness was dying with impatience to see the chalice, and commissioned Messer Ruberto Pucci to give heed to what I was about. That right worthy fellow came daily to visit me, and always gave me some kindly word, which I returned. The time was drawing nigh now for the Pope to travel toward Bologna; so at last, perceiving that I did not mean to come to him, he made Messer Ruberto bid me bring my work, that he might see how I was getting on. Accordingly, I took it; and having shown, as the piece itself proved, that the most important part was finished, I begged him to advance me five hundred crowns, partly on account, and partly because I wanted gold to complete the chalice. The Pope said: 'Go on, go on at work till it is finished.' I answered, as I took my leave, that I would finish it if he paid me the money. And so I went away.

When the Pope took his journey to Bologna, he left Cardinal Salviati as Legate of Rome, and gave him commission to push the work that I was doing forward, adding: 'Benvenuto is a fellow who esteems his own great talents but slightly, and us less; look to it then that you keep him always going, so that I may find the chalice finished on my return.'

That beast of a Cardinal sent for me after eight days, bidding me bring the piece up. On this I went to him without the piece. No sooner had I shown my face, than he called out: 'Where is

that onion-stew of yours? Have you got it ready?' I answered: 'O most reverend Monsignor, I have not got my onion-stew ready, nor shall I make it ready, unless you give me onions to concoct it with.' At these words, the Cardinal, who looked more like a donkey than a man, turned uglier by half than he was naturally; and wanting at once to cut the matter short, cried out: 'I'll send you to a galley, and then perhaps you'll have the grace to go on with your labour.' The bestial manners of the man made me a beast too; and I retorted: 'Monsignor, send me to the galleys when I've done deeds worthy of them; but for my present laches, I snap my fingers at your galleys; and what is more, I tell you that, just because of you, I will not set hand further to my piece. Don't send for me again, for I won't appear, no, not if you summon me by the police.'

145 The Pope came back from Bologna, and sent at once for me, because the Cardinal had written the worst he could of my affairs in his despatches. He was in the hottest rage imaginable, and bade me come upon the instant with my piece. I obeyed. When I arrived in the presence, he broke out coarsely at me: 'Come here with your work; is it finished?' I displayed it; and his temper rising, he exclaimed: 'In God's truth I tell thee, thou that makest it thy business to hold no man in regard, that, were it not for decency and order, I would have thee chucked together with thy work there out of windows.'

It happened that Cardinal Salviati, who, as I have related, entertained an old hostility against
146 me, had been appointed Legate to Parma. In that city a certain Milanese goldsmith, named
147 Tobbia, was taken up for false coining, and condemned to the gallows and the stake. Representations in his favour, as being a man of great ability, were made to the Cardinal, who suspended the execution of the sentence, and wrote to the Pope, saying the best goldsmith in the world had come into his hands, sentenced to death for coining false money, but that he was a good simple fellow, who could plead in his excuse that he had taken counsel with his confessor, and had received, as he said, from him permission to do this. Thereto he added: 'If you send for this great artist to Rome, your Holiness will bring down the over-weening arrogance of your favourite Benvenuto, and I am quite certain that Tobbia's work will please you far more than his.' The Pope accordingly sent for him at once; and when the man arrived, he made us both appear before him, and commissioned each of us to furnish a design for mounting an unicorn's horn, the finest which had ever been seen, and which had been sold for 17,000 ducats of the Camera. The Pope meant to give it to King Francis; but first he wished it richly set in gold, and ordered us to make sketches for this purpose. When they were finished, we took them to the Pope. That of Tobbia was in the form of a candlestick, the horn being stuck in it like a candle, and at the base of the piece he had introduced four little unicorns' heads of a very poor design. When I saw the thing, I could not refrain from laughing gently in my sleeve. The Pope noticed this, and cried: 'Here, show me your sketch!' It was a single unicorn's head, proportioned in size to the horn. I had designed the finest head imaginable; for I took it partly from the horse and partly from the stag, enriching it with fantastic mane and other ornaments. Accordingly, no sooner was it seen, than every one decided in my favour. There were, however, present at the competition certain Milanese gentlemen of the first consequence, who said: 'Most blessed Father, your Holiness is sending this magnificent present into France; please to reflect that the French are people of no culture, and will not understand the excellence of Benvenuto's work; pyxes like this one of Tobbia's will suit their taste well, and these too can be finished quicker. Benvenuto will devote himself to completing your chalice, and you will get two pieces done in the same time; moreover, this poor man, whom you have brought to Rome, will have the chance to be employed.' The Pope, who was anxious to obtain his chalice, very willingly adopted the advice of the Milanese gentlefolk.

Next day, therefore, he commissioned Tobbia to mount the unicorn's horn, and sent his
148 Master of the Wardrobe to bid me finish the chalice. I replied that I desired nothing in the world more than to complete the beautiful work I had begun; and if the material had been anything but gold, I could very easily have done so by myself; but it being gold, his Holiness must give me some of the metal if he wanted me to get through with my work. To this the

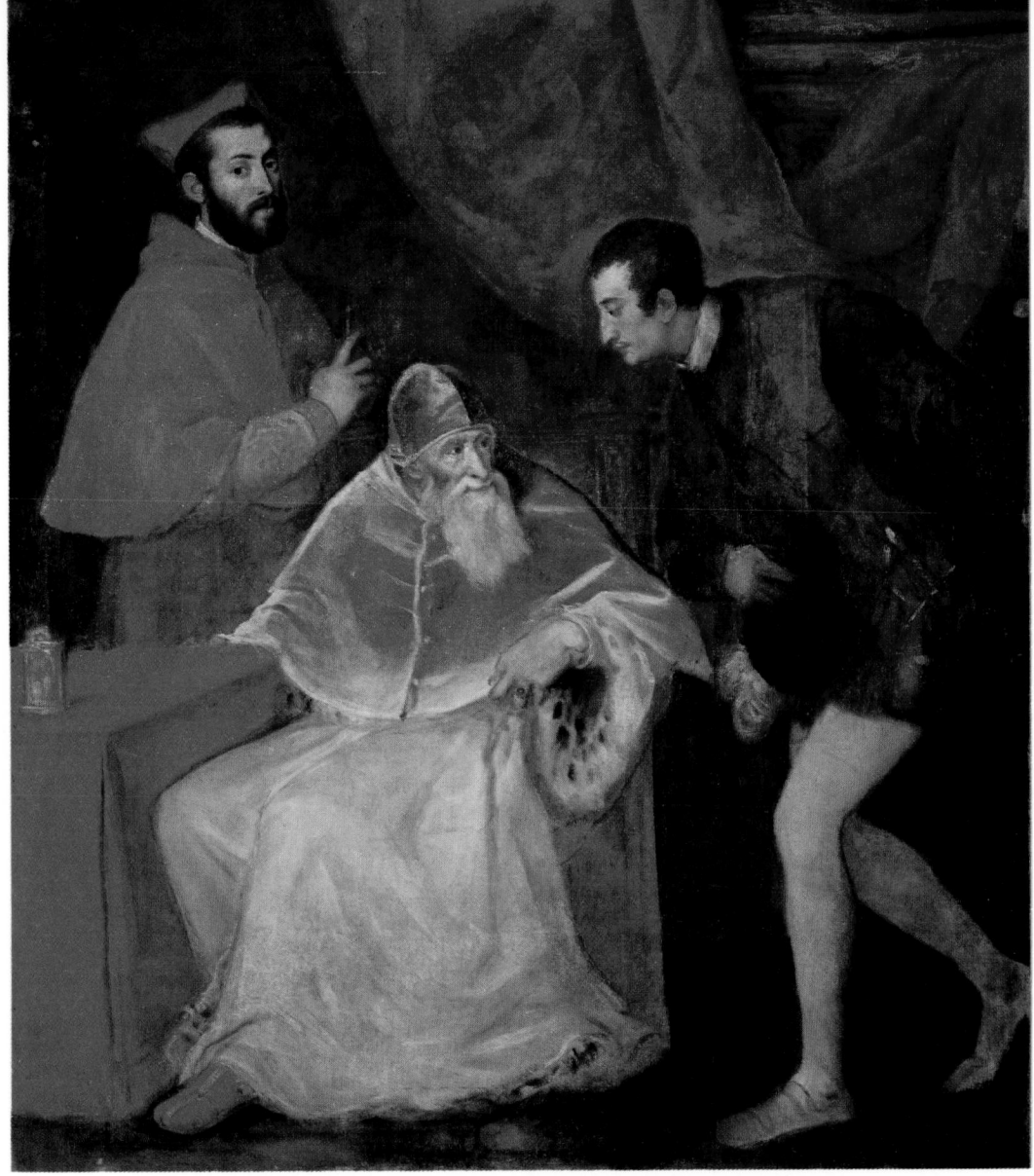

29 *Pope Paul III and his Grandsons* (Cardinal Alessandro and Ottavio Farnese) by Titian, 1546. 82 × 68 ins (208 × 172.5 cm). Naples, Gallerie Nazionali di Capodimonte

vulgar courtier answered: 'Zounds! don't ask the Pope for gold, unless you mean to drive him into such a fury as will ruin you.' I said: 'Oh, my good lord, will your lordship please to tell me how one can make bread without flour? Even so without gold this piece of mine cannot be finished.' The Master of the Wardrobe, having an inkling that I had made a fool of him, told me he should report all I had spoken to his Holiness; and this he did. The Pope flew into a bestial passion, and swore he would wait to see if I was so mad as not to finish it. More than two months passed thus; and though I had declared I would not give a stroke to the chalice, I did not do so, but always went on working with the greatest interest. When he perceived I was not going to bring it, he began to display real displeasure, and protested he would punish me in one way or another.

 A jeweller from Milan in Papal service happened to be present when these words were spoken. He was called Pompeo, and was closely related to Messer Trajano, the most favoured servant of Pope Clement. The two men came, upon a common understanding, to him and said: 'If your Holiness were to deprive Benvenuto of the Mint, perhaps he would take it into

his head to complete the chalice.' To this the Pope answered: 'No; two evil things would happen: first, I should be ill served in the Mint, which concerns me greatly; and secondly, I should certainly not get the chalice.' The two Milanese, observing the Pope indisposed towards me, at last so far prevailed that he deprived me of the Mint, and gave it to a young Perugian, commonly known as Fagiuolo. Pompeo came to inform me that his Holiness had taken my place in the Mint away, and that if I did not finish the chalice, he would deprive me of other things besides. I retorted: 'Tell his Holiness that he has deprived himself and not me of the Mint, and that he will be doing the same with regard to those other things of which he speaks; and that if he wants to confer the post on me again, nothing will induce me to accept it.' The graceless and unlucky fellow went off like an arrow to find the Pope and report this conversation; he added also something of his own invention. Eight days later, the Pope sent the same man to tell me that he did not mean me to finish the chalice, and wanted to have it back precisely at the point to which I had already brought it. I told Pompeo: 'This thing is not like the Mint, which it was in his power to take away; but five hundred crowns which I received belong to his Holiness, and I am ready to return them; the piece itself is mine, and with it I shall do what I think best.' Pompeo ran off to report my speech, together with some biting words which in my righteous anger I had let fly at himself.

Tobbia the goldsmith meanwhile worked at the setting and the decoration of the unicorn's horn. The Pope, moreover, commissioned him to begin the chalice upon the model he had seen in mine. But when Tobbia came to show him what he had done, he was very discontented, and greatly regretted that he had broken with me, blaming all the other man's works and the people who had introduced them to him; and several times Baccino della Croce came from him to tell me that I must not neglect the reliquary. I answered that I begged his Holiness to let me breathe a little after the great illness I had suffered, and from which I was not as yet wholly free, adding that I would make it clear to him that all the hours in which I could work should be spent in his service. I had indeed begun to make his portrait, and was executing a medal in secret. I fashioned the steel dies for stamping this medal in my own house; while I kept a partner in my workshop, who had been my prentice and was called Felice.

At that time, as is the wont of young men, I had fallen in love with a Sicilian girl, who was exceedingly beautiful. On it becoming clear that she returned my affection, her mother perceived how the matter stood, and grew suspicious of what might happen. The truth is that I had arranged to elope with the girl for a year to Florence, unknown to her mother; but she, getting wind of this, left Rome secretly one night, and went off in the direction of Naples. She gave out that she was gone by Cività Vecchia, but she really went by Ostia. I followed them to Cività Vecchia, and did a multitude of mad things to discover her.

It happened through a variety of singular accidents that I became intimate with a Sicilian priest, who was a man of very elevated genius and well instructed in both Latin and Greek letters. In the course of conversation one day we were led to talk about the art of necromancy; apropos of which I said: 'Throughout my whole life I have had the most intense desire to see or learn something of this art.' Thereto the priest replied: 'A stout soul and a steadfast must the man have who sets himself to such an enterprise.' I answered that of strength and steadfastness of soul I should have enough and to spare, provided I found the opportunity. Then the priest said: 'If you have the heart to dare it, I will amply satisfy your curiosity.' Accordingly we agreed upon attempting the adventure.

The priest one evening made his preparations, and bade me find a comrade, or not more than two. I invited Vincenzio Romoli, a very dear friend of mine, and the priest took with him a native of Pistoja, who also cultivated the black art. We went together to the Coliseum; and there the priest, having arrayed himself in necromancer's robes, began to describe circles on the earth with the finest ceremonies that can be imagined. I must say that he had made us bring precious perfumes and fire, and also drugs of fetid odour. When the preliminaries were completed, he made the entrance into the circle; and taking us by the hand, introduced us one by one inside it. Then he assigned our several functions; to the necromancer, his comrade, he

gave the pentacle to hold; the other two of us had to look after the fire and the perfumes; and then he began his incantations. This lasted more than an hour and a half; when several legions appeared, and the Coliseum was all full of devils. I was occupied with the precious perfumes, and when the priest perceived in what numbers they were present, he turned to me and said: 'Benvenuto, ask them something.' I called on them to reunite me with my Sicilian Angelica. That night we obtained no answer; but I enjoyed the greatest satisfaction of my curiosity in such matters. The necromancer said that we should have to go a second time, and that I should obtain the full accomplishment of my request; but he wished me to bring with me a little boy of pure virginity.

I chose one of my shop-lads, who was about twelve years old, and invited Vincenzio Romoli again; and we also took a certain Agnolino Gaddi, who was a very intimate friend of both. When we came once more to the place appointed, the necromancer made just the same preparations, attended by the same and even more impressive details. Then he introduced us into the circle, which he had reconstructed with art more admirable and yet more wondrous ceremonies. Afterwards he appointed my friend Vincenzio to the ordering of the perfumes and the fire, and with him Agnolino Gaddi. He next placed in my hand the pentacle, which he bid me turn toward the points he indicated, and under the pentacle I held the little boy, my workman. Now the necromancer began to utter those awful invocations, calling by name on multitudes of demons who are captains of their legions, and these he summoned by the virtue and potency of God, the Uncreated, Living, and Eternal, in phrases of the Hebrew, and also of the Greek and Latin tongues; insomuch that in a short space of time the whole Coliseum was full of a hundredfold as many as had appeared upon the first occasion. Vincenzio Romoli, together with Agnolino, tended the fire and heaped on quantities of precious perfumes. At the advice of the necromancer, I again demanded to be reunited with Angelica. The sorcerer turned to me and said: 'Hear you what they have replied; that in the space of one month you will be where she is?' Then once more he prayed me to stand firm by him, because the legions were a thousandfold more than he had summoned, and were the most dangerous of all the denizens of hell; and now that they had settled what I asked, it behoved us to be civil to them and dismiss them gently. On the other side, the boy, who was beneath the pentacle, shrieked out in terror that a million of the fiercest men were swarming round and threatening us. He said, moreover, that four huge giants had appeared, who were striving to force their way inside the circle. Meanwhile the necromancer, trembling with fear, kept doing his best with mild and soft persuasions to dismiss them. Vincenzio Romoli, who quaked like an aspen leaf, looked after the perfumes. Though I was quite as frightened as the rest of them, I tried to show it less, and inspired them all with marvellous courage; but the truth is that I had given myself up for dead when I saw the terror of the necromancer. The boy had stuck his head between his knees, exclaiming: 'This is how I will meet death, for we are certainly dead men.' Again I said to him: 'These creatures are all inferior to us, and what you see is only smoke and shadow; so then raise your eyes.' When he had raised them he cried out: 'The whole Coliseum is in flames, and the fire is advancing on us'; then covering his face with his hands, he groaned again that he was dead, and that he could not endure the sight longer. The necromancer appealed for my support, entreating me to stand firm by him, and to have assafetida flung upon the coals; so I turned to Vincenzio Romoli, and told him to make the fumigation at once. While uttering these words I looked at Agnolino Gaddi, whose eyes were starting from their sockets in his terror, and who was more than half dead, and said to him: 'Agnolo, in time and place like this we must not yield to fright, but do the utmost to bestir ourselves; therefore, up at once, and fling a handful of that assafetida upon the fire.' Agnolo, at the moment when he moved to do this, let fly such a volley from his breech, that it was far more effectual than the assafetida. The boy, roused by that great stench and noise, lifted his face a little, and hearing me laugh, he plucked up courage, and said the devils were taking to flight tempestuously. So we abode thus until the matin-bells began to sound. Then the boy told us again that but few remained, and those were at a distance. When the necromancer had concluded his ceremonies, he put off his

wizard's robe, and packed up a great bundle of books which he had brought with him; then, all together, we issued with him from the circle, huddling as close as we could to one another, especially the boy, who had got into the middle, and taken the necromancer by his gown and me by the cloak. All the while that we were going toward our houses in the Banchi, he kept saying that two of the devils he had seen in the Coliseum were gambolling in front of us, skipping now along the roofs and now upon the ground. The necromancer assured me that, often as he had entered magic circles, he had never met with such a serious affair as this. He also tried to persuade me to assist him in consecrating a book, by means of which we should extract immeasurable wealth, since we could call up fiends to show us where treasures were, whereof the earth is full; and after this wise we should become the richest of mankind: love affairs like mine were nothing but vanities and follies without consequence. I replied that if I were a Latin scholar I should be very willing to do what he suggested. He continued to persuade me by arguing that Latin scholarship was of no importance, and that, if he wanted, he could have found plenty of good Latinists; but that he had never met with a man of soul so firm as mine, and that I ought to follow his counsel. Engaged in this conversation, we reached our homes, and each of us dreamed all that night of devils.

As we were in the habit of meeting daily, the necromancer kept urging me to join in his adventure. This priestly sorcerer moved me so by his persuasions that I was well disposed to comply with his request; but I said I wanted first to finish the medals I was making for the Pope. I had confided what I was doing about them to him alone, begging him to keep my secret. At the same time I never stopped asking him if he believed that I should be reunited to my Sicilian Angelica at the time appointed; for the date was drawing near, and I thought it singular that I heard nothing about her. The necromancer told me that it was quite certain I should find myself where she was, since the devils never break their word when they promise, as they did on that occasion; but he bade me keep my eyes open, and be on the lookout against some accident which might happen to me in that connection, and put restraint upon myself to endure somewhat against my inclination, for he could discern a great and imminent danger in it: well would it be for me if I went with him to consecrate the book, since this would avert the peril that menaced me, and would make us both most fortunate.

I was beginning to hanker after the adventure more than he did; but I said that a certain *153* Maestro Giovanni of Castel Bolognese had just come to Rome, very ingenious in the art of making medals of the sort I made in steel, and that I thirsted for nothing more than to compete with him and take the world by storm with some great masterpiece, which I hoped would annihilate all those enemies of mine by the force of genius and not the sword. The sorcerer on his side went on urging: 'Nay, prithee, Benvenuto, come with me and shun a great disaster which I see impending over you.' However, I had made my mind up, come what would, to finish my medal, and we were now approaching the end of the month. I was so absorbed and enamoured by my work that I thought no more about Angelica or anything of that kind, but gave my whole self up to it.

It happened one day, close on the hours of vespers, that I had to go at an unusual time for me from my house to my workshop; for I ought to say that the latter was in the Banchi, while I lived behind the Banchi, and went rarely to the shop; all my business there I left in the hands of my partner, Felice. Having stayed a short while in the workshop, I remembered that I had to say something to Alessandro del Bene. So I arose, and when I reached the Banchi, I met a man called Ser Benedetto, who was a great friend of mine. He was a notary, born in Florence, son of a blind man who said prayers about the streets for alms, and a Sienese by race. This Ser Benedetto had been very many years at Naples; afterwards he had settled in Rome, where he transacted business for some Sienese merchants of the Chigi. My partner had over and over

30 *Cardinal Ippolito de'Medici in Hungarian Costume* by Titian, 1532.
$54\frac{1}{2} \times 32$ ins (138.4 × 81 cm). Florence, Palazzo Pitti

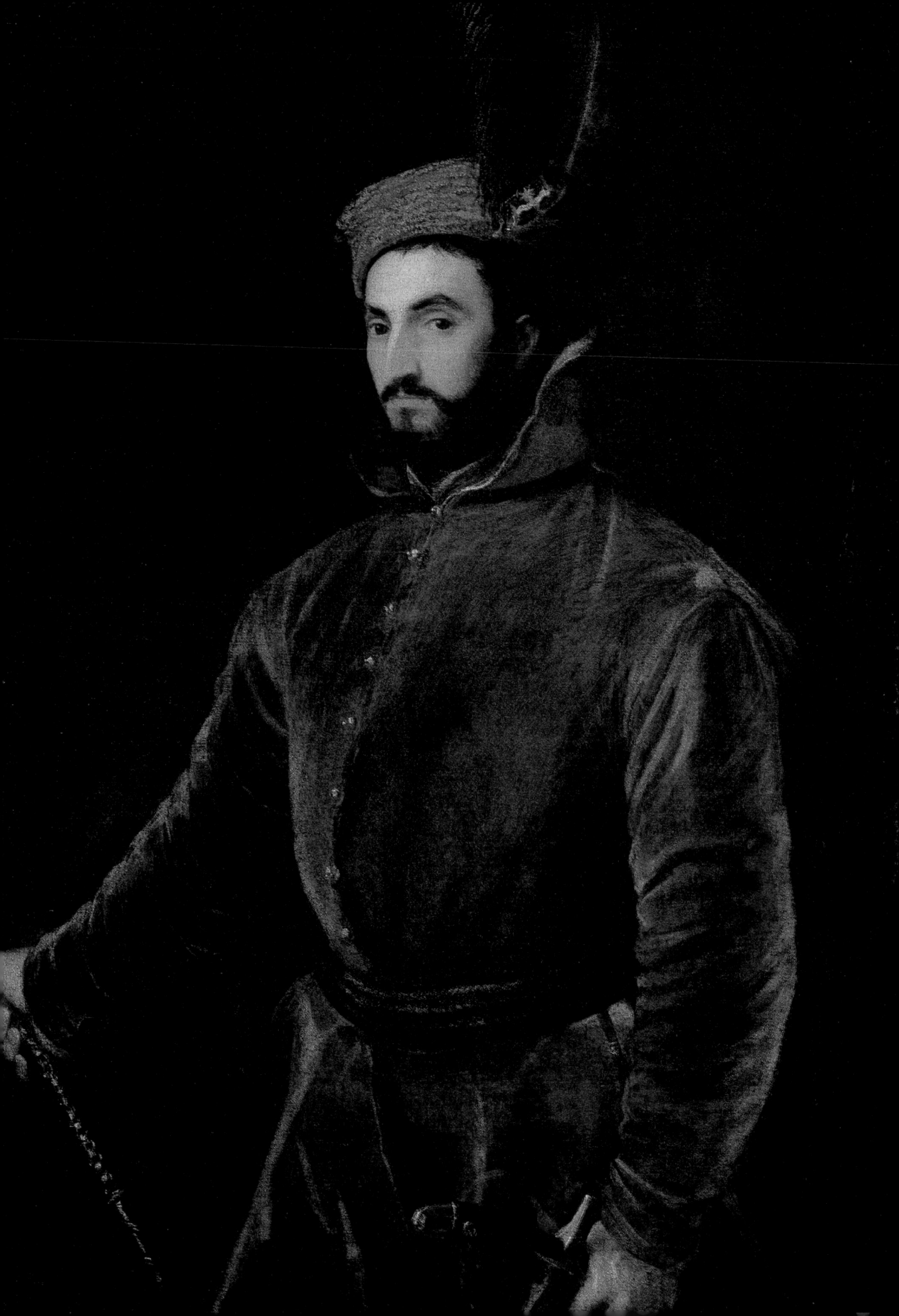

again asked him for some moneys which were due for certain little rings confided to Ser
Benedetto. That very day, meeting him in the Banchi, he demanded his money rather roughly,
as his wont was. Benedetto was walking with his masters, and they, annoyed by the
interruption, scolded him sharply, saying they would be served by somebody else, in order not
to have to listen to such barking. Ser Benedetto did the best he could to excuse himself, swore
that he had paid the goldsmith, and said he had no power to curb the rage of madmen. The
Sienese took his words ill, and dismissed him on the spot. Leaving them, he ran like an arrow to
my shop, probably to take revenge upon Felice. It chanced that just in the middle of the street
we met. I, who had heard nothing of the matter, greeted him most kindly, according to my
custom, to which courtesy he replied with insults. Then what the sorcerer had said flashed all at
once upon my mind; and bridling myself as well as I was able, in the way he bade me, I
answered: 'Good brother Benedetto, don't fly into a rage with me, for I have done you no
harm, nor do I know anything about these affairs of yours. Please go and finish what you have
to do with Felice. He is quite capable of giving you a proper answer; but inasmuch as I know
nothing about it, you are wrong to abuse me in this way, especially as you are well aware that I
am not the man to put up with insults.' He retorted that I knew everything, and that he was the
man to make me bear a heavier load than that, and that Felice and I were two great rascals. By
this time a crowd had gathered round to hear the quarrel. Provoked by his ugly words, I
stooped and took up a lump of mud – for it had rained – and hurled it with a quick and
unpremeditated movement at his face. He ducked his head, so that the mud hit him in the
middle of the skull. There was a stone in it with several sharp angles, one of which striking him,
he fell stunned like a dead man: whereupon all the bystanders, seeing the great quantity of
blood, judged that he was really dead.

 While he was still lying on the ground, and people were preparing to carry him away,
Pompeo the jeweller passed by. The Pope had sent for him to give orders about some jewels.
Seeing the fellow in such a miserable plight, he asked who had struck him; on which they told
him: 'Benvenuto did it, but the stupid creature brought it down upon himself.' No sooner had
Pompeo reached the Pope than he began to speak: 'Most blessed Father, Benvenuto has this
very moment murdered Tobbia; I saw it with my own eyes.' On this the Pope in a fury
ordered the Governor, who was in the presence, to take and hang me at once in the place where
the homicide had been committed, adding that he must do all he could to catch me, and not
appear again before him until he had hanged me.

 When I saw the unfortunate Benedetto stretched upon the ground, I thought at once of the
peril I was in, considering the power of my enemies, and what might ensue from this disaster.
154 Making off, I took refuge in the house of Messer Giovanni Gaddi, clerk of the Camera, with
the intention of preparing as soon as possible to escape from Rome. He, however, advised me
not to be in such a hurry, for it might turn out perhaps that the evil was not so great as I
imagined; and calling Messer Annibal Caro, who lived with him, bade him go for
information.

 While these arrangements were being made, a Roman gentleman appeared, who belonged
155 to the household of Cardinal de' Medici, and had been sent by him. Taking Messer Giovanni
and me apart, he told us that the Cardinal had reported to him what the Pope said, and that
there was no way of helping me out of the scrape; it would be best for me to shun the first fury
of the storm by flight, and not to risk myself in any house in Rome. Upon this gentleman's
departure, Messer Giovanni looked me in the face as though he were about to cry, and said:
'Ah me! Ah woe is me! There is nothing I can do to aid you!' I replied: 'By God's means, I shall
aid myself alone; only I request you to put one of your horses at my disposition.' They had
already saddled a black Turkish horse, the finest and the best in Rome. I mounted with an
arquebuse upon the saddlebow, wound up in readiness to fire, if need were. When I reached
156 Ponte Sisto, I found the whole of the Bargello's guard there, both horse and foot. So, making a
virtue of necessity, I put my horse boldly to a sharp trot, and with God's grace, being somehow
unperceived by them, passed freely through. Then, with all the speed I could, I took the road to

31 *Annibale Caro*, bust by Calcagni, *c.* 1550. Victoria and Albert Museum

Palombara, a fief of my lord Giovanbatista Savello, whence I sent the horse back to Messer 157
Giovanni, without, however, thinking it well to inform him where I was. Lord Giovanbatista,
after very kindly entertaining me two days, advised me to remove and go toward Naples till
the storm blew over. So, providing me with company, he set me on the way to Naples.

While travelling, I met a sculptor of my acquaintance, who was going to San Germano to
finish the tomb of Piero de' Medici at Monte Cassino. His name was Solosmeo, and he gave me 158
the news that on the very evening of the fray, Pope Clement sent one of his chamberlains to
inquire how Tobbia was getting on. Finding him at work, unharmed, and without even
knowing anything about the matter, the messenger went back and told the Pope, who turned
round to Pompeo and said: 'You are a good-for-nothing rascal; but I promise you well that
you have stirred a snake up which will sting you, and serve you right!' Then he addressed

32 ABOVE *Niccolò Tribolo*, detail from the fresco by Vasari in the Palazzo Vecchio (plate 35)

33 RIGHT Medal for Pope Clement VII by Cellini, 1534. Obverse, *Clement VII*; reverse, *Moses striking water from the rock*. Florence, Bargello

himself to Cardinal de' Medici, and commissioned him to look after me, adding that he should be very sorry to let me slip through his fingers. And so Solosmeo and I went on our way singing toward Monte Cassino, intending to pursue our journey thence in company toward Naples.

When Solosmeo had inspected his affairs at Monte Cassino, we resumed our journey; and having come within a mile of Naples, we were met by an innkeeper, who invited us to his house, and said he had been at Florence many years with Carlo Ginori; adding, that if we put up at his inn, he would treat us most kindly, for the reason that we both were Florentines. We told him frequently that we did not want to go to him. However, he kept passing, sometimes in front and sometimes behind, perpetually repeating that he would have us stop at his hostelry. When this began to bore me, I asked if he could tell me anything about a certain Sicilian woman called Beatrice, who had a beautiful daughter named Angelica, and both were courtesans. Taking it into his head that I was jeering him, he cried out: 'God send mischief to all courtesans and such as favour them!' Then he set spurs to his horse, and made off as though he was resolved to leave us. I felt some pleasure at having rid myself in so fair a manner of that ass of an innkeeper; and yet I was rather the loser than the gainer; for the great love I bore Angelica had come back to my mind, and while I was conversing, not without some lover's sighs, upon this subject with Solosmeo, we saw the man returning to us at a gallop. When he drew up, he said: 'Two or perhaps three days ago a woman and a girl came back to a house in my neighbourhood; they had the names you mentioned; but whether they are Sicilians I cannot say.' I answered: 'Such power over me has that name of Angelica, that I am now determined to put up at your inn.'

We rode on all together with mine host into the town of Naples, and descended at his house. Minutes seemed years to me till I had put my things in order, which I did in the twinkling of an eye; then I went to the house, which was not far from our inn, and found there my Angelica, who greeted me with infinite demonstrations of the most unbounded passion. I stayed with her from evenfall until the following morning, and enjoyed such pleasure as I never had before or since; but while drinking deep of this delight, it occurred to my mind how exactly on that day the month expired, which had been prophesied within the necromantic circle by the devils. So then let every man who enters into relation with those spirits weigh well the inestimable perils I have passed through!

I happened to have in my purse a diamond, which I showed about among the goldsmiths; and though I was but young, my reputation as an able artist was so well known even at Naples that they welcomed me most warmly. Among others, I made acquaintance with a most excellent companion, a jeweller, Messer Domenico Fontana by name. This worthy man left his shop for the three days that I spent in Naples, nor ever quitted my company, but showed me many admirable monuments of antiquity in the city and its neighbourhood. Moreover, he took me to pay my respects to the Viceroy of Naples, who had let him know that he should like to see me. When I presented myself to his Excellency, he received me with much honour, and while we were exchanging compliments, the diamond which I have mentioned caught his eye. He made me show it him, and prayed me, if I parted with it, to give him the refusal. Having taken back the stone, I offered it again to his Excellency, adding that the diamond and I were at his service. Then he said that the diamond pleased him well, but that he should be much better pleased if I were to stay with him; he would make such terms with me as would cause me to feel satisfied. We spoke many words of courtesy on both sides; and then coming to the merits of the diamond, his Excellency bade me without hesitation name the price at which I valued it. Accordingly I said that it was worth exactly two hundred crowns. He rejoined that in his opinion I had not overvalued it; but that since I had set it and he knew me for the first artist in the world, it would not make the same effect when mounted by another hand. To this I said that I had not set the stone, and that it was not well set; its brilliancy was due to its own excellence; and that if I were to mount it afresh, I could make it show far better than it did. Then I put my thumb-nail to the angles of its facets, took it from the ring, cleaned it up a little,

and handed it to the Viceroy. Delighted and astonished, he wrote me out a cheque for the two hundred crowns I had demanded.

When I returned to my lodging, I found letters from the Cardinal de' Medici, in which he told me to come back post-haste to Rome, and to dismount without delay at the palace of his most reverend lordship. I read the letter to my Angelica, who begged me with tears of affection either to remain in Naples or to take her with. I replied that if she was disposed to come with me, I would give up to her keeping the two hundred ducats I had received from the Viceroy. Her mother perceiving us in this close conversation, drew nigh and said: 'Benvenuto, if you want to take my daughter to Rome, leave me a sum of fifteen ducats, to pay for my lying-in, and then I will travel after you.' I told the old harridan that I would very gladly leave her thirty if she would give me my Angelica. We made the bargain, and Angelica entreated me to buy her a gown of black velvet, because the stuff was cheap at Naples. I consented to everything, sent for the velvet, settled its price and paid for it; then the old woman, who thought me over head and ears in love, begged for a gown of fine cloth for herself as well as other outlays for her sons, and a good bit more money than I had offered. I turned to her with a pleasant air and said: 'My dear Beatrice, are you satisfied with what I offered?' She answered that she was not; thereupon I said that what was not enough for her would be quite enough for me; and having kissed Angelica, we parted, she with tears, and I with laughter, and off at once I set for Rome.

When I got there, I dismounted at the palace of Cardinal de' Medici, and having obtained an audience of his most reverend lordship, paid my respects, and thanked him warmly for my recall. I then entreated him to secure me from imprisonment, and even from a fine if that were possible. The Cardinal was very glad to see me; told me to stand in no fear; then turned to one of his gentlemen, called Messer Pier Antonio Pecci of Siena, ordering him to tell the Bargello *161* not to touch me. He then asked him how the man was going on whose head I had broken with the stone. Messer Pier Antonio replied that he was very ill, and that he would probably be even worse; for when he heard that I was coming back to Rome, he swore he would die to serve me an ill turn. When the Cardinal heard that, he burst into a fit of laughter, and cried: 'The fellow could not have taken a better way than this to make us know that he was born a Sienese.' After that he turned to me and said: 'For our reputation and your own, refrain these four or five days from going about in the Banchi; after that go where you like, and let fools die at their own pleasure.'

I went home and set myself to finishing the medal which I had begun, with the head of Pope Clement and a figure of Peace on the reverse. The figure was a slender woman, dressed in very thin drapery, gathered at the waist, with a little torch in her hand, which was burning a heap of arms bound together like a trophy. In the background I had shown part of a temple, where was Discord chained with a load of fetters. Round about it ran a legend in these words: *Clauduntur belli portæ.* *162*

During the time that I was finishing this medal, the man whom I had wounded recovered, and the Pope kept incessantly asking for me. I, however, avoided visiting Cardinal de' Medici; for whenever I showed my face before him, his lordship gave me some commission of importance, which hindered me from working at my medal to the end. Consequently Messer Pier Carnesecchi, who was a great favourite of the Pope's, undertook to keep me in sight, and *163* let me adroitly understand how much the Pope desired my services. I told him that in a few days I would prove to his Holiness that his service had never been neglected by me.

Not many days had passed before, my medal being finished, I stamped it in gold, silver, and copper. After I had shown it to Messer Piero, he immediately introduced me to the Pope. It was on a day in April after dinner, and the weather very fine; the Pope was in the Belvedere. After entering the presence, I put my medals together with the dies of steel into his hand. He took them, and recognizing at once their mastery of art, looked Messer Piero in the face and said: 'The ancients never had such medals made for them as these.' His Holiness then asked *164* what method I had used to stamp them so marvellously, large as they were; for he had never

34 ABOVE *Self-portrait* of Vasari, from his fresco in the Palazzo Vecchio
(plate 35)

35 RIGHT *Duke Cosimo I surrounded by his artists*, fresco by Giorgio Vasari,
c. 1557. Florence, Palazzo Vecchio (Quartiere di Leone X, Sala di Cosimo I)

met with ancient pieces of that size. We talked a little on this subject; he praised my medals, and
said they gave him the greatest satisfaction, but that he should like another reverse made
according to a fancy of his own, if it were possible to stamp them with two different patterns. I
said that it was possible to do so. Then his Holiness commissioned me to design the history of
165 Moses when he strikes the rock and water issues from it, with this motto: *Ut bibat populus.* At
last he added: 'Go, Benvenuto; you will not have finished it before I have provided for your
fortune.' After I had taken leave, the Pope proclaimed before the whole company that he
would give me enough to live on wealthily without the need of labouring for any one but him.
So I devoted myself entirely to working out this reverse with the Moses on it.
 In the meantime the Pope was taken ill, and his physicians thought the case was dangerous.
Accordingly my enemy began to be afraid of me, and engaged some Neapolitan soldiers to do
166 to me what he was dreading I might do to him. I had therefore much trouble to defend my
poor life. In course of time, however, I completed the reverse; and when I took it to the Pope, I
found him in bed in a most deplorable condition. Nevertheless, he received me with the
greatest kindness, and wished to inspect the medals and the dies. He sent for spectacles and
lights, but was unable to see anything clearly. Then he began to fumble with his fingers at

them, and having felt them a short while, he fetched a deep sigh, and said to his attendants that he was much concerned about me, but that if God gave him back his health he would make it all right.

Three days afterwards the Pope died, and I was left with all my labour lost; yet I plucked up courage, and told myself that these medals had won me so much celebrity, that any Pope who was elected would give me work to do, and peradventure bring me better fortune. Thus I encouraged and put heart into myself, and buried in oblivion all the injuries which Pompeo had done me. Then putting on my arms and girding my sword, I went to San Piero, and kissed the feet of the dead Pope, not without shedding tears. Afterwards I returned to the Banchi to look on at the great commotion which always happens on such occasions.

While I was sitting in the street with several of my friends, Pompeo went by, attended by ten men very well armed; and when he came just opposite, he stopped, as though about to pick a quarrel with myself. My companions, brave and adventurous young men, made signs to me to draw my sword; but it flashed through my mind that if I drew, some terrible mischief might result for persons who were wholly innocent. Therefore I considered that it would be better if I put my life to risk alone. When Pompeo had stood there time enough to say two Ave Marias, he

laughed derisively in my direction; and going off, his fellows also laughed and wagged their heads, with many other insolent gestures.

Some business or other made Pompeo enter the apothecary's shop which stood at the corner of Chiavica, and there he stayed a while transacting it. I had just been told that he had boasted of the insult which he fancied he had put upon me; be that as it may, it was to his misfortune; for precisely when I came up to the corner, he was leaving the shop, and his bravi had opened their ranks and received him in their midst. I drew a little dagger with a sharpened edge, and breaking the line of his defenders, laid my hands upon his breast so quickly and coolly, that none of them were able to prevent me. Then I aimed to strike him in the face; but fright made him turn his head round; and I stabbed him just beneath the ear. I only gave two blows, for he fell stone dead at the second. I had not meant to kill him; but as the saying goes, knocks are not dealt by measure. With my left hand I plucked back the dagger, and with my right hand drew my sword to defend my life. However, all those bravi ran up to the corpse and took no action
168 against me; so I went back alone through Strada Giulia, considering how best to put myself in
169 safety. I had walked about three hundred paces, when Piloto the goldsmith, my very good friend, came up and said: 'Brother, now that the mischief's done, we must see to saving you.'
170 Cardinal Cornaro, on hearing of the affair, despatched thirty soldiers, with as many partisans, pikes, and arquebuses, to bring me with all due respect to his quarters. This he did unasked; whereupon I accepted the invitation, and went off with them, while more than as many of the young men bore me company. Meanwhile, Messer Traiano, Pompeo's relative and first chamberlain to the Pope, sent a Milanese of high rank to Cardinal de' Medici, giving him news of the great crime I had committed, and calling on his most reverend lordship to chastise me. The Cardinal retorted on the spot: 'His crime would indeed have been great if he had not committed this lesser one; thank Messer Traiano from me for giving me this information of a fact of which I had not heard before.' Then he turned and in presence of the
171 nobleman said to the Bishop of Frulli, his gentleman and intimate acquaintance: 'Search diligently after my friend Benvenuto; I want to help and defend him; and whoso acts against him acts against myself.' The Milanese nobleman went back, much disconcerted, while the Bishop of Frulli came to visit me at Cardinal Cornaro's palace. Presenting himself to the Cardinal, he related how Cardinal de' Medici had sent for Benvenuto, and wanted to be his protector. Now Cardinal Cornaro, who had the touchy temper of a bear, flew into a rage, and told the Bishop he was quite as well able to defend me as Cardinal de' Medici. The Bishop, in reply, entreated to be allowed to speak with me on some matters of his patron which had nothing to do with the affair. Cornaro bade him for that day make as though he had already talked with me.

Cardinal de' Medici was very angry. However, I went the following night, without Cornaro's knowledge, and under good escort, to pay him my respects. Then I begged him to grant me the favour of leaving me where I was, and told him of the great courtesy which Cornaro had shown me; adding that if his most reverend lordship suffered me to stay, I should gain one friend the more in my hour of need; otherwise his lordship might dispose of me exactly as he thought best. He told me to do as I liked; so I returned to Cornaro's palace, and a
172 few days afterwards the Cardinal Farnese was elected Pope.

After he had put affairs of greater consequence in order, the new Pope sent for me, saying that he did not wish any one else to strike his coins. To these words of his Holiness a gentleman
173 very privately acquainted with him, named Messer Latino Juvinale, made answer that I was in hiding for a murder committed on the person of one Pompeo of Milan, and set forth what could be argued for my justification in the most favourable terms. The Pope replied: 'I knew nothing of Pompeo's death, but plenty of Benvenuto's provocation; so let a safe-conduct be at once made out for him, in order that he may be placed in perfect security.' A great friend of Pompeo's, who was also intimate with the Pope, happened to be there; he was a Milanese,
174 called Messer Ambrogio. This man said: 'In the first days of your papacy it were not well to grant pardons of this kind.' The Pope turned to him and answered: 'You know less about such

matters than I do. Know then that men like Benvenuto, unique in their profession, stand above
the law; and how far more he, then, who received the provocation I have heard of?' When my *175*
safe-conduct had been drawn out, I began at once to serve him, and was treated with the
utmost favour.

Messer Latino Juvinale came to call on me, and gave me orders to strike the coins of the
Pope. This roused up all my enemies, who began to look about how they should hinder me;
but the Pope, perceiving their drift, scolded them, and insisted that I should go on working. I
took the dies in hand, designing a St. Paul, surrounded with this inscription: *Vas electionis*. This *176*
piece of money gave far more satisfaction than the models of my competitors; so that the Pope
forbade any one else to speak to him of coins, since he wished me only to have to do with them.
This encouraged me to apply myself with untroubled spirit to the task; and Messer Latino
Juvinale, who had received such orders from the Pope, used to introduce me to his Holiness. I
had it much at heart to recover the post of stamper to the Mint; but on this point the Pope took
advice, and then told me I must first obtain pardon for the homicide, and this I should get at the
holy Maries' day in August through the Caporioni of Rome. I may say that it is usual every *177*
year on this solemn festival to grant the freedom of twelve outlaws to these officers. Meanwhile
he promised to give me another safe-conduct, which should keep me in security until that time.

When my enemies perceived that they were quite unable to devise the means of keeping me
out of the Mint, they resorted to another expedient. The deceased Pompeo had left three
thousand ducats as dowry to an illegitimate daughter of his; and they contrived that a certain
favourite of Signor Pier Luigi, the Pope's son, should ask her hand in marriage through the *178*
medium of his master. Accordingly the match came off; but this fellow was an insignificant
country lad, who had been brought up by his lordship; and, as folk said, he got but little of the
money, since his lordship laid his hands on it and had the mind to use it. Now the husband of the
girl, to please his wife, begged the prince to have me taken up; and he promised to do so when
the first flush of my favour with the Pope had passed away. Things stood so about two months,
the servant always suing for his wife's dower, the master putting him off with pretexts, but
assuring the woman that he would certainly revenge her father's murder. I obtained an inkling
of these designs; yet I did not omit to present myself pretty frequently to his lordship, who
made show of treating me with great distinction. He had, however, decided to do one or other
of two things – either to have me assassinated, or to have me taken up by the Bargello. Not
many days after, a friend of mine informed me that Signor Pier Luigi had given strict orders
that I should be taken that very evening. The order had been given for one hour after sunset;
accordingly at twenty-three I left in the post for Florence.

I reached Florence in due course, and paid my respects to the Duke Alessandro, who greeted
me with extraordinary kindness and pressed me to remain in his service. There was then at

36 Gold *scudo* for Pope Paul III by Cellini, 1534. Obverse, the Farnese coat-
of-arms; reverse, *St Paul*. British Museum

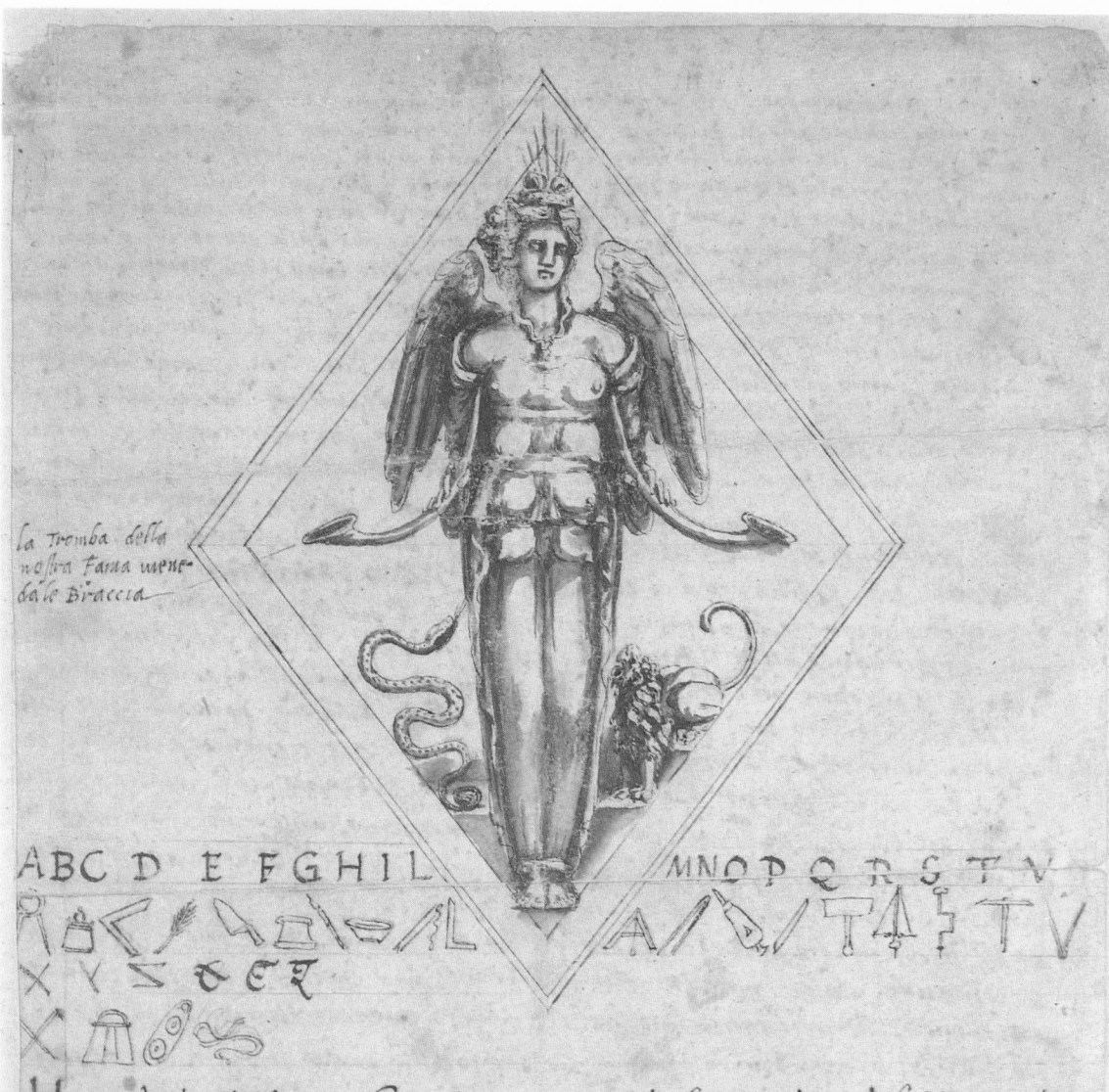

la tromba della
nostra Fama uiene
de le Braccia

ABCD E FGHIL MNOPQRSTV

Hauendo io cosiderato quáto, qste nostre arti, che procedono dal disegno, siano
gradi, nõ potendo l'huomõ alcuna cosa pfettamẽte opare, senza riferirsi
al disegno, dal quale egli trae semp̄ i miglior cõsigli, Et p̄che io crederrei beniss.
far capaci tutti gl'huomini cõ uiue ragioni, à le quasi nõ si potrebbe cõtradire
essere uerissimo, che il disegno essendo ueramẽte origine, e principio di tutte
le azzioni dell'huomo, e solo quella Iddea uera della Natura, che fu da gl'
Antiani cõ molte poppe figurata, p̄ significare, ch'ella nutrisce ogni cosa, come
sola, e principale ministra di Dio, che di Terra sculsi, e creo il primo huomo
ad imagine, e similitudine di sé, et che p̄ cõseguenẕa nõ possono i professori del-
l'Arti del disegno hauere p̄ Suggello, e p̄ Impresa loro, niuna cosa, ne piu somigliã-
te ai uero, ne piu ppria degli eserciẕij loro, che la detta Iddea della Natura, come piu
largamẽte dimostrarci, senza ristringẽermi à tãta breuità, se io nõ conoscessi uoi tãti
Artefici nobilissimi, nõ meno esercitati in discorrere le merauigliose op̄e della Natura
che uirtuosissimi, et eccellenti nelle cose, che dal disegno procedono. Hora quãto è
la ferma similmẽte del nostro Suggello, hauedomi uoi fatto degnio di dire il parer mio
tra uoi bellissi. Ingegni, che riaccendere il gran Lume poco manco che spento, di
una cosi g̃ade, e honorata scuola com'è la nostra, et aiutati dalla diuina et im-
mortal uirtù del n̄ro Ill.mo e glorios.simo Duca Cosimo de Medici Amatore d'uero

S. Benuenuto Cellini

Florence a sculptor called Il Tribolino, and we were gossips, for I had stood godfather to his *179*
son. In course of conversation he told me that a certain Giacopo del Sansovino, his first master, *180*
had sent for him; and whereas he had never seen Venice, and because of the gains he expected,
he was very glad to go there. On his asking me if I had ever been at Venice, I said no; this made
him invite me to accompany him, and I agreed. So then I told Duke Alessandro that I wanted
first to go to Venice, and that afterwards I would return to serve him. He exacted a formal
promise to this effect, and bade me present myself before I left the city. Next day, having made
my preparations, I went to take leave of the Duke, whom I found in the palace of the Pazzi, at
that time inhabited by the wife and daughters of Signor Lorenzo Cibo. Having sent word to his *181*
Excellency that I wished to set off for Venice with his good leave, Signor Cosimino de' Medici,
now Duke of Florence, returned with the answer that I must go to Niccolò da Monte Aguto,
who would give me fifty golden crowns, which his Excellency bestowed on me in sign of his
good-will, and afterwards I must return to serve him. *182*

I got the money from Niccolò, and then went to fetch Tribolo, whom I found ready to start;
and he asked me whether I had bound my sword. I answered that a man on horseback about to

37 OPPOSITE *Diana of Ephesos*, drawing by Cellini for the seal of the
Academy of Florence, 1563. Pen, ink and wash. British Museum

38 BELOW *Alessandro de' Medici* by Pontormo, 1534–5. Panel, 32½ × 39¾ ins
(82.5 × 101 cm). Philadelphia, John G. Johnson Coll.

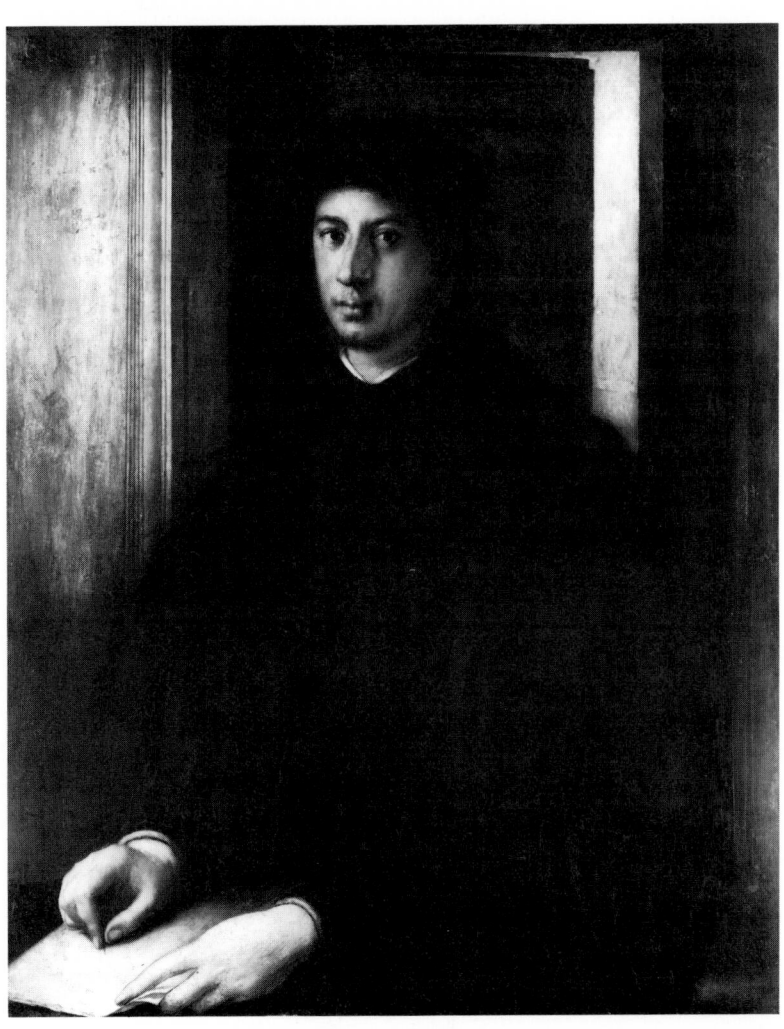

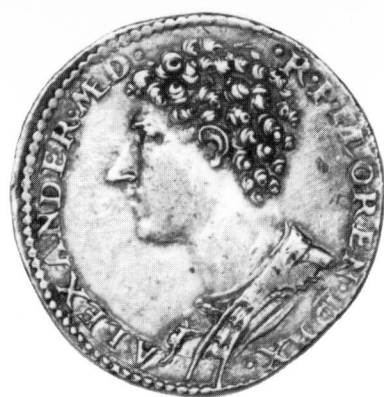

39 Silver coin for Alessandro de'Medici by Cellini, 1535. Obverse, *Alessandro de'Medici*; reverse, *Sts Cosmas and Damian*. Diameter $1\frac{1}{8}$ ins (19 mm). Vienna, Kunsthistorisches Museum

183

take a journey ought not to bind his sword. He said that the custom was so in Florence, since a certain Ser Maurizio then held office, who was capable of putting St. John the Baptist to the rack for any trifling peccadillo. Accordingly one had to carry one's sword bound till the gates were passed. I laughed at this, and so we set off.

When we arrived in Venice, I went to visit Jacopo del Sansovino, the sculptor, who had sent for Tribolo. He received me most kindly, and invited us to dinner, and we stayed with him. In course of conversation with Tribolo, he told him that he had no work to give him at the moment, but that he might call again. Hearing this, I burst out laughing, and said pleasantly to Sansovino: 'Your house is too far off from his, if he must call again.' Poor Tribolo, all in dismay, exclaimed: 'I have got your letter here, which you wrote to bid me come.' Sansovino rejoined that men of his sort, men of worth and genius, were free to do that and greater things besides. Tribolo shrugged up his shoulders and muttered: 'Patience, patience,' several times. Thereupon, without regarding the copious dinner which Sansovino had given me, I took the part of my comrade Tribolo, for he was in the right. All the while at table Sansovino had never stopped chattering about his great achievements, abusing Michel Agnolo and the rest of his fellow-sculptors, while he bragged and vaunted himself to the skies. This had so annoyed me that not a single mouthful which I ate had tasted well; but I refrained from saying more than these two words: 'Messer Jacopo, men of worth act like men of worth, and men of genius, who produce things beautiful and excellent, shine forth far better when other people praise them than when they boast so confidently of their own achievements.' Upon this he and I rose from table blowing off the steam of our choler.

A few days afterwards we set out on our return to Florence. We lay one night at a place on this side Chioggia, on the left hand as you go toward Ferrara. Here the host insisted upon being paid before we went to bed, and in his own way; and when I observed that it was the custom everywhere else to pay in the morning, he answered: 'I insist on being paid overnight, and in my own way.' I retorted that men who wanted everything their own way ought to make a world after their own fashion, since things were differently managed here. Our host told me not to go on bothering his brains, because he was determined to do as he had said. Tribolo stood trembling with fear, and nudged me to keep quiet, lest they should do something worse to us; so we paid them in the way they wanted, and afterwards we retired to rest. We had, I must admit, the most capital beds, new in every particular, and as clean as they could be. Nevertheless I did not get one wink of sleep, because I kept on thinking how I could revenge myself. At one time it came into my head to set fire to his house; at another to cut the throats of four fine horses which he had in the stable; I saw well enough that it was easy for me to do all this; but I could not see how it was easy to secure myself and my companion. At last I resolved to put my things and my comrade's on board the boat; and so I did. When the towing-horses had been harnessed to the cable, I ordered the people not to stir before I returned, for I had left a

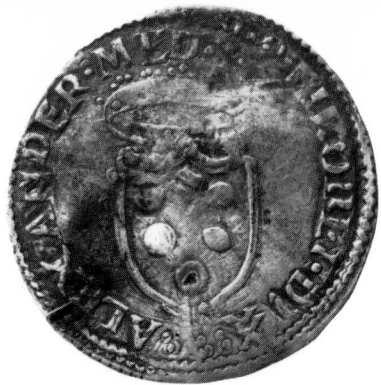

40 *Mezzo giulio* or *grossone* for Alessandro de' Medici by Cellini, 1535.
Obverse, the Medici coat-of-arms; reverse, *The infant St John the Baptist.*
British Museum

pair of slippers in my bedroom. Accordingly I went back to the inn and called our host, who told me he had nothing to do with us, and that we might go to Jericho. There was a ragged stable-boy about, half asleep, who cried out to me: 'The master would not move to please the Pope, because he has got a wench in bed with him, whom he has been wanting this long while.' Then he asked me for a tip, and I gave him a few Venetian coppers, and told him to make the barge-man wait till I had found my slippers and returned. I went upstairs, took out a little knive as sharp as a razor, and cut the four beds that I found there into ribbons. I had the satisfaction of knowing I had done a damage of more than fifty crowns. Then I ran down to the boat with some pieces of the bed-covers in my pouch, and bade the bargee start at once without delay. We had not gone far before my gossip Tribolo said that he had left behind some little straps belonging to his carpet-bag, and that he must be allowed to go back for them. I answered that he need not take thought for a pair of little straps, since I could make him as many big ones as he liked. He told me I was always joking, but that he must really go back for his straps. Then he began ordering the bargee to stop, while I kept ordering him to go on. Meanwhile I informed my friend what kind of trick I had played our host, and showed him specimens of the bed-covers and other things, which threw him into such a quaking fright that he roared out to the bargee: 'On with you, on with you, as quick as you can!' and never thought himself quite safe until we reached the gates of Florence.

When we arrived there, Tribolo said: 'Let us bind our swords up, for the love of God; and play me no more of your games, I beg; for all this while I've felt as though my guts were in the saucepan.' I made answer: 'Gossip Tribolo, you need not tie your sword up, for you have never loosed it'; and this I said at random, because I never once had seen him act the man upon that journey. When he heard the remark, he looked at his sword and cried out: 'In God's name, you speak true! Here it is tied, just as I arranged it before I left my house.'

No sooner had I dismounted than I went to visit Duke Alessandro, and thanked him greatly for his present of the fifty crowns, telling his Excellency that I was always ready to serve him according to my abilities. He gave me orders at once to strike dies for his coinage; and the first I made was a piece of forty soldi, with the Duke's head on one side and San Cosimo and San Damiano on the other. This was in silver, and it gave so much satisfaction that the Duke did not hesitate to say they were the best pieces of money in Christendom. The same said all Florence and every one who saw them.

I then made dies for a giulio, it had San Giovanni in profile, seated with a book in his hand, finer in my judgment than anything which I had done; and on the other side were the armorial bearings of Duke Alessandro. Next I made dies for half-giulios, on which I struck the full face of San Giovanni in small. This was the first coin with a head in full face on so thin a piece of silver that had yet been seen. The difficulty of executing it is apparent only to the eyes of such as are past-masters in these crafts. Afterwards I made dies for the golden crowns; this crown had a

185 cross upon one side with some little cherubim, and on the other side his Excellency's arms.

186 Two days afterward I brought some drawings which his Excellency had commissioned for gold-work he wanted to give his wife, who was at that time still in Naples. I again asked him to settle my affairs. Then his Excellency told me that he should like me first to execute the die of his portrait in fine style, as I had done for Pope Clement. I began it in wax; and the Duke gave orders, while I was at work upon it, that whenever I went to take his portrait, I should be admitted. Perceiving that I had a lengthy piece of business on my hands, I sent for a certain

187 Pietro Pagolo from Monte Ritondo, in the Roman district, who had been with me from his

188 boyhood in Rome. I found him with one Bernardonaccio, a goldsmith, who did not treat him well; so I brought him away from there, and taught him minutely how to strike coins from those dies. Meanwhile, I went on making the Duke's portrait; and oftentimes I found him

189 napping after dinner with that Lorenzino of his, who afterwards murdered him, and no other company; I marvelled that a Duke of that sort showed such confidence about his safety.

190 It happened at this time that Ottaviano de' Medici, who to all appearances had got the government of everything in his own hands, favoured the old Master of the Mint against the

191 Duke's will. This man was called Bastiano Cennini, an artist of the antiquated school, and of little skill in his craft. Ottaviano mixed his stupid dies with mine in the coinage of crown-pieces. I complained of this to the Duke, who, when he saw how the matter stood, took it very ill, and said to me: 'Go, tell this to Ottaviano de' Medici, and show him how it is.' I lost no time; and when I had pointed out the injury that had been done to my fine coins, he answered, like the donkey that he was: 'We choose to have it so.' I replied that it ought not to be so, and that I did not choose to have it so. He said: 'And if the Duke likes to have it so?' I answered: 'It would not suit me, for the thing is neither just nor reasonable.' He told me to take myself off, and that I should have to swallow it in this way, even if I burst.

That very day, which was a Thursday, I received from Rome a full safe-conduct from the Pope, with advice to go there at once and get the pardon of Our Lady's feast in mid-August, in order that I might clear myself from the penalties attaching to my homicide. I went to the Duke, whom I found in bed, for they told me he was suffering the consequence of a debauch. In little more than two hours I finished what was wanted for his waxen medal; and when I showed it him, it pleased him extremely. Then I exhibited the safe-conduct sent me at the order of the Pope, and told him how his Holiness had recalled me to execute certain pieces of work; on this account I should like to regain my footing in the fair city of Rome, which would not

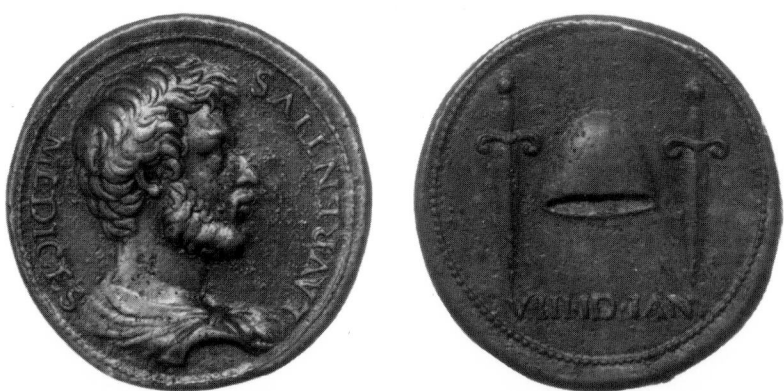

41 Medal for Lorenzino de'Medici (by Giovanni dal Cavino?), 16th century. Obverse, *Lorenzino as Brutus*; reverse, *The Cap of Liberty between two daggers*. Washington DC, National Gallery (Samuel H. Kress Coll.)

prevent my attending to his medal. During this conversation, the Lorenzino de' Medici whom I have above mentioned was present, and no one else. The Duke frequently signed to him that he should join in pressing me to stay; but Lorenzino never said anything except: 'Benvenuto, you would do better to remain where you are.' I answered that I wanted by all means to regain my hold on Rome. He made no reply, but continued eyeing the Duke with very evil glances. When I had finished the medal to my liking, and shut it in its little box, I said to the Duke: 'My lord, pray let me have your good-will, for I will make you a much finer medal than the one I made for Pope Clement. It is only reasonable that I should, since that was the first I ever made. Messer Lorenzo here will give me some exquisite reverse, as he is a person learned and of the greatest genius.' To these words Lorenzo suddenly made answer: 'I have been thinking of nothing else but how to give you a reverse worthy of his Excellency.' The Duke laughed a little, and looking at Lorenzo, said: 'Lorenzo, you shall give him the reverse, and he shall do it here and shall not go away.' Lorenzo took him up at once, saying: 'I will do it as quickly as I can, and I hope to do something that shall make the whole world wonder.' The Duke, who held him sometimes for a fool and sometimes for a coward, turned about in bed, and laughed at his bragging words. I took my leave without further ceremony, and left them alone together.

On my arrival in Rome, I found that the little house I had in Strada Giulia was not ready; so I dismounted at the house of Messer Giovanni Gaddi, clerk of the Camera, to whose keeping I had committed, on leaving Rome, many of my arms and other things I cared for. So I did not choose to alight at my shop, but sent for Felice, my partner, and got him to put my little dwelling forthwith into excellent order. The day following, I went to sleep there, after well providing myself with clothes and all things requisite, since I intended to go and thank the Pope next morning. _192_

Meanwhile the feast of Our Lady came round. Now it is the custom for those who get a pardon upon this occasion to give themselves up to prison; in order to avoid doing which I returned to the Pope, and told his Holiness that I was very unwilling to go to prison, and that I begged him to grant me the favour of a dispensation. The Pope answered that such was the custom, and that I must follow it. Thereupon I fell again upon my knees, and thanked him for the safe-conduct he had given me, saying at the same time that I should go back with it to serve my Duke in Florence, who was waiting for me so impatiently. On hearing this, the Pope turned to one of his confidential servants and said: 'Let Benvenuto get his grace without the prison, and see that his _moto proprio_ is made out in due form.' As soon as the document had been drawn up, his Holiness signed it; it was then registered at the Capitol; afterwards, upon the day _193_ appointed, I walked in procession very honourably between two gentlemen, and so got clear at last.

Four days had passed when I was attacked with violent fever attended by extreme cold; and taking to my bed, I made my mind up that I was sure to die. I had the first doctors of Rome called in, among whom was Francesco da Norcia, a physician of great age, and of the best _194_ repute in Rome.

Every day Messer Giovanni Gaddi came to see me two or three times, and each time he took up one or other of my handsome fowling-pieces, coats of mail, or swords, using words like these: 'That is a handsome thing, that other is still handsomer'; and likewise with my models and other trifles, so that at last he drove me wild with annoyance. In his company came a certain Mattio Franzesi; and this man also appeared to be waiting impatiently for my death, not indeed because he would inherit anything from me, but because he wished for what his master seemed to have so much at heart.

Felice, my partner, was always at my side, rendering the greatest services which it is possible for one man to give another. Nature in me was utterly debilitated and undone; I had not strength enough to fetch my breath back if it left me; and yet my brain remained as clear and strong as it had been before my illness. Nevertheless, although I kept my consciousness, a terrible old man used to come to my bedside, and make as though he would drag me by force into a huge boat he had with him. This made me call out to my Felice to draw near and chase

that malignant old man away. Felice, who loved me most affectionately, ran weeping and crying: 'Away with you, old traitor; you are robbing me of all the good I have in this world.' Messer Giovanni Gaddi, who was present, then began to say: 'The poor fellow is delirious, and *195* has only a few hours to live.' His fellow, Mattio Franzesi, remarked: 'He has read Dante, and in the prostration of his sickness this apparition has appeared to him'; then he added laughingly: 'Away with you, old rascal, and don't bother our friend Benvenuto.' When I saw that they were making fun of me, I turned to Messer Gaddi and said: 'My dear master, know that I am not raving, and that it is true that this old man is really giving me annoyance; but the best that you can do for me would be to drive that miserable Mattio from my side, who is laughing at my affliction; afterwards if your lordship deigns to visit me again, let me beg you to come with Messer Antonio Allegretti, or with Messer Annibal Caro, or with some other of your accomplished friends, who are persons of quite different intelligence and discretion from that beast.' Thereupon Messer Giovanni told Mattio in jest to take himself out of his sight for ever; but because Mattio went on laughing, the joke turned to earnest, for Messer Giovanni would not look upon him again, but sent for Messer Antonio Allegretti, Messer Ludovico, and Messer Annibal Caro. On the arrival of these worthy men, I was greatly comforted, and talked reasonably with them awhile, not however without frequently urging Felice to drive the old man away. Messer Ludovico asked me what it was I seemed to see, and how the man was shaped. While I portrayed him accurately in words, the old man took me by the arm and dragged me violently towards him. This made me cry out for aid, because he was going to fling *196* me under hatches in his hideous boat. On saying that last word, I fell into a terrible swoon, and seemed to be sinking down into the boat. They say that during that fainting-fit I flung myself about and cast bad words at Messer Giovanni Gaddi, to wit, that he came to rob me, and not from any motive of charity, and other insults of the kind, which caused him to be much ashamed. Later on, they say I lay still like one dead; and after waiting by me more than an hour, thinking I was growing cold, they left me for dead. When they returned home, Mattio Franzesi was informed, who wrote to Florence to Messer Benedetto Varchi, my very dear friend, that they had seen me die at such and such an hour of the night. When he heard the news, that most accomplished man and my dear friend composed an admirable sonnet upon my supposed but not real death, which shall be reported in its proper place.

Maestro Francesco sat down to write, and prescribed for me perfumes, lotions, unctions, plasters, and a heap of other precious things. Meanwhile I came to life again by the means of more than twenty leeches applied to my buttocks, but with my body bored through, bound, and ground to powder. Many of my friends crowded in to behold the miracle of the resuscitated dead man, and among them people of the first importance.

In their presence I declared that the small amount of gold and money I possessed, perhaps some eight hundred crowns, what with gold, silver, jewels, and cash, should be given by my will to my poor sister in Florence, called Mona Liperata; all the remainder of my property, armour and everything besides, I left to my dearest Felice, together with fifty golden ducats, in order that he might buy mourning. At those words Felice flung his arms around my neck, protesting that he wanted nothing but to have me as he wished alive with him. Then I said: 'If you want me alive, touch me as you did before, and threaten the old man, for he is afraid of you.' At these words some of the folk were terrified, knowing that I was not raving, but talking to the purpose and with all my wits. Thus my wretched malady went dragging on, and I got but little better. Maestro Francesco, that most excellent man, came four or five times a day; Messer Giovanni Gaddi, who felt ashamed, did not visit me again. My brother-in-law, the husband of my sister, arrived; he came from Florence for the inheritance; but as he was a very worthy man, he rejoiced exceedingly to have found me alive. The sight of him did me a world of good, and he began to caress me at once, saying he had only come to take care of me in person; and this he did for several days. Afterwards I sent him away, having almost certain hope of my recovery. On this occasion he left the sonnet of Messer Benedetto Varchi, which runs as follows:

Who shall, Mattio, yield our pain relief?
 Who shall forbid the said expense of tears?
 Alas! 'tis true that in his youthful years
Our friend hath flown, and left us here to grief.

He hath gone up to heaven, who was the chief
 Of men renowned in art's immortal spheres;
 Among the mighty dead he had no peers,
Nor shall earth see his like, in my belief.

O gentle sprite! if love still sway the blest,
 Look down on him thou here didst love, and view
 These tears that mourn my loss, not thy great good.

There dost thou gaze on His beatitude
 Who made our universe, and findest true
 The form of Him thy skill for men expressed.

My sickness had been of such a very serious nature that it seemed impossible for me to fling it off. Maestro Francesco then gave orders that I should be removed from my room and carried to one of the hills there are in Rome. Cardinal Cornaro, when he heard of my improvement, had me transported to a place of his on Monte Cavallo. That very evening I was taken with great precautions in a chair, well wrapped up and protected from the cold. No sooner had I reached the place than I began to vomit, during which there came from my stomach a hairy worm about a quarter of a cubit in length: the hairs were long, and the worm was very ugly, speckled of divers colours, green, black, and red. They kept and showed it to the doctor, who said he had never seen anything of the sort before, and afterwards remarked to Felice: 'Now take care of your Benvenuto, for he is cured. Do not permit him any irregularities; for though he has escaped this time, another disorder now would be the death of him. You see his malady has been so grave, that if we had brought him the extreme unction, we might not have been in time. Now I know that with a little patience and time he will live to execute more of his fine works.' Then he turned to me and said: 'My Benvenuto, be prudent, commit no excesses, and when you are quite recovered, I beg you to make me a Madonna with your own hand, and I will always pay my devotions to it for your sake.' This I promised to do, and then asked him whether it would be safe for me to travel so far as to Florence. He advised me to wait till I was stronger, and till we could observe how Nature worked in me.

When eight days had come and gone, my amendment was so slight that life itself became almost a burden to me; indeed I had been more than fifty days in that great suffering. So I made my mind up, and prepared to travel. My dear Felice and I went toward Florence in a pair of baskets; and as I had not written, when I reached my sister's house, she wept and laughed over me all in one breath. That day many of my friends came to see me; among others Pier Landi, 197 who was the best and dearest friend I ever had. Next day there came a certain Niccolò da Monte Aguto, who was also a very great friend of mine. Now he had heard the Duke say: 'Benvenuto would have done much better to die, because he is come to put his head into a noose, and I will never pardon him.' Accordingly when Niccolò arrived, he said to me in desperation: 'Alas! my dear Benvenuto, what have you come to do here? Did you not know what you have done to displease the Duke? I have heard him swear that you were thrusting your head into a halter.' Then I replied: 'Niccolò, remind his Excellency that Pope Clement wanted to do as much to me before, and quite as unjustly; tell him to keep his eye on me, and give me time to recover; then I will show his Excellency that I have been the most faithful servant he will ever have in all his life; and forasmuch as some enemy must have served me this bad turn through envy, let him wait till I get well; for I shall then be able to give such an account of myself as will make him marvel.'

This bad turn had been done me by Giorgetto Vassellario of Arezzo, the painter; perchance 198

in recompense for many benefits conferred on him. I had harboured him in Rome and provided for his costs, while he had turned my whole house upside down; for the man was subject to a species of dry scab, which he was always in the habit of scratching with his hands. It happened, then, that sleeping in the same bed as an excellent workman, named Manno, who was in my service, when he meant to scratch himself, he tore the skin from one of Manno's legs with his filthy claws, the nails of which he never used to cut. The said Manno left my service, and was resolutely bent on killing him. I made the quarrel up, and afterwards got Giorgio into Cardinal de' Medici's household, and continually helped him. For these deserts, then, he told Duke Alessandro that I had abused his Excellency, and had bragged I meant to be the first to leap upon the walls of Florence with his foes the exiles. These words, as I afterwards learned, had been put into Vasari's lips by that excellent fellow Ottaviano de' Medici, who wanted to revenge himself for the Duke's irritation against him, on account of the coinage and my departure from Florence. I, being innocent of the crime falsely ascribed to me, felt no fear whatever. Meanwhile that able physician Francesco da Monte Varchi attended to my cure with great skill. He had been brought by my very dear friend Luca Martini, who passed the larger portion of the day with me.

During this while I had sent my devoted comrade Felice back to Rome, to look after our business there. When I could raise my head a little from the bolster, which was at the end of fifteen days, although I was unable to walk upon my feet, I had myself carried to the palace of the Medici, and placed upon the little upper terrace. There they seated me to wait until the Duke went by. Many of my friends at court came up to greet me, and expressed surprise that I had undergone the inconvenience of being carried in that way, while so shattered by illness; they said that I ought to have waited till I was well, and then to have visited the Duke. A crowd of them collected, all looking at me as a sort of miracle; not merely because they had heard that I was dead, but far more because I had the look of a dead man. Then publicly, before them all, I said how some wicked scoundrel had told my lord the Duke that I had bragged I meant to be the first to scale his Excellency's walls, and also that I had abused him personally; whereupon I had not the heart to live or die till I had purged myself of that infamy, and found out who the audacious rascal was who had uttered such calumnies against me. At these words a large number of those gentlemen came round, expressing great compassion for me; one said one thing, one another, and I told them I would never go thence before I knew who had accused me. At these words Maestro Agostino, the Duke's tailor, made his way through all those gentlemen, and said: 'If that is all you want to know, you shall know it at this very moment.'

Giorgio the painter, whom I have mentioned, happened just then to pass, and Maestro Agostino exclaimed: 'There is the man who accused you; now you know yourself if it be true or not.' As fiercely as I could, not being able to leave my seat, I asked Giorgio if it was true that he had accused me. He denied that it was so, and that he had ever said anything of the sort. Maestro Agostino retorted: 'You gallows-bird! don't you know that I know it for most certain?' Giorgio made off as quickly as he could, repeating that he had not accused me. Then, after a short while, the Duke came by; whereupon I had myself raised up before his Excellency, and he halted. I told him that I had come there in that way solely in order to clear my character. The Duke gazed at me, and marvelled I was still alive; afterwards he bade me take heed to be an honest man and regain my health.

I paid the best attention to my health, gave Pietro Pagolo advice about stamping the coins, and then went off upon my way to Rome without saying a word to the Duke or anybody else.

When I reached Rome, and had enjoyed the company of my friends awhile, I began the Duke's medal. In a few days I finished the head in steel, and it was the finest work of the kind which I had ever produced. At least once every day there came to visit me a sort of blockhead named Messer Francesco Soderini. When he saw what I was doing, he used frequently to exclaim: 'Barbarous wretch! you want then to immortalize that ferocious tyrant! You have never made anything so exquisite, which proves you our inveterate foe and their devoted friend; and yet the Pope and he have had it twice in mind to hang you without any fault of

yours. That was the Father and the Son; now beware of the Holy Ghost.' It was firmly believed that Duke Alessandro was the son of Pope Clement. Messer Francesco used also to say and swear by all his saints that, if he could, he would have robbed me of the dies for that medal. I would take such care of them that he should never see them more.

I now sent to Florence to request Lorenzino that he would send me the reverse of the medal. Niccolò da Monte Aguto, to whom I had written, wrote back, saying that he had spoken to that mad melancholy philosopher Lorenzino for it; he had replied that he was thinking night and day of nothing else, and that he would finish it as soon as he was able. Nevertheless, I was not to set my hopes upon his reverse, but I had better invent one out of my own head, and when I had finished it, I might bring it without hesitation to the Duke, for this would be to my advantage.

I composed the design of a reverse which seemed to me appropriate, and pressed the work forward to my best ability. Not being, however, yet recovered from that terrible illness, I gave myself frequent relaxation by going out on fowling expeditions with my friend Felice.

I remember in particular the day of Epiphany, when we were together near La Magliana. It *204* was close upon nightfall, and during the day I had shot a good number of ducks and geese; then, as I had almost made my mind up to shoot no more that time, we were returning briskly toward Rome. Calling to my dog by his name, Barucco, and not seeing him in front of me, I turned round and noticed that the well-trained animal was pointing at some geese which had settled in a ditch. I therefore dismounted at once, got my fowling-piece ready, and at a very long range brought two of them down with a single ball. I never used to shoot with more than one ball, and was usually able to hit my mark at two hundred cubits, which cannot be done by other ways of loading. Of the two geese, one was almost dead, and the other, though badly wounded, was flying lamely. My dog retrieved the one and brought it to me; but noticing that the other was diving down into the ditch, I sprang forward to catch it. Trusting to my boots, which came high up the leg, I put one foot forward; it sank in the oozy ground; and so, although I got the goose, the boot of my right leg was full of water. I lifted my foot and let the water run out; then, when I had mounted, we made haste for Rome. The cold, however, was very great, and I felt my leg freeze, so that I said to Felice: 'We must do something to help this leg, for I don't know how to bear it longer.' The good Felice, without a word, leapt from his horse, and gathering some thistles and bits of stick, began to build a fire. I meanwhile was waiting, and put my hands among the breast-feathers of the geese, and felt them very warm. So I told him not to make the fire, but filled my boot with the feathers of the goose, and was immediately so much comforted that I regained vitality.

We mounted, and rode rapidly toward Rome; and when we had reached a certain gently rising ground – night had already fallen – looking in the direction of Florence, both with one breath exclaimed in the utmost astonishment: 'O God of heaven! what is that great thing one sees there over Florence?' It resembled a huge beam of fire, which sparkled and gave out extraordinary lustre. I said to Felice: 'Assuredly we shall hear to-morrow that something of vast importance has happened in Florence.' *205*

As we rode into Rome, the darkness was extreme. On entering the house, I found some friends of mine there, to whom, while we were supping together, I related the adventures of the day's chase and the diabolical apparition of the fiery beam which we had seen. They exclaimed: 'What shall we hear to-morrow which this portent has announced?' I answered: 'Some revolution must certainly have occurred in Florence.' So we supped agreeably; and late the next day there came the news to Rome of Duke Alessandro's death. Upon this many of my acquaintances came to me and said: 'You were right in conjecturing that something of great importance had happened at Florence.' Just then Francesco Soderini appeared jogging along upon a wretched mule he had, and laughing all the way like a madman. He said to me: 'This is the reverse of that vile tyrant's medal which your Lorenzino de' Medici promised you.' Then he added: 'You wanted to immortalize the dukes for us; but we mean to have no more dukes': and thereupon he jeered me, as though I had been the captain of the factions which make dukes.

206 Meanwhile a certain Baccio Bettini, who had an ugly big head like a bushel, came up and began to banter me in the same way about dukes, calling out: 'We have dis-duked them, and won't have any more of them; and you were for making them immortal for us!' with many other tiresome quips of the same kind. I lost my patience at this nonsense, and said to them: 'You blockheads! I am a poor goldsmith, who serve whoever pays me; and you are jeering me as though I were a party-leader. However, this shall not make me cast in your teeth the insatiable greediness, idiocy, and good-for-nothing-ness of your predecessors. But this one answer I will make to all your silly railleries; that before two or three days at the longest have passed by, you will have another duke, much worse perhaps than he who now has left you.'

The following day Bettini came to my shop and said: 'There is no need to spend money in couriers, for you know things before they happen. What spirit tells them to you?' Then he
207 informed me that Cosimo de' Medici, the son of Signor Giovanni, was made Duke; but that certain conditions had been imposed at his election, which would hold him back from kicking up his heels at his own pleasure. I now had my opportunity for laughing at them, and saying: 'Those men of Florence have set a young man upon a mettlesome horse; next they have buckled spurs upon his heels, and put the bridle freely in his hands, and turned him out upon a magnificent field, full of flowers and fruits and all delightful things; next they have bidden him not to cross certain indicated limits: now tell me, you, who there is that can hold him back, whenever he has but the mind to cross them? Laws cannot be imposed on him who is the master of the law.' So they left me alone, and gave me no further annoyance.

208 About this time the Emperor returned victorious from his expedition against Tunis, and the Pope sent for me to take my advice concerning the present of honour it was fit to give him. I answered that it seemed to me most appropriate to present his Imperial Majesty with a golden crucifix, for which I had almost finished an ornament quite to the purpose, and which would confer the highest honour upon his Holiness and me. I had already made three little figures of gold in the round, about a palm high; they were those which I had begun for the chalice of Pope Clement, representing Faith, Hope, and Charity. To these I added in wax what was wanting for the basement of the cross. I carried the whole to the Pope, with the Christ in wax, and many other exquisite decorations which gave him complete satisfaction. Before I took leave of his Holiness, we had agreed on every detail, and calculated the price of the work.

This was one evening four hours after nightfall, and the Pope had ordered Messer Latino Juvenale to see that I had money paid to me next morning. This Messer Latino, who had a pretty big dash of the fool in his composition, bethought him of furnishing the Pope with a new idea, which was, however, wholly of his own invention. So he altered everything which had been arranged; and next morning, when I went for the money, he said with his usual brutal arrogance: 'It is our part to invent, and yours to execute; before I left the Pope last night we thought of something far superior.' To these first words I answered, without allowing him to proceed: 'Neither you nor the Pope can think of anything better than a piece in which Christ plays a part; so you may go on with your courtier's nonsense till you have no more to say.'

Without uttering one word, he left me in a rage, and tried to get the work given to another goldsmith. The Pope, however, refused, and sent for me at once, and told me I had spoken well, but that they wanted to make use of a Book of Hours of Our Lady, which was marvellously illuminated, and had cost the Cardinal de' Medici more than two thousand crowns. They thought that this would be an appropriate present to the Empress, and that for the Emperor they would afterwards make what I had suggested, which was indeed a present worthy of him; but now there was no time to lose, since the Emperor was expected in Rome in about a month and a half. He wanted the book to be enclosed in a case of massive gold, richly worked, and adorned with jewels valued at about six thousand crowns. Accordingly, when the jewels and the gold were given me, I began the work, and driving it briskly forward, in a few days brought it to such beauty that the Pope was astonished, and showed me the most distinguished signs of favour, conceding at the same time that that beast Juvenale should have nothing more to do with me.

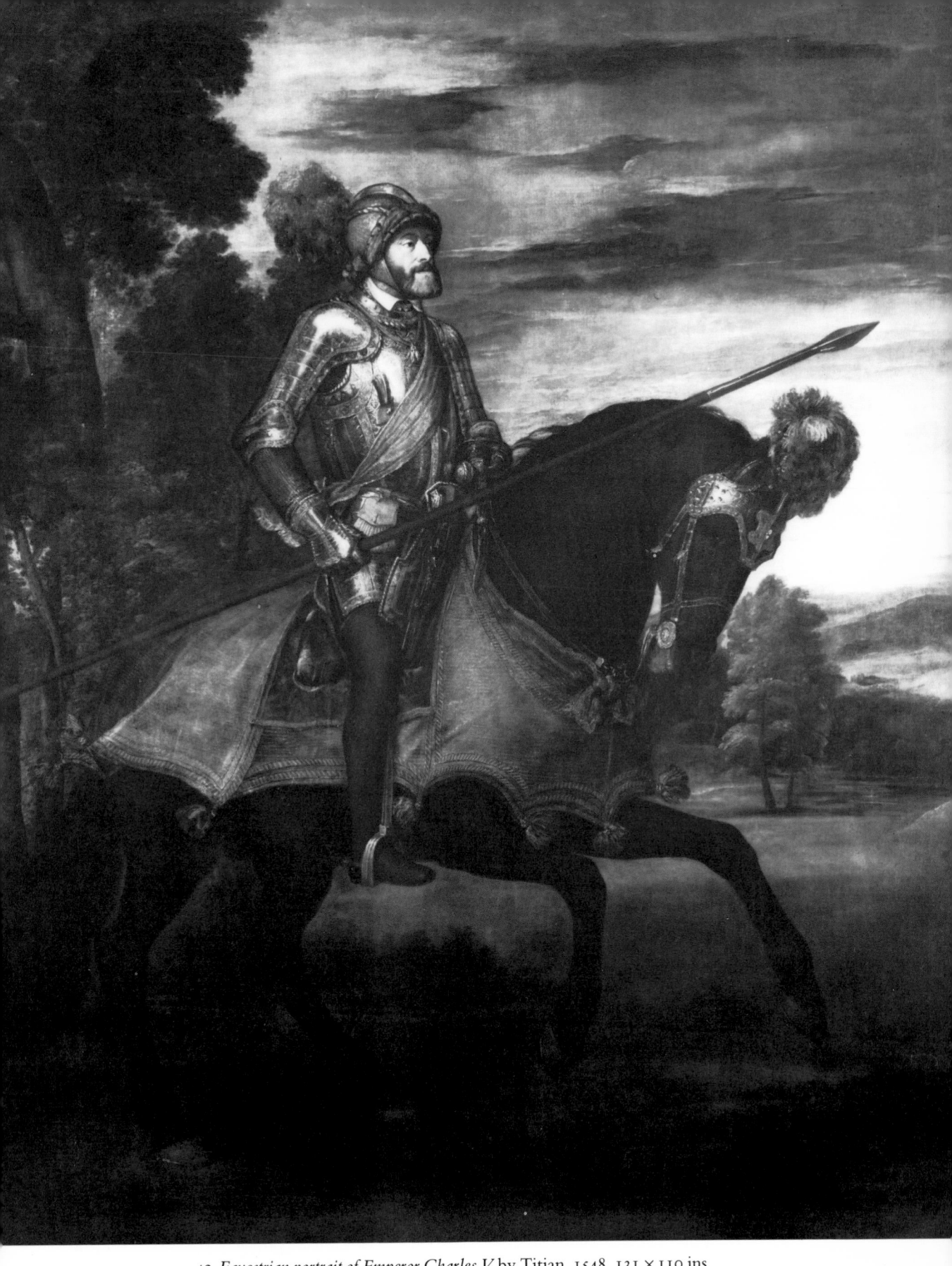

42 *Equestrian portrait of Emperor Charles V* by Titian, 1548. 131 × 110 ins
(332 × 279 cm). Madrid, Prado

209 I had nearly brought my work to its completion when the Emperor arrived, and numerous triumphal arches of great magnificence were erected in his honour. He entered Rome with extraordinary pomp. Immediately after his arrival, he gave the Pope a diamond which he had bought for twelve thousand crowns. This diamond the Pope committed to my care, ordering me to make a ring to the measure of his Holiness's finger; but first he wished me to bring the book in the state to which I had advanced it.

 The Pope ordered out two Turkish horses, which had belonged to Pope Clement, and were 210 the most beautiful that ever came to Christendom. Messer Durante, his chamberlain, was bidden to bring them through the lower galleries of the palace, and there to give them to the Emperor, repeating certain words which his Holiness dictated to him. We both went down together, and when we reached the presence of the Emperor, the horses made their entrance through those halls with so much spirit and such a noble carriage that the Emperor and every one were struck with wonder. Thereupon Messer Durante advanced in so graceless a manner, and delivered his speech with so much of Brescian lingo, mumbling his words over in his mouth, that one never saw or heard anything worse; indeed the Emperor could not refrain from smiling at him. I meanwhile had already uncovered my piece; and observing that the Emperor had turned his eyes towards me with a very gracious look, I advanced at once and said: 'Sacred Majesty, our most holy Father, Pope Paolo, sends this book of the Virgin as a present to your Majesty, the which is written in a fair clerk's hand, and illuminated by the 211 greatest master who ever professed that art; and this rich cover of gold and jewels is unfinished, as you here behold it, by reason of my illness: wherefore his Holiness, together with the book, presents me also, and attaches me to your Majesty in order that I may complete the work; nor this alone, but everything which you may have it in your mind to execute so long as life is left me, will I perform at your service.' Thereto the Emperor responded: 'The book is acceptable to me, and so are you; but I desire you to complete it for me in Rome; when it is finished, and you are restored to health, bring it me and come to see me.'

 I went on working at my book, and when I had finished it I took it to the Pope, who was in good truth unable to refrain from commending it greatly. I begged him to send me with it to the Emperor, as he had promised. He replied that he would do what he thought fit, and that I had performed my part of the business. So he gave orders that I should be well paid. These two pieces of work, on which I had spent upwards of two months, brought me in five hundred crowns: for the diamond I was paid one hundred and fifty crowns and no more; the rest was given me for the cover of the book, which, however, was worth more than a thousand, being enriched with multitudes of figures, arabesques, enamellings, and jewels. I took what I could get, and made my mind up to leave Rome without permission. The Pope meanwhile sent my 212 book to the Emperor by the hand of his grandson, Signor Sforza. Upon accepting it, the Emperor expressed great satisfaction, and immediately asked to see me. Young Signor Sforza, who had received his instructions, said that I had been prevented by illness from coming.

 I had formed the resolution to go toward France; partly because I saw that the Pope did not hold me in the same esteem as formerly, my faithful service having been besmirched by lying tongues; and also because I feared lest those who had the power might play me some worse trick. So I was determined to seek better fortune in a foreign land, and wished to leave Rome without company or license. On the eve of my projected departure, I told my faithful friend Felice to make free use of all my effects during my absence; and in the case of my not returning, left him everything I possessed. Now there was a Perugian workman in my employ, who had helped me on those commissions from the Pope; and after paying his wages, I told him he must leave my service. He begged me in reply to let him go with me, and said he would come at his own charges; and so I consented to take both him and my young servant Ascanio.

 From home I travelled to Florence, from Florence to Bologna, from Bologna to Venice, and 213 from Venice to Padua. There my dear friend Albertaccio del Bene made me leave the inn for 214 his house; and next day I went to kiss the hand of Messer Pietro Bembo, who was not yet a

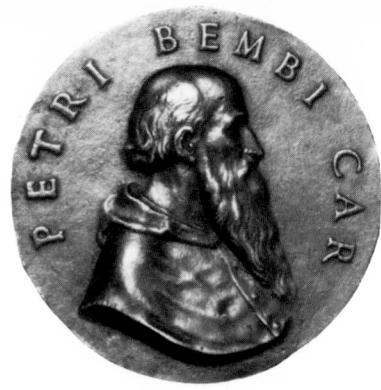

43 Medal for Cardinal Pietro Bembo by Cellini, 1539. Obverse, *Pietro Bembo*; reverse, *Pegasus*. Victoria and Albert Museum

Cardinal. He received me with marks of the warmest affection which could be bestowed on any man; then turning to Albertaccio, he said: 'I want Benvenuto to stay here, with all his followers, even though they be a hundred men; make then your mind up, if you want Benvenuto also, to stay here with me, for I do not mean elsewise to let you have him.' Accordingly I spent a very pleasant visit at the house of that most accomplished gentleman. He had a room prepared for me which would have been too grand for a cardinal, and always insisted on my taking my meals beside him. Later on, he began to hint in very modest terms that he should greatly like me to take his portrait. I, who desired nothing in the world more, prepared some snow-white plaster in a little box, and set to work at once. The first day I spent two hours on end at my modelling, and blocked out the fine head of that eminent man with so much grace of manner that his lordship was fairly astounded. Now, though he was a man of profound erudition and without a rival in poetry, he understood nothing at all about my art; this made him think that I had finished when I had hardly begun, so that I could not make him comprehend what a long time it took to execute a thing of that sort thoroughly. At last I resolved to do it as well as I was able, and to spend the requisite time upon it; but since he wore his beard short after the Venetian fashion, I had great trouble in modelling a head to my own satisfaction. However, I finished it, and judged it about the finest specimen I had produced in all the points pertaining to my art. Great was the astonishment of Messer Pietro, who conceived that I should have completed the waxen model in two hours and the steel in ten, when he found that I employed two hundred on the wax, and then was begging for leave to pursue my journey toward France. This threw him into much concern, and he implored me at least to design the reverse for his medal, which was to be a Pegasus encircled with a wreath of myrtle. I performed my task in the space of some three hours, and gave it a fine air of elegance. He was exceedingly delighted, and said: 'This horse seems to me ten times more difficult to do than the little portrait on which you have bestowed so much pains. I cannot understand what made it such a labour.' All the same, he kept entreating me to execute the piece in steel, exclaiming: 'For Heaven's sake, do it; I know that, if you choose, you will get it quickly finished.' I told him that I was not willing to make it there, but promised without fail to take it in hand wherever I might stop to work.

While this debate was being carried on I went to bargain for three horses which I wanted on my travels; and he took care that a secret watch should be kept over my proceedings, for he had vast authority in Padua; wherefore, when I proposed to pay for the horses, which were to cost five hundred ducats, their owner answered: 'Illustrious artist, I make you a present of the three horses.' I replied: 'It is not you who give them me; and from the generous donor I cannot accept them, seeing I have been unable to present him with any specimen of my craft.' The good fellow said that, if I did not take them, I should get no other horses in Padua, and should have to make my journey on foot. Upon that I returned to the magnificent Messer Pietro, who affected to be ignorant of the affair, and only begged me with marks of kindness to remain in

215

216

Padua. This was contrary to my intention, for I had quite resolved to set out; therefore I had to accept the three horses, and with them we began our journey.

I chose the route through the Grisons, all other passes being unsafe on account of war. We crossed the mountains of the Alba and Berlina; it was the 8th of May, and the snow upon them lay in masses. Taking horse next morning, we came to a lake between Wallenstadt and Weesen; it is fifteen miles long when one reaches Weesen. On beholding the boats upon that lake I took fright; because they are of pine, of no great size and no great thickness, loosely put together, and not even pitched. If I had not seen four German gentlemen, with their four horses, embarking in one of the same sort as ours, I should never have set my foot in it; indeed I should far more likely have turned tail; but when I saw their hare-brained recklessness, I took it into my head that those German waters would not drown folk, as ours do in Italy. However, my two young men kept saying to me: 'Benvenuto, it is surely dangerous to embark in this craft with four horses.' I replied: 'You cowards, do you not observe how those four gentlemen have taken boat before us, and are going on their way with laughter? If this were wine, as indeed 'tis water, I should say that they were going gladly to drown themselves in it; but as it is but water, I know well that they have no more pleasure than we have in drowning there.' The lake was fifteen miles long and about three broad; on one side rose a mountain very tall and cavernous, on the other some flat land and grassy. When we had gone about four miles, it began to storm upon the lake, and our oarsmen asked us to help in rowing; this we did awhile. I made gestures and directed them to land us on the farther shore; they said it was not possible, because there was not depth of water for the boat, and there were shoals there, which would make it go to pieces and drown us all; and still they kept on urging us to help them. The boatmen shouted one to the other, calling for assistance. When I saw them thus dismayed, my horse being an intelligent animal, I arranged the bridle on his neck and took the end of the halter with my left hand. The horse, like most of his kind, being not devoid of reason, seemed to have an instinct of my intention; for having turned his face towards the fresh grass, I meant that he should swim and draw me after him. Just at that moment a great wave broke over the boat. Ascanio shrieked out: 'Mercy, my father; save me,' and wanted to throw himself upon my neck. Accordingly, I laid hand to my little dagger, and told them to do as I had shown them, seeing that the horses would save their lives as well as I too hoped to escape with mine by the same means; but that if he tried to jump on me, I should kill him. So we went forward several miles in this great peril of our lives.

When we had reached the middle of the lake, we found a little bit of level ground where we could land, and I saw that those four German gentlemen had already come to shore there; but on our wishing to disembark, the boatmen would hear nothing of it. Then I said to my young men: 'Now is the time to show what stuff we are made of; so draw your swords, and force these fellows to put us on shore.' This we did, not however without difficulty, for they offered a stubborn resistance. When at last we got to land, we had to climb that mountain for two miles, and it was more troublesome than getting up a ladder. I was completely clothed in mail, with big boots, and a gun in my hand; and it was raining as though the fountains of the heavens were opened. Those devils, the German gentlemen, leading their little horses by the bridle, accomplished miracles of agility; but our animals were not up to the business, and we burst with the fatigue of making them ascend that hill of difficulty. We had climbed a little way, when Ascanio's horse, an excellent beast of Hungarian race, made a false step. He was going a few paces before the courier Busbacca, to whom Ascanio had given his lance to carry for him. Well, the path was so bad that the horse stumbled, and went on scrambling backwards, without being able to regain his footing, till he stuck upon the point of the lance, which that rogue of a courier had not the wit to keep out of his way. The weapon passed right through his throat; and when my other workman went to help him, his horse also, a black-coloured animal, slipped towards the lake, and held on by some shrub which offered but a slight support. This horse was carrying a pair of saddle-bags, which contained all my money and other valuables. I cried out to the young man to save his own life, and let the horse go to the devil. The fall was

more than a mile of precipitous descent above the waters of the lake. Just below the place our boatmen had taken up their station; so that if the horse fell, he would have come precisely on them. I was ahead of the whole company, and we waited to see the horse plunge headlong; it seemed certain that he must go to perdition. During this I said to my young men: 'Be under no concern; let us save our lives, and give thanks to God for all that happens. I am only distressed for that poor fellow Busbacca, who tied his goblet and his jewels to the value of several thousands of ducats on the horse's saddle-bow, thinking that the safest place. My things are but a few hundred crowns, and I am in no fear whatever, if only I get God's protection.' Then Busbacca cried out: 'I am not sorry for my own loss, but for yours.' 'Why,' said I to him, 'are you sorry for my trifles, and not for all that property of yours?' He answered: 'I will tell you in God's name; in these circumstances and at the point of peril we have reached, truth must be spoken. I know that yours are crowns, and are so in good sooth; but that case in which I said I had so many jewels and other lies, is all full of caviare.' On hearing this I could not hold from laughing; my young men laughed too; and he began to cry. The horse extricated itself by a great effort when we had given it up for lost. So then, still laughing, we summoned our forces, and bent ourselves to making the ascent. The four German gentlemen, having gained the top before us, sent down some folk who gave us aid. Thus at length we reached our lodging in the wilderness. Here, being wet to the skin, tired out, and famished, we were most agreeably entertained; we dried ourselves, took rest, and satisfied our hunger, while certain wild herbs were applied to the wounded horse. They pointed out to us the plant in question, of which the hedges were full; and we were told that if the wound was kept continually plugged with its leaves, the beast would not only recover, but would serve us just as if it had sustained no injury. We proceeded to do as they advised. Then having thanked those gentlemen, and feeling ourselves entirely refreshed, we quitted the place, and travelled onwards, thanking God for saving us from such great perils.

So we arrived at Zurich, a marvellous city, bright and polished like a little gem. There we rested a whole day, then left betimes one morning, and reached another fair city called Solothurn. Thence we came to Lausanne, from Lausanne to Geneva, from Geneva to Lyons, always singing and laughing.

After taking some repose in Paris, I went to visit the painter Rosso, who was in the King's *219* service. I thought to find in him one of the sincerest friends I had in the world, seeing that in Rome I had done him the greatest benefits which one man can confer upon another. As these may be described briefly, I will not here omit their mention, in order to expose the shamelessness of such ingratitude. While he was in Rome, then, being a man given to backbiting, he spoke so ill of Raffaello da Urbino's works, that the pupils of the latter were quite resolved to murder him. From this peril I saved him by keeping a close watch upon him day and night. Again, the evil things said by Rosso against San Gallo, that excellent architect, *220* caused the latter to get work taken from him which he had previously procured for him from Messer Agnolo da Cesi; and after this San Gallo used his influence so strenuously against him *221* that he must have been brought to the verge of starvation, had not I pitied his condition and lent him some scores of crowns to live upon. So then, not having been repaid, and knowing that he held employment under the King, I went, as I have said, to look him up. I did not merely expect him to discharge his debt, but also to show me favour and assist in placing me in that great monarch's service.

When Rosso set eyes on me, his countenance changed suddenly, and he exclaimed: 'Benvenuto, you have taken this long journey at great charges to your loss; especially at this present time, when all men's thoughts are occupied with war, and not with the bagatelles of our profession.' I replied that I had brought money enough to take me back to Rome as I had come to Paris, and that this was not the proper return for the pains I had endured for him, and that now I began to believe what Maestro Antonio da San Gallo said of him. When he tried to turn the matter into jest on this exposure of his baseness, I showed him a letter of exchange for five hundred crowns upon Ricciardo del Bene. Then the rascal was ashamed, and wanted to *222*

detain me almost by force; but I laughed at him, and took my leave in the company of a painter
whom I found there. This man was called Sguazzella: he too was a Florentine; and I went to
lodge in his house, with three horses and three servants, at so much per week. He treated me very
well, and was even better paid by me in return.

Afterwards I sought audience of the King, through the introduction of his treasurer, Messer
Giuliano Buonaccorti. I met, however, with considerable delays, owing, as I did not then
know, to the strenuous exertions Rosso made against my admission to his Majesty. When
Messer Giuliano became aware of this, he took me down at once to Fontana Bilio, and brought
me into the presence of the King, who granted me a whole hour of very gracious audience.
Since he was then on the point of setting out for Lyons, he told Messer Giuliano to take me
with him, adding that on the journey we could discuss some works of art his Majesty had it in
his head to execute. Accordingly, I followed the court; and on the way I entered into close
relations with the Cardinal of Ferrara, who had not at that period obtained the hat. Every
evening I used to hold long conversations with the Cardinal, in the course of which his lordship
advised me to remain at an abbey of his in Lyons, and there to abide at ease until the King
returned from this campaign, adding that he was going on to Grenoble, and that I should enjoy
every convenience in the abbey.

When we reached Lyons I was already ill, and my lad Ascanio had taken a quartan fever. The
French and their court were both grown irksome to me, and I counted the hours till I could
find myself again in Rome. On seeing my anxiety to return home, the Cardinal gave me
money sufficient for making him a silver basin and jug. So we took good horses, and set our
faces in the direction of Rome, passing the Simplon, and travelling for some while in the
company of certain Frenchmen; Ascanio troubled by his quartan, and I by a slow fever which I
found it quite impossible to throw off. I had, moreover, got my stomach out of order to such
an extent, that for the space of four months, as I verily believe, I hardly ate one whole loaf of
bread in the week; and great was my longing to reach Italy, being desirous to die there rather
than in France.

I reached Ferrara, with my three horses, and having dismounted, I went to court in order to
pay my reverence to the Duke, and gain permission to depart next morning for Loreto. When
I had waited until two hours after nightfall, his Excellency appeared. I kissed his hands; he
received me with much courtesy, and ordered that water should be brought for me to wash my
hands before eating. To this compliment I made a pleasant answer: 'Most excellent lord, it is
now more than four months that I have eaten only just enough to keep life together; knowing
therefore that I could not enjoy the delicacies of your royal table, I will stay and talk with you
while your Excellency is supping; in this way we shall both have more pleasure than if I were
to sup with you.' Accordingly, we entered into conversation, and prolonged it for the next

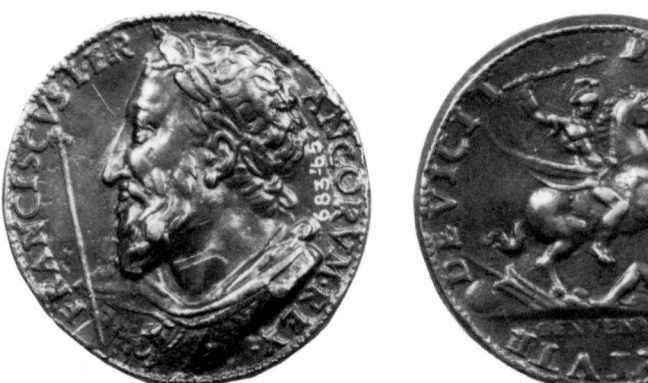

44 Medal for King Francis I by Cellini, 1537–8. Obverse, *Francis I*; reverse,
Virtue defeating Fortune. Victoria and Albert Museum (*See note 226*)

three hours. At that time I took my leave, and when I got back to the inn, found a most excellent meal ready; for the Duke had sent me the plates from his own banquet, together with some famous wine. Having now fasted two full hours beyond my usual hour for supping, I fell to with hearty appetite; and this was the first time since four months that I felt the power or will to eat.

Leaving Ferrara in the morning, I went to Santa Maria at Loreto; and thence, having performed my devotions, pursued the journey to Rome. I thought for certain that the great King Francis would not have remembered me. Therefore I accepted commissions from several noblemen; and in the meanwhile began the basin and jug ordered by the Cardinal of Ferrara. I had a crowd of workmen, and many large affairs on hand in gold and silver.

Now the arrangement I had made with that Perugian workman was that he should write *229* down all the monies which had been disbursed on his account, chiefly for clothes and divers other sundries; and these, together with the costs of travelling, amounted to about seventy crowns. We agreed that he should discharge the debt by monthly payments of three crowns; and this he was well able to do, since he gained more than eight through me. At the end of two months the rascal decamped from my shop, leaving me in the lurch with a mass of business on my hands, and saying that he did not mean to pay me a farthing more. I was resolved to seek redress, but allowed myself to be persuaded to do so by the way of justice. At first I thought of lopping off an arm of his; and assuredly I should have done so, if my friends had not told me that it was a mistake, seeing I should lose my money and perhaps Rome too a second time, forasmuch as blows cannot be measured, and that with the agreement I held of his I could at any moment have him taken up. I listened to their advice, though I should have liked to conduct the affair more freely. As a matter of fact, I sued him before the auditor of the Camera, and gained my suit; in consequence of that decree, for which I waited several months, I had him thrown into prison.

Now let the world take notice, and all the folk that dwell on it, what power malignant stars with adverse fortune exercise upon us human beings! That traitor, the Perugian workman, devised a piece of malice against me, which succeeded at once, owing to the avarice of Pope Paolo da Farnese, but also far more to that of his bastard, who was then called Duke of Castro. *230* The fellow in question informed one of Signor Pier Luigi's secretaries that, having been with me as workman several years, he was acquainted with all my affairs, on the strength of which he gave his word to Signor Pier Luigi that I was worth more than eighty thousand ducats, and that the greater part of this property consisted in jewels, which jewels belonged to the Church, and that I had stolen them in Castel Sant' Agnolo during the sack of Rome, and that all they had to do was to catch me on the spot with secrecy.

It so happened that I had been at work one morning, more than three hours before

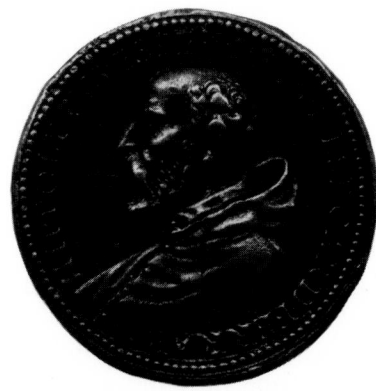

45 Medal for Cardinal Ippolito d'Este of Ferrara by Gian Federigo Bonzagna, after 1547. Washington DC, National Gallery (Samuel H. Kress Coll.)

daybreak; then, while my shop was being opened and swept out, I put my cape on to go
abroad and take the air. Directing my steps along the Strada Giulia, I turned into Chiavica, and
at this corner Crespino, the Bargello, with all his constables, made up to me, and said: 'You are
the Pope's prisoner.' I answered: 'Crespino, you have mistaken your man.' 'No,' said
Crespino, 'you are the artist Benvenuto, and I know you well, and I have to take you to the
Castle of Sant' Angelo, where lords go, and men of accomplishments, your peers.' Upon that
four of his under-officers rushed on me, and would have seized by force a dagger which I wore,
and some rings I carried on my finger; but Crespino rebuked them: 'Not a man of you shall
touch him: it is quite enough if you perform your duty, and see that he does not escape me.'
Then he came up, and begged me with words of courtesy to surrender my arms. While I was
engaged in doing this, it crossed my mind that exactly on that very spot I had assassinated
Pompeo. They took me straightway to the castle, and locked me in an upper chamber in the
keep. This was the first time that I ever smelt a prison up to the age I then had of thirty-seven
years.

 The castellan of Sant' Angelo was one of our Florentines, called Messer Giorgio, a knight of
the Ugolini family. This worthy man showed me the greatest courtesy, and let me go free
about the castle on parole. He was well aware how greatly I had been wronged: and when I
wanted to give security for leave to walk about the castle, he replied that though he could not
take that, seeing the Pope set too much importance upon my affair, yet he would frankly trust
my word, because he was informed by every one what a worthy man I was. So I passed my
parole, and he granted me conveniences for working at my trade. I had made my mind up
rather to lose my life than to break the promise I had given that good man the castellan. So I
bore the extreme discomforts of my situation, and had for companion of misery a friar of the
Palavisina [Pallavicini] house, who was a very famous preacher.

 This man had been arrested as a Lutheran. He was an excellent companion; but, from the
point of view of his religion, I found him the biggest scoundrel in the world, to whom all kinds
of vices were acceptable. His fine intellectual qualities won my admiration; but I hated his dirty
vices, and frankly taxed him with them. This friar kept perpetually reminding me that I was in
no wise bound to observe faith with the castellan, since I had become a prisoner. I replied to
these arguments that he might be speaking the truth as a friar, but that as a man he spoke the
contrary; for every one who called himself a man, and not a monk, was bound to keep his word
under all circumstances in which he chanced to be. I therefore, being a man, and not a monk,
was not going to break the simple and loyal word which I had given. Seeing then that he could
not sap my honour by the subtle and ingenious sophistries he so eloquently developed, the friar
hit upon another way of tempting me. He allowed some days to pass, during which he read me
the sermons of Fra Jerolimo Savonarola; and these he expounded with such lucidity and
learning that his comment was even finer than the text. I remained in ecstasies of admiration;
and there was nothing in the world I would not have done for him, except, as I have said, to
break my promised word. When he saw the effect his talents had produced upon my mind, he
thought of yet another method. Cautiously he began to ask what means I should have taken,
supposing my jailors had locked me up, in order to set the dungeon doors open and effect my
flight. I then, who wanted to display the sharpness of my own wits to so ingenious a man,
replied that I was quite sure of being able to open the most baffling locks and bars, far more
those of our prison, to do which would be the same to me as eating a bit of new cheese. In order
then to gain my secret, the friar now made light of these assertions, averring that persons who
have gained some credit by their abilities, are wont to talk big of things which, if they had to
put their boasts in action, would speedily discredit them, and much to their dishonour. Himself
had heard me speak so far from the truth, that he was inclined to think I should, when pushed to
proof, end in a dishonourable failure. Upon this, feeling myself stung to the quick by that devil
of a friar, I responded that I always made a practice of promising in words less than I could
perform in deeds; what I had said about the keys was the merest trifle; in a few words I could
make him understand that the matter was as I had told it; then, all too heedlessly, I

demonstrated the facility with which my assertions could be carried into act. He affected to pay little attention; but all the same he learned my lesson well by heart with keen intelligence.

As I have said above, the worthy castellan let me roam at pleasure over the whole fortress. Not even at night did he lock me in, as was the custom with the other prisoners. Moreover, he allowed me to employ myself as I liked best, with gold or silver or with wax according to my whim. So then I laboured several weeks at the basin ordered by Cardinal Ferrara, but the irksomeness of my imprisonment bred in me a disgust for such employment, and I took to modelling in wax some little figures of my fancy, for mere recreation. Of the wax which I used, the friar stole a piece; and with this he proceeded to get false keys made, upon the method I had heedlessly revealed to him. He had chosen for his accomplice a registrar named Luigi, a Paduan, who was in the castellan's service. When the keys were ordered, the locksmith revealed their plot; and the castellan, who came at times to see me in my chamber, noticing the wax which I was using, recognized it at once and exclaimed: 'It is true that this poor fellow Benvenuto has suffered a most grievous wrong; yet he ought not to have dealt thus with me, for I have ever strained my sense of right to show him kindness. Now I shall keep him straitly under lock and key, and shall take good care to do him no more service.' Accordingly, he had me shut up with disagreeable circumstances, among the worst of which were the words flung at me by some of his devoted servants, who were indeed extremely fond of me, but now, on this occasion, cast in my teeth all the kind offices the castellan had done me; they came, in fact, to calling me ungrateful, light, and disloyal. One of them in particular used those injurious terms more insolently than was decent; whereupon I, being convinced of my innocence, retorted hotly that I had never broken faith, and would maintain these words at the peril of my life, and that if he or any of his fellows abused me so unjustly, I would fling the lie back in his throat. The man, intolerant of my rebuke, rushed to the castellan's room, and brought me the wax with the model of the keys. No sooner had I seen the wax than I told him that both he and I were in the right; but I begged him to procure for me an audience with the castellan, for I meant to explain frankly how the matter stood, which was of far more consequence than they imagined. The castellan sent for me at once, and I told him the whole course of events. This made him arrest the friar, who betrayed the registrar, and the latter ran a risk of being hanged. However, the castellan hushed the affair up, although it had reached the Pope's ears; he saved his registrar from the gallows, and gave me the same freedom as I had before.

When I saw how rigorously this affair was prosecuted, I began to think of my own concerns, and said: 'Supposing another of these storms should rise, and the man should lose confidence in me, I should then be under no obligation to him.' So I began to have new sheets of a coarse fabric brought me, and did not send the dirty ones away. When my servants asked for them, I bade them hold their tongues, saying I had given the sheets to some of those poor soldiers; and if the matter came to knowledge, the wretched fellows ran risk of the galleys. This made my young men and attendants, especially Felice, keep the secret of the sheets in all loyalty. I meanwhile set myself to emptying a straw mattress, the stuffing of which I burned, having a chimney in my prison. Out of the sheets I cut strips, the third of a cubit in breadth; and when I had made enough in my opinion to clear the great height of the central keep of Sant' Agnolo, I told my servants that I had given away what I wanted; they must now bring me others of finer fabric, and I would always send back the dirty ones. This affair was presently forgotten.

The castellan was subject to a certain sickness, which came upon him every year and deprived him of his wits. The sign of its approach was that he kept continually talking, or rather jabbering, to no purpose. These humours took a different shape each year; one time he thought he was an oil-jar; another time he thought he was a frog, and hopped about as frogs do; another time he thought he was dead, and then they had to bury him; not a year passed but he got some such hypochondriac notions into his head. At this season he imagined that he was a bat, and when he went abroad to take the air, he used to scream like bats in a high thin tone; and then he would flap his hands and body as though he were about to fly. The doctors, when they saw the fit was coming on him, and his old servants, gave him all the distractions they could

think of; and since they had noticed that he derived much pleasure from my conversation, they were always fetching me to keep him company. At times the poor man detained me for four or five stricken hours without ever letting me cease talking. He used to keep me at his table, eating opposite to him, and never stopped chatting and making me chat; but during those discourses I contrived to make a good meal. He, poor man, could neither eat nor sleep; so that at last he wore me out. I was at the end of my strength; and sometimes when I looked at him, I noticed that his eyeballs were rolling in a frightful manner, one looking one way and the other in another.

He took it into his head to ask me whether I had ever had a fancy to fly. I answered that it had always been my ambition to do those things which offer the greatest difficulties to men, and that I had done them; as to flying, the God of Nature had gifted me with a body well suited for running and leaping far beyond the common average, and that with the talents I possessed for manual art I felt sure I had the courage to try flying. He then inquired what methods I should use; to which I answered that, taking into consideration all flying creatures, and wishing to imitate by art what they derived from nature, none was so apt a model as the bat. No sooner had the poor man heard the name bat, which recalled the humour he was suffering under, than he cried out at the top of his voice: 'He says true – he says true; the bat's the thing – the bat's the thing!' Then he turned to me and said: 'Benvenuto, if one gave you the opportunity, should you have the heart to fly?' I said that if he would set me at liberty, I felt quite up to flying down to Prati, after making myself a pair of wings out of waxed linen. Thereupon he replied: 'I too should be prepared to take flight; but since the Pope has bidden me guard you as though you were his own eyes, and I know you a clever devil who would certainly escape, I shall now have you locked up with a hundred keys in order to prevent you slipping through my fingers.' I then began to implore him, and remind him that I might have fled, but that on account of the word which I had given him I would never have betrayed his trust: therefore I begged him for the love of God, and by the kindness he had always shown me, not to add greater evils to the misery of my present situation. While I was pouring out these entreaties, he gave strict orders to have me bound and taken and locked up in prison. On seeing that it could not be helped, I told him before all his servants: 'Lock me well up, and keep good watch on me; for I shall certainly contrive to escape.' So they took and confined me with the utmost care.

I had abstracted a pair of large pincers from one of the guards; I now hid it in my straw mattress. I began to try the nails which kept the hinges of my door in place. Meanwhile the castellan kept dreaming every night that I had escaped, which made him send from time to time to inspect my prison. The man who came was called Bozza, and used always to bring with him another named Giovanni and nicknamed Pedignone; the latter was a soldier, and Bozza a serving-man. Giovanni never entered my prison without saying something offensive to me. Every evening he minutely examined the holdfasts of the hinges and the whole chamber, and I used to say: 'Keep a good watch over me, for I am resolved by all means to escape.' These words bred a great enmity between him and me, so that I was obliged to use precautions to conceal my tools, that is to say, my pincers and a great big poniard and other appurtenances. All these I put away together in my mattress, where I also kept the strips of linen I had made.

On the evening of a certain feast-day, I made my mind up to escape, come what might; and first I prayed most devoutly to God, imploring His Divine Majesty to protect and succour me in that so perilous a venture. Afterwards I set to work at all the things I needed, and laboured the whole of the night. It was two hours before daybreak when at last I removed the door-hinges with the greatest toil; but the wooden panel itself and the bolt too offered such resistance that I could not open the door; so I had to cut into the wood; yet in the end I got it open, and shouldering the strips of linen which I had rolled up like bundles of flax upon two sticks, I went forth and directed my steps toward the latrines of the keep. Spying from within two tiles upon the roof, I was able at once to clamber up with ease. I wore a white doublet with a pair of white hose and a pair of half boots, into which I had stuck my poniard.

After scaling the roof, I took one end of my linen roll and attached it to a piece of antique tile

which was built into the fortress wall; it happened to jut out scarcely four fingers. In order to fix the band, I gave it the form of a stirrup. When I had attached it to that piece of tile, I turned to God and said: 'Lord God, give aid to my good cause; you know that it is good; you see that I am aiding myself.' Then I let myself go gently by degrees, supporting myself with the sinews of my arms, until I touched the ground. There was no moonshine, but the light of a fair open heaven. When I stood upon my feet on solid earth, I looked up at the vast height which I had descended with such spirit, and went gladly away, thinking I was free. But this was not the case; for the castellan on that side of the fortress had built two lofty walls, the space between which he used for stable and henyard; the place was barred with thick iron bolts outside. I was terribly disgusted to find there was no exit from this trap; but while I paced up and down debating what to do, I stumbled on a long pole which was covered up with straw. Not without great trouble I succeeded in placing it against the wall, and then swarmed up it by the force of my arms until I reached the top. But since the wall ended in a sharp ridge, I had not strength enough to drag the pole up after me. Accordingly I made my mind up to use a portion of the second roll of linen which I had there; the other was left hanging from the keep of the castle. So I cut a piece off, tied it to the pole, and clambered down the wall, enduring the utmost toil and fatigue. I was quite exhausted, and had, moreover, flayed the inside of my hands, which bled freely. This compelled me to rest awhile, and I bathed my hands in my own urine. When I thought that my strength was recovered, I advanced quickly toward the last rampart, which faces toward Prati. There I put my bundle of linen lines down upon the ground, meaning to fasten them round a battlement, and descend the lesser as I had the greater height. But no sooner had I placed the linen, than I became aware behind me of a sentinel, who was going the rounds. Seeing my designs interrupted and my life in peril, I resolved to face the guard. This fellow, when he noticed my bold front, and that I was marching on him with weapon in hand, quickened his pace and gave me a wide berth. I had left my lines some little way behind; so I turned with hasty steps to regain them; and though I came within sight of another sentinel, he seemed as though he did not choose to take notice of me. Having found my lines and attached them to the battlement, I let myself go. On the descent, whether it was that I thought I had really come to earth and relaxed my grasp to jump, or whether my hands were so tired that they could not keep their hold, at any rate I fell, struck my head in falling, and lay stunned for more than an hour and a half, so far as I could judge.

It was just upon daybreak, when the fresh breeze which blows an hour before the sun revived me; yet I did not immediately recover my senses, for I thought my head had been cut off and fancied that I was in purgatory. With time, little by little, my faculties returned, and I perceived that I was outside the castle, and in a flash remembered all my adventures. I was aware of the wound in my head before I knew my leg was broken; for I put my hands up, and withdrew them covered with blood. Then I searched the spot well, and judged and ascertained that I had sustained no injury of consequence there; but when I wanted to stand up, I discovered that my right leg was broken three inches above the heel. Not even this dismayed me: I drew forth my poniard with its scabbard; the latter had a metal point ending in a large ball, which had caused the fracture of my leg; for the bone, coming into violent contact with the ball, and not being able to bend, had snapped at that point. I threw the sheath away, and with the poniard cut a piece of the linen which I had left. Then I bound my leg up as well as I could, and crawled on all fours with the poniard in my hand toward the city gate. When I reached it, I found it shut; but I noticed a stone just beneath the door which did not appear to be very firmly fixed. This I attempted to dislodge; after setting my hands to it, and feeling it move, it easily gave way, and I drew it out. Through the gap thus made I crept into the town.

On arriving at the opening of the street which leads to Sant' Agnolo, I turned off in the direction of San Piero; and now the dawn had risen over me, and I felt myself in danger. When therefore I chanced to meet a water-carrier driving his donkey laden with full buckets, I called the fellow, and begged him to carry me upon his back to the terrace by the steps of San Piero, adding: 'I am an unfortunate young man, who, while escaping from a window in a love-

adventure, have fallen and broken my leg. The place from which I made my exit is one of great importance; and if I am discovered, I run risk of being cut to pieces; so for heaven's sake lift me quickly, and I will give you a crown of gold.' Saying this, I clapped my hand to my purse, where I had a good quantity. He took me up at once, hitched me on his back, and carried me to the raised terrace by the steps to San Piero. There I bade him leave me, saying he must run back to his donkey.

236 I resumed my march, crawling always on all fours, and making for the palace of the Duchess, wife of Duke Ottavio and daughter of the Emperor. She was his natural child, and had been married to Duke Alessandro. I chose her house for refuge, because I was quite certain that many of my friends, who had come with that great princess from Florence, were tarrying there; also because she had taken me into favour through something which the castellan had said in my behalf. Wishing to be of service to me, he told the Pope that I had saved the city more than a thousand crowns of damage, caused by heavy rain on the occasion when the Duchess made her entrance into Rome. He related how he was in despair, and how I put heart into him, and went on to describe how I had pointed several large pieces of artillery in the direction where the clouds were thickest, and whence a deluge of water was already pouring; then, when I began to fire, the rain stopped, and at the fourth discharge the sun shone out; and so I was the sole cause of the festival succeeding, to the joy of everybody. On hearing this narration the Duchess said: 'That Benvenuto is one of the artists of merit, who enjoyed the good-will of my late husband, Duke Alessandro, and I shall always hold them in mind if an opportunity comes of doing such men service.' She also talked of me to Duke Ottavio. For these reasons I meant to go straight to the house of her Excellency, which was a very fine palace
237 situated in Borgio Vecchio.

 I should have been quite safe from recapture by the Pope if I could have stayed there; but my exploits up to this point had been too marvellous for a human being, and God was unwilling to encourage my vainglory; accordingly, for my own good, He chastised me a second time worse even than the first. The cause of this was that while I was crawling on all fours up those steps, a
238 servant of Cardinal Cornaro recognized me. His master was then lodging in the palace; so the servant ran up to his room and woke him, crying: 'Most reverend Monsignor, your friend Benvenuto is down there; he has escaped from the castle, and is crawling on all fours, streaming with blood; to all appearance he has broken a leg, and we don't know whither he is going.' The Cardinal exclaimed at once: 'Run and carry him upon your back into my room here.' When I arrived, he told me to be under no apprehension, and sent for the first physicians
239 of Rome to take my case in hand. Among them was Maestro Jacomo of Perugia, a most excellent and able surgeon. He set the bone with dexterity, then bound the limb up, and bled me with his own hand. The Cardinal had me placed in a secret chamber, and went off immediately to beg me from the Pope.

 During this while all Rome was in an uproar; for they had observed the bands of linen fastened to the great keep of the castle, and folk were running in crowds to behold so extraordinary a thing. The castellan had gone off into one of his worst fits of frenzy; in spite of all his servants, he insisted upon taking his flight also from the tower, saying that no one could
240 recapture me except himself if he were to fly after me. Messer Ruberto Pucci, the father of Messer Pandolfo, having heard of the great event, went in person to inspect the place; afterwards he came to the palace, where he met with Cardinal Cornaro, who told him exactly what had happened, and how I was lodged in one of his own chambers, and already in the doctor's hands. These two worthy men went together, and threw themselves upon their knees before the Pope; but he, before they could get a word out, cried aloud: 'I know all that you want of me.' Messer Ruberto Pucci then began: 'Most blessed Father, we beg you for Heaven's grace to give us up that unfortunate man; surely his great talents entitle him to exceptional treatment; moreover, he has displayed such audacity, blent with so much ingenuity, that his exploit might seem superhuman. We know not for what crimes your Holiness has kept him so long in prison; however, if those crimes are too exorbitant, your Holiness is wise and holy, and

may your will be done unquestioned; still, if they are such as can be condoned, we entreat you to pardon him for our sake.' Pier Luigi, the Pope's son, who happened to be present, began to speak as follows: 'Most blessed Father, if you set that man free, he will do something still more marvellous, because he has by far too bold a spirit. I will tell you another story about him which you do not know. That Benvenuto of yours, before he was imprisoned, came to words with a gentleman of Cardinal Santa Fiore, about some trifle which the latter had said to him. *241* Now Benvenuto's retort was so swaggeringly insolent that it amounted to throwing down a cartel. The gentleman referred the matter to the Cardinal, who said that if he once laid hands on Benvenuto he would soon clear his head of such folly. When the fellow heard this, he got a little fowling-piece of his ready, with which he is accustomed to hit a penny in the middle; accordingly, one day when the Cardinal was looking out of the window, Benvenuto's shop being under the palace of the Cardinal, he took his gun and pointed it at the Cardinal. The *242* Cardinal, however, had been warned, and presently withdrew. Benvenuto, in order that his intention might escape notice, aimed at a pigeon which was brooding high up in the hole of the palace, and hit it exactly in the head – a feat one would have thought incredible. Now let your Holiness do what you think best about him; I have discharged my duty by saying what I have. It might even come into his head, imagining that he had been wrongly imprisoned, to fire upon your Holiness. Indeed he is too truculent, by far too confident in his own powers. When he killed Pompeo, he gave him two stabs with a poniard in the throat, in the midst of ten men who were guarding him; then he escaped, to their great shame, and yet they were no inconsiderable persons.' While these words were being spoken, the gentleman of Santa Fiore with whom I had that quarrel was present, and confirmed to the Pope what had been spoken by his son. The Pope swelled with rage, but said nothing.

The Pope now sent at once and had me lodged in the ground-floor chamber of his private garden. The Cardinal Cornaro sent me word not to eat the food provided for me by the Pope; *243* he would supply me with provisions; meanwhile I was to keep my spirits up, for he would work in my cause till I was set free. Matters being thus arranged, I received daily visits and generous offers from many great lords and gentlemen. Food came from the Pope, which I refused to touch, only eating that which came from Cardinal Cornaro; and thus I remained awhile.

Then one day there came abundant provisions from the kitchen of the Pope; the Cardinal Cornaro also sent good store of viands from his kitchen; and some friends of mine being present when they arrived, I made them stay to supper, and enjoyed their society, keeping my leg in splints beneath the bed-clothes. An hour after night-fall they left me; and two of my servants, having made me comfortable for the night, went to sleep in the antechamber. I had a dog, black as a mulberry, one of those hairy ones, who followed me admirably when I went out shooting, and never left my side. During the night he lay beneath my bed, and I had to call out at least three times to my servant to turn him out, because he howled so fearfully. When the servants entered, the dog flew at them and tried to bite them. They were frightened, and thought he must be mad, because he went on howling. In this way he passed the first four hours of the night. At the stroke of four the Bargello came into my room with a band of constables. Then the dog sprang forth and flew at them with such fury, tearing their capes and hose, that in their fright they fancied he was mad. But the Bargello, like an experienced person, told them: 'It is the nature of good dogs to divine and foretell the mischance coming on their masters. Two of you take sticks and beat the dog off; while the other strap Benvenuto on this chair; then carry him to the place you wot of.' It was the night after Corpus Domini, and about four o'clock. *244*

The officers carried me, well shut up and covered, and four of them went in front, making the few passengers who were still abroad get out of the way. So they bore me to Torre di Nona, *245* such is the name of the place, and put me in the condemned cell. I was left upon a wretched mattress under the care of a guard, who kept all night mourning over my bad luck, and saying to me: 'Alas! poor Benvenuto, what have you done to those great folk?' I could now form a

46 Map of Rome by Du Pérac–Lafréry, 1577. British Library (23805/8)

very good opinion of what was going to happen to me, partly by the place in which I found myself, and also by what the man had told me.

I abode in extreme discomfort, and my heart kept thumping against my ribs. Not less was the discomfort of the men appointed to discharge the evil business of my execution; but when the hour for dinner was already past, they betook themselves to their several affairs, and my meal was also served me. This filled me with a glad astonishment, and I exclaimed: 'For once truth has been stronger than the malice of the stars! I pray God, therefore, that, if it be His pleasure, He will save me from this fearful peril.' Then I fell to eating with the same stout heart for my salvation as I had previously prepared for my perdition. I dined well, and afterwards remained without seeing or hearing any one until an hour after nightfall. At that time the Bargello arrived with a large part of his guard, and had me replaced in the chair which brought me on the previous evening to the prison. He spoke very kindly to me, bidding me be under no apprehension; and bade his constables take good care not to strike against my broken leg, but to treat me as though I were the apple of their eye. The men obeyed, and brought me to the castle whence I had escaped; then, when we had mounted to the keep, they left me shut up in a dungeon opening upon a little court there.

The castellan, meanwhile, ill and afflicted as he was, had himself transported to my prison, and exclaimed: 'You see that I have recaptured you!' 'Yes,' said I, 'but you see that I escaped, as I told you I would. And if I had not been sold by a Venetian Cardinal, under Papal guarantee, for the price of a bishopric, the Pope a Roman and a Farnese (and both of them have scratched with impious hands the face of the most sacred laws), you would not have recovered me. But now that they have opened this vile way of dealing, do you the worst you can in your turn; I care for nothing in the world.' The wretched man began shouting at the top of his voice: 'Ah, woe is me! woe is me! It is all the same to this fellow whether he lives or dies, and behold, he is more fiery than when he was in health. Put him down there below the garden, and do not speak to me of him again, for he is the destined cause of my death.'

So I was taken into a gloomy dungeon below the level of a garden, which swam with water, and was full of big spiders and many venomous worms. They flung me a wretched mattress of coarse hemp, gave me no supper, and locked four doors upon me. In that condition I abode until the nineteenth hour of the following day. Then I received food, and I requested my jailors to give me some of my books to read. None of them spoke a word, but they referred my prayer to the unfortunate castellan, who had made inquiries concerning what I said. Next morning they brought me an Italian Bible which belonged to me, and a copy of the Chronicles of Giovanni Villani. When I asked for certain other of my books, I was told that I could have no more, and that I had got too many already.

Thus, then, I continued to exist in misery upon that rotten mattress, which in three days soaked up water like a sponge. I could hardly stir because of my broken leg; and when I had to get out of bed to obey a call of nature, I crawled on all fours with extreme distress, in order not to foul the place I slept in. For one hour and a half each day I got a little glimmering of light, which penetrated that unhappy cavern through a very narrow aperture. Only for so short a space of time could I read; the rest of the day and night I abode in darkness, enduring my lot, nor ever without meditations upon God and on our human frailty. I thought it certain that a few more days would put an end to my unlucky life in that sad place and in that miserable manner.

I began the Bible from the commencement, reading and reflecting on it so devoutly, and finding in it such deep treasures of delight, that, if I had been able, I should have done naught else but study it. However, light was wanting; and the thought of all my troubles kept recurring and gnawing at me in the darkness, until I often made my mind up to put an end somehow to my own life. They did not allow me a knife, however, and so it was no easy matter to commit suicide. Once, notwithstanding, I took and propped a wooden pole I found there, in position like a trap. I meant to make it topple over on my head, and it would certainly have dashed my brains out; but when I had arranged the whole machine, and was approaching

to put it in motion, just at the moment of my setting my hand to it, I was seized by an invisible power and flung four cubits from the spot, in such terror that I lay half dead. Like that I remained from dawn until the nineteenth hour, when they brought my food. The jailors must have visited my cell several times without my taking notice of them; for when at last I heard them, Captain Sandrino Monaldi had entered, and I heard him saying: 'Ah, unhappy man! behold the end to which so rare a genius has come!' Roused by these words, I opened my eyes, and caught sight of priests with long gowns on their backs, who were saying: 'Oh, you told us he was dead!' Then they lifted me from where I lay, and after shaking up the mattress, which was now as soppy as a dish of maccaroni, they flung it outside the dungeon. The castellan, when these things were reported to him, sent me another mattress. Thereafter, when I searched my memory to find what could have diverted me from that design of suicide, I came to the conclusion that it must have been some power divine and my good guardian angel.

247

During the following night there appeared to me in dreams a marvellous being in the form of a most lovely youth, who cried, as though he wanted to reprove me: 'Knowest thou who lent thee that body, which thou wouldst have spoiled before its time?' I seemed to answer that I recognized all things pertaining to me as gifts from the God of nature. 'So, then,' he said, 'thou hast contempt for His handiwork, through this thy will to spoil it? Commit thyself unto His guidance, and lose not hope in His great goodness!' Much more he added, in words of marvellous efficacy, the thousandth part of which I cannot now remember.

I began to consider that the angel of my vision spoke the truth. So I cast my eyes around the prison, and saw some scraps of rotten brick, with the fragments of which, rubbing one against the other, I composed a paste. Then, creeping on all fours, as I was compelled to go, I crawled up to an angle of my dungeon door, and gnawed a splinter from it with my teeth. Having achieved this feat, I waited till the light came on my prison; that was from the hour of twenty and a half to twenty-one and a half. When it arrived, I began to write, the best I could, on some blank pages in my Bible, and rebuked the regents of my intellectual self for being too impatient to endure this life; they replied to my body with excuses drawn from all that they had suffered; and the body gave them hope of better fortune. To this effect, then, by way of dialogue, I wrote as follows:

Benvenuto in the body.

Afflicted regents of my soul!
 Ah, cruel ye! have ye such hate of life?

The Spirits of his soul.

If Heaven against you roll,
 Who stands for us? who saves us in the strife?
 Let us, O let us go toward better life!

Benvenuto.

Nay, go not yet awhile!
 Ye shall be happier and lighter far –
 Heaven gives this hope – than ye were ever yet!

The Spirits.

We will remain some little while,
 If only by great God you promised are
 Such grace that no worse woes on us be set.

After this I recovered strength; and when I had heartened up myself, I continued reading in the Bible, and my eyes became so used to that darkness that I could now read for three hours instead of the bare hour and a half I was able to employ before.

With profound astonishment I dwelt upon the force of God's Spirit in those men of great

simplicity, who believed so fervently that He would bring all their heart's desire to pass. I then proceeded to reckon in my own case too on God's assistance, both because of His divine power and mercy, and also because of my own innocence; and at all hours, sometimes in prayer and sometimes in communion with God, I abode in those high thoughts of Him. There flowed into my soul so powerful a delight from these reflections upon God, that I took no further thought for all the anguish I had suffered, but rather spent the day in singing psalms and divers other compositions on the theme of His divinity.

I was greatly troubled, however, by one particular annoyance: my nails had grown so long that I could not touch my body without wounding it; I could not dress myself but what they turned inside or out, to my great torment. Moreover, my teeth began to perish in my mouth. I became aware of this because the dead teeth being pushed out by the living ones, my gums were gradually perforated, and the points of the roots pierced through the tops of their cases. When I was aware of this, I used to pull one out, as though it were a weapon from a scabbard, without any pain or loss of blood. Very many of them did I lose in this way. Nevertheless, I accommodated myself to these new troubles also; at times I sang, at times I prayed, and at times I wrote by means of the paste of brick-dust I have described above.

On the last day of July Captain Sandrino Monaldi came into my prison with about twenty of the castellan's servants. The men were carrying me away with a great lighted torch; and I thought that they were about to throw me down the oubliette of Sammabo. This was the name given to a fearful place which had swallowed many men alive; for when they are cast into it, they fall to the bottom of a deep pit in the foundations of the castle. This did not, however, happen to me; wherefore I thought that I had made a very good bargain when they placed me in that hideous dungeon, where Fra Foiano died of hunger, and left me there without doing me further injury.

When I was alone, I began to sing a *De profundis clamavi*, a *Miserere*, and *In te Domine speravi*. During the whole of that first day of August I kept festival with God, my heart rejoicing ever in the strength of hope and faith. On the second day they drew me from that hole, and took me back again to the prison. All the disagreeable circumstances of my prison had become, as it were, to me friendly and companionable; not one of them gave me annoyance. Nevertheless, I ought to say that the castellan's parasites, who were waiting for him to hang me from the battlement whence I had made my escape, when they saw that he had changed his mind to the exact opposite of what he previously threatened, were unable to endure the disappointment. Accordingly, they kept continually trying to inspire me with the fear of imminent death by means of various terrifying hints. But, as I have already said, I had become so well acquainted with troubles of this sort that I was incapable of fear, and nothing any longer could disturb me; only I had that one great longing to behold the sphere of the sun, if only in a dream.

Thus then, while I spent many hours a day in prayer with deep emotion of the spirit toward Christ, I used always to say: 'Ah, very Son of God! I pray Thee by Thy birth, by Thy death upon the cross, and by Thy glorious resurrection, that Thou wilt deign to let me see the sun, if not otherwise, at least in dreams. But if Thou wilt grant me to behold it with these mortal eyes of mine, I engage myself to come and visit Thee at Thy holy sepulchre.' This vow and these my greatest prayers to God I made upon the 2nd of October in the year 1539. Upon the following morning, which was the 3rd of October, I woke at daybreak, perhaps an hour before the rising of the sun. Dragging myself from the miserable lair in which I lay, I put some clothes on, for it had begun to be cold; then I prayed more devoutly than ever I had done in the past, fervently imploring Christ that He would at least grant me the favour of knowing by divine inspiration what sin I was so sorely expiating; and since His Divine Majesty had not deemed me worthy of beholding the sun even in a dream I besought Him to let me know the cause of my punishment.

I had barely uttered these words, when that invisible being, like a whirlwind, caught me up and bore me away into a large room, where he made himself visible to my eyes in human form, appearing like a young man whose beard is just growing, with a face of indescribable beauty, but austere, not wanton. He bade me look around the room, and said: 'The crowd of men thou seest in this place are all those who up to this day have been born and afterwards have died upon

the earth.' Thereupon I asked him why he brought me hither, and he answered: 'Come with me and thou shalt soon behold.' In my hand I had a poniard, and upon my back a coat of mail; and so he led me through that vast hall, pointing out the people who were walking by innumerable thousands up and down, this way and that. He led me onward, and went forth in front of me through a little low door into a place which looked like a narrow street; and when he drew me after him into the street, at the moment of leaving the hall, behold I was disarmed and clothed in a white shirt, with nothing on my head, and I was walking on the right hand of my companion. Finding myself in this condition, I was seized with wonder, because I did not recognize the street; and when I lifted my eyes, I discerned that the splendour of the sun was striking on a wall, as it were a house-front, just above my head. Then I said: 'Oh, my friend! what must I do in order to be able to ascend so high that I may gaze upon the sphere of the sun himself?' He pointed out some huge stairs which were on my right hand, and said to me: 'Go up thither by thyself.' Quitting his side, I ascended the stairs backwards, and gradually began to come within the region of the sunlight. Then I hastened my steps, and went on, always walking backwards as I have described, until I discovered the whole sphere of the sun. The strength of his rays, as is their wont, first made me close my eyes; but becoming aware of my misdoing, I opened them wide, and gazing steadfastly at the sun, exclaimed: 'Oh, my sun, for whom I have so passionately yearned! Albeit your rays may blind me, I do not wish to look on anything again but this!' So I stayed awhile with my eyes fixed steadily on him; and after a brief space I beheld in one moment the whole might of those great burning rays fling themselves upon the left side of the sun; so that the orb remained quite clear without its rays, and I was able to contemplate it with vast delight. It seemed to me something marvellous that the rays should be removed in that manner. Then I reflected what divine grace it was which God had granted me that morning, and cried aloud: 'Oh, wonderful Thy power! oh, glorious Thy virtue! How far greater is the grace which Thou art granting me than that which I expected!' The sun without his rays appeared to me to be a bath of the purest molten gold, neither more nor less. While I stood contemplating this wondrous thing, I noticed that the middle of the sphere began to swell, and the swollen surface grew, and suddenly a Christ upon the cross formed itself out of the same substance as the sun. He bore the aspect of divine benignity, with such fair grace that the mind of man could not conceive the thousandth part of it; and while I gazed in ecstasy, I shouted: 'A miracle! a miracle! O God! O clemency Divine! O immeasurable Goodness! what is it Thou hast deigned this day to show me!' While I was gazing and exclaiming thus, the Christ moved toward that part where his rays were settled, and the middle of the sun once more bulged out as it had done before; the boss expanded, and suddenly transformed itself into the shape of a most beautiful Madonna, who appeared to be sitting enthroned on high, holding her child in her arms with an attitude of the greatest charm and a smile upon her face. On each side of her was an angel, whose beauty far surpasses man's imagination. I also saw within the rondure of the sun, upon the right hand, a figure robed like a priest; this turned its back to me, and kept its face directed to the Madonna and the Christ. All these things I beheld, actual, clear, and vivid, and kept returning thanks to the glory of God as loud as I was able. The marvellous apparition remained before me little more than half a quarter of an hour; then it dissolved, and I was carried back to my dark lair.

I began at once to shout aloud: 'The virtue of God hath deigned to show me all His glory, the which perchance no mortal eye hath ever seen before. Therefore I know surely that I am free and fortunate and in the grace of God; but you miscreants shall be miscreants still, accursed, and in the wrath of God. Mark this, for I am certain of it, that on the day of All Saints, the day upon which I was born in 1500, on the first of November, at four hours after nightfall, on that day which is coming you will be forced to lead me from this gloomy dungeon; less than this you will not be able to do, because I have seen it with these eyes of mine and in that throne of God. The priest who kept his face turned to God and his back to me, that priest was St Peter, pleading my cause, for the shame he felt that such foul wrongs should be done to Christians in his own house. You may go and tell it to whom you like; for none on earth has the

249

power to do me harm henceforward; and tell that lord who keeps me here, that if he will give me wax or paper and the means of portraying this glory of God which was revealed to me, most assuredly shall I convince him of that which now perhaps he holds in doubt.'

250 After the lapse of a few days, the castellan succumbed to his disease and departed this life. In his room remained his brother, Messer Antonio Ugolini, who had informed the deceased governor that I was duly released. From what I learned, this Messer Antonio received commission from the Pope to let me occupy that commodious prison until he had decided what to do with me.

251 Messer Durante of Brescia, whom I have previously mentioned, engaged the soldier (formerly druggist of Prato) to administer some deadly liquor in my food; the poison was to work slowly, producing its effect at the end of four or five months. They resolved on mixing pounded diamond with my victuals. Now the diamond is not a poison in any true sense of the word, but its incomparable hardness enables it, unlike ordinary stones, to retain very acute angles. When every other stone is pounded, that extreme sharpness of edge is lost; their fragments becoming blunt and rounded. The diamond alone preserves its trenchant qualities; wherefore, if it chances to enter the stomach together with food, the peristaltic motion needful to digestion brings it into contact with the coats of the stomach and the bowels, where it sticks, and by the action of fresh food forcing it farther inwards, after some time perforates the organs. This eventually causes death. Any other sort of stone or glass mingled with the food has not the power to attach itself, but passes onward with the victuals. Now Messer Durante entrusted a

252 diamond of trifling value to one of the guards; and it is said that a certain Lione, a goldsmith of Arezzo, my great enemy, was commissioned to pound it. The man happened to be very poor, and the diamond was worth perhaps some scores of crowns. He told the guard that the dust he gave him back was the diamond in question properly ground down. The morning when I took it, they mixed it with all I had to eat; it was a Friday, and I had it in salad, sauce, and pottage. That morning I ate heartily, for I had fasted on the previous evening; and this day was a festival. It is true that I felt the victuals scrunch beneath my teeth; but I was not thinking about knaveries of this sort. When I had finished, some scraps of salad remained upon my plate, and certain very fine and glittering splinters caught my eye among those remnants. I collected them, and took them to the window, which let a flood of light into the room; and while I was examining them I remembered that the food I ate that morning had scrunched more than usual. On applying my senses strictly to the matter, the verdict of my eyesight was that they were certainly fragments of pounded diamond. Now hope is immortal in the human breast; therefore I felt myself, as it were, lured onward by a gleam of idle expectation. Accordingly, I took up a little knife and a few of those particles, and placed them on an iron bar of my prison. Then I brought the knife's point with a slow strong grinding pressure to bear upon the stone, and felt it crumble. Examining the substance with my eyes, I saw that it was so. In a moment new hope took possession of my soul, and I exclaimed: 'Here I do not find my true foe, Messer Durante, but a piece of bad soft stone, which cannot do me any harm whatever!' Previously I had been resolved to remain quiet and to die in peace; now I resolved other plans; but first I rendered thanks to God and blessed poverty; for though poverty is oftentimes the cause of bringing men to death, on this occasion it had been the very cause of my salvation. I mean in this way: Messer Durante, my enemy, or whoever it was, gave a diamond to Lione to pound for me of the worth of more than a hundred crowns; poverty induced him to keep this for himself, and to pound for me a greenish beryl of the value of two carlins, thinking perhaps, because it also was a stone, that it would work the same effect as the diamond.

253 At this time the Bishop of Pavia, brother of the Count of San Secondo, and commonly called Monsignor de' Rossi of Parma, happened to be imprisoned in the castle for some troublesome affairs at Pavia. Knowing him to be my friend, I thrust my head out of the hole in my cell, and called him with a loud voice, crying that those thieves had given me a pounded diamond with the intention of killing me. I also sent some of the splinters which I had preserved, by the hand of one of his servants, for him to see. I did not disclose my discovery that

47 Façade of Palazzo Farnese, Rome, begun by Antonio da Sangallo
the Younger and completed by Michelangelo, 1549

the stone was not a diamond, but told him that they had most assuredly poisoned me, after the death of that most worthy man the castellan. During the short space of time I had to live, I begged him to allow me one loaf a day from his own stores, seeing that I had resolved to eat nothing coming from them. To this he answered that he would supply me with victuals.

Messer Antonio, who was certainly not cognisant of the plot against my life, stirred up a great noise, and demanded to see the pounded stone, being also persuaded that it was a diamond; but on reflection that the Pope was probably at the bottom of the affair, he passed it over lightly after giving his attention to the incident.

Henceforth I ate victuals sent me by the Bishop. But Messer Antonio also sent me food, and he did this by the hand of that Giovanni of Prato, the druggist, then soldier in the castle, whom I have previously mentioned. He was a deadly foe of mine, and was the man who had administered the powdered diamond. So I told him that I would partake of nothing he brought me unless he tasted it before my eyes. The man replied that Popes have their meat tasted. I answered: 'Noblemen are bound to taste the meat for Popes; in like measure, you, soldier, druggist, peasant from Prato, are bound to taste the meat for a Florentine of my station.' He retorted with coarse words, which I was not slow to pay back in kind.

Now Messer Antonio felt a certain shame for his behaviour; he had it also in his mind to make me pay the costs which the late castellan, poor man, remitted in my favour. So he hunted out another of his servants, who was my friend, and sent me food by this man's hands. The meat was tasted for me now with good grace, and no need for altercation. The servant in question told me that the Pope was being pestered every day by Monsignor di Morluc, who kept asking for my extradition on the part of the French King. The Pope, however, showed little disposition to give me up; and Cardinal Farnese, formerly my friend and patron, had declared that I ought not to reckon on issuing from that prison for some length of time. I replied that I should get out in spite of them all.

A few days had passed when the Cardinal of Ferrara arrived in Rome. He went to pay his respects to the Pope, and the Pope detained him up to supper-time. Now the Pope was a man of great talent for affairs, and he wanted to talk at his ease with the Cardinal about French politics. Everybody knows that folk, when they are feasting together, say things which they would otherwise retain. This therefore happened. The great King Francis was most frank and liberal in all his dealings, and the Cardinal was well acquainted with his temper. Therefore the latter could indulge the Pope beyond his boldest expectations. This raised his Holiness to a high pitch of merriment and gladness, all the more because he was accustomed to drink freely once a week, and went indeed to vomit after his indulgence. When, therefore, the Cardinal observed that the Pope was well disposed, and ripe to grant favours, he begged for me at the King's demand, pressing the matter hotly, and proving that his Majesty had it much at heart. Upon this the Pope laughed aloud; he felt the moment for his vomit at hand; the excessive quantity of wine which he had drunk was also operating; so he said: 'On the spot, this instant, you shall take him to your house.' Then, having given express orders to this purpose, he rose from table. The Cardinal immediately sent for me, before Signor Pier Luigi could get wind of the affair; for it was certain that he would not have allowed me to be loosed from prison.

The Pope's mandatary came together with two great gentlemen of the Cardinal's, and when four o'clock of the night was passed, they removed me from my prison, and brought me into
256 the presence of the Cardinal, who received me with indescribable kindness. I was well lodged, and left to enjoy the comforts of my situation.

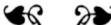

257 I remained for some time in the Cardinal of Ferrara's palace, very well regarded in general by everybody, and much more visited even than I had previously been. Everybody was astonished that I should have come out of prison and have been able to live through such indescribable afflictions. Afterwards, with a view to re-establishing my strength, I determined to take a journey of a few days for change of air. We left Rome, and took the road to Tagliacozzo, intending to visit my pupil Ascanio, who lived there. On our arrival, I found the lad, together with his father, brothers, sisters, and stepmother. I was entertained by them two days with indescribable kindness; then I turned my face towards Rome, taking Ascanio with me. On the road we fell to conversing about our art, which made me die of impatience to get back and recommence my labours.

Having reached Rome, I got myself at once in readiness to work, and was fortunate enough to find again a silver basin which I had begun for the Cardinal before I was imprisoned. Together with this basin I had begun a very beautiful little jug; but this had been stolen, with a great quantity of other valuable articles. I recommenced the jug, which was designed with round figures and bas-reliefs. The basin was executed in a similar style, with round figures and fishes in bas-relief. The whole had such richness and good keeping, that every one who beheld it expressed astonishment at the force of the design and beauty of invention, and also at the delicacy with which these young men worked.

The Cardinal came at least twice a day to see me, bringing with him Messer Luigi Alamanni
258 and Messer Gabriel Cesano; and here we used to pass an hour or two pleasantly together. Notwithstanding I had very much to do, he kept giving me fresh commissions. Among others, I had to make his pontifical seal, of the size of the hand of a boy of twelve. On it I engraved in intaglio two little histories, the one of San Giovanni preaching in the wilderness, the other of Sant' Ambrogio expelling the Arians on horseback with a lash in his hand. The fire and correctness of design of this piece, and its nicety of workmanship, made every one say that I had
259 surpassed the great Lautizio, who ranked alone in this branch of the profession. The Cardinal was so proud of it that he used to compare it complacently with the other seals of the Roman cardinals, which were nearly all from the hand of Lautizio.
260 In addition to these things the Cardinal ordered me to make the model for a salt-cellar; but

he said he should like me to leave the beaten track pursued by such as fabricated these things. Messer Luigi, apropos of this salt-cellar, made an eloquent description of his own idea; Messer Gabriello Cesano also spoke exceedingly well to the same purpose. The Cardinal, who was a very kindly listener, showed extreme satisfaction with the designs which these two able men of letters had described in words. Then he turned to me and said: 'My Benvenuto, the design of Messer Luigi and that of Messer Gabriello please me both so well that I know not how to choose between them; therefore I leave the choice to you, who will have to execute the work.' I replied as follows: 'It is apparent, my lords, of what vast consequence are the sons of kings and emperors, and what a marvellous brightness of divinity appears in them; nevertheless, if you ask some poor humble shepherd which he loves best, those royal children or his sons, he will certainly tell you that he loves his own sons best. Now I too have a great affection for the children which I bring forth from my art; consequently the first which I will show you, most reverend monsignor my good master, shall be of my own making and invention. There are many things beautiful enough in words which do not match together well when executed by an artist.' Then I turned to the two scholars and said: 'You have spoken, I will do.' Upon this Messer Luigi Alamanni smiled, and added a great many witty things, with the greatest charm of manner, in my praise; they became him well, for he was handsome of face and figure, and had a gentle voice. Messer Gabriello Cesano was quite the opposite, as ugly and displeasing as the other was agreeable; accordingly he spoke as he looked.

Messer Luigi had suggested that I should fashion a Venus with Cupid, surrounded by a crowd of pretty emblems, all in proper keeping with the subject. Messer Gabriello proposed that I should model an Amphitrite, the wife of Neptune, together with those Tritons of the sea, and many such-like fancies, good enough to describe in words, but not to execute in metal.

I first laid down an oval framework, considerably longer than half a cubit – almost two-thirds, in fact; and upon this ground, wishing to suggest the interminglement of land and ocean, I modelled two figures, considerably taller than a palm in height, which were seated with their legs interlaced, suggesting those lengthier branches of the sea which run up into the continents. The sea was a man, and in his hand I placed a ship, elaborately wrought in all its details, and well adapted to hold a quantity of salt. Beneath him I grouped the four sea-horses, and in his right hand he held his trident. The earth I fashioned like a woman, with all the beauty of form, the grace and charm of which my art was capable. She had a richly decorated temple firmly based upon the ground at one side; and here her hand rested. This I intended to receive the pepper. In her other hand I put a cornucopia, overflowing with all the natural treasures I could think of. Below this goddess, in the part which represented earth, I collected the fairest animals that haunt our globe. In the quarter presided over by the deity of ocean, I fashioned such choice kinds of fishes and shells as could be properly displayed in that small space. What remained of the oval I filled in with luxuriant ornamentation.

Then I waited for the Cardinal; and when he came, attended by the two accomplished gentlemen, I produced the model I had made in wax. On beholding it, Messer Gabriel Cesano was the first to lift his voice up, and to cry: 'This is a piece which it will take the lives of ten men to finish: do not expect, most reverend monsignor, if you order it, to get it in your lifetime. Benvenuto, it seems, has chosen to display his children in a vision, but not to give them to the touch, as we did when we spoke of things that could be carried out, while he has shown a thing beyond the bounds of possibility.' Messer Alamanni took my side; but the Cardinal said he did not care to undertake so important an affair. Then I turned to them and said: 'Most reverend monsignor, and you, gentlemen, fulfilled with learning; I tell you that I hope to complete this piece for whosoever shall be destined to possess it; and each one of you shall live to see it executed a hundred times more richly than the model. Indeed, I hope that time will be left me to produce far greater things than this.' The Cardinal replied in heat: 'Unless you make it for the King, to whom I mean to take you, I do not think that you will make it for another man alive.' Then he showed me letters in which the King, under one heading, bade him return as soon as possible, bringing Benvenuto with him. At this I raised my hands to heaven, exclaiming: 'Oh, when will that

261

48 LEFT *Portrait of Cardinal Pietro Bembo* by Titian, *c.* 1540. 37 × 30 ins
(94.5 × 76.5 cm). Washington DC, National Gallery (Samuel H. Kress Coll.)

49 ABOVE *Portrait of Pierluigi Farnese* by Titian, 1546. Naples, Gallerie
Nazionali di Capodimonte

moment come, and quickly?' The Cardinal bade me put myself in readiness, and arrange the affairs I had in Rome. He gave me ten days for these preparations.

262 When the time came to travel, he gave me a fine and excellent horse. The animal was called Tornon, because it was a gift from the Cardinal Tornon. My apprentices, Pagolo and Ascanio, were also furnished with good mounts.

The Cardinal divided his household, which was very numerous, into two sections. The first, and the more distinguished, he took with him, following the route of Romagna, with the object of visiting Madonna del Loreto, and then making for Ferrara, his own home. The other section he sent upon the road to Florence. This was the larger train; it counted a great multitude, including the flower of his horse. He told me that if I wished to make the journey without peril, I had better go with him, otherwise I ran some risk of my life.

263 In Ferrara the Cardinal sent me to reside at a palace of his, a very handsome place called Belfiore, close under the city walls. There he provided me with all things necessary for my work. A little later, he arranged to leave for France without me; and observing that I was very ill pleased with this, he said to me: 'Benvenuto, I am acting for your welfare; before I take you out of Italy, I want you to know exactly what you will have to do when you come to France. Meanwhile, push on my basin and the jug with all the speed you can. I shall leave orders with my factor to give you everything that you may want.'

He then departed, and I remained sorely dissatisfied and more than once I was upon the point of taking myself off without license. The only thing which kept me back was that he had procured my freedom from Pope Paolo; for the rest, I was ill-contented and put to considerable losses. The air was unwholesome where we lodged, and toward summer we all of us suffered somewhat in our health. During our indisposition we went about inspecting the domain; it was very large, and left in a wild state for about a mile of open ground, haunted too by multitudes of peacocks, which bred and nested there like wildfowl. This put it into my head to charge my gun with a noiseless kind of powder; then I tracked some of the young birds, and every other day killed one, which furnished us with abundance of meat, of such excellent quality that we shook our sickness off. For several months following we went on working merrily, and got the jug and basin forward; but it was a task that required much time.

264 At that period the Duke of Ferrara came to terms with Pope Paul about some old matters in dispute between them relating to Modena and certain other cities. The Church having a strong claim to them, the Duke was forced to purchase peace by paying down an enormous sum of
265 money; I think that it exceeded three hundred thousand ducats of the Camera. There was an old treasurer in the service of the Duke, who had been brought up by his father, Duke Alfonso, and was called Messer Girolamo Giliolo. He could not endure to see so much money going to the Pope, and went about the streets crying: 'Duke Alfonso, his father, would sooner have attacked and taken Rome with this money than have shown it to the Pope.' Nothing would induce him to disburse it; at last, however, the Duke compelled him to make the payments, which caused the old man such anguish that he sickened of a dangerous colic and was brought to death's door. During this man's illness the Duke sent for me, and bade me take his portrait; this I did upon a circular piece of black stone about the size of a little trencher. The Duke took so much pleasure in my work and conversation, that he not unfrequently posed through four or five hours at a stretch for his own portrait, and sometimes invited me to supper. It took me eight days to complete his likeness; then he ordered me to design the reverse. On it I modelled Peace, giving her the form of a woman with a torch in her hand, setting fire to a trophy of arms; I portrayed her in an attitude of gladness, with very thin drapery, and below her feet lay Fury in despair, downcast and sad, and loaded with chains. I devoted much study and attention
266 to this work, and it won me the greatest honour. The Duke was never tired of expressing his satisfaction, and gave me inscriptions for both sides of the medal. That on the reverse ran as follows: *Pretiosa in conspectu Domini*; it meant that his peace with the Pope had been dearly bought.

While I was still engaged upon the reverse of this medal, the Cardinal sent me letters bidding

me prepare for my journey, since the King had asked after me. His next communication would contain full details respecting all that he had promised. Accordingly, I had my jug and basin packed up, after showing them to the Duke. Now a Ferrarese gentleman named Alberto Bendedio was the Cardinal's agent, and he had been twelve years confined to his house, without once leaving it, by reason of some physical infirmity. One day he sent in a vast hurry for me, saying I must take the post at once, in order to present myself before the King of France, who had eagerly been asking for me, under the impression that I was in France. By way of apology, the Cardinal told him that I was staying, slightly indisposed, in his abbey at Lyons, but that he would have me brought immediately to his Majesty. Therefore I must lose no time, but travel with the post.

267

Now Messer Alberto was a man of sterling worth, but proud, and illness had made his haughty temper insupportable. As I have just said, he bade me to get ready on the spot and take the journey by the common post. I said that it was not the custom to pursue my profession in the post, and that if I had to go, it was my intention to make easy stages and to take with me the workmen Ascanio and Pagolo, whom I had brought from Rome. Moreover, I wanted a servant on horseback to be at my orders, and money sufficient for my costs upon the way. The infirm old man replied, upon a tone of mighty haughtiness, that the sons of dukes were wont to travel as I had described, and in no other fashion. I retorted that the sons of my art travelled in the way I had informed him, and that not being a duke's son, I knew nothing about the customs of such folk; if he treated me to language with which my ears were unfamiliar, I would not go at all; the Cardinal having broken faith with me, and such scurvy words having been spoken, I should make my mind up once for all to take no further trouble with the Ferrarese. Then I turned my back, and, he threatening, I grumbling, took my leave.

I next went to the Duke with my medal, which was finished. He received me with the highest marks of honour and esteem. It seems that he had given orders to Messer Girolamo Giliolo to reward me for my labour with a diamond ring worth two hundred crowns, which was to be presented by Fiaschino, his chamberlain. Accordingly, this fellow, on the evening after I had brought the medal, at one hour past nightfall, handed me a ring with a diamond of showy appearance, and spoke as follows on the part of his master: 'Take this diamond as a remembrance of his Excellency, to adorn the unique artist's hand which has produced a masterpiece of so singular merit.' When day broke, I examined the ring, and found the stone to be a miserable thin diamond, worth about ten crowns. I felt sure that the Duke had not meant to accompany such magnificent compliments with so trifling a gift, but that he must have intended to reward me handsomely. Being then convinced that the trick proceeded from his rogue of a treasurer, I gave the ring to a friend of mine, begging him to return it to the chamberlain, Fiaschino, as he best could. The man I chose was Bernardo Saliti, who executed his commission admirably. Fiaschino came at once to see me, and declared, with vehement expostulations, that the Duke would take it very ill if I refused a present he had meant so kindly; perhaps I should have to repent of my waywardness. I answered that the ring his Excellency had given me was worth about ten crowns, and that the work I had done for him was worth more than two hundred. Wishing, however, to show his Excellency how highly I esteemed his courtesy, I should be happy if he bestowed on me only one of those rings for the cramp, which come from England and are worth tenpence. I would treasure that so long as I lived in remembrance of his Excellency, together with the honourable message he had sent me; for I considered that the splendid favours of his Excellency had amply recompensed my pains, whereas that paltry stone insulted them. This speech annoyed the Duke so much that he sent for his treasurer, and scolded him more sharply than he had ever done before. At the same time he gave me orders, under pain of his displeasure, not to leave Ferrara without duly informing him; and commanded the treasurer to present me with a diamond up to three hundred crowns in value. The miserly official found a stone rising a trifle above sixty crowns, and let it be heard that it was worth upwards of two hundred.

Meanwhile Messer Alberto returned to reason, and provided me with all I had demanded.

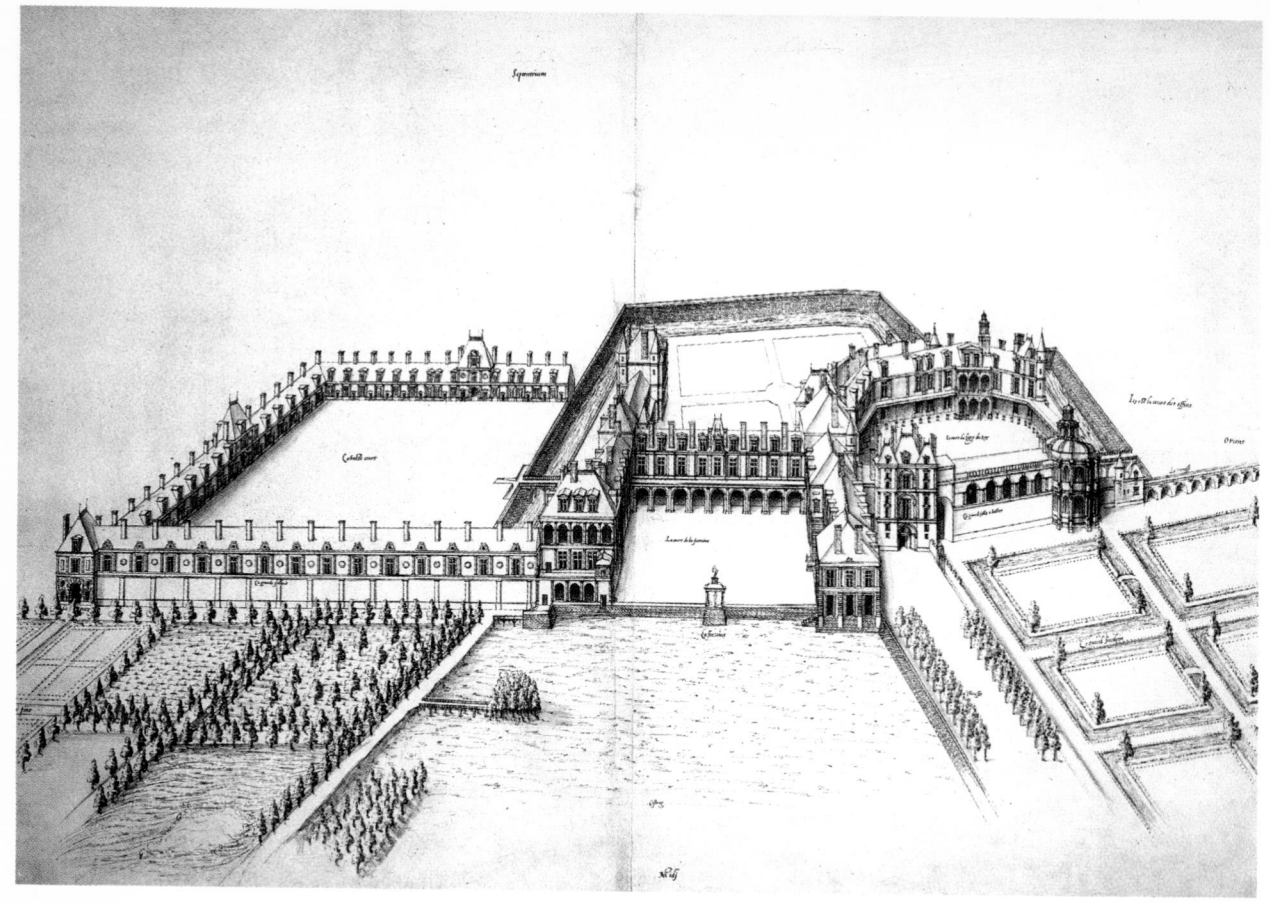

50 ABOVE *Château de Fontainebleau*, drawing by Androuet du Cerceau. *c.*
1570. Pen, ink and wash on vellum. From J. A. Du Cerceau, *Bastiments de
France* (II, 10). British Museum

51 RIGHT *Portrait of Francis I* by François Clouet, *c.* 1545–6. Panel,
$37\frac{3}{4} \times 29$ ins (96 × 73.5 cm). Paris, Louvre

My mind was made up to quit Ferrara without fail that very day; but the Duke's attentive
chamberlain arranged with Messer Alberto that I should get no horses then. I had loaded a
mule with my baggage, including the case which held the Cardinal's jug and basin. Just then a
Ferrarese nobleman named Messer Alfonso de' Trotti arrived. He was far advanced in years,
and a person of excessive affectation; a great dilettante of the arts, but one of those men who are
very difficult to satisfy, and who, if they chance to stumble on something which suits their
taste, exalt it so in their own fancy that they never expect to see the like of it again. Well, this
Messer Alfonso arrived, and Messer Alberto said to him: 'I am sorry that you are come so late;
the jug and basin we are sending to the Cardinal in France have been already packed.' He
answered that it did not signify to him; and beckoning to his servant, sent him home to fetch a
jug in white Faenzo clay, the workmanship of which was very exquisite. During the time the
servant took to go and return, Messer Alfonso said to Messer Alberto: 'I will tell you why I do
not care any longer to look at vases; it is that I once beheld a piece of silver, antique, of such
beauty and such finish that the human imagination cannot possibly conceive its rarity.
Therefore I would rather not inspect any objects of the kind, for fear of spoiling the unique
impression I retained of that. I must tell you that a gentleman of great quality and
accomplishments, who went to Rome upon matters of business, had this antique vase shown to
him in secret. By adroitly using a large sum of money, he bribed the person in whose hands it
was, and brought it with him to these parts; but he keeps it jealously from all eyes, in order that
the Duke may not get wind of it, fearing he should in some way be deprived of his treasure.'

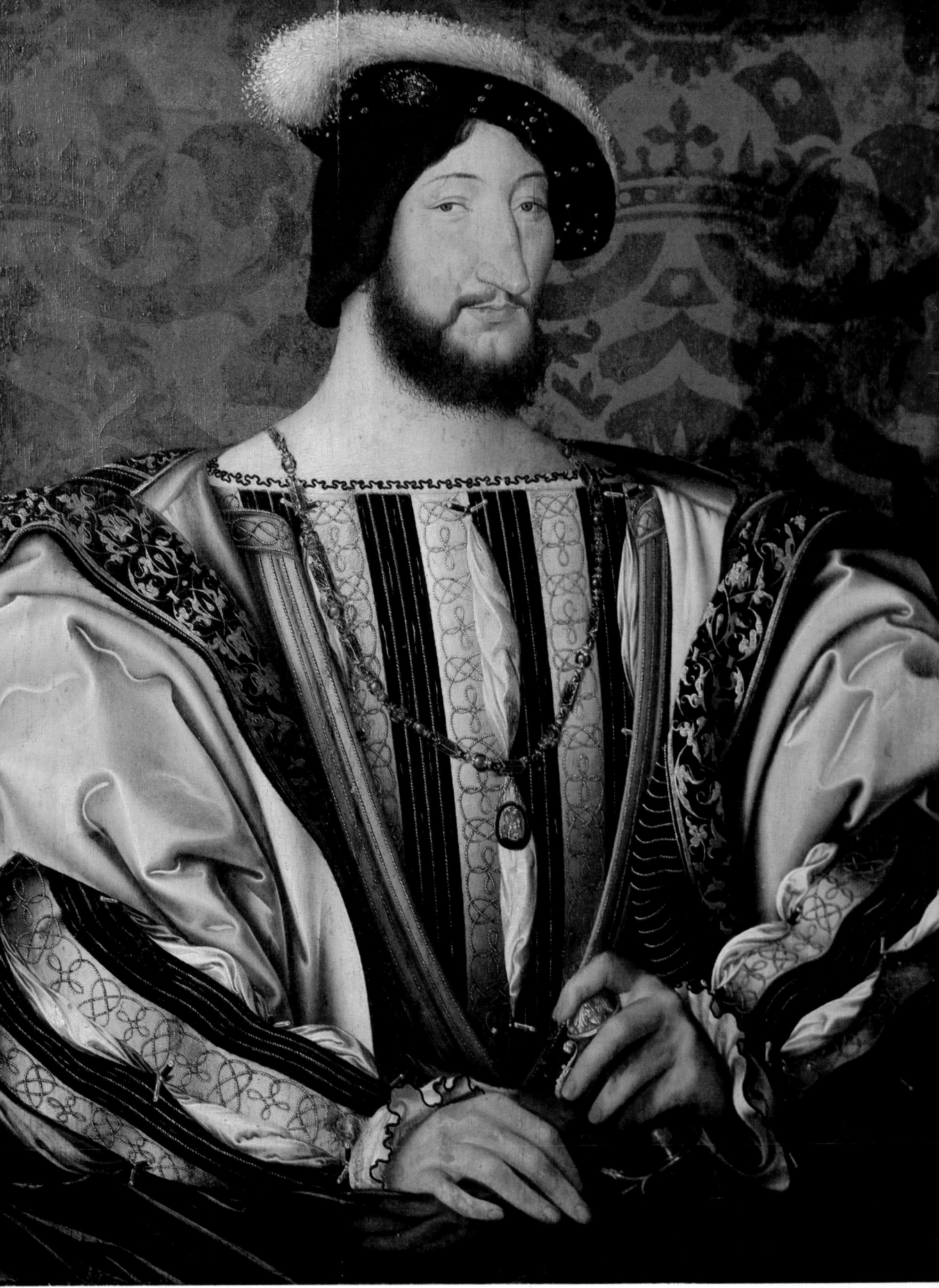

While spinning out this lengthy yarn, Messer Alfonso did not look at me, because we were not previously acquainted. But when that precious clay model appeared, he displayed it with such airs of ostentation, pomp, and mountebank ceremony, that, after inspecting it, I turned to Messer Alberto and said: 'I am indeed lucky to have had the privilege to see it!' Messer Alfonso, quite affronted, let some contemptuous words escape him, and exclaimed: 'Who are you, then, you who do not know what you are saying?' I replied: 'Listen for a moment, and afterwards judge which of us knows best what he is saying!' Then turning to Messer Alberto, who was a man of great gravity and talent, I began: 'This is a copy from a little silver goblet, of such and such a weight, which I made at such and such a time for that charlatan Maestro
269 Jacopo, the surgeon from Carpi. He came to Rome and spent six months there, during which he bedaubed some scores of noblemen and unfortunate gentlefolk with his dirty salves, extracting many thousands of ducats from their pockets. At that time I made for him this vase and one of a different pattern. He paid me very badly; and at the present moment in Rome all the miserable people who used his ointment are crippled and in a deplorable state of health. It is indeed great glory for me that my works are held in such repute among you wealthy lords; but I can assure you that during these many years past I have been progressing in my art with all my might, and I think that the vase I am taking with me into France is far more worthy of cardinals and kings than that piece belonging to your little quack doctor.'

After I had made this speech, Messer Alfonso seemed dying with desire to see the jug and basin, but I refused to open the box. We remained some while disputing the matter, when he said that he would go to the Duke and get an order from his Excellency to have it shown him. Then Messer Alberto Bendedio, in the high and mighty manner which belonged to him, exclaimed: 'Before you leave this room, Messer Alfonso, you shall see it, without employing the Duke's influence.' On hearing these words I took my leave, and left Ascanio and Pagolo to show it. They told me afterwards that he had spoken enthusiastically in my praise. After this he wanted to become better acquainted with me; but I was wearying to leave Ferrara and get away from all its folk. The only advantages I had enjoyed there were the society of Cardinal
270 Salviati and the Cardinal of Ravenna, and the friendship of some ingenious musicians; no one else had been to me of any good; for the Ferrarese are a very avaricious people, greedy of their neighbours' money, however they may lay their hands on it; they are all the same in this respect.

That evening I rode more than ten miles, always at a trot; and when, upon the next day, I found myself outside the Ferrarese domain, I felt excessively relieved; indeed I had met with nothing to my liking there, except those peacocks which restored my health. We journeyed by the Monsanese, avoiding the city of Milan on account of the apprehension I have spoken of; so that we arrived safe and sound at Lyons. Counting Pagolo and Ascanio and a servant, we were four men, with four very good horses. At Lyons we waited several days for the muleteer, who carried the silver cup and basin, as well as our other baggage; our lodging was in an abbey of
271 the Cardinal's. When the muleteer arrived, we loaded all our goods upon a little cart, and then set off towards Paris. On the road we met with some annoyances, but not of any great moment.

We found the Court of the King at Fontainebleau; there we presented ourselves to the
272 Cardinal, who provided us at once with lodgings, and that evening we were comfortable. On the following day the cart turned up; so we unpacked our things, and when the Cardinal heard this he told the King, who expressed a wish to see me at once. I went to his Majesty with the cup and basin; then, upon entering his presence, I kissed his knee, and he received me very graciously. I thanked his Majesty for freeing me from prison. The King, while I was delivering this speech, continued listening till the end with the utmost courtesy, dropping a few words such as only he could utter. Then he took the vase and basin, and exclaimed: 'Of a truth I hardly think the ancients can have seen a piece so beautiful as this. I well remember to have inspected all the best works, and by the greatest masters of all Italy, but I never set my eyes on anything which stirred me to such admiration.' These words the king addressed in French to the

Cardinal of Ferrara, with many others of even warmer praise. Then he turned to me and said in Italian: 'Benvenuto, amuse yourself for a few days, make good cheer, and spend your time in pleasure; in the meanwhile we will think of giving you the wherewithal to execute some fine works of art for us.'

The Cardinal of Ferrara saw that the King had been vastly pleased by my arrival; he also judged that the trifles which I showed him of my handicraft had encouraged him to hope for the execution of some considerable things he had in mind. One morning, at his dinner, the King called me. He began to talk to me in Italian, saying he had it in his mind to execute several great works, and that he would soon give orders where I was to labour, and provide me with all necessaries. These communications he mingled with discourse on divers pleasant matters. The Cardinal of Ferrara was there, because he almost always ate in the morning at the King's table. He had heard our conversation, and when the King rose, he spoke in my favour to this purport, as I afterwards was informed: 'Sacred Majesty, this man Benvenuto is very eager to get to work again; it seems almost a sin to let an artist of his abilities waste his time.' The King replied that he had spoken well, and told him to arrange with me all things for my support according to my wishes.

On our way to the lodgings of the King Ascanio and I passed before those of the Cardinal of Ferrara. Standing at his door, he called to me and said: 'Our most Christian monarch has of his own accord assigned you the same appointments which his Majesty allowed the painter Leonardo da Vinci, that is, a salary of seven hundred crowns; in addition, he will pay you for all the works you do for him; also for your journey hither he gives you five hundred golden crowns, which will be paid you before you quit this place.' At the end of this announcement, I replied that those were offers worthy of the great King he was. 273

On the day following I went to thank the King, who ordered me to make the models of twelve silver statues, which were to stand as candelabra round his table. He wanted them to represent six gods and six goddesses, and to have exactly the same height as his Majesty, which was a trifle under four cubits. Having dictated this commission, he turned to his treasurer, and asked whether he had paid me the five hundred crowns. The official said that he had received no orders to that effect. The King took this very ill, for he had requested the Cardinal to speak to him about it. Furthermore, he told me to go to Paris and seek out a place to live in, fitted for the execution of such works; he would see that I obtained it. 274 275

I got the five hundred crowns of gold, and took up my quarters at Paris in a house of the Cardinal of Ferrara. There I began, in God's name, to work, and fashioned four little waxen models, about two-thirds of a cubit each in height. They were Jupiter, Juno, Apollo, and Vulcan. In this while the King returned to Paris; whereupon I went to him at once, taking my models with me, and my two prentices, Ascanio and Pagolo. On perceiving that the King was pleased with my work, and being commissioned to execute the Jupiter in silver of the height above described, I introduced the two young men, and said that I had brought them with me out of Italy to serve his Majesty; for inasmuch as they had been brought up by me, I could at the beginning get more help from them than from the Paris workmen. To this the King replied that I might name a salary which I thought sufficient for their maintenance. I said that a hundred crowns of gold apiece would be quite proper, and that I would make them earn their wages well. This agreement was concluded. Then I said that I had found a place which seemed to me exactly suited to my industry; it was his Majesty's own property, and called the Little Nello. The Provost of Paris was then in possession of it from his Majesty; but since the Provost made no use of the castle, his Majesty perhaps might grant it me to employ in his service. He 276 replied upon the instant: 'That place is my own house, and I know well that the man I gave it to does not inhabit or use it. So you shall have it for the work you have to do.' He then told his lieutenant to install me in the Nello. This officer made some resistance, pleading that he could not carry out the order. The King answered in anger that he meant to bestow his property on whom he pleased, and on a man who would serve him, seeing that he got nothing from the other; therefore he would hear no more about it. The lieutenant then submitted that some

Junone —

era istera esisecie da
grāde piu del uiuo
francesche. Ipa
auenano a essere
sisini il giove solar

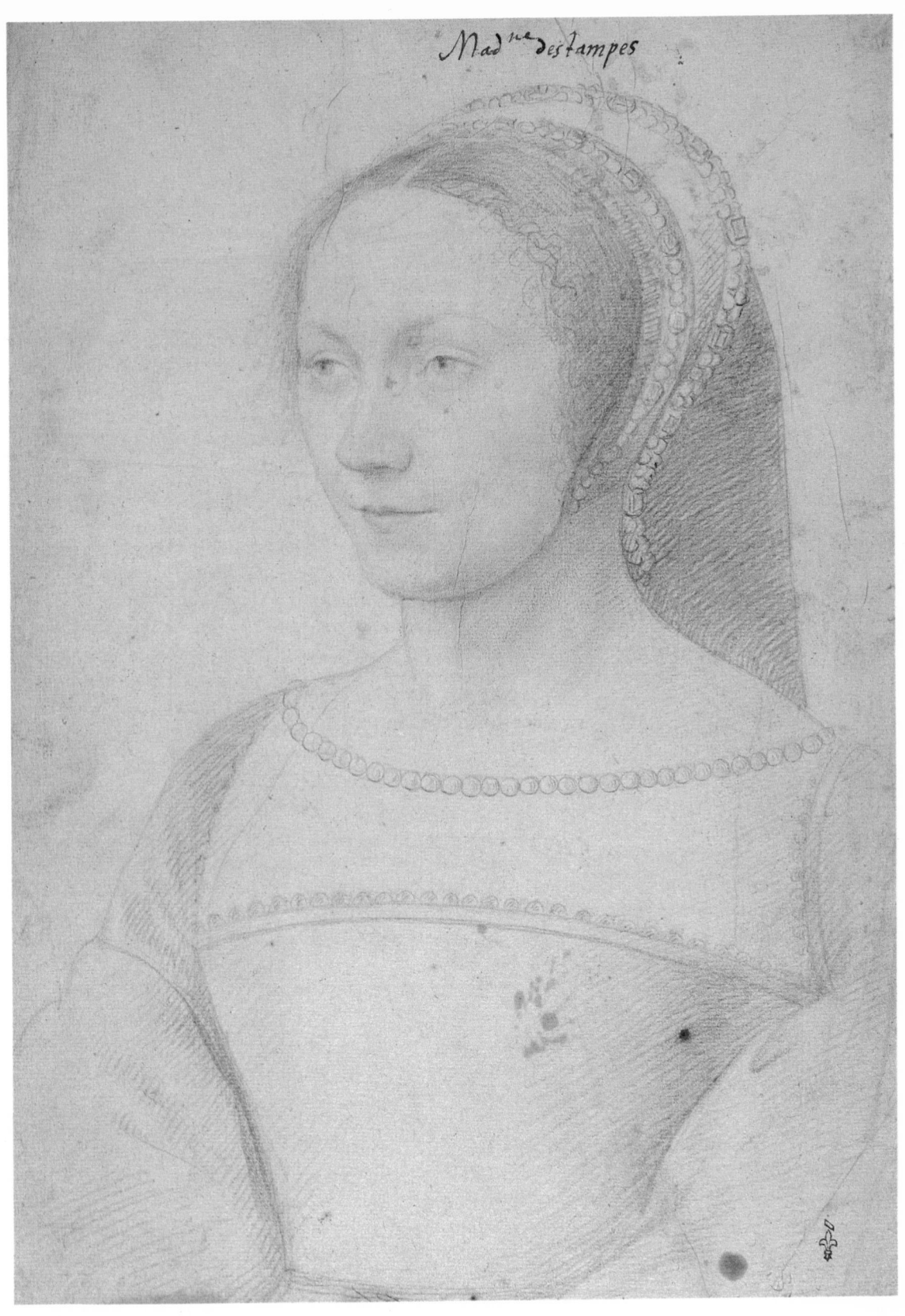

Mad.ᵗᵉ destampes

52 LEFT Drawing by Cellini for the statue of *Juno* commissioned by
Francis I, 1540–4. Paris, Louvre (Cabinet des Dessins)

53 ABOVE *The Duchesse d'Etampes*, drawing by François Clouet, *c.* 1535.
Chantilly, Musée Condé

small force would have to be employed in order to effect an entrance. To which the King answered: 'Go, then, and if a small force is not enough, use a great one.'

The officer took me immediately to the castle, and there put me in possession, not, however, without violence; after that he warned me to take very good care that I was not murdered. I installed myself, enrolled serving-men, and bought a quantity of pikes and partisans; but I remained for several days exposed to grievous annoyances, for the Provost was a great nobleman of Paris, and all the other gentlefolk took part against me; they attacked me with such insults that I could hardly hold my own against them. I must not omit to mention that I entered the service of his Majesty in the year 1540, which was exactly the year in which I reached the age of forty.

The affronts and insults I received made me have recourse to the King, begging his Majesty to establish me in some other place. He answered: 'Who are you, and what is your name?' I remained in great confusion, and could not comprehend what he meant. Holding my tongue thus, the King repeated the same words a second time angrily. Then I said my name was Benvenuto. 'If, then, you are the Benvenuto of whom I have heard,' replied the King, 'act according to your wont, for you have my full leave to do so.' I told his Majesty that all I wanted was to keep his favour; for the rest, I knew of nothing that could harm me. He gave a little laugh, and said: 'Go your ways, then; you shall never want my favour.' Upon this he told his *277* first secretary, Monsignor di Villerois, to see me provided and accommodated with all I needed.

This Villerois was an intimate friend of the Provost, to whom the castle had been given. It was built in a triangle, right up against the city walls, and was of some antiquity, but had no garrison. The building was of considerable size. Monsignor di Villerois counselled me to look about for something else, and by all means to leave this place alone, seeing that its owner was a man of vast power, who would most assuredly have me killed. I answered that I had come from Italy to France only in order to serve that illustrious King; and as for dying, I knew for certain that die I must; a little earlier or a little later was a matter of supreme indifference to me.

Now Villerois was a man of the highest talent, exceptionally distinguished in all points, and possessed of vast wealth. There was nothing he would not gladly have done to harm me, but he made no open demonstration of his mind. He was grave, and of a noble presence, and spoke *278* slowly, at his ease. To another gentleman, Monsignor di Marmagna, the treasurer of Languedoc, he left the duty of molesting me. The first thing which this man did was to look out the best apartments in the castle, and to have them fitted up for himself. I told him that the King had given me the place to serve him in, and that I did not choose it should be occupied by any but myself and my attendants. The fellow, who was haughty, bold, and spirited, replied that he meant to do just what he liked; that I should run my head against a wall if I presumed to oppose him, and that Villerois had given him authority to do what he was doing. I told him that, by the King's authority given to me, neither he nor Villerois could do it. When I said that he gave vent to offensive language in French, whereat I retorted in my own tongue that he lied. Stung with rage, he clapped his hand upon a little dagger which he had; then I set my hand also to a large dirk which I always wore for my defence, and cried out: 'If you dare to draw, I'll kill you on the spot.' He had two servants to back him, and I had my two lads. For a moment or two Marmagna stood in doubt, not knowing exactly what to do, but rather inclined to mischief, and muttering: 'I will never put up with such insults.' Seeing then that the affair was taking a bad turn, I took a sudden resolution, and cried to Pagolo and Ascanio: 'When you see me draw my dirk, throw yourselves upon those serving-men, and kill them if you can; I mean to kill this fellow at the first stroke, and then we will decamp together, with God's grace.' Marmagna, when he understood my purpose, was glad enough to get alive out of the castle.

All these things, toning them down a trifle, I wrote to the Cardinal of Ferrara, who related them at once to the King. The King, deeply irritated, committed me to the care of another *279* officer of his bodyguard who was named Monsignor lo Iscontro d'Orbech. By him I was accommodated with all that I required in the most gracious way imaginable.

After fitting up my own lodgings in the castle and the workshop with all conveniences for carrying on my business, and putting my household upon a most respectable footing, I began at once to construct three models exactly of the size which the silver statues were to be. These were Jupiter, Vulcan, and Mars. I moulded them in clay, and set them well up on irons; then I went to the King, who disbursed three hundred pounds weight of silver, if I remember rightly, for the commencement of the undertaking. While I was getting these things ready, we brought the little vase and oval basin to completion, which had been several months in hand. Then I had them richly gilt, and they showed like the finest piece of plate which had been seen in France.

Afterwards I took them to the Cardinal, who thanked me greatly; and, without requesting my attendance, carried and presented them to the King. He was delighted with the gift, and *280* praised me as no artist was ever praised before. In return, he bestowed upon the Cardinal an abbey worth seven thousand crowns a year, and expressed his intention of rewarding me too. The Cardinal, however, prevented him, telling his Majesty that he was going ahead too fast, since I had as yet produced nothing for him. The King, who was exceedingly generous, replied: 'For that very reason will I put heart and hope into him.'

When I returned to Paris, the great favour shown me by the King made me a mark for all men's admiration. I received the silver and began my statue of Jupiter. Many journeymen were now in my employ; and the work went onward briskly day and night; so that, by the time I had finished the clay models of Jupiter, Vulcan, and Mars, and had begun to get the silver statue forward, my workshop made already a grand show.

The King now came to Paris, and I went to pay him my respects. No sooner had his Majesty set eyes upon me than he called me cheerfully, and asked if I had something fine to exhibit at my lodging, for he would come to inspect it. I related all I had been doing; upon which he was seized with a strong desire to come. Accordingly, after his dinner, he set off with Madame de Tampes, the Cardinal of Lorraine, and some other of his greatest nobles, among whom were the King of Navarre, his cousin, and the Queen, his sister; the Dauphin and Dauphiness also attended him; so that upon that day the very flower of the French court came to visit me. I had *281* been some time at home, and was hard at work. When the King arrived at the door of the castle, and heard our hammers going, he bade his company keep silence. Everybody in my house was busily employed, so that the unexpected entrance of his Majesty took me by surprise. The first thing he saw on coming into the great hall was myself with a huge plate of silver in my hand, which I was beating for the body of my Jupiter; one of my men was *282* finishing the head, another the legs; and it is easy to imagine what a din we made between us. It happened that a little French lad was working at my side, who had just been guilty of some trifling blunder. I gave the lad a kick, and, as my good luck would have it, caught him with my foot exactly in the fork between his legs, and sent him spinning several yards, so that he came stumbling up against the King precisely at the moment when his Majesty arrived. The King was vastly amused, but I felt covered with confusion. He began to ask me what I was engaged upon, and told me to go on working; then he said that he would much rather have me not employ my strength on manual labour, but take as many men as I wanted, and make them do the rough work; he should like me to keep myself in health, in order that he might enjoy my services through many years to come. I replied to his Majesty that the moment I left off working I should fall ill; also that my art itself would suffer, and not attain the mark I aimed at for his Majesty.

On the following day he sent for me at his dinner-hour. The Cardinal of Ferrara was there at meat with him. When I arrived, the King had reached his second course; he began at once to speak to me, saying, with a pleasant cheer, that having now so fine a basin and jug of my workmanship, he wanted an equally handsome salt-cellar to match them; and begged me to make a design, and to lose no time about it. I replied: 'Your Majesty shall see a model of the sort even sooner than you have commanded; for while I was making the basin, I thought there ought to be a salt-cellar to match it; therefore I have already designed one, and if it is your pleasure, I will at once exhibit my conception.' The King turned with a lively movement of

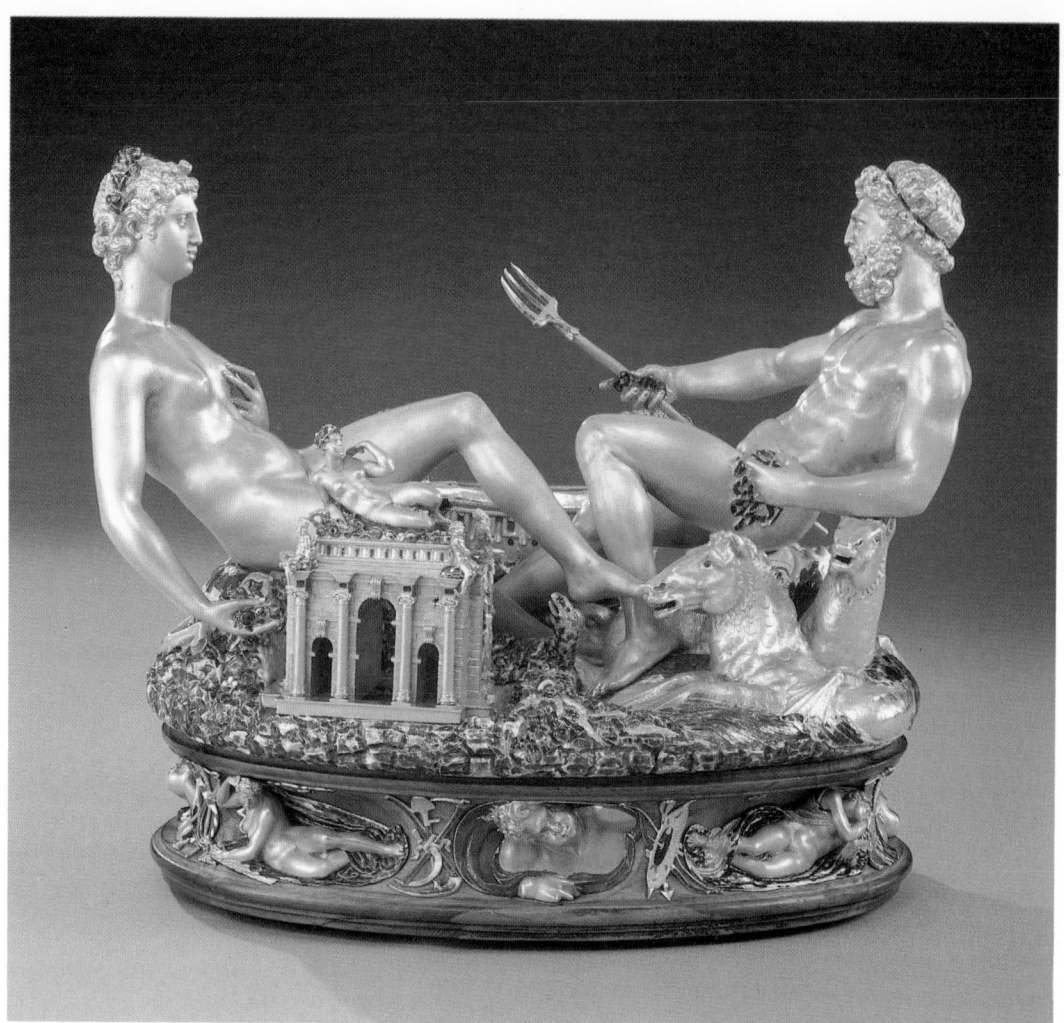

54, 55 *The Salt-Cellar of Francis I* by Cellini, 1540–3. Gold and enamel,
$10\frac{1}{4} \times 13$ ins (26 × 33cm). Vienna, Kunsthistorisches Museum

surprise and pleasure to the lords in his company – they were the King of Navarre, the Cardinal of Lorraine, and the Cardinal of Ferrara – exclaiming as he did so: 'Upon my word, this is a man to be loved and cherished by every one who knows him.' Then he told me that he would very gladly see my model.

283 I set off, and returned in a few minutes; for I had only to cross the river, that is, the Seine. I carried with me the wax model which I had made in Rome at the Cardinal of Ferrara's request. When I appeared again before the King and uncovered my piece, he cried out in astonishment: 'This is a hundred times more divine a thing than I had ever dreamed of. What a miracle of a man! He ought never to stop working.' Then he turned to me with a beaming countenance, and told me that he greatly liked the piece, and wished me to execute it in gold. The Cardinal of Ferrara looked me in the face, and let me understand that he recognized the model as the same which I had made for him in Rome. I replied that I had already told him I should carry it out for one who was worthy of it. The King rose from table, called me into his chamber, and asked how much gold was wanted for the salt-cellar. 'A thousand crowns,' I answered. He called his treasurer at once, who was the Viscount of Orbec, and ordered him that very day to disburse to me a thousand crowns of good weight and old gold.

On the morning which followed these events, I made the first step in my work upon the great salt-cellar, pressing this and my other pieces forward with incessant industry. My workpeople at this time, who were pretty numerous, included both sculptors and goldsmiths. They belonged to several nations, Italian, French, and German; for I took the best I could find,

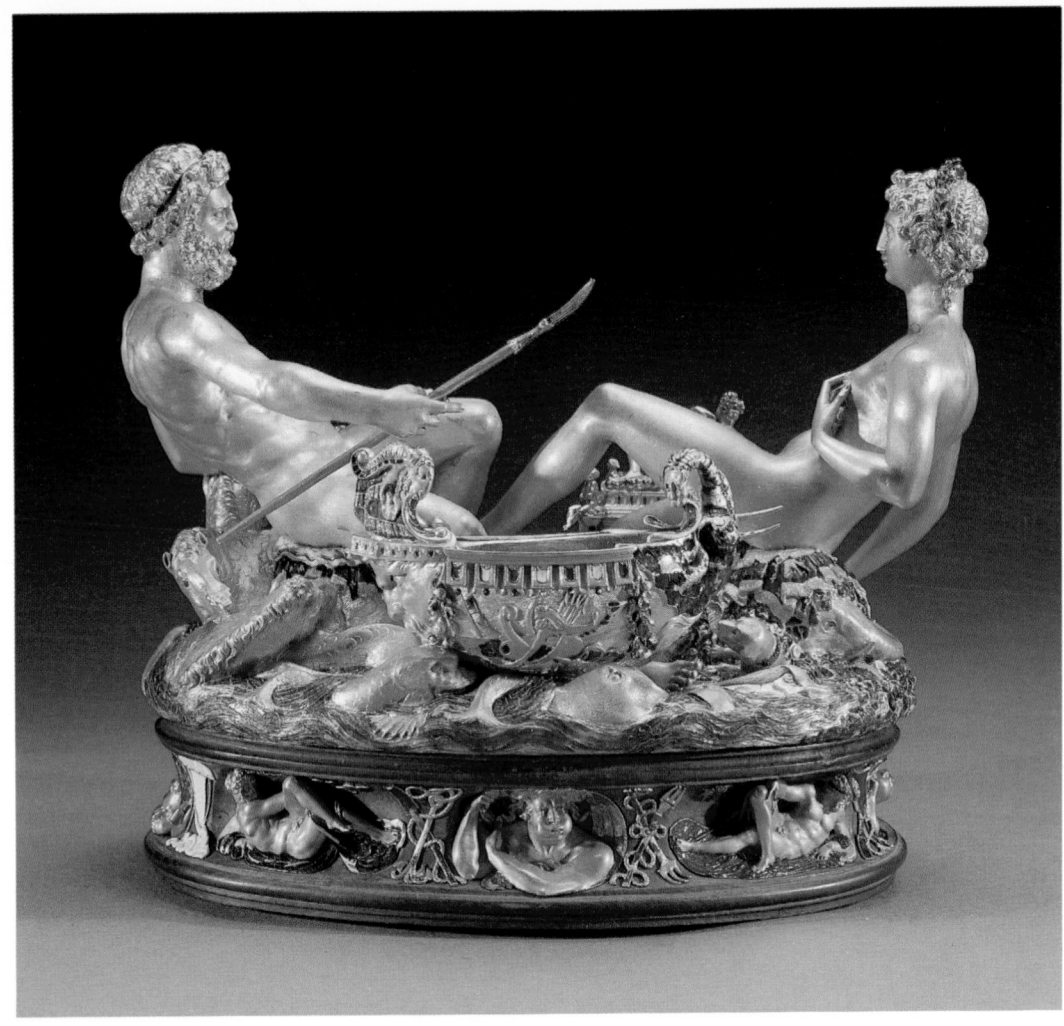

and changed them often, retaining only those who knew their business well. These select craftsmen I worked to the bone with perpetual labour. They wanted to rival me; but I had a better constitution. Consequently, in their inability to bear up against such a continuous strain, they took to eating and drinking copiously; some of the Germans in particular, who were more skilled than their comrades, and wanted to march apace with me, sank under these excesses, and perished.

While I was at work upon the Jupiter, I noticed that I had plenty of silver to spare. So I took in hand, without consulting the King, to make a great two-handled vase, about one cubit and a half in height. I also conceived the notion of casting the large model of my Jupiter in bronze. Having up to this date done nothing of the sort, I conferred with certain old men experienced in that art at Paris, and described to them the methods in use with us in Italy. They told me they had never gone that way about the business; but that if I gave them leave to act upon their own principles, they would bring the bronze out as clean and perfect as the clay. I chose to strike an agreement, throwing on them the responsibility, and promising several crowns above the price they bargained for. Thereupon they put the work in progress; but I soon saw that they were going the wrong way about it, and began on my own account a head of Julius Cæsar, bust and armour, much larger than the life, which I modelled from a reduced copy of a splendid antique portrait I had brought with me from Rome. I also undertook another head of the same size, studied from a very handsome girl, whom I kept for my own pleasures. I called this Fontainebleau, after the place selected by the King for his particular delight.

We constructed an admirable little furnace for the casting of the bronze, got all things ready, and baked our moulds; those French masters undertaking the Jupiter, while I looked after my two heads. Then I said: 'I do not think you will succeed with your Jupiter, because you have not provided sufficient vents beneath for the air to circulate; therefore you are but losing your time and trouble.' They replied that, if their work proved a failure, they would pay back the money I had given on account, and recoup me for current expenses; but they bade me give good heed to my own proceedings, for the fine heads I meant to cast in my Italian fashion would never succeed.

At this dispute between us there were present the treasurers and other gentlefolk commissioned by the King to superintend my proceedings. Everything which passed by word or act was duly reported to his Majesty. The two old men who had undertaken to cast my Jupiter postponed the experiment, saying they would like to arrange the moulds of my two heads. They argued that, according to my method, no success could be expected, and it was a pity to waste such fine moulds. When the King was informed of this, he sent word that they should give their minds to learning, and not try to teach their master.

So then they put their own piece into the furnace with much laughter; while I, maintaining a firm carriage, showing neither mirth nor anger (though I felt it), placed my two heads, one on each side of the Jupiter. The metal came all right to melting, and we let it in with joy and gladness; it filled the mould of the Jupiter most admirably, and at the same time my two heads. This furnished them with matter for rejoicing and me with satisfaction; for I was not sorry to have predicted wrongly of their work, and they made as though they were delighted to have been mistaken about mine. Then, as the custom in France is, they asked to drink, in high good spirits. I was very willing, and ordered a handsome collation for their entertainment. When this was over, they requested me to pay the money due to them and the surplus I had promised. I replied: 'You have been laughing over what, I fear, may make you weep. On reflection, it seems to me that too much metal flowed into your mould. Therefore I shall wait until to-morrow before I disburse more money.' The poor fellows swallowed my words and chewed the cud of them; then they went home without further argument.

At daybreak they began, quite quietly, to break into the pit of the furnace. They could not uncover their large mould until they had extracted my two heads; these were in excellent condition, and they placed them where they could be well seen. When they came to Jupiter, and had dug but scarcely two cubits, they set up such a yell, they and their four workmen, that it woke me up. Fancying it was a shout of triumph, I set off running, for my bedroom was at the distance of more than five hundred paces. On reaching the spot, I found them looking like the guardians of Christ's sepulchre in a picture, downcast and terrified. Casting a hasty glance upon my two heads, and seeing they were all right, I tempered my annoyance with the pleasure that sight gave me. Then they began to make excuses, crying: 'Our bad luck!' I retorted: 'Your luck has been most excellent, but what has been indeed bad is your deficiency of knowledge; had I only seen you put the soul into your mould, I could have taught you with one word how to cast the figure without fault. This would have brought me great honour and you much profit. I shall be able to make good my reputation; but you will now lose both your honour and your profit. Let then this lesson teach you another time to work, and not to poke fun at your masters.'

They prayed me to have pity on them, confessing I was right, but pleading that, unless I helped them, the costs they had to bear and the loss they had sustained would turn them and their families upon the streets a-begging. I answered that if the King's treasurers obliged them to pay according to their contract, I would defray the cost out of my own purse, because I saw that they had honestly and heartily performed their task according to their knowledge. This way of mine in dealing with them raised the good-will of the King's treasurers and other officers toward me to a pitch which cannot be described. The whole affair was written to his Majesty, who being without a paragon for generosity, gave directions that all I ordered in this matter should be done.

56 *Draped female figure*, drawing by Cellini, *c.* 1563. Pen and ink. Paris, Louvre (Cabinet des Dessins)

57 *Diana as goddess of fertility*, drawing by Cellini, 1563. Pen
and ink. Paris, Louvre (Cabinet des Dessins)

About this time the illustrious soldier Piero Strozzi arrived in France, and reminded the King *285*
that he had promised him letters of naturalization. These were accordingly made out; and at
the same time the King said: 'Let them be also given to Benvenuto, *mon ami*, and take them
immediately to his house, and let him have them without the payment of any fees.' Those of
the great Strozzi cost him several hundred ducats: mine were brought me by one of the King's
chief secretaries, Messer Antonio Massone. These letters of naturalization, together with the *286*
patent for the castle, I brought with me when I returned to Italy; wherever I go and wherever I
may end my days, I shall endeavour to preserve them. *287*

❧ ❧

I shall now proceed with the narration of my life. I had on hand the following works already
mentioned, namely, the silver Jupiter, the golden salt-cellar, the great silver vase, and the two
bronze heads. I also began to cast the pedestal for Jupiter, which I wrought very richly in
bronze, covered with ornaments, among which was a bas-relief, representing the rape of
Ganymede, and on the other side Leda and the Swan. On casting this piece it came out *288*
admirably. I also made another pedestal of the same sort for the statue of Juno, intending to
begin that too, if the King gave me silver for the purpose. By working briskly I had put *289*
together the silver Jupiter and the golden salt-cellar; the vase was far advanced; the two bronze
heads were finished. I had also made several little things for the Cardinal of Ferrara, and a small
silver vase of rich workmanship, which I meant to present to Madame d'Etampes. Several
Italian noblemen, to wit, Signor Piero Strozzi, the Count of Anguillara, the Count of
Pitigliano, the Count of Mirandola, and many others, gave me employment also. *290*

Madame d'Etampes told his Majesty he ought to commission me to execute something
beautiful for the decoration of his favourite residence. He answered on the instant: 'You say
well, and here upon the spot I will make up my mind what I mean him to do.' Then he turned
to me, and asked me what I thought would be appropriate for that beautiful fountain. I
suggested several ideas, and his Majesty expressed his own opinion. Afterwards he said that he
was going to spend fifteen or twenty days at San Germano del Aia, a place twelve leagues *291*
distant from Paris; during his absence he wished me to make a model for that fair fountain of
his in the richest style I could invent, seeing he delighted in that residence more than in
anything else in his whole realm. Accordingly he commanded and besought me to do my
utmost to produce something really beautiful; and I promised that I would do so. In addition
to the things I had begun, I now took the model of the fountain in hand, at which I worked
assiduously.

At the end of a month and a half the King returned to Paris; and I, who had been working
day and night, went to present myself before him, taking my models, so well blocked out that
my intention could be clearly understood. The first of these was intended for the door of the
palace at Fontainebleau. I had been obliged to make some alterations in the architecture of this
door, which was wide and low, in their vicious French style. The opening was very nearly
square, and above it was a hemicycle, flattened like the handle of a basket; here the King
wanted a figure placed to represent the genius of Fontainebleau. I corrected the proportions of
the doorway, and placed above it an exact half circle; at the sides I introduced projections, with
socles and cornices properly corresponding: then, instead of the columns demanded by this
disposition of parts, I fashioned two satyrs, one upon each side. The first of these was in
somewhat more than half-relief, lifting one hand to support the cornice, and holding a thick
club in the other; his face was fiery and menacing, instilling fear into the beholders. The other *292*
had the same posture of support; but I varied his features and some other details; in his hand,
for instance, he held a lash with three balls attached to chains. Though I call them satyrs, they
showed nothing of the satyr except little horns and a goatish head; all the rest of their form was
human. In the lunette above I placed a female figure lying in an attitude of noble grace; she *293*
rested her left arm on a stag's neck, this animal being one of the King's emblems. On one side I

58 *The Nymph of Fontainebleau* by Cellini, 1543. Bronze. Paris, Louvre

worked little fawns in half relief, with some wild boars and other game in lower relief; on the other side were hounds and divers dogs of the chase of several species, such as may be seen in that fair forest where the fountain springs. The whole of this composition was enclosed in an oblong, each angle of which contained a Victory in bas-relief, holding torches after the manner of the ancients. Above the oblong was a salamander, the King's particular device, with many other ornaments appropriate to the Ionic architecture of the whole design.

When the King had seen this model, it restored him to cheerfulness, and distracted his mind from the fatiguing debates he had been holding during the past two hours. Seeing him cheerful as I wished, I uncovered the other model, which he was far from expecting, since he not unreasonably judged that the first had work in it enough. This one was a little higher than two cubits; it figured a fountain shaped in a perfect square, with handsome steps all round, intersecting each other in a way which was unknown in France, and is indeed very uncommon in Italy. In the middle of the fountain I set a pedestal, projecting somewhat above the margin of the basin, and upon this a nude male figure, of the right proportion to the whole design, and of a very graceful form. In his right hand he raised a broken lance on high; his left hand rested on a scimitar; he was poised upon the left foot, the right being supported by a helmet of the richest imaginable workmanship. At each of the four angles of the fountain a figure was sitting, raised above the level of the base, and accompanied by many beautiful and appropriate emblems.

The King began by asking me what I meant to represent by the fine fancy I had embodied in this design, saying that he had understood the door without explanation, but that he could not take the conception of my fountain, although it seemed to him most beautiful; at the same time, he knew well that I was not like those foolish folk who turn out something with a kind of grace, but put no intention into their performances. I then addressed myself to the task of exposition; for having succeeded in pleasing him with my work, I wanted him to be no less pleased with my discourse. 'Let me inform your sacred Majesty,' I thus began, 'that the whole

of this model is so exactly made to scale, that, if it should come to be executed in the large, none of its grace and lightness will be sacrificed. The figure in the middle is meant to stand fifty-four feet above the level of the ground.' At this announcement the King made a sign of surprise. 'It is, moreover, intended to represent the god Mars. The other figures embody those arts and sciences in which your Majesty takes pleasure, and which you so generously patronize. This one, upon the right hand, is designed for Learning; you will observe that the accompanying emblems indicate Philosophy, and her attendant branches of knowledge. By the next I wished to personify the whole Art of Design, including Sculpture, Painting, and Architecture. The third is Music, which cannot be omitted from the sphere of intellectual culture. That other, with so gracious and benign a mien, stands for Generosity, lacking which the mental gifts bestowed on us by God will not be brought to view. I have attempted to portray your Majesty, your very self, in the great central statue; for you are truly a god Mars, the only brave upon this globe, and all your bravery you use with justice and with piety in the defence of your own glory.' Scarcely had he allowed me to finish this oration, when he broke forth with a strong voice: 'Verily I have found a man here after my own heart.' Then he called the treasurers who were appointed for my supplies, and told them to disburse whatever I required, let the cost be what it might. Next, he laid his hand upon my shoulder, saying: '*Mon ami* (which is the same as *my friend*), I know not whether the pleasure be greater for the prince who finds a man after his own heart, or for the artist who finds a prince willing to furnish him with means for carrying out his great ideas.' I answered that, if I was really the man his Majesty described, my good fortune was by far the greater. He answered laughingly: 'Let us agree, then, that our luck is equal!' Then I departed in the highest spirits, and went back to my work.

My ill-luck willed that I was not wide-awake enough to play the like comedy with Madame d'Etampes. That evening, when she heard the whole course of events from the King's own lips, it bred such poisonous fury in her breast that she exclaimed with anger: 'If Benvenuto had shown me those fine things of his, he would have given me some reason to be mindful of him at the proper moment.' The King sought to excuse me, but he made no impression on her temper. Being informed of what had passed, I waited fifteen days, during which they made a tour through Normandy, visiting Rouen and Dieppe; then, when they returned to St Germain-en-Laye, I took the handsome little vase which I had made at the request of Madame d'Etampes, hoping, if I gave it her, to recover the favour I had lost. With this in my hand, then, I announced my presence to her nurse, and showed the gift which I had brought her mistress; the woman received me with demonstrations of good-will, and said that she would speak a word to Madame, who was still engaged upon her toilette; I should be admitted on the instant, when she had discharged her embassy. The nurse made her report in full to Madame, who retorted scornfully: 'Tell him to wait.' On hearing this, I clothed myself with patience, which of all things I find the most difficult. Nevertheless, I kept myself under control until the hour for dinner was past. Then, seeing that time dragged on, and being maddened by hunger, I could no longer hold out, but flung off, sending her most devoutly to the devil.

I next betook myself to the Cardinal of Lorraine, and made him a present of the vase, only petitioning his Eminence to maintain me in the King's good graces. He said there was no need for this; and if there were need he would gladly speak for me. The King heard the whole history, and Madame d'Etampes was well laughed at in their company. This increased her animosity against me, and led to an attack upon my life, of which I speak in the proper time and place.

Far back in my autobiography I ought to have recorded the friendship which I won with the most cultivated, the most affectionate, and the most companionable man of worth I ever knew in this world. He was Messer Guido Guidi, an able physician and doctor of medicine, and a *296* nobleman of Florence. The infinite troubles brought upon me by my evil fortune caused me to omit the mention of him at an earlier date; and though my remembrance may be but a trifle, I deemed it sufficient to keep him always in my heart. Yet, finding that the drama of my life requires his presence, I shall introduce him here at the moment of my greatest trials, in order

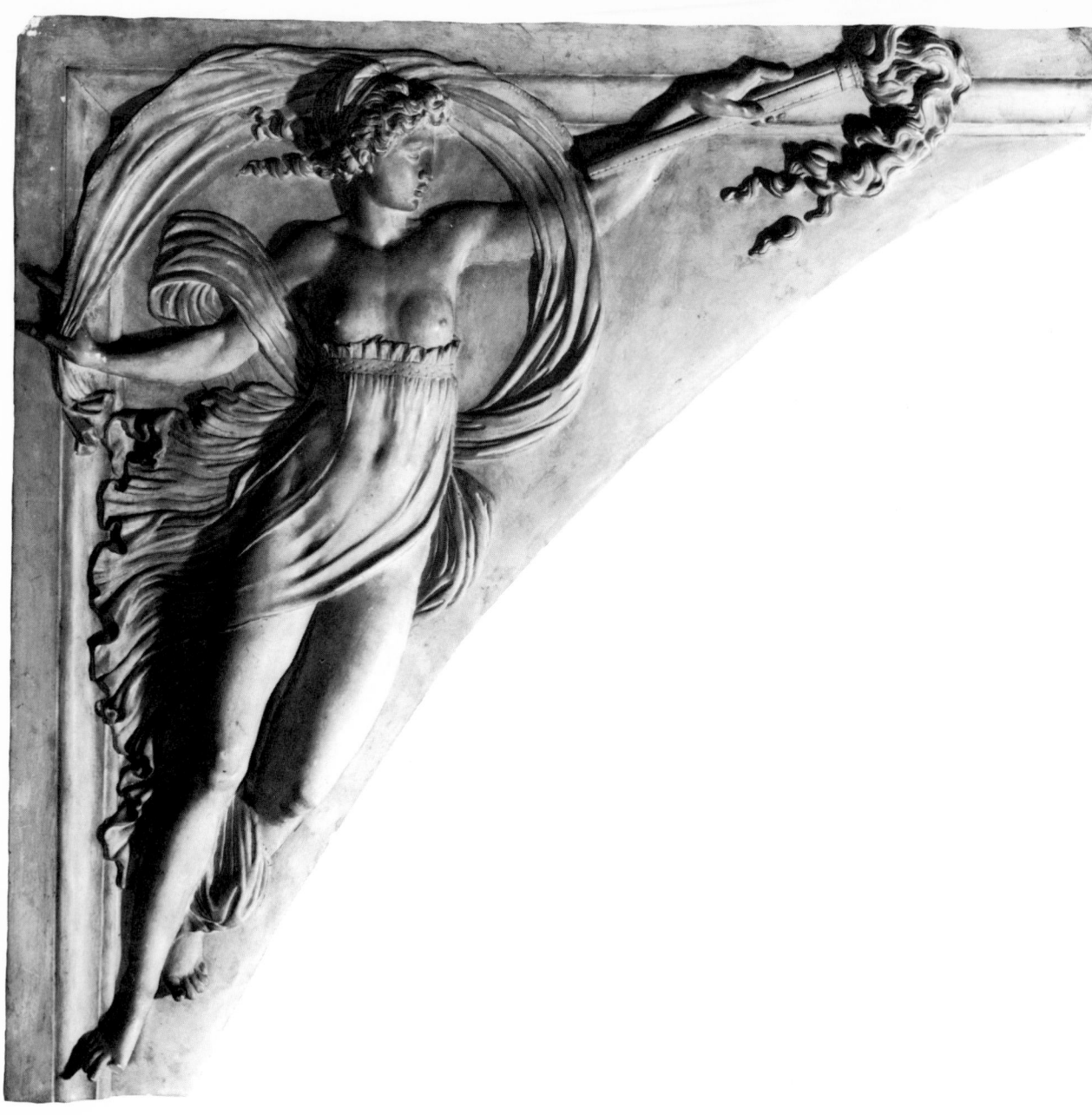

that, as he was then my comfort and support, I may now recall to memory the good he did me.

Well, then, Messer Guido came to Paris; and not long after making his acquaintance, I took him to my castle, and there assigned him his own suite of apartments. We enjoyed our lives together in that place for several years. The Bishop of Pavia, that is to say, Monsignore de' Rossi, brother of the Count of San Secondo, also arrived. This gentleman I removed from his hotel, and took him to my castle, assigning him in like manner his own suite of apartments, where he sojourned many months with serving-men and horses. On another occasion I lodged Messer Luigi Alamanni and his sons for some months. It was indeed God's grace to me that I should thus, in my poor station, be able to render services to men of great position and acquirements.

I had a tennis-court in my castle, from which I drew considerable profit. The building also contained some little dwellings inhabited by different sorts of men, among whom was a printer of books of much excellence in his own trade. Nearly the whole of his premises lay inside the castle, and he was the man who printed Messer Guido's first fine book on medicine. Wanting

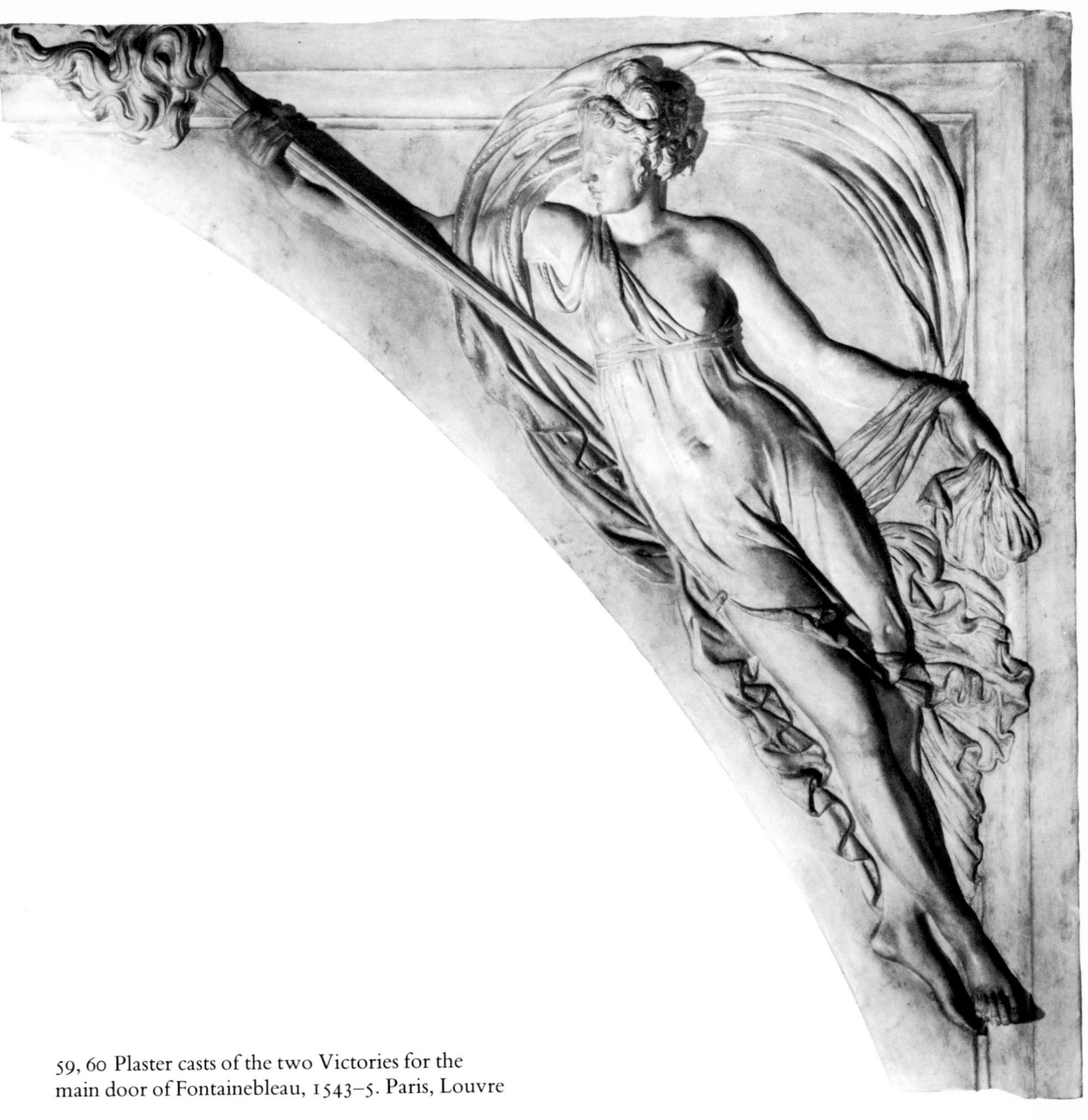

59, 60 Plaster casts of the two Victories for the
main door of Fontainebleau, 1543–5. Paris, Louvre

to make use of his lodging, I turned him out, but not without some trouble. There was also a
manufacturer of saltpetre; and when I wished to assign his apartments to some of my German
workmen, the fellow refused to leave the place. I asked him over and over again in gentle terms
to give me up my rooms, because I wanted to employ them for my workpeople in the service
of the King. The more moderately I spoke, the more arrogantly did the brute reply; till at last I
gave him three days' notice to quit. He laughed me in the face, and said that he would begin to
think of it at the end of three years. I had not then learned that he was under the protection of
Madame d'Etampes; but had it not been that the terms on which I stood toward that lady made
me a little more circumspect than I was wont to be, I should have ousted him at once; now,
however, I thought it best to keep my temper for three days. When the term was over, I said
nothing, but took Germans, Italians, and Frenchmen, bearing arms, and many hand-labourers
whom I had in my employ, and in a short while gutted all his house and flung his property
outside my castle. The man, dumbfounded and affrighted, got his furniture together as well as
he was able; then he ran off to Madame d'Etampes, and painted a picture of me like the very

61 Bedroom of the Duchesse d'Etampes at Fontainebleau, c. 1541–5,
decorated by Primaticcio

fiend. She being my great enemy, painted my portrait still blacker to the King, with all her
greater eloquence and all her greater weight of influence.

The rage of this vindictive woman kept continually on the increase. She sent for a painter
who was established at Fontainebleau, where the King resided nearly all his time. The painter
was an Italian and a Bolognese, known then as Il Bologna; his right name, however, was
Francesco Primaticcio. Madame d'Etampes advised him to beg that commission for the
fountain which his Majesty had given me, adding that she would support him with all her
ability; and upon this they agreed. Bologna was in an ecstasy of happiness, and thought himself
sure of the affair, although such things were not in his line of art. He was, however, an excellent
master of design, and had collected round him a troop of work-people formed in the school
of Rosso, our Florentine painter, who was undoubtedly an artist of extraordinary merit; his
own best qualities indeed were derived from the admirable manner of Rosso, who by this time
had died.

These ingenious arguments, and the weighty influence of Madame d'Etampes, prevailed
with the King; for they kept hammering at him night and day, Madame at one time, and
Bologna at another. What worked most upon his mind was that both of them combined to
speak as follows: 'How is it possible, sacred Majesty, that Benvenuto should accomplish the
twelve silver statues which you want? He has not finished one of them yet. If you employ him
on so great an undertaking, you will, of necessity, deprive yourself of those other things on

which your heart is set. A hundred of the ablest craftsmen could not complete so many great works as this one able man has taken in hand to do. One can see clearly that he has a passion for labour; but this ardent temper will be the cause of your Majesty's losing both him and his masterpieces at the same moment.' By insinuating these and other suggestions of the same sort at a favourable opportunity, the King consented to their petition; and yet Bologna had at this time produced neither designs nor models for the fountain.

It happened that just at this period an action was brought against me in Paris by the second lodger I had ousted from my castle, who pretended that on that occasion I had stolen a large quantity of his effects. This lawsuit tormented me beyond measure, and took up so much of my time that I often thought of decamping in despair from the country. Now the French are in the habit of making much capital out of any action they commence against a foreigner, or against such persons as they notice to be indolent in litigation. No sooner do they observe that they are getting some advantage in the suit, than they find the means to sell it; some have even been known to give a lawsuit in dowry with their daughters to men who make a business out of such transactions. They have another ugly custom, which is that the Normans, nearly all of them, traffic in false evidence; so that the men who buy up lawsuits, engage at once the services of four or six of these false witnesses, according to their need; their adversary, if he neglect to produce as many on the other side, being perhaps unacquainted with the custom, is certain to have the verdict given against him.

All this happened in my case, and thinking it a most disgraceful breach of justice, I made my appearance in the great hall of Paris, to defend my right. There I saw a judge, lieutenant for the King in civil causes, enthroned upon a high tribunal. He was tall, stout, and fat, and of an extremely severe countenance. All round him on each side stood a crowd of solicitors and advocates, ranged upon the right hand and the left. Others were coming, one by one, to explain their several causes to the judge. From time to time, too, I noticed that the attorneys at the side of the tribunal talked all at once: and much admiration was roused in me by that extraordinary man, the very image of Pluto, who listened with marked attention first to one and then to the other, answering each with learning and sagacity. I have always delighted in watching and experiencing every kind of skill; so I would not have lost this spectacle for much. It happened that the hall being very large, and filled with a multitude of folk, they were strict in excluding every one who had no business there, and kept the door shut with a guard to hold it. Sometimes the guardian, in his effort to prevent the entrance of some improper person, interrupted the judge by the great noise he made, and the judge in anger turned to chide him. This happened frequently, so that my attention was directed to the fact. On one occasion, when two gentlemen were pushing their way in as spectators, and the porter was opposing them with violence, the judge raised his voice, and spoke the following words precisely as I heard them: 'Keep peace, Satan, begone, and hold your tongue.' These words in the French tongue sound as follows: *Phe phe, Satan, phe phe, alé, phe!* Now I had learned the French tongue well; and on hearing this sentence, the meaning of that phrase used by Dante came into my memory, when he and his master Virgil entered the doors of Hell. Dante and the painter Giotto were together in France, and particularly in the city of Paris, where, owing to the circumstances I have just described, the hall of justice may be truly called a hell. Dante then, who also understood French well, made use of the phrase in question, and it has struck me as singular that this interpretation has never yet been put upon the passage; indeed, it confirms my opinion that the commentators make him say things which never came into his head.

Well, then, to return to my affairs. When certain decisions of the court were sent me by those lawyers, and I perceived that my cause had been unjustly lost, I had recourse for my defence to a great dagger which I carried; for I have always taken pleasure in keeping fine weapons. The first man I attacked was the plaintiff who had sued me; and one evening I wounded him in the legs and arms so severely, taking care, however, not to kill him, that I deprived him of the use of both his legs. Then I sought out the other fellow who had bought the suit, and used him also in such wise that he dropped it.

302
303

Returning thanks to God for this and every other dispensation, and hoping to be left awhile without worries, I bade the young men of my household, especially the Italians, for God's sake to attend each diligently to the work I set him, and to help me till such time as I could finish the things I had in hand. I thought they might soon be completed, and then I meant to return to Italy, being no longer able to put up with the rogueries of those Frenchmen; the good King too, if he once grew angry, might bring me into mischief for many of my acts in self-defence. I will describe who these Italians were; the first, and the one I liked best, was Ascanio, from Tagliacozzo in the kingdom of Naples; the second was Pagolo, a Roman of such humble origin that he did not know his own father. These were the two men who had been with me in Rome, and whom I had taken with me on the journey. Another Roman had also come on purpose to enter my service; he too bore the name of Pagolo, and was the son of a poor nobleman of the family of the Macaroni; he had small acquirements in our art, but was an excellent and courageous swordsman. I had another from Ferrara called Bartolommeo Chioccia. There was also another from Florence named Pagolo Micceri; his brother, nicknamed 'Il Gatta', was a clever clerk but had spent too much money in managing the property of Tommaso Guadagni, a very wealthy merchant. This Gatta put in order for me the books in which I wrote the accounts of his most Christian Majesty and my other employers. Now Pagolo Micceri, having learned how to keep them from his brother, went on doing this work for me in return for a liberal salary. He appeared, so far as I could judge, to be a very honest lad, for I noticed him to be devout, and when I heard him sometimes muttering psalms, and sometimes telling his beads, I reckoned much upon his feigned virtue.

304

Accordingly I called the fellow apart and said to him, 'Pagolo, my dearest brother, you know what a good place you have with me, and how you had formerly nothing to depend on; besides, you are a Florentine. I have also the greater confidence in you because I observe that you are pious and religious, which is a thing that pleases me. I beg you therefore to assist me, for I cannot put the same trust in any of your companions: so then I shall ask you to keep watch over two matters of the highest importance, which might prove a source of much annoyance to me. In the first place, I want you to guard my property from being stolen, and not touch it yourself. In the next place, you know that poor young girl, Caterina; I keep her principally for my art's sake, since I cannot do without a model; but being a man also, I have used her for my pleasures, and it is possible that she may bear me a child. Now I do not want to maintain another man's bastards, nor will I sit down under such an insult. If any one in this house had the audacity to attempt anything of the sort, and I were to become aware of it, I verily believe that I should kill both her and him. Accordingly, dear brother, I entreat you to be my helper; should you notice anything, tell it me at once; for I am sure to send her and her mother and her fellow to the gallows. Be you the first upon your watch against falling into this snare.' The rascal made a sign of the cross from his head to his feet and cried out: 'O blessed Jesus! God preserve me from ever thinking of such a thing! In the first place, I am not given to those evil ways; in the next place, do you imagine I am ignorant of your great benefits toward me?' When I heard these words, which he uttered with appearance of simplicity and affection for me, I believed that matters stood precisely as he asserted.

305

Two days after this conversation, M. Mattio del Nazaro took the occasion of some feast-day to invite me and my workpeople to an entertainment in a garden. He was an Italian in the King's service, and practised the same art as we did with remarkable ability. I got myself in readiness, and told Pagolo that he might go abroad too and amuse himself with us; the annoyances arising from that lawsuit being, as I judged, now settled down. The young man replied in these words: 'Upon my word, it would be a great mistake to leave the house so unprotected. Only look how much of gold, silver, and jewels you have here. Living as we do in a city of thieves, we ought to be upon our guard by day and night. I will spend the time in religious exercises, while I keep watch over the premises. Go then with mind at rest to take your pleasure and divert your spirits. Some other day another man will take my place as guardian here.'

Thinking that I could go off with a quiet mind, I took Pagolo, Ascanio, and Chioccia to the garden, where we spent a large portion of the day agreeably. Toward the middle of the afternoon, however, when it began to draw toward sundown, a suspicion came into my head, and I recollected the words which that traitor had spoken with his feigned simplicity. So I mounted my horse, and with two servants to attend me, returned to the castle, where I all but caught Pagolo and that little wretch Caterina *in flagrante*. No sooner had I reached the place, than that French bawd, her mother, screamed out: 'Pagolo! Caterina! here is the master!' When I saw the pair advancing, overcome with fright, their clothes in disorder, not knowing what they said, nor, like people in a trance, where they were going, it was only too easy to guess what they had been about. The sight drowned reason in rage, and I drew my sword, resolved to kill them both. The man took to his heels; the girl flung herself upon her knees, and shrieked to Heaven for mercy. In my first fury I wanted to strike at the male; but before I had the time to catch him up, second thoughts arose which made me think it would be best for me to drive them both away together. I had so many acts of violence upon my hands, that if I killed him I could hardly hope to save my life. I said then to Pagolo: 'Had I seen with my own eyes, scoundrel, what your behaviour and appearance force me to believe, I should have run you with this sword here ten times through the guts. Get out of my sight; and if you say a Paternoster, let it be San Giuliano's.' Then I drove the whole lot forth, mother and daughter, *306* lamming into them with fist and foot. They made their minds up to have the law of me, and consulted a Norman advocate, who advised them to declare that I had used the girl after the Italian fashion; what this meant I need hardly explain. The man argued: 'At the very least, *307* when this Italian hears what you are after, he will pay down several hundred ducats, knowing how great the danger is, and how heavily that offence is punished in France.' Upon this they were agreed. The accusation was brought against me, and I received a summons from the court.

When we appeared before the judges for criminal affairs, I found Caterina and her mother waiting; and on the moment of my arrival, the two women were laughing with their advocate. I pushed my way in, and called boldly for the judge, who was seated, blown out big and fat, upon a tribunal high above the rest. On catching sight of me he threatened with his head, and spoke in a subdued voice: 'Although your name is Benvenuto, this time you are an ill-comer.' I understood his speech, and called out the second time: 'Despatch my business quickly. Tell me what I have come to do here.' Then the judge turned to Caterina, and said: 'Caterina, relate all that happened between you and Benvenuto.' She answered that I had used her after the Italian fashion. The judge turned to me and said: 'You hear what Caterina deposes, Benvenuto.' I replied: 'If I have consorted with her after the Italian fashion, I have only done the same as you folk of other nations do.' He demurred: 'She means that you improperly abused her.' I retorted that, so far from being the Italian fashion, it must be some French habit, seeing she knew all about it, while I was ignorant; and I commanded her to explain precisely how I had consorted with her. Then the impudent baggage entered into plain and circumstantial details regarding all the filth she lyingly accused me of. I made her repeat her deposition three times in succession. When she had finished, I cried out with a loud voice: 'Lord judge, lieutenant of the Most Christian King, I call on you for justice. Well I know that by the laws of his Most Christian Majesty both agent and patient in this kind of crime are punished with the stake. The woman confesses her guilt; I admit nothing whatsoever of the sort with regard to her; her go-between of a mother is here, who deserves to be burned for either one or the other offence. Therefore I appeal to you for justice.' These words I repeated over and over again at the top of my voice, continually calling out: 'To the stake with her and her mother!' I also threatened the judge that, if he did not send her to prison there before me, I would go to the King at once, and tell him how his lieutenant in criminal affairs of justice had wronged me. When they heard what a tumult I was making, my adversaries lowered their voices, but I lifted mine the more. The little hussy and her mother fell to weeping, while I shouted to the judge: 'Fire, fire! to the stake with them!' The coward on the bench, finding

that the matter was not going as he intended, began to use soft words and excuse the weakness of the female sex. Thereupon I felt that I had won the victory in a nasty encounter; and, muttering threats between my teeth, I took myself off, not without great inward satisfaction. Indeed, I would gladly have paid five hundred crowns down to have avoided that appearance in court. However, after escaping from the tempest, I thanked God with all my heart, and returned in gladness with my young men to the castle.

I went to Fontainebleau to consult with the King; for he had written me a letter saying he wanted me to stamp the coins of his whole realm, and enclosing some little drawings to explain his wishes in the matter; at the same time he left me free to execute them as I liked; upon which I made new designs according to my own conception, and according to the ideal of art. When I reached Fontainebleau, one of the treasurers commissioned by the King to defray my expenses (he was called Monsignor della Fa) addressed me in these words: 'Benvenuto, the painter Bologna has obtained commission from the King to execute your great Colossus, and all the orders previously given as on your behalf have been transferred to him. We are all indignant; and it seems to us that that countryman of yours has acted towards you in a most unwarrantable manner. The work was assigned you on the strength of your models and studies. He is robbing you of it, only through the favour of Madame d'Etampes; and though several months have passed since he received the order, he has not yet made any sign of commencing it.'

When I felt how greatly and how wrongfully I had been betrayed, and saw a work which I had gained with my great toil thus stolen from me, I made my mind up for a serious stroke of business, and marched off with my good sword at my side to find Bologna. He was in his room, engaged in studies; after telling the servant to introduce me, he greeted me with some of his Lombard compliments, and asked what good business had brought me hither. I replied: 'A most excellent business, and one of great importance.' He then sent for wine, and said: 'Before we begin to talk, we must drink together, for such is the French custom.' I answered: 'Messer Francesco, you must know that the conversation we have to engage in does not call for drinking at the commencement; after it is over, perhaps we shall be glad to take a glass.' Then I opened the matter in this way: 'All men who wish to pass for persons of worth allow it to be seen that they are so by their actions; if they do the contrary, they lose the name of honest men. I am aware that you knew the King had commissioned me with that great Colossus; it had been talked of these eighteen months past; yet neither you nor anybody else came forward to speak a word about it. By my great labours I made myself known to his Majesty, who approved of my models and gave the work into my hands. During many months I have heard nothing to the contrary; only this morning I was informed that you have got hold of it, and have filched it from me. I earned it by the talents I displayed, and you are robbing me of it merely by your idle talking.'

To this speech Bologna answered: 'O Benvenuto! all men try to push their affairs in every way they can. If this is the King's will, what have you to say against it? You would only throw away your time, because I have it now, and it is mine. Now tell me what you choose, and I will listen to you.' I replied: 'I should like you to know, Messer Francesco, that I could say much which would prove irrefragably, and make you admit, that such ways of acting as you have described and used are not in vogue among rational animals. I will, however, come quickly to the point at issue; give close attention to my meaning, because the affair is serious.' He made as though he would rise from the chair on which he was sitting, since he saw my colour heightened and my features greatly discomposed. I told him that the time had not yet come for moving; he had better sit and listen to me. Then I recommenced: 'Messer Francesco, you know that I first received the work, and that the time has long gone by during which my right could be reasonably disputed by any one. Now I tell you that I shall be satisfied if you will make a model, while I make another in addition to the one I have already shown. Then we will take them without any clamour to our great King; and whosoever in this way shall have gained the credit of the best design will justly have deserved the commission. If it falls to you, I will dismiss

from my mind the memory of the great injury you have done me, and will bless your hands, as being worthier than mine of so glorious a performance. Let us abide by this agreement, and we shall be friends; otherwise we must be enemies; and God, who always helps the right, and I, who know how to assert it, will show you to what extent you have done wrong.' Messer Francesco answered: 'The work is mine, and since it has been given me, I do not choose to put what is my own to hazard.' To this I retorted: 'Messer Francesco, if you will not take the right course which is just and reasonable, I will show you another which shall be like your own, that is to say, ugly and disagreeable. I tell you plainly that if I ever hear that you have spoken one single word about this work of mine, I will kill you like a dog. We are neither in Rome, nor in Bologna, nor in Florence; here one lives in quite a different fashion; if then it comes to my ears that you talk about this to the King or anybody else, I vow that I will kill you. Reflect upon the way you mean to take, whether that for good which I formerly described, or this latter bad one I have just now set before you.'

The man did not know what to say or do, and I was inclined to cut the matter short upon the spot rather than to postpone action. Bologna found no other words than these to utter: 'If I act like a man of honesty, I shall stand in no fear.' I replied: 'You have spoken well, but if you act otherwise, you will have to fear, because the affair is serious.' Upon this I left him, and betook myself to the King. With his Majesty I disputed some time about the fashion of his coinage.

The King had now returned to Paris; and when I paid him my respects, I took the salt-cellar with me. As I have already related, it was oval in form, standing about two-thirds of a cubit, wrought of solid gold, and worked entirely with the chisel. While speaking of the model, I said before how I had represented Sea and Earth, seated, with their legs interlaced, as we observe in the case of firths and promontories; this attitude was therefore metaphorically appropriate. The Sea carried a trident in his right hand, and in his left I put a ship of delicate workmanship to hold the salt. Below him were his four sea-horses, fashioned like our horses from the head to the front hoofs; all the rest of their body, from the middle backwards, resembled a fish, and the tails of these creatures were agreeably interwoven. Above this group the Sea sat throned in an attitude of pride and dignity; around him were many kinds of fishes and other creatures of the ocean. The water was represented with its waves, and enamelled in the appropriate colour. I had portrayed earth under the form of a very handsome woman, holding her horn of plenty, entirely nude like the male figure; in her left hand I placed a little temple of Ionic architecture, most delicately wrought, which was meant to contain the pepper. Beneath her were the handsomest living creatures which the earth produces; and the rocks were partly enamelled, partly left in gold. The whole piece reposed upon a base of ebony, properly proportioned, but with a projecting cornice, upon which I introduced four golden figures in rather more than half-relief. They represented Night, Day, Twilight, and Dawn. I put, moreover, into the same frieze four other figures, similar in size, and intended for the four chief winds; these were executed, and in part enamelled, with the most exquisite refinement. *310*

When I exhibited this piece to his Majesty, he uttered a loud outcry of astonishment, and could not satiate his eyes with gazing at it. Then he bade me take it back to my house, saying he would tell me at the proper time what I should have to do with it. So I carried it home, and sent at once to invite several of my best friends; we dined gaily together, placing the salt-cellar in the middle of the table, and thus we were the first to use it. After this, I went on working at my Jupiter in silver, and also at the great vase I have already described, which was richly decorated with a variety of ornaments and figures.

At that time Bologna, the painter, suggested to the King that it would be well if his Majesty sent him to Rome, with letters of recommendation, to the end that he might cast the foremost masterpieces of antiquity, namely, the Laocoon, the Cleopatra, the Venus, the Commodus, the Zingara, and the Apollo. These, of a truth, are by far the finest things in Rome. He told the *311* King that when his Majesty had once set eyes upon those marvellous works, he would then, and not till then, be able to criticize the arts of design, since everything which he had seen by us moderns was far removed from the perfection of the ancients. The King accepted his proposal,

and gave him the introductions he required. Accordingly that beast went off, and took his bad luck with him. Not having the force and courage to contend with his own hands against me, he adopted the truly Lombard device of depreciating my performances by becoming a copyist of antiques. In its own proper place I shall relate how, though he had these statues excellently cast, he obtained a result quite contrary to his imagination.

I had now done for ever with that disreputable Caterina, and the unfortunate Pagolo Micceri had decamped from Paris. Wanting then to finish off my Fontainebleau, which was already cast in bronze, as well as to execute the two Victories which were going to fill the angles above the lunette of the door, I engaged a poor girl of the age of about fifteen. She was beautifully made and of a brunette complexion. Being somewhat savage in her ways and spare of speech, quick in movement, with a look of sullenness about her eyes, I nicknamed her *312* Scorzone; her real name was Jeanne. With her for model, I gave perfect finish to the bronze Fontainebleau, and also to the two Victories.

Now this girl was a clean maid, and I got her with child. She gave birth to a daughter on the 7th of June, at thirteen hours of the day, in 1544, when I had exactly reached the age of forty-four. I named the infant Constanza; and M. Guido Guidi, the King's physician, and my most intimate friend, as I have previously related, held her at the font. He was the only godfather; for it is customary in France to have but one godfather and two godmothers. One of the latter *313* was Madame Maddalena, wife to M. Luigi Alamanni, a gentleman of Florence and an accomplished poet. The other was the wife of M. Ricciardo del Bene, our Florentine burgher, *314* and a great merchant in Paris; she was herself a French lady of distinguished family. This was the first child I ever had, so far as I remember. I settled money enough upon the girl for dowry to satisfy an aunt of hers, under whose tutelage I placed her, and from that time forwards I had nothing more to do with her.

The day after his arrival in Paris, the King, without solicitation upon my part, came of his own accord to my house. I went to meet him, and conducted him through several rooms where divers works of art were on view. Beginning with the less important, I pointed out a quantity of things in bronze; and it was long since he had seen so many at once. Then I took him to see the Jupiter in silver, now nearly completed, with all its splendid decorations. It so happened that a grievous disappointment which he had suffered a few years earlier, made him think this piece more admirable than it might perhaps have appeared to any other man. The occasion to *315* which I refer was this: After the capture of Tunis, the Emperor passed through Paris with the consent of his brother-in-law, King Francis, who wanted to present him with something *316* worthy of so great a potentate. Having this in view, he ordered a Hercules to be executed in silver, exactly of the same size as my Jupiter. The King declared this Hercules to be the ugliest work of art that he had ever seen, and spoke his opinion plainly to the craftsmen of Paris. At the last, just when he was taking leave, I pointed out upon the lawn of the castle that great giant, which roused him to higher astonishment than any of the other things he had inspected.

In the meantime I brought my silver Jupiter to completion, together with its gilded pedestal, which I placed upon a wooden plinth that only showed a very little; upon the plinth I introduced four little round balls of hard wood, more than half hidden in their sockets, like the nut of a crossbow. They were so nicely arranged that a child could push the statue forwards and backwards, or turn it round with ease. Having arranged it thus to my mind, I went with it to Fontainebleau, where the King was then residing.

At that time, Bologna, of whom I have already said so much, had brought from Rome his statues, and had cast them very carefully in bronze. I knew nothing about this, partly because he kept his doings very dark, and also because Fontainebleau is forty miles distant from Paris. On asking the King where he wanted me to set up my Jupiter, Madame d'Etampes, who happened to be present, told him there was no place more appropriate than his own handsome *317* gallery. This was, as we should say in Tuscany, a loggia, or, more exactly, a large lobby; it ought indeed to be called a lobby, because what we mean by loggia is open at one side. The hall was considerably longer than 100 paces, decorated, and very rich with pictures from the hand

of that admirable Rosso, our Florentine master. Among the pictures were arranged a great variety of sculptured works, partly in the round, and partly in bas-relief. The breadth was about twelve paces. Now Bologna had brought all his antiques into this gallery, wrought with great beauty in bronze, and had placed them in a handsome row upon their pedestals; and they were, as I have said, the choicest of the Roman antiquities. Into this same gallery I took my Jupiter; and when I saw that grand parade, so artfully planned, I said to myself: 'This is like running the gauntlet; now may God assist me'. I placed the statue, and having arranged it as well as I was able, waited for the coming of the King. The Jupiter was raising his thunderbolt with the right hand in the act to hurl it; his left hand held the globe of the world. Among the flames of the thunderbolt I had very cleverly introduced a torch of white wax. Now Madame d'Etampes detained the King till nightfall, wishing to do one of two mischiefs, either to prevent his coming, or else to spoil the effect of my work by its being shown off after dark; but as God has promised to those who trust in Him, it turned out exactly opposite to her calculations; for when night came, I set fire to the torch, which, standing higher than the head of Jupiter, shed light from above and showed the statue far better than by daytime.

62 Gallery of King Francis I at Fontainebleau, 1533–40, originally decorated by Rosso Fiorentino and Primaticcio and later repainted

318
319

At length the King arrived; he was attended by his Madame d'Etampes, his son the Dauphin and the Dauphiness, together with the King of Navarre his brother-in-law, Madame Marguerite his daughter, and several other great lords, who had been instructed by Madame d'Etampes to speak against me. When the King appeared, I made my prentice Ascanio push the Jupiter toward his Majesty. As it moved smoothly forwards, my cunning in its turn was amply rewarded, for this gentle motion made the figure seem alive; the antiques were left in the background, and my work was the first to take the eye with pleasure. The King exclaimed at once: 'This is by far the finest thing that has ever been seen; and I, although I am an amateur and judge of art, could never have conceived the hundredth part of its beauty.' The lords whose cue it was to speak against me, now seemed as though they could not praise my masterpiece enough. Madame d'Etampes said boldly: 'One would think you had no eyes! Don't you see all those fine bronzes from the antique behind there? In those consists the real distinction of this art, and not in that modern trumpery.' Then the King advanced, and the others with him. After casting a glance at the bronzes, which were not shown to advantage from the light being below them, he exclaimed: 'Whoever wanted to injure this man has done him a great service; for the comparison of these admirable statues demonstrates the immeasurable superiority of his work in beauty and in art. Benvenuto deserves to be made much of, for his

320

performances do not merely rival, but surpass the antique.' In reply to this, Madame d'Etampes observed that my Jupiter would not make anything like so fine a show by daylight; besides, one had to consider that I had put a veil upon my statue to conceal its faults. I had indeed flung a gauze veil with elegance and delicacy over a portion of my statue, with the view of augmenting its majesty. This, when she had finished speaking, I lifted from beneath, uncovering the handsome genital members of the god; then tore the veil to pieces with vexation. She imagined I had disclosed those parts of the statue to insult her. The King noticed how angry she was, while I was trying to force some words out in my fury; so he wisely spoke, in his own language, precisely as follows: 'Benvenuto, I forbid you to speak; hold your tongue, and you shall have a thousand times more wealth than you desire.' Not being allowed to speak, I writhed my body in a rage; this made her grumble with redoubled spite; and the King departed sooner that he would otherwise have done, calling aloud, however, to encourage me: 'I have brought from Italy the greatest man who ever lived, endowed with all the talents.'

I left the Jupiter there, meaning to depart the next morning. Before I took horse, one thousand crowns were paid me, partly for my salary, and partly on account of monies I had disbursed. Having received this sum, I returned with a light heart and satisfied to Paris. No sooner had I reached home and dined with merry cheer, than I called for all my wardrobe, which included a great many suits of silk, choice furs, and also very fine cloth stuffs. From these I selected presents for my workpeople, giving each something according to his desert, down to the servant-girls and stable-boys, in order to encourage them to aid me heartily.

Being then refreshed in strength and spirits, I attacked the great statue of Mars, which I had set up solidly upon a frame of well-connected woodwork. Over this there lay a crust of plaster, about the eighth of a cubit in thickness, carefully modelled for the flesh of the Colossus. Lastly, I prepared a great number of moulds in separate pieces to compose the figure, intending to dovetail them together in accordance with the rules of art; and this task involved no difficulty.

I will not here omit to relate something which may serve to give a notion of the size of this great work, and is at the same time highly comic. It must first be mentioned that I had forbidden all the men who lived at my cost to bring light women into my house or anywhere within the castle precincts. Upon this point of discipline I was extremely strict. Now my lad Ascanio loved a very handsome girl, who returned his passion. One day she gave her mother the slip, and came to see Ascanio at night. Finding that she would not take her leave, and being driven to his wits' ends to conceal her, like a person of resources, he hit at last upon the plan of installing her inside the statue. There, in the head itself, he made her up a place to sleep in; this lodging she occupied some time, and he used to bring her forth at whiles with secrecy by night. I meanwhile having brought this part of the Colossus almost to completion, left it alone, and

indulged my vanity a bit by exposing it to sight; it could, indeed, be seen by more than half Paris. The neighbours, therefore, took to climbing their house-roofs, and crowds came on purpose to enjoy the spectacle. Now there was a legend in the city that my castle had from olden times been haunted by a spirit, though I never noticed anything to confirm this belief; and folk in Paris called it popularly by the name of Lemmonio Boreò. The girl, while she sojourned in the statue's head, could not prevent some of her movements to and fro from being perceptible through its eye-holes; this made stupid people say that the ghost had got into the body of the figure, and was setting its eyes in motion, and its mouth, as though it were about to talk. Many of them went away in terror; others, more incredulous, came to observe the phenomenon, and when they were unable to deny the flashing of the statue's eyes, they too declared their credence in a spirit – not guessing that there was a spirit there, and sound young flesh to boot.

All this while I was engaged in putting my door together, with its several appurtenances. As it is no part of my purpose to include in this autobiography such things as annalists record, I have omitted the coming of the Emperor with his great host, and the King's mustering of his whole army. At the time when these events took place, his Majesty sought my advice with regard to the instantaneous fortification of Paris. He came on purpose to my house, and took me all round the city; and when he found that I was prepared to fortify the town with expedition on a sound plan, he gave express orders that all my suggestions should be carried out. His Admiral was directed to command the citizens to obey me under pain of his displeasure.

Now the Admiral had been appointed through Madame d'Etampes' influence rather than from any proof of his ability, for he was a man of little talent. He bore the name of M. d'Annebault, which in our tongue is Monsignor d'Aniballe; but the French pronounce it so that they usually made it sound like Monsignore Asino Bue. This animal then referred to Madame d'Etampes for advice upon the matter, and she ordered him to summon Girolamo Bellarmato without loss of time. He was an engineer from Siena, at that time in Dieppe, which is rather more than a day's journey distant from the capital. He came at once, and set the work of fortification going on a very tedious method, which made me throw the job up. If the Emperor had pushed forward at this time, he might easily have taken Paris.

One morning I went to his Majesty and no sooner had he caught sight of me, than he swore it was his intention to come to me upon the spot. Going then, according to his wont, to take leave of his dear Madame d'Etampes, this lady saw that all her influence had not been able to divert him from his purpose; so she began with that biting tongue of hers to say the worst of me that could be insinuated against a deadly enemy of this most worthy crown of France. The good King appeased her by replying that the sole object of his visit was to administer such a scolding as should make me tremble in my shoes. This he swore to do upon his honour. Then he came to my house, and I conducted him through certain rooms upon the basement, where I had put the whole of my great door together. Upon beholding it, the King was struck with stupefaction, and quite lost his cue for reprimanding me, as he had promised Madame d'Etampes. Still he did not choose to go away without finding some opportunity for scolding; so he began in this wise: 'There is one most important matter, Benvenuto, which men of your sort, though full of talent, ought always to bear in mind; it is that you cannot bring your great gifts to light by your own strength alone; you show your greatness only through the opportunities we give you. Now you ought to be a little more submissive, not so arrogant and headstrong. I remember that I gave you express orders to make me twelve silver statues; and this was all I wanted. You have chosen to execute a salt-cellar, and vases and busts and doors, and a heap of other things, which quite confound me, when I consider how you have neglected my wishes and worked for the fulfilment of your own. If you mean to go on in this way, I shall presently let you understand what is my own method of procedure when I choose to have things done in my own way. I tell you, therefore, plainly: do your utmost to obey my commands; for if you stick to your own fancies, you will run your head against a wall.'

63 *The Masquerade at Persepolis*, drawing by Primaticcio for the bedroom of the Duchesse d'Etampes, 1541–5. Pen, brown ink, wash and chalk, 100 × 120 ins (255 × 305 cm). Paris, Louvre (Cabinet des Dessins)

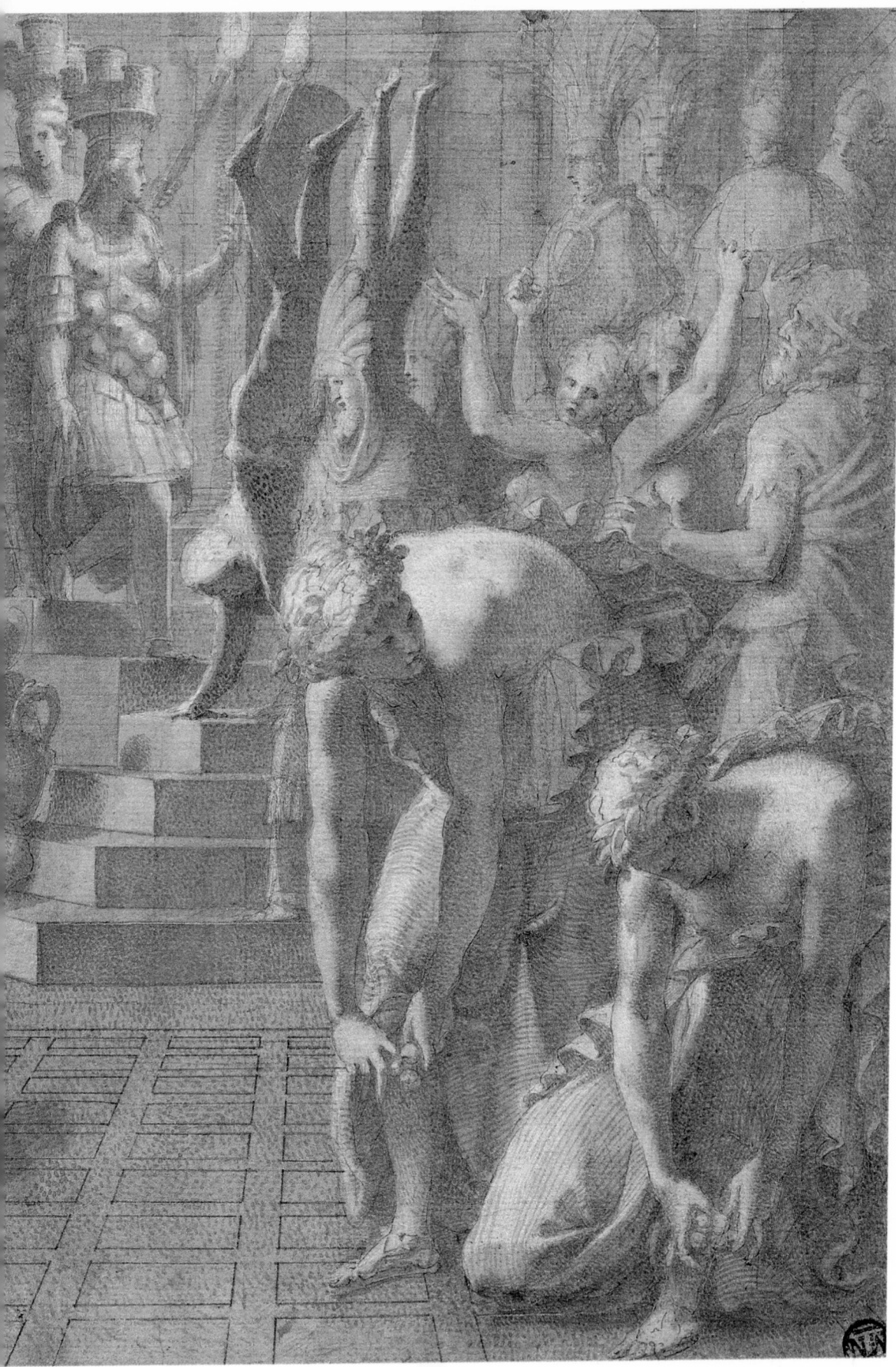

Several months passed without my receiving money or commissions; accordingly, I dismissed my workpeople with the exception of the two Italians, whom I set to making two big vases out of my own silver; for these men could not work in bronze. After they had finished these, I took them to a city which belonged to the Queen of Navarre; it is called Argentana, and is distant several days' journey from Paris. On arriving at this place, I found that the King was indisposed; and the Cardinal of Ferrara told his Majesty that I was come. He made no answer, which obliged me to stay several days kicking my heels. Of a truth, I never was more uncomfortable in my life; but at last I presented myself one evening and offered the two vases for the King's inspection. He was excessively delighted, and when I saw him in good humour, I begged his Majesty to grant me the favour of permitting me to travel into Italy; I would leave the seven months of my salary which were due, and his Majesty might condescend to pay me when I required money for my return journey. I entreated him to grant this petition, seeing that the times were more for fighting than for making statues; moreover, his Majesty had allowed a similar license to Bologna the painter, wherefore I humbly begged him to concede the same to me. While I was uttering these words the King kept gazing intently on the vases, and from time to time shot a terrible glance at me; nevertheless, I went on praying to the best of my ability that he would favour my petition. All of a sudden he rose angrily from his seat, and said to me in Italian: 'Benvenuto, you are a great fool. Take these vases back to Paris, for I want to have them gilt.' Without making any other answer he then departed.

I went up to the Cardinal of Ferrara, who was present, and besought him, since he had already conferred upon me the great benefit of freeing me from prison in Rome, with many others besides, to do me this one favour more of procuring for me leave to travel into Italy. He answered that he should be very glad to do his best to gratify me in this matter; I might leave it without farther thought to him, and even if I chose, might set off at once, because he would act for the best in my interest with the King. I told the Cardinal that since I was aware his Majesty had put me under the protection of his most reverend lordship, if he gave me leave, I felt ready to depart, and promised to return upon the smallest hint from his reverence. The Cardinal then bade me go back to Paris and wait there eight days, during which time he would procure the King's license for me; if his Majesty refused to let me go, he would without fail inform me; but if I received no letters, that would be a sign that I might set off with an easy mind.

I obeyed the Cardinal, and returned to Paris, where I made excellent cases for my three silver vases. After the lapse of twenty days, I began my preparations, and packed the three vases upon a mule. This animal had been lent me for the journey to Lyons by the Bishop of Pavia, who was now once more installed in my castle.

Then I departed in my evil hour, together with Signor Ippolito Gonzaga, at that time in the pay of the King, and also in the service of Count Galeotto della Mirandola. Some other gentlemen of the said count went with us, as well as Lionardo Tedaldi, our fellow-citizen of Florence.

I made Ascanio and Pagolo guardians of my castle and all my property, including two little vases which were only just begun; those I left behind in order that the two young men might not be idle. I had lived very handsomely in Paris, and therefore there was a large amount of costly household furniture: the whole value of these effects exceeded 1500 crowns. I bade Ascanio remember what great benefits I had bestowed upon him, and that up to the present he had been a mere thoughtless lad; the time was now come for him to show the prudence of a man; therefore I thought fit to leave him in the custody of all my goods, as also of my honour. If he had the least thing to complain of from those brutes of Frenchmen, he was to let me hear at once, because I would take post and fly from any place in which I found myself, not only to discharge the great obligations under which I lay to that good King, but also to defend my honour. Ascanio replied with the tears of a thief and hypocrite: 'I have never known a father better than you are, and all things which a good son is bound to perform for a good father will I ever do for you.' So then I took my departure, attended by a servant and a little French lad.

It was just past noon, when some of the King's treasurers, by no means friends of mine, made

a visit to my castle. The rascally fellows began by saying that I had gone off with the King's silver, and told Messer Guido and the Bishop of Pavia to send at once off after his Majesty's vases; if not, they would themselves despatch a messenger to get them back, and do me some great mischief. The Bishop and Messer Guido were much more frightened than was necessary; so they sent that traitor Ascanio by the post off on the spot. He made his appearance before me about midnight. I had not been able to sleep, and kept revolving sad thoughts to the following effect: 'In whose hands have I left my property, my castle? Oh, what a fate is this of mine, which forces me to take this journey! May God grant only that the Cardinal is not of one mind with Madame d'Etampes, who has nothing else so much at heart as to make me lose the grace of that good King.'

While I was thus dismally debating with myself, I heard Ascanio calling me. On the instant I jumped out of bed, and asked if he brought good or evil tidings. The knave answered: 'They are good news I bring; but you must only send back those three vases, for the rascally treasurers keep shouting, "Stop, thief!" So the Bishop and Messer Guido say that you must absolutely send them back. For the rest you need have no anxiety, but may pursue your journey with a light heart.' I handed over the vases immediately, two of them being my own property, together with the silver and much else besides. I had meant to take them to the Cardinal of Ferrara's abbey at Lyons; for though people accused me of wanting to carry them into Italy, everybody knows quite well that it is impossible to export money, gold, or silver from France without special license. Consider, therefore, whether I could have crossed the frontier with those three great vases, which, together with their cases, were a whole mule's burden! It is certainly true that, since these articles were of great value and the highest beauty, I felt uneasiness in case the King should die, and I had lately left him in a very bad state of health; therefore I said to myself: 'If such an accident should happen, having these things in the keeping of the Cardinal, I shall not lose them.'

Well, to cut the story short, I sent back the mule with the vases, and other things of importance; then, upon the following morning, I travelled forward with the company I have already mentioned.

We were one day distant from Lyons, and it was close upon the hour of twenty-two, when the heavens began to thunder with sharp rattling claps, although the sky was quite clear at the time. I was riding a cross-bow shot before my comrades. After the thunder the heavens made a noise so great and horrible that I thought the last day had come; so I reined in for a moment while a shower of hail began to fall without a drop of water. At first the hail was somewhat larger than pellets from a popgun, and when these struck me, they hurt considerably. Little by little it increased in size, until the stones might be compared to balls from a crossbow. My horse became restive with fright; so I wheeled round, and returned at a gallop to where I found my comrades taking refuge in a fir-wood. The hail now grew to the size of big lemons. I began to sing a Miserere; and while I was devoutly uttering this psalm to God, there fell a stone so huge that it smashed the thick branch of the pine under which I had retired for safety. Another of the hailstones hit my horse upon the head, and almost stunned him; one struck me also, but not directly, else it would have killed me. In like manner, poor old Lionardo Tedaldi, who like me was kneeling on the ground, received so shrewd a blow that he fell grovelling upon all fours. When I saw that the fir bough offered no protection, and that I ought to act as well as to intone my Misereres, I began at once to wrap my mantle round my head. At the same time I cried to Lionardo, who was shrieking for succour, 'Jesus! Jesus!' that Jesus would help him if he helped himself. I had more trouble in looking after this man's safety than my own. The storm raged for some while, but at last it stopped; and we, who were pounded black and blue, scrambled as well as we could upon our horses. Pursuing the way to our lodging for the night, we showed our scratches and bruises to each other; but about a mile farther on we came upon a scene of devastation which surpassed what we had suffered, and defies description. All the trees were stripped of their leaves and shattered; the beasts in the field lay dead; many of the herdsmen had also been killed; we observed large quantities of hailstones which could not have been grasped

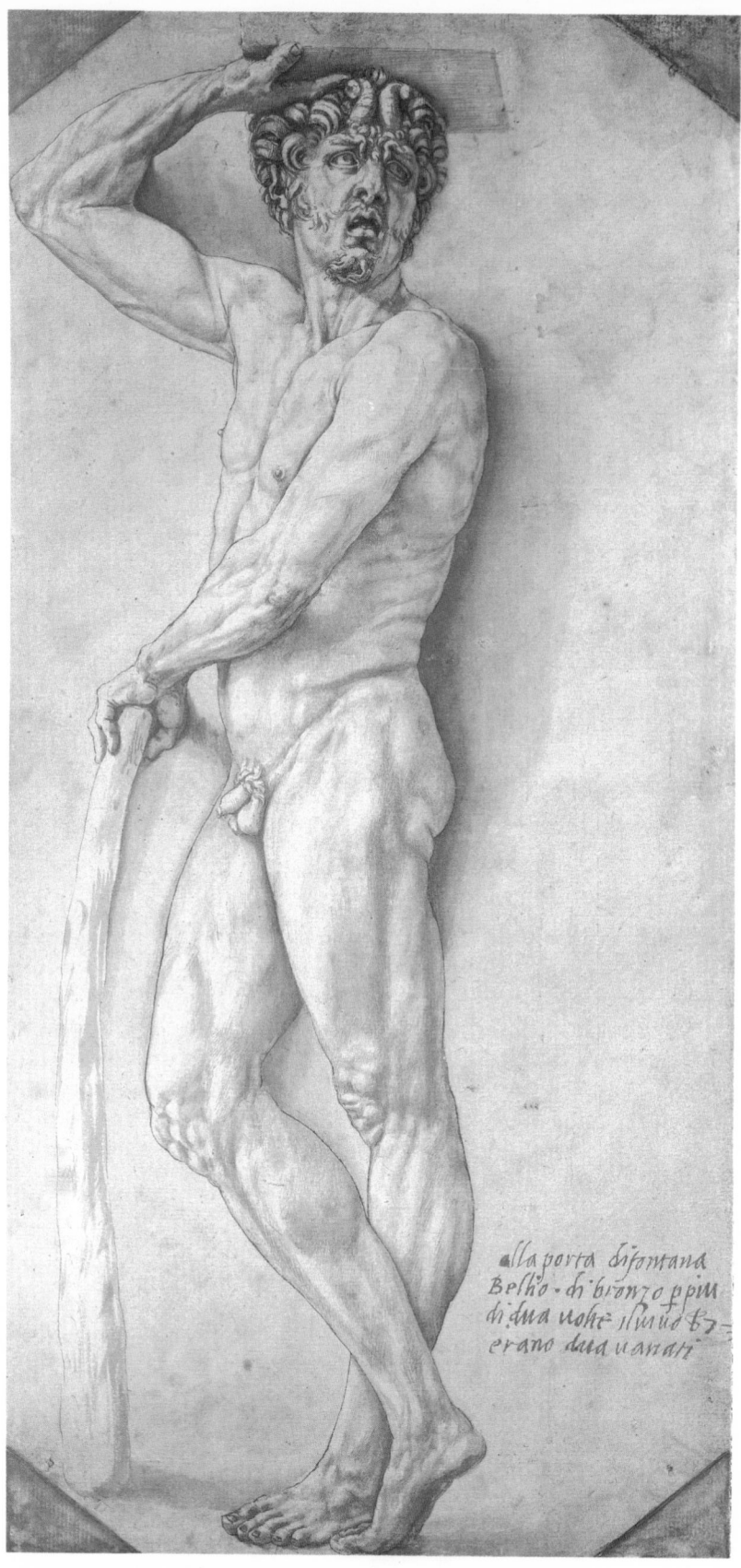

64 *Satyr*, drawing by Cellini for a statue for the main door of
Fontainebleau, 1542–3. Pen and wash, 16 × 8 ins (41.5 × 20.7 cm). New
York, Woodner Coll. (*See page 131*)

65 *Two male nudes*, drawing by Cellini, *c.* 1560. Pen and brown ink. Berlin (West), Staatliche Museen Preussischer Kulturbesitz (Kupferstichkabinett)

with two hands. Feeling then that we had come well out of a great peril, we acknowledged that our prayers to God and Misereres had helped us more than we could have helped ourselves. Returning thanks to God, therefore, we entered Lyons in the course of the next day, and tarried there eight days.

327

My heart was now sorely torn asunder, at one moment by the desire to reach Florence as quickly as I could, and at another by the conviction that I ought to regain France. At last, in order to end the fever of this irresolution, I determined to take the post for Florence. I could not make arrangements with the first postmaster, but persisted in my purpose to press forward and endure an anxious life at Florence.

I parted company with Signor Ippolito Gonzaga, who took the route for Mirandola, while I diverged upon the road to Parma and Piacenza. In the latter city I met Duke Pier Luigi upon the street, who stared me in the face, and recognized me. Since I knew him to have been the sole cause of my imprisonment in the castle of S. Angelo, the sight of him made my blood boil. Yet being unable to escape from the man, I decided to pay him my respects, and arrived just after he had risen from table in the company of the Landi, who afterwards murdered him. On my appearance he received me with unbounded marks of esteem and affection, among which he took occasion to remark to the gentlemen present that I was the first artist of the world in my own line, and that I had been for a long while in prison at Rome. Then he turned to me and said: 'My Benvenuto, I was deeply grieved for your misfortune, and knew well that you were innocent but could not do anything to help you. In short, it was my father, who chose to gratify some enemies of yours, from whom, moreover, he heard that you had spoken ill of him. I am convinced this was not true, and indeed I was heartily sorry for your troubles.' These words he kept piling up and repeating until he seemed to be begging my pardon. Afterwards he inquired about the work I had been doing for his Most Christian Majesty; and on my furnishing him with details, he listened as attentively and graciously as possible. Then he asked if I had a mind to serve him. To this I replied that my honour would not allow me to do so; but that if I had completed those extensive works begun for the King, I should be disposed to quit any great prince merely to enter his Excellency's service.

328

329

Hereby it may be seen how the power and goodness of God never leave unpunished any sort or quality of men who act unjustly toward the innocent. This man did what was equivalent to begging my pardon in the presence of those very persons who subsequently took revenge on him for me and many others whom he had massacred. Let then no prince, however great he be, laugh at God's justice, in the way that many whom I know are doing, and who have cruelly maltreated me, as I shall relate at the proper time.

When I returned to my inn, I found that the Duke had sent me abundance to eat and drink of very excellent quality. I made a hearty meal, then mounted and rode toward Florence. The Duke of Florence at this time, which was the month of August 1545, had retired to Poggio a Cajano, ten miles distant from Florence. Thither then I went to pay him my respects, with the sole object of acting as duty required, first because I was a Florentine, and next because my forefathers had always been adherents of the Medicean party, and I yielded to none of them in affection for this Duke Cosimo. As I have said, then, I rode to Poggio with the sole object of paying my respects, and with no intention of accepting service under him, as God, who does all things well, did then appoint for me.

330

331

When I was introduced, the Duke received me very kindly; then he and the Duchess put questions concerning the works which I had executed for the King. I answered willingly and in detail. After listening to my story, he answered that he had heard as much, and that I spoke the truth. Then he assumed a tone of sympathy, and added: 'How small a recompense for such great and noble masterpieces! Friend Benvenuto, if you feel inclined to execute something for me too, I am ready to pay you far better than that King of yours has done, for whom your excellent nature prompts you to speak so gratefully.' When I understood his drift, I described the deep obligations under which I lay to his Majesty, who first obtained my liberation from that iniquitous prison, and afterwards supplied me with the means of carrying out more

332

66 *The Villa Medici at Poggio a Caiano.* Fresco of it in its original state by Justus Utens, 17th century. Florence, Museo di Firenze Com'Era

admirable works than any artist of my quality had ever had the chance to do. While I was thus speaking, my lord the Duke writhed on his chair, and seemed as though he could not bear to hear me to the end. Then, when I had concluded, he rejoined: 'If you are disposed to work for me, I will treat you in a way that will astonish you, provided the fruits of your labours give me satisfaction, of which I have no doubt.' I, poor unhappy mortal, burning with desire to show the noble school of Florence that, after leaving her in youth, I had practised other branches of the art than she imagined, gave answer to the Duke that I would willingly erect for him in marble or in bronze a mighty statue on his fine piazza. He replied that, for a first essay, he should like me to produce a Perseus; he had long set his heart on having such a monument, and he begged me to begin a model for the same. I very gladly sent myself to the task, and in a few weeks I finished my model, which was about a cubit high, in yellow wax and very delicately finished in all its details. I had made it with the most thorough study and art.

The Duke returned to Florence, but several days passed before I had an opportunity of showing my model. It seemed indeed as though he had never set eyes on me or spoken with me, and this caused me to augur ill of my future dealings with his Excellency. Later on, however, one day after dinner, I took it to his wardrobe, where he came to inspect it with the Duchess and a few gentlemen of the court. No sooner had he seen it than he expressed much pleasure, and extolled it to the skies; wherefrom I gathered some hope that he might really be a connoisseur of art. After having well considered it for some time, always with greater satisfaction, he began as follows: 'If you could only execute this little model, Benvenuto, with the same perfection on a large scale, it would be the finest piece in the piazza.' I replied: 'Most excellent my lord, upon the piazza are now standing works by the great Donatello and the incomparable Michel Angelo, the two greatest men who have ever lived since the days of the ancients. But since your Excellence encourages my model with such praise, I feel the heart to execute it at least thrice as well in bronze.' No slight dispute arose upon this declaration; the

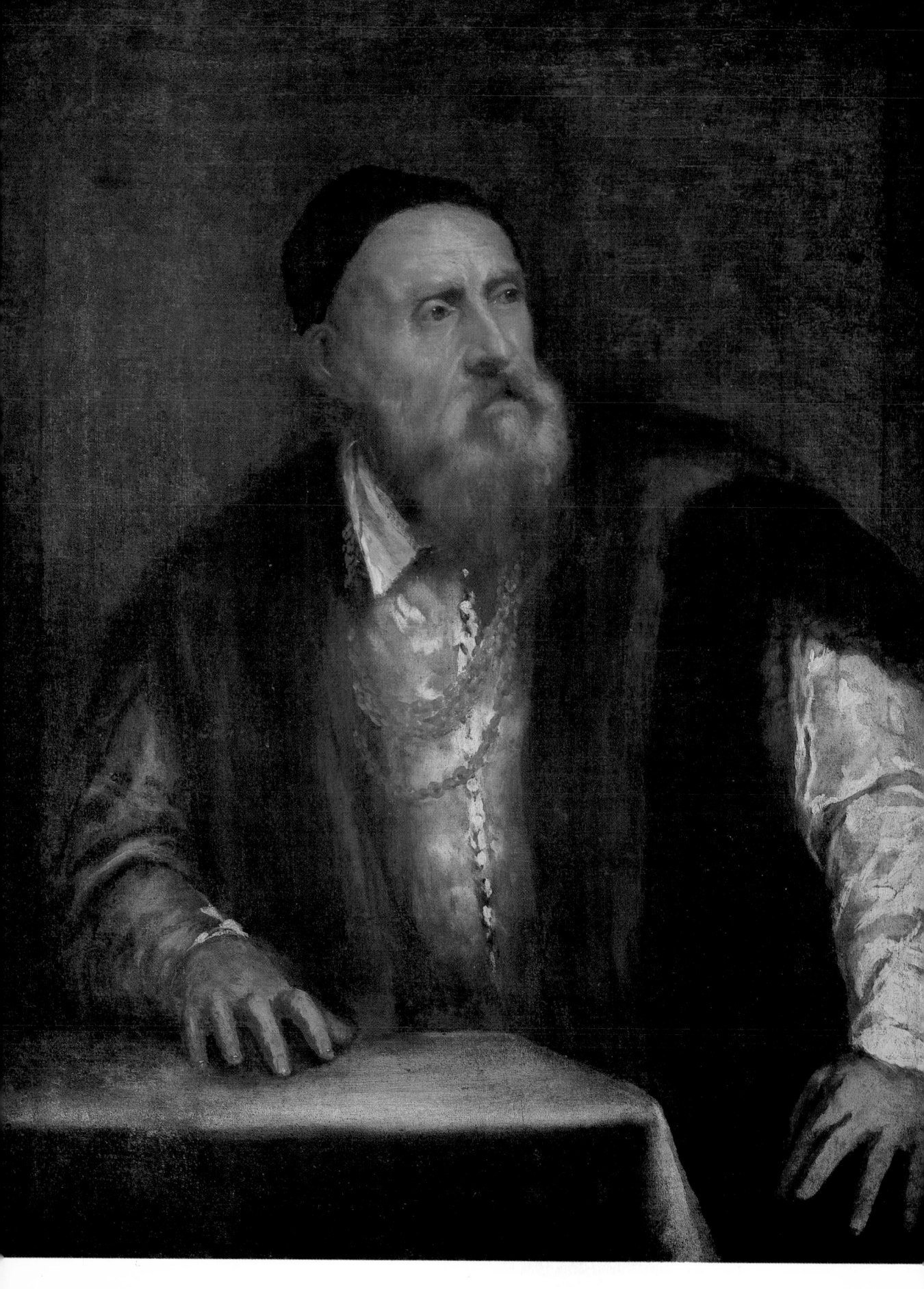

67 LEFT *Self-portrait* of Titian, early 1550s. Berlin (West), Staatliche Museen Preussischer Kulturbesitz (Gemäldegalerie)

68 ABOVE *Battista del Tasso*, detail from the fresco by Vasari in the Palazzo Vecchio (plate 35)

Duke protesting that he understood these matters perfectly, and was quite aware what could be done. I rejoined that my achievements would resolve his dubitations and debates; I was absolutely sure of being able to perform far more than I had promised for his Excellency, but that he must give me means for carrying my work out, else I could not fulfil my undertaking. In return for this his Excellency bade me formulate my demands in a petition, detailing all my requirements; he would see them liberally attended to.

It is certain that if I had been cunning enough to secure by contract all I wanted for my work, I should not have incurred the great troubles which came upon me through my own fault. But he showed the strongest desire to have the work done, and the most perfect willingness to arrange preliminaries. I therefore, not discerning that he was more a merchant than a duke, dealt very frankly with his Excellency, just as if I had to do with a prince, and not with a commercial man. *337*

His Excellency committed the execution of these orders to his majordomo, who was named Ser Pier Francesco Riccio. The man came from Prato, and had been the Duke's pedagogue. I *338* talked, then, to this donkey, and described my requirements, for there was a garden adjoining the house, on which I wanted to erect a workshop. He handed the matter over to a paymaster, dry and meagre, who bore the name of Lattanzio Gorini. This flimsy little fellow, with his tiny *339* spider's hands and small gnat's voice, moved about the business at a snail's pace; yet in an evil hour he sent me stones, sand, and lime enough to build perhaps a pigeon-house with careful management. When I saw how coldly things were going forward, I began to feel dismayed; however, I said to myself: 'Little beginnings sometimes have great endings.' Under these difficulties, and by the use of my own money, I had soon marked out the foundations of the workshop and cleared the ground of trees and vines, labouring on, according to my wont, with fire, and perhaps a trifle of impatience.

On the other side, I was in the hands of Tasso the carpenter, a great friend of mine, who had *340* received my instructions for making a wooden framework to set up the Perseus. This Tasso was a most excellent craftsman, the best, I believe, who ever lived in his own branch of art. Personally, he was gay and merry by temperament; and whenever I went to see him, he met me laughing, with some little song in falsetto on his lips. Half in despair as I then was, news coming that my affairs in France were going wrong, and these in Florence promising but ill through the lukewarmness of my patron, I could never stop listening till half the song was finished; and so in the end I used to cheer up a little with my friend, and drove away, as well as I was able, some few of the gloomy thoughts which weighed upon me.

I received frequent letters from France, written by my most faithful friend Messer Guido Guidi. As yet they told nothing but good news; and Ascanio also bade me enjoy myself without uneasiness, since, if anything happened, he would let me know at once.

Now the King was informed that I had commenced working for the Duke of Florence, and being the best man in the world, he often asked: 'Why does not Benvenuto come back to us?' He put searching questions on the subject to my two workmen, both of whom replied that I kept writing I was well off where I was, adding they thought I did not want to re-enter the service of his Majesty. Incensed by these presumptuous words, which were none of my saying, the King exclaimed: 'Since he left us without any cause, I shall not recall him; let him e'en stay where he is.' Thus the thievish brigands brought matters exactly to the pass they desired; for if I had returned to France, they would have become mere workmen under me once more, whereas, while I remained away, they were their own masters and in my place; consequently, they did everything in their power to prevent my coming back.

69 FAR LEFT Wax model for the *Perseus* by Cellini, 1545. Florence, Bargello

70 LEFT Bronze model for the *Perseus*, 1545–54. Florence, Bargello

While the workshop for executing my Perseus was in building, I used to work in a ground-floor room. Here I modelled the statue in plaster, giving it the same dimensions as the bronze was meant to have, and intending to cast it from this mould. But finding that it would take rather long to carry it out in this way, I resolved upon another expedient, especially as now a wretched little studio had been erected, brick on brick, so miserably built that the mere recollection of it gives me pain. So then I began the figure of Medusa, and constructed the skeleton in iron. Afterwards I put on the clay, and when that was modelled, baked it.

341

I had no assistants except some little shopboys, among whom was one of great beauty; he was the son of a prostitute called La Gambetta. I made use of the lad as a model, for the only books which teach this art are the natural human body. Meanwhile, as I could not do everything alone, I looked about for workmen in order to put the business quickly through; but I was unable to find any. There were indeed some in Florence who would willingly have come, but Bandinello prevented them, and after keeping me in want of aid awhile, told the Duke that I was trying to entice his workpeople because I was quite incapable of setting up so great a statue by myself. I complained to the Duke of the annoyance which the brute gave me, and begged him to allow me some of the labourers from the Opera. My request inclined him to lend ear to Bandinello's calumnies; and when I noticed that, I set about to do my utmost by myself alone. The labour was enormous: I had to strain every muscle night and day; and just then the husband of my sister sickened, and died after a few days' illness. He left my sister, still young, with six girls of all ages, on my hands. This was the first great trial I endured in Florence, to be made the father and guardian of such a distressed family.

342

343

344

345

Just at this time I suffered slightly in the loins, and being unable to work hard, I was glad to pass my time in the Duke's wardrobe with a couple of young goldsmiths called Gianpagolo and Domenico Poggini, who made a little golden cup under my direction. It was chased in bas-relief with figures and other pretty ornaments, and his Excellency meant it for the Duchess to drink water out of. He furthermore commissioned me to execute a golden belt, which I enriched with gems and delicate masks and other fancies. The Duke came frequently into the wardrobe, and took great pleasure in watching me at work and talking to me. When my health improved, I had clay brought, and took a portrait of his Excellency, considerably larger than life-size, which I modelled while he stayed with me for pastime. He was highly delighted with this piece, and conceived such a liking for me that he earnestly begged me to take up my working quarters in the palace, selecting rooms large enough for my purpose, and fitting them up with furnaces and all I wanted, for he greatly enjoyed watching the processes of art. I replied that this was impossible; I should not have finished my undertakings in a hundred years.

346
347

348

The Duchess also treated me with extraordinary graciousness, and would have been pleased if I had worked for her alone, forgetting Perseus and everything besides. I for my part, while these vain favours were being showered upon me, knew only too well that my perverse and biting fortune could not long delay to send me some fresh calamity.

About this time Bernardone Baldini, broker in jewels to the Duke, brought a big diamond from Venice, which weighed more than thirty-five carats. Antonio, son of Vittorio Landi, was also interested in getting the Duke to purchase it. The stone had been cut with a point; but since it did not yield the purity of lustre which one expects in such a diamond, its owners had cropped the point, and, in truth, it was not exactly fit for either point or table cutting. Our Duke, who greatly delighted in gems, though he was not a sound judge of them, held out good hopes to the rogue Bernardaccio that he would buy this stone; and the fellow, wanting to secure for himself alone the honour of palming it off upon the Duke of Florence, abstained from taking his partner Antonio Landi into the secret. Now Landi had been my intimate friend from childhood, and when he saw that I enjoyed the Duke's confidence, he called me aside (it was just before noon, at a corner of the Mercato Nuovo), and spoke as follows: 'Benvenuto, I am convinced that the Duke will show you a diamond, which he seems disposed to buy; you will find it a big stone. Pray assist the purchase; I can give it for seventeen thousand crowns. I feel sure he will ask your advice; and if you see that he has a mind for it, we will contrive that he

349
350

351

71 *Eleonora di Toledo, Duchess of Florence, with her son Francesco,* by
Bronzino, 1545. Florence, Galleria degli Uffizi

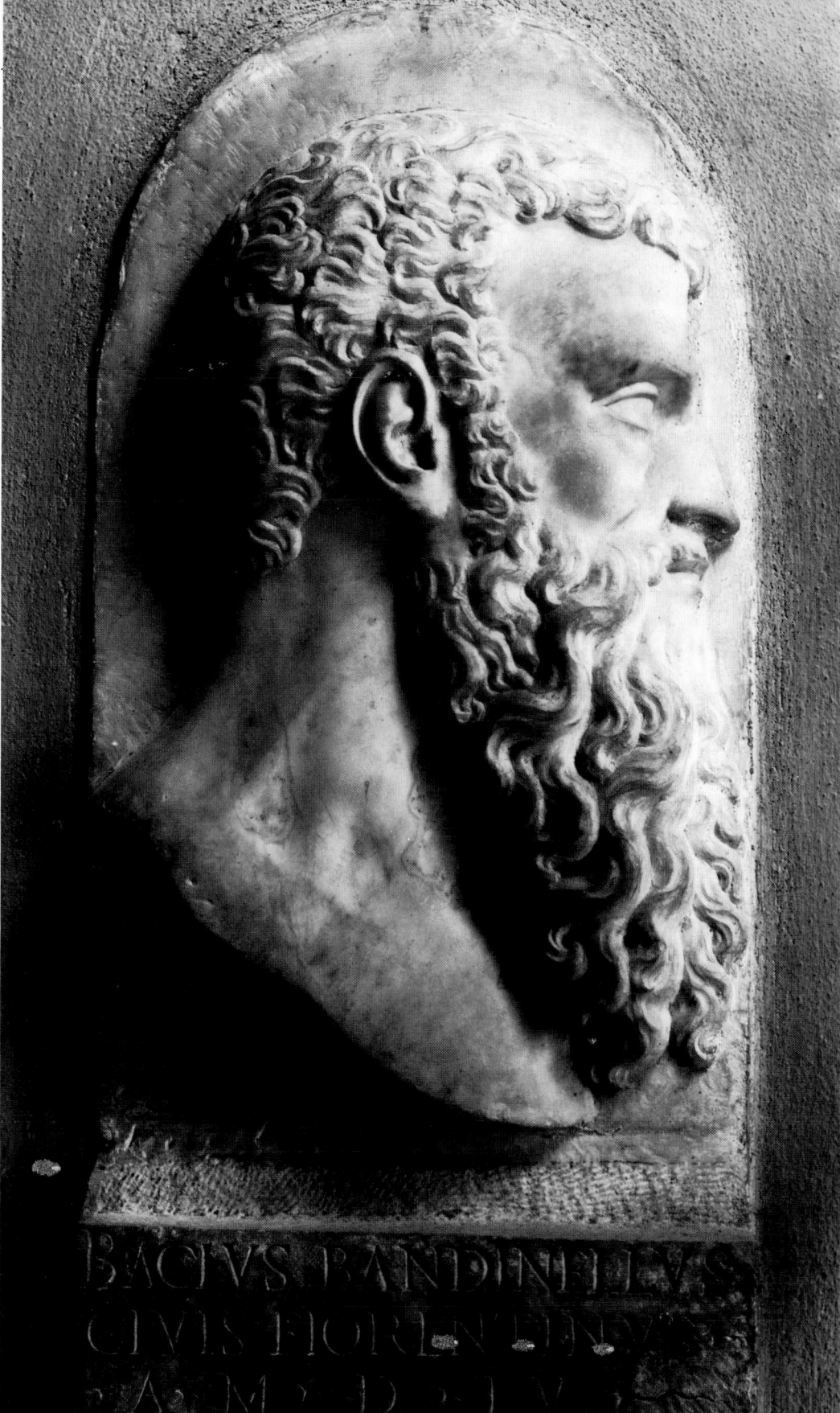

BACIVS BANDINELLVS
CIVIS FLOREN DINVS
A M D L V

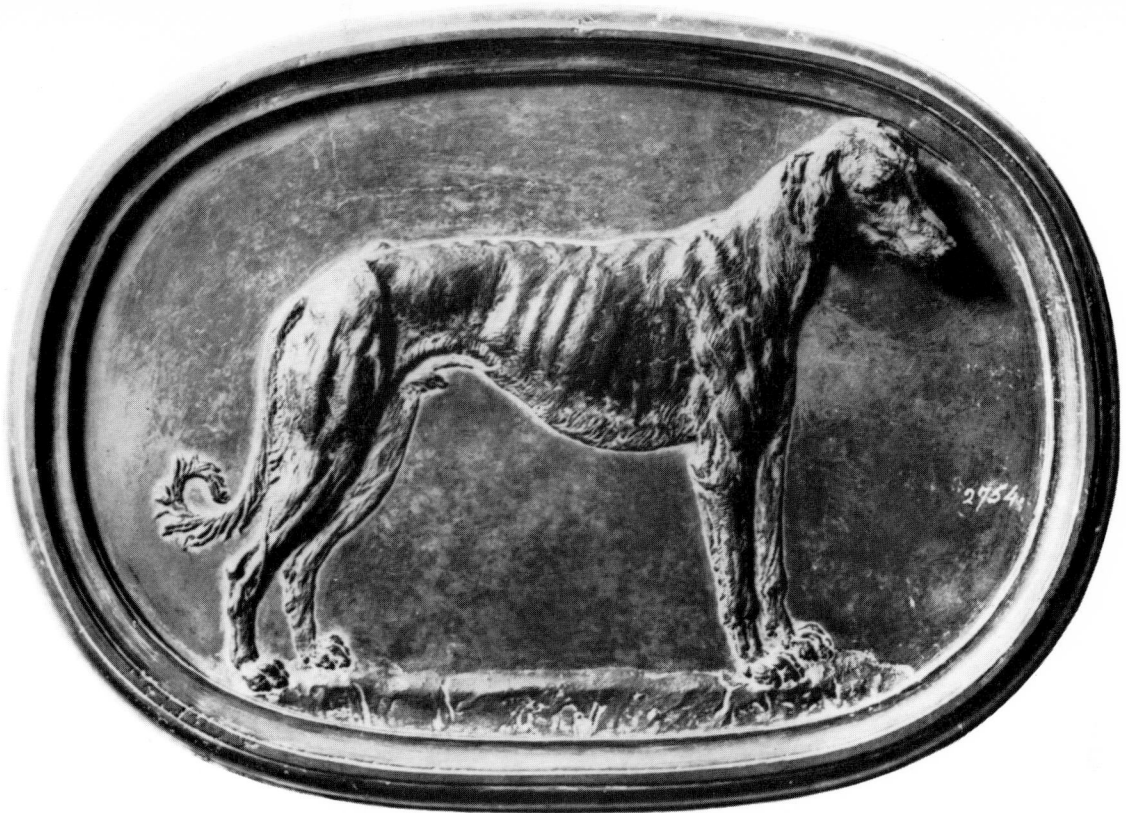

72 LEFT *Self-portrait* of Baccio Bandinelli, 1556. Florence, Museo dell'Opera del Duomo

73 ABOVE *A Greyhound*, bronze medallion by Cellini, 1545. Florence, Bargello (*See note 348*)

secures it.' Antonio professed great confidence in being able to complete the bargain for the jewel at that price. In reply, I told him that if my advice was taken, I would speak according to my judgment, without prejudice to the diamond.

As I have above related, the Duke came daily into our goldsmith's workshop for several hours; and about a week after this conversation with Antonio Landi he showed me one day after dinner the diamond in question, which I immediately recognized by its description, both as to form and weight. I have already said that its water was not quite transparent, for which reason it had been cropped; so, when I found it of that kind and quality, I felt certainly disinclined to recommend its acquisition. However, I asked his Excellency what he wanted me to say; because it was one thing for jewellers to value a stone after a prince had bought it, and another thing to estimate it with a view to purchase. He replied that he had bought it, and that he only wanted my opinion. I did not choose to abstain from hinting what I really thought about the stone. Then he told me to observe the beauty of its great facets. I answered that this feature of the diamond was not so great a beauty as his Excellency supposed, but came from the point having been cropped. At these words my prince, who perceived that I was speaking the truth, made a wry face, and bade me give good heed to valuing the stone, and saying what I thought it worth. I reckoned that, since Landi had offered it to me for 17,000 crowns, the Duke might have got it for 15,000 at the highest; so, noticing that he would take it ill if I spoke the truth, I made my mind up to uphold him in his false opinion, and handing back the diamond, said: 'You will probably have paid 18,000 crowns.' On hearing this the Duke uttered a loud 'Oh!' opening his mouth as wide as a well, and cried out: 'Now am I convinced that you

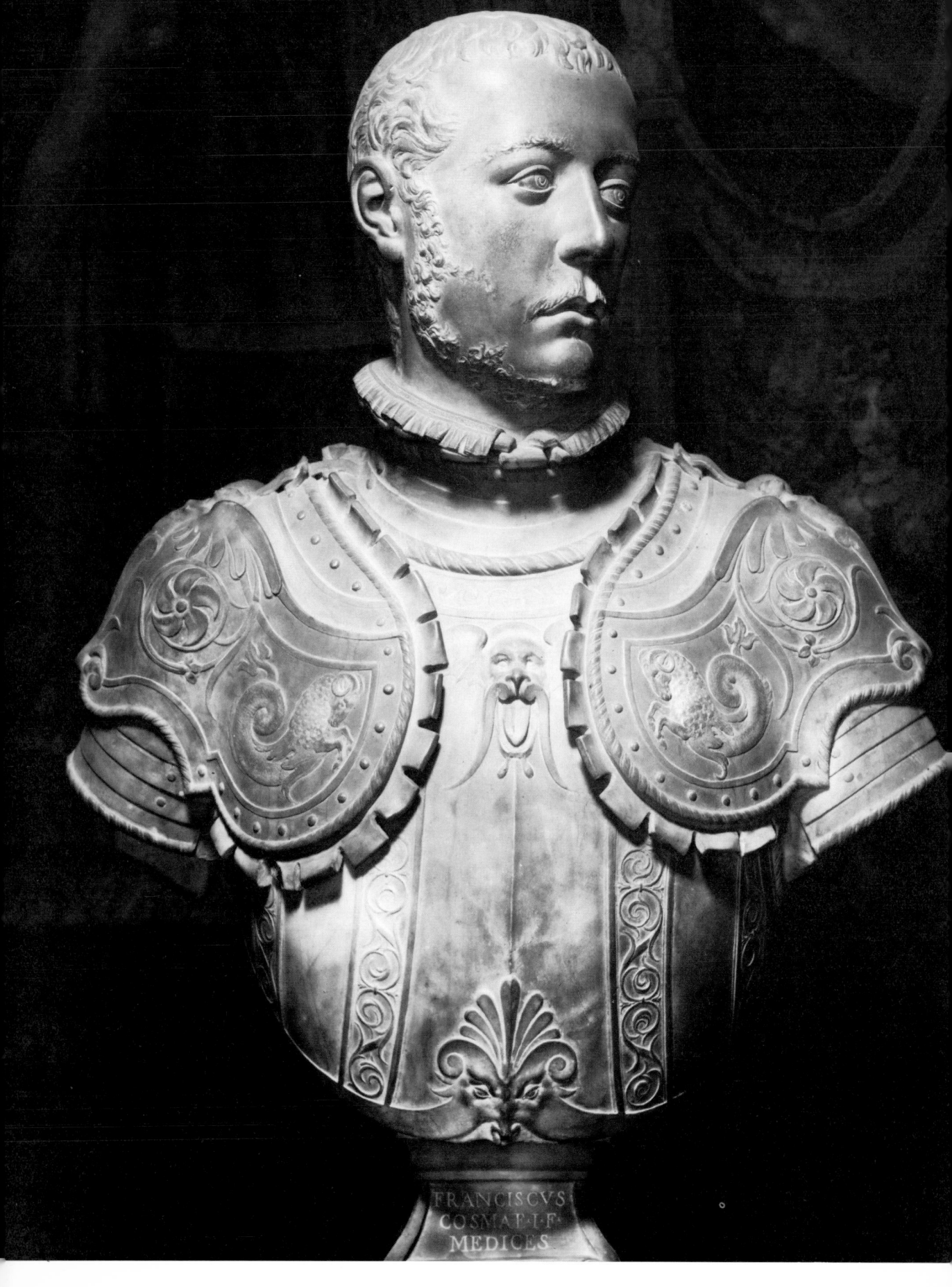

FRANCISCVS
COSMAE·I·F·
MEDICES

understand nothing about the matter.' I retorted: 'You are certainly in the wrong there, my lord. Do you attend to maintaining the credit of your diamond, while I attend to understanding my trade. But pray tell me at least how much you paid, in order that I may learn to understand it according to the way of your Excellency.' The Duke rose, and, with a little sort of angry grin, replied: 'Twenty-five thousand crowns and more, Benvenuto, did that stone cost me!'

Having thus spoken, he departed. Giovanpagolo and Domenico Poggini, the goldsmiths, were present; and Bachiacca, the embroiderer, who was working in an adjacent room, ran up at the noise. I told them that I should never have advised the Duke to purchase it; but if his heart was set on having it, Antonio Landi had offered me the stone eight days ago for 17,000 crowns. I think I could have got it for 15,000 or less. But the Duke apparently wishes to maintain his gem in credit; for when Antonio Landi was willing to let it go at that price, how the devil can Bernardone have played off such a shameful trick upon his Excellency? Never imagining that the matter stood precisely as the Duke averred, we laughingly made light of his supposed credulity. 352

Meanwhile I was advancing with my great statue of Medusa. I had covered the iron skeleton with clay, which I modelled like an anatomical subject, and about half an inch thinner than the bronze would be. This I baked well, and then began to spread on the wax surface, in order to complete the figure to my liking. The Duke, who often came to inspect it, was so anxious lest I should not succeed with the bronze, that he wanted me to call in some master to cast it for me.

He was continually talking in the highest terms of my acquirements and accomplishments. This made his majordomo no less continually eager to devise some trap for making me break my neck. Well, one Saturday evening, after sunset, Gambetta came to my house with her son, and told me she had kept him several days indoors for my welfare. I answered that there was no reason to keep him shut up on my account; and laughing her whorish arts to scorn, I turned to the boy in her presence, and said these words: 'You know, Cencio, whether I have sinned with you!' He began to shed tears, and answered, 'No!' Upon this the mother, shaking her head, cried out at him: 'Ah! you little scoundrel! Do you think I do not know how these things happen?' Then she turned to me, and begged me to keep the lad hidden in my house, because the Bargello was after him, and would seize him anywhere outside my house, but there they would not dare to touch him. I made answer that in my house lived my widowed sister and six girls of holy life, and that I wanted nobody else there. Upon that she related that the majordomo had given orders to the Bargello, and that I should certainly be taken up: only, if I would not harbour her son, I might square accounts by paying her a hundred crowns; the majordomo was her crony, and I might rest assured that she could work him to her liking, provided I paid down the hundred crowns. This cozenage goaded me into such a fury that I cried: 'Out with you, shameful strumpet! Were it not for my good reputation, and for the innocence of this unhappy boy of yours here, I should long ago have cut your throat with the dagger at my side; and twice or thrice I have already clasped my fingers on the handle.' With words to this effect, and many ugly blows to boot, I drove the woman and her son into the street. 353 354

When I reflected on the roguery and power of that evil-minded pedant, I judged it best to give a wide berth to his infernal machinations; so early next morning I mounted my horse and took the road for Venice, leaving in my sister's hands jewels and articles to the value of nearly two thousand crowns. I took with me my servant Bernardino of Mugello; and when I reached Ferrara, I wrote word to his Excellency the Duke, that though I had gone off without being sent, I should come back again without being called for. 355

On arriving at Venice, and pondering upon the divers ways my cruel fortune took to 356

74 *Francesco I de' Medici*, bust by Domenico Poggini. Florence, Galleria degli Uffizi

torment me, yet at the same time feeling myself none the less sound in health and hearty, I made up my mind to fence with her according to my wont. While thus engrossed in thoughts about my own affairs, I went abroad for pastime through that beautiful and sumptuous city, and paid visits to the admirable painter Titian, and to Jacopo del Sansovino, our able sculptor and architect from Florence. The latter enjoyed an excellent appointment under the Signoria of Venice; and we had been acquainted during our youth in Rome and Florence. These two men of genius received me with marked kindness. The day afterwards I met Messer Lorenzo de' Medici, who took me by the hand at once, giving me the warmest welcome which could be imagined, because we had known each other in Florence when I was coining for Duke Alessandro, and afterwards in Paris while I was in the King's service. At that time he sojourned in the house of Messer Giuliano Buonaccorsi, and having nowhere else to go for pastime without the greatest peril of his life, he used to spend a large part of the day in my house, watching me working at the great pieces I produced there. As I was saying, our former acquaintance led him to take me by the hand and bring me to his dwelling, where I found the Prior degli Strozzi, brother of my lord Piero. While making good cheer together, they asked me how long I intended to remain in Venice, thinking that I was on my return journey into France. To these gentlemen I replied that I had left Florence on account of the events I have described above, and that I meant to go back after two or three days, in order to resume my service with the Duke. On hearing this, the Prior and Messer Lorenzo turned round on me with such sternness that I felt extremely uneasy; then they said to me: 'You would do far better to return to France, where you are rich and well known; for if you go back to Florence, you will lose all that you have gained in France, and will earn nothing there but annoyances.'

I made no answer to these words, and departed the next day as secretly as I was able, turning my face again towards Florence. In the meanwhile that infernal plot had come to a head and broken, for I had written to my great master, the Duke, giving him a full account of the causes of my escapade to Venice. I went to visit him without any ceremony, and was received with his usual reserve and austerity. Having maintained this attitude awhile, he turned toward me pleasantly, and asked where I had been. I answered that my heart had never moved one inch from his most illustrious Excellency, although some weighty reasons had forced me to go a roaming for a little while. Then softening still more in manner, he began to question me concerning Venice, and after this wise we conversed some space of time. At last he bade me apply myself to business, and complete his Perseus. So I returned home glad and light-hearted, and comforted my family, that is to say, my sister and her six daughters. Then I resumed my work, and pushed it forward as briskly as I could.

The first piece I cast in bronze was that great bust, the portrait of his Excellency, which I had modelled in the goldsmith's workroom while suffering from those pains in my back. It gave much pleasure when it was completed, though my sole object in making it was to obtain experience of clays suitable for bronze-casting. I was of course aware that the admirable sculptor Donatello had cast his bronzes with the clay of Florence; yet it seemed to me that he had met with enormous difficulties in their execution. As I thought that this was due to some fault in the earth, I wanted to make these first experiments before I undertook my Perseus. From them I learned that the clay was good enough, but had not been well understood by Donatello, inasmuch as I could see that his pieces had been cast with the very greatest trouble. Accordingly, as I have described above, I prepared the earth by artificial methods, and found it serve me well, and with it I cast the bust; but since I had not yet constructed my own furnace, I employed that of Maestro Zanobi di Pagno, a bell-founder.

When I saw that this bust came out sharp and clean, I set at once to construct a little furnace in the workshop erected for me by the Duke, after my own plans and design, in the house

75 *Cosimo I*, attrib. Cellini, after 1548. Marble, 30 ins (75 cm) high. San Francisco, M.H. de Young Memorial Museum (Gift of Roscoe and Margaret Oakes Foundn.)

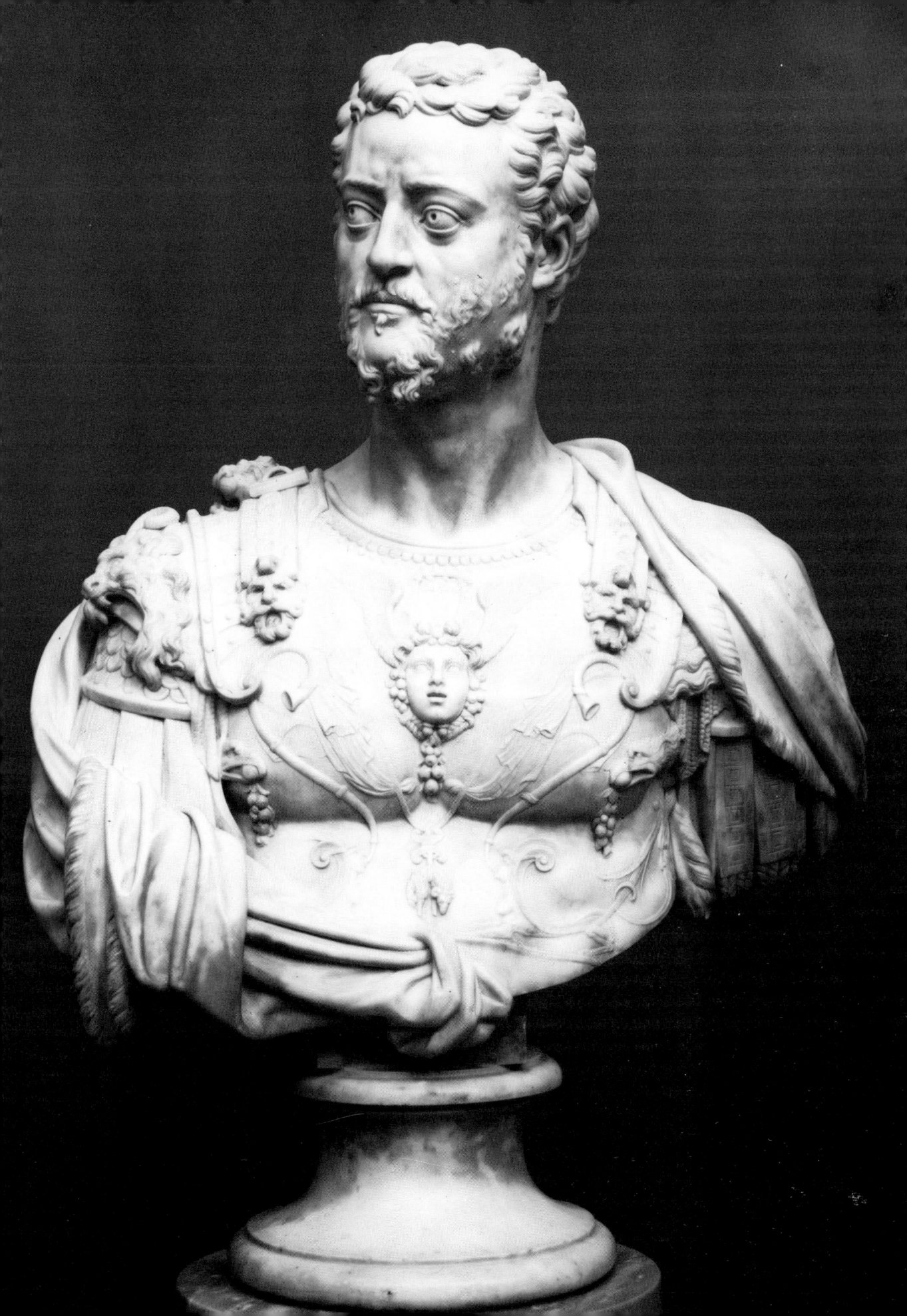

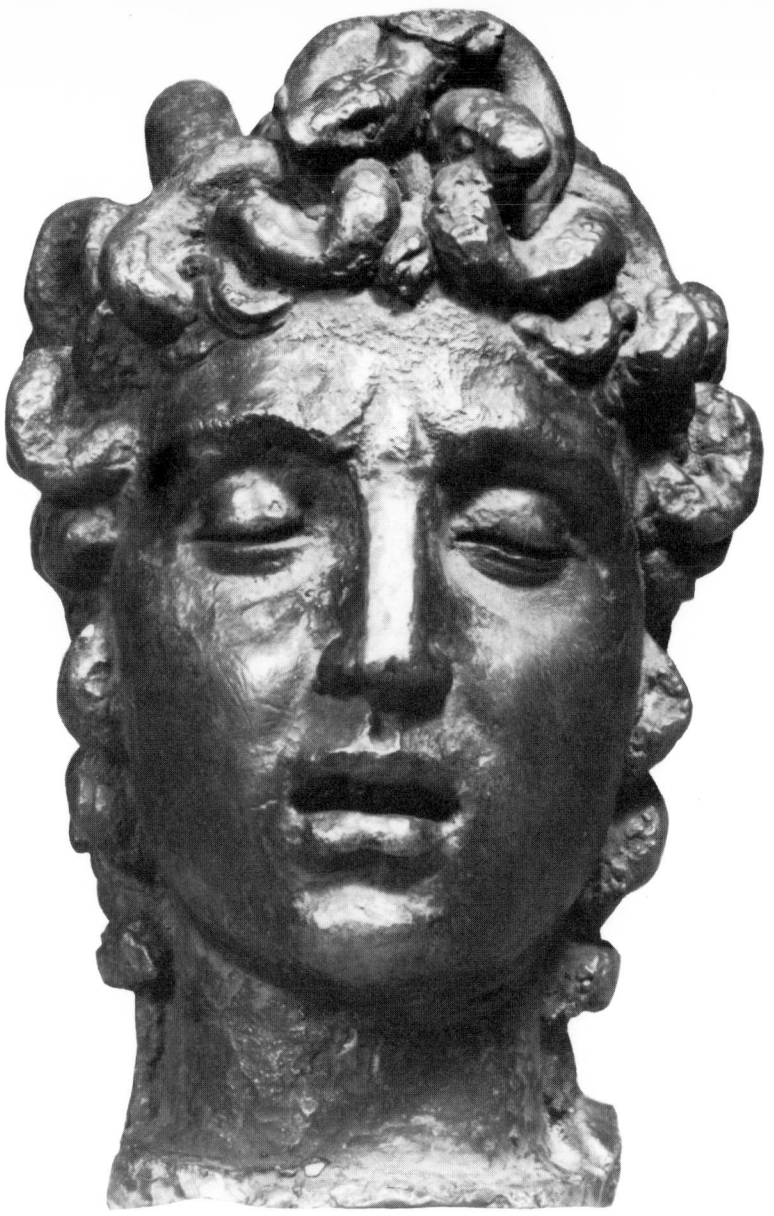

76, 77 *Head of the Medusa*, front and back views of bronze model for the
Perseus by Cellini, 1545–54. Victoria and Albert Museum

which the Duke had given me. No sooner was the furnace ready than I went to work with all
diligence upon the casting of Medusa, that is, the woman twisted in a heap beneath the feet of
Perseus. It was an extremely difficult task, and I was anxious to observe all the niceties of art
which I had learned, so as not to lapse into some error. The first cast I took in my furnace
succeeded in the superlative degree, and was so clean that my friends thought I should not need to
retouch it.

The result of this casting greatly pleased his Excellency, who often came to my house to
inspect it, encouraging me by the interest he showed to do my best. The furious envy of
Bandinello, however, who kept always whispering in the Duke's ears, had such effect that he
made him believe my first successes with a single figure or two proved nothing; I should never
be able to put the whole large piece together, since I was new to the craft, and his Excellency
ought to take good heed he did not throw his money away. These insinuations operated so
efficiently upon the Duke's illustrious ears, that part of my allowance for workpeople was

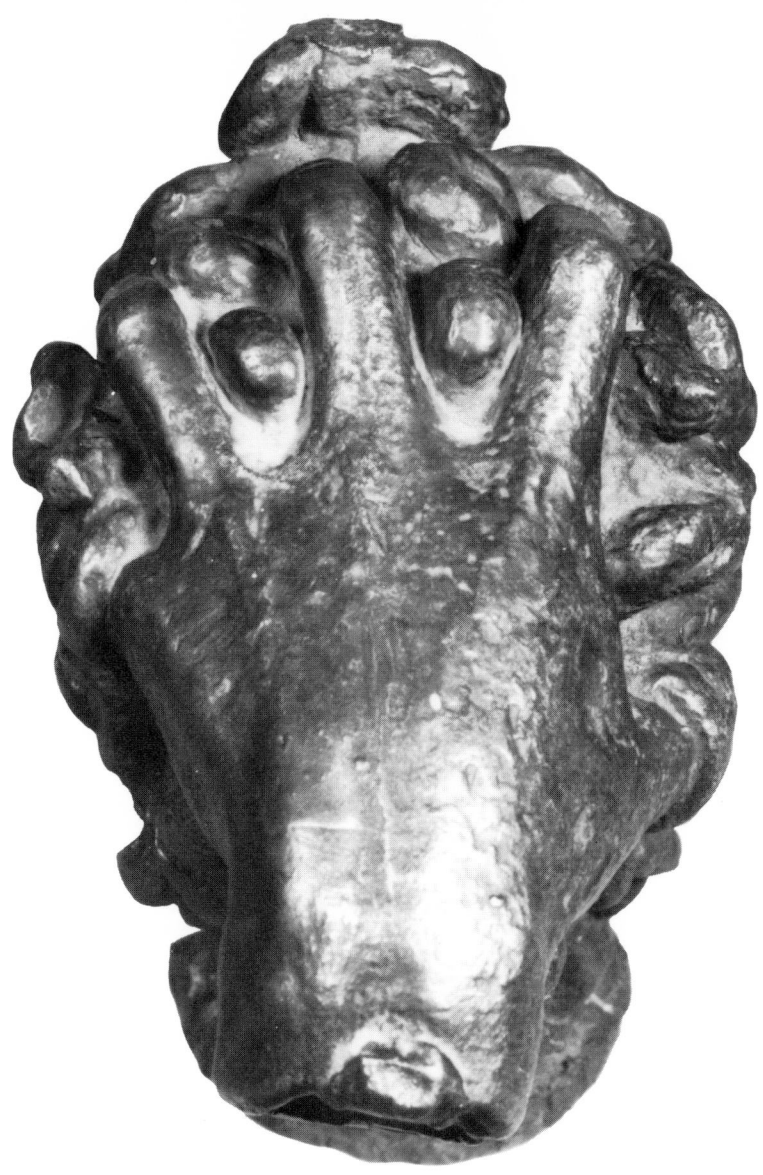

withdrawn. I felt compelled to complain pretty sharply to his Excellency; and having gone to wait on him one morning in the Via de' Servi, I spoke as follows: 'My lord, I do not now receive the monies necessary for my task, which makes me fear that your Excellency has lost confidence in me. Once more then I tell you that I feel quite able to execute this statue three times better than the model, as I have before engaged my word.' 361

I could see that this speech made no impression on the Duke, for he kept silence; then, seized with sudden anger and a vehement emotion, I began again to address him: 'My lord, this city of a truth has ever been the school of the most noble talents. Yet when a man has come to know what he is worth, after gaining some acquirements, and wishing to augment the glory of his town and of his glorious prince, it is quite right that he should go and labour elsewhere. To prove the truth of these words, I need only remind your Excellency of Donatello and the great Leonardo da Vinci in the past, and of our incomparable Michel Angelo Buonarroti in the present; they augment the glory of your Excellency by their genius. I in my turn feel the same

desire and hope to play my part like them; therefore, my lord, give me the leave to go. But beware of letting Bandinello quit you; rather bestow upon him always more than he demands; for if he goes into foreign parts, his ignorance is so presumptuous that he is just the man to disgrace our most illustrious school. Now grant me my permission, prince! I ask no further reward for my labours up to this time than the gracious favour of your most illustrious Excellency.' When he saw the firmness of my resolution, he turned with some irritation and exclaimed: 'Benvenuto, if you want to finish the statue, you shall lack for nothing.' Then I thanked him and said I had no greater desire than to show those envious folk that I had it in me to execute the promised work. When I left his Excellency, I received some slight assistance; but this not being sufficient, I had to put my hand into my own purse, in order to push the work forward at something better than a snail's pace.

The Duchess kept urging me to do goldsmith's work for her. I frequently replied that everybody, nay, all Italy, knew well I was an excellent goldsmith; but Italy had not yet seen what I could do in sculpture. Among artists, certain enraged sculptors laughed at me, and called me the new sculptor. 'Now I hope to show them that I am an old sculptor, if God shall grant me the boon of finishing my Perseus for that noble piazza of his most illustrious Excellency.' After this I shut myself up at home, working day and night, not even showing my face in the palace. I wished, however, to keep myself in favour with the Duchess; so I got some little cups made for her in silver, no larger than twopenny milk-pots, chased with exquisite masks in the rarest antique style. When I took them to her Excellency, she received me most graciously, and repaid the gold and silver I had spent upon them. Then I made my suit to her and prayed her tell the Duke that I was getting small assistance for so great a work; I begged her also to warn him not to lend so ready an ear to Bandinello's evil tongue, which hindered me from finishing my Perseus. In reply to these lamentable complaints the Duchess shrugged her shoulders and exclaimed: 'Of a surety the Duke ought only too well to know that this Bandinello of his is worth nothing.'

362 I had resolved, in the heat of my despair, if I met Bandinello, who went every evening to a farm of his above San Domenico, that I would hurl him to destruction. Taking the road toward Florence, just when I entered the piazza of San Domenico, Bandinello was arriving from the other side. On the instant I decided upon bloodshed; but when I reached the man and raised my eyes, I saw him unarmed, riding a sorry mule or rather donkey, and he had with him a boy of ten years old. No sooner did he catch sight of me than he turned the colour of a corpse, and trembled from head to foot. Perceiving at once how base the business would be, I exclaimed: 'Fear not, vile coward! I do not condescend to smite you.' He looked at me submissively and said nothing.

363 About this time a young fellow called Francesco, the son of a smith, Matteo, left Bandinello's employment, and inquired whether I would give him work. I agreed, and sent him to retouch my Medusa, which had been new cast in bronze. After a fortnight he mentioned that he had been speaking with his master, that is, Bandinello, who told him, if I cared to make a marble statue, he would give me a fine block of stone. I replied at once: 'Tell him I accept his offer; perhaps this marble will prove a stumbling-block to him, for he keeps on provoking me, and does not bear in mind the great peril he ran upon the piazza of San Domenico. Tell him I will have the marble by all means. I never speak about him, and the beast is perpetually causing me annoyance. I verily believe you came to work here at his orders for the mere purpose of spying upon me. Go, then, and tell him I insist on having the marble, even against his will: see that you do not come back without it.'

<div align="center">❧ ❧</div>

Many days had elapsed during which I had not shown my face in the palace, when the fancy took me to go there one morning just as the Duke was finishing his dinner. From what I heard, his Excellency had been talking of me that morning, commending me highly, and in particular

78 *Portrait of King Philip II of Spain* by Titian, 1550–1. 76 × 44 ins
(193 × 112 cm). Madrid, Prado

praising my skill in setting jewels. Therefore, when the Duchess saw me, she called for me by
Messer Sforza; and on my presenting myself to her most illustrious Excellency, she asked me to 364
set a little point-diamond in a ring, saying she wished always to wear it; at the same time she
gave me the measure and the stone, which was worth about a hundred crowns, begging me to
be quick about the work. Upon this the Duke began speaking to the Duchess, and said: 'There
is no doubt that Benvenuto was formerly without his peer in this art; but now that he has
abandoned it, I believe it will be too much trouble for him to make a little ring of the sort you
want. I pray you, therefore, not to importune him about this trifle, which would be no trifle to
him owing to his want of practice.' I thanked the Duke for his kind words, but begged him to
let me render this trifling service to the Duchess. Then I took the ring in hand, and finished it
within a few days. It was meant for the little finger; accordingly I fashioned four tiny children
in the round and four masks, which figures composed the hoop. I also found room for some
enamelled fruits and connecting links, so that the stone and setting went uncommonly well
together. Then I took it to the Duchess, who told me graciously that I had produced a very fine
piece, and that she would remember me. She afterwards sent the ring as a present to King
Philip, and from that time forward kept charging me with commissions, so kindly, however, 365

that I did my best to serve her, although I saw but very little of her money. God knows I had great need of that, for I was eager to finish my Perseus, and had engaged some journeymen, whom I paid out of my own purse. I now began to show myself more often than I had recently been doing.

It happened on one feast-day that I went to the palace after dinner, and when I reached the clockroom, I saw the door of the wardrobe standing open. As I drew nigh it, the Duke called me, and after a friendly greeting said: 'You are welcome! Look at that box which has been sent me by my lord Stefano of Palestrina. Open it, and let us see what it contains.' When I had opened the box, I cried to the Duke: 'My lord, this is a statue in Greek marble, and it is a miracle of beauty. I must say that I have never seen a boy's figure so excellently wrought and in so fine a style among all the antiques I have inspected. If your Excellency permits, I should like to restore it – head and arms and feet. I will add an eagle, in order that we may christen the lad Ganymede. It is certainly not my business to patch up statues, that being the trade of botchers, who do it in all conscience villainously ill; yet the art displayed by this great master of antiquity

79 BELOW *Portrait of Stefano Colonna* by Bronzino. Rome, Galleria Nazionale d'Arte Antica

80 OPPOSITE *Ganymede,* marble restored by Cellini, 1548–50. Florence, Bargello

cries out to me to help him.' The Duke was highly delighted to find the statue so beautiful, and put me a multitude of questions, saying: 'Tell me, Benvenuto, minutely, in what consists the skill of this old master, which so excites your admiration.' I then attempted, as well as I was able, to explain the beauty of workmanship, the consummate science, and the rare manner displayed by the fragment. I spoke long upon these topics, and with the greater pleasure because I saw that his Excellency was deeply interested.

While I was thus pleasantly engaged in entertaining the Duke, a page happened to leave the wardrobe, and at the same moment Bandinello entered. When the Duke saw him, his countenance contracted, and he asked him drily: 'What are you about here?' Bandinello, without answering, cast a glance upon the box, where the statue lay uncovered. Then breaking into one of his malignant laughs and wagging his head, he turned to the Duke and said: 'My lord, this exactly illustrates the truth of what I have so often told your Excellency. You must know that the ancients were wholly ignorant of anatomy, and therefore their works abound in *369* mistakes.' I kept silence, and paid no heed to what he was saying; nay, indeed, I had turned my back on him. But when the brute had brought his disagreeable babble to an end, the Duke exclaimed: 'O Benvenuto, this is the exact opposite of what you were just now demonstrating with so many excellent arguments. Come and speak a word in defence of the statue.' In reply to this appeal, so kindly made me by the Duke, I spoke as follows: 'My lord, your most illustrious Excellency must please to know that Baccio Bandinello is made up of everything bad, and thus has he ever been; therefore, whatever he looks at, be the thing superlatively excellent, becomes in his ungracious eyes as bad as can be. I, who incline to the good only, discern the truth with purer senses. Consequently, what I told your Excellency about this lovely statue is mere simple truth; whereas what Bandinello said is but a portion of the evil out of which he is composed.' The Duke listened with much amusement; but Bandinello writhed and made the most ugly faces – his face itself being by nature hideous beyond measure – which could be imagined by the mind of man.

The Duke at this point moved away, and proceeded through some ground-floor rooms, while Bandinello followed. The chamberlains twitched me by the mantle, and sent me after; so we all attended the Duke until he reached a certain chamber, where he seated himself, with Bandinello and me standing at his right hand and his left. I kept silence, and the gentlemen of his Excellency's suite looked hard at Bandinello, tittering among themselves about the speech I had made in the room above. So then Bandinello began again to chatter, and cried out: 'Prince, when I uncovered my Hercules and Cacus, I verily believe a hundred sonnets were written on *370* me, full of the worst abuse which could be invented by the ignorant rabble.' I rejoined: 'Prince, *371* when Michel Agnolo Buonarroti displayed his Sacristy to view, with so many fine statues in it, the men of talent in our admirable school of Florence, always appreciative of truth and goodness, published more than a hundred sonnets, each vying with his neighbour to extol these masterpieces to the skies. So then, just as Bandinello's work deserved all the evil which, he tells us, was then said about it, Buonarroti's deserved the enthusiastic praise which was bestowed upon it.' These words of mine made Bandinello burst with fury; he turned on me, and cried: 'And you, what have you got to say against my work?' 'I will tell you if you have the patience to hear me out.' 'Go along then,' he replied. The Duke and his attendants prepared themselves to listen. I began and opened my oration thus: 'You must know that it pains me to point out the faults of your statue; I shall not, however, utter my own sentiments, but shall recapitulate what our most virtuous school of Florence says about it.' The brutal fellow kept making disagreeable remarks and gesticulating with his hands and feet, until he enraged me so that I began again, and spoke far more rudely than I should otherwise have done, if he had behaved with decency. 'Well, then, this virtuous school says that if one were to shave the hair of your Hercules, there

81 *Hercules and Cacus* by Baccio Bandinelli, 1534. Florence, Piazza della Signoria

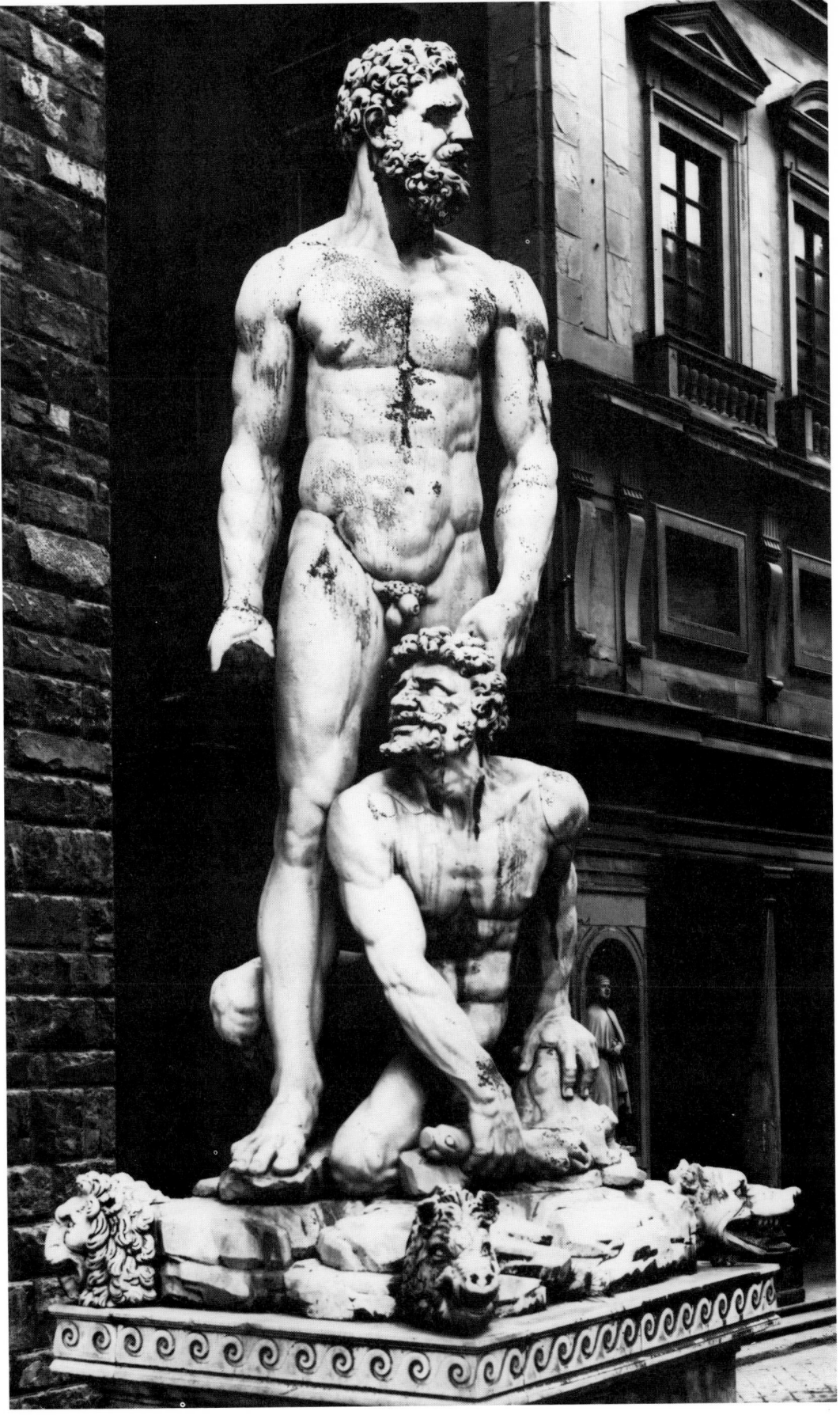

would not be skull enough left to hold his brain; it says that it is impossible to distinguish whether his features are those of a man or of something between a lion and an ox; the face too is turned away from the action of the figure, and is so badly set upon the neck, with such poverty of art and so ill a grace, that nothing worse was ever seen; his sprawling shoulders are like the two pommels of an ass's pack-saddle; his breasts and all the muscles of the body are not portrayed from a man, but from a big sack full of melons set upright against a wall. The loins seem to be modelled from a bag of lanky pumpkins; nobody can tell how his two legs are attached to that vile trunk; it is impossible to say on which leg he stands, or which he uses to exert his strength; nor does he seem to be resting upon both, as sculptors who know something of their art have occasionally set the figure. It is obvious that the body is leaning forward more than one-third of a cubit, which alone is the greatest and most insupportable fault committed by vulgar commonplace pretenders. Concerning the arms, they say that these are both stretched out without one touch of grace or one real spark of artistic talents just as if you had never seen a naked model. Again, the right leg of Hercules and that of Cacus have got one mass of flesh between them, so that if they were to be separated, not only one of them, but both together, would be left without a calf at the point where they are touching. They say, too, that Hercules has one of his feet underground, while the other seems to be resting on hot coals.'

The fellow could not stand quiet to hear the damning errors of his Cacus in their turn enumerated. For one thing, I was telling the truth; for another, I was unmasking him to the Duke and all the people present, who showed by face and gesture first their surprise, and next their conviction that what I said was true. All at once he burst out: 'Ah, you slanderous tongue! why don't you speak about my design?' I retorted: 'A good draughtsman can never produce bad works; therefore I am inclined to believe that your drawing is no better than your statues.' When he saw the amused expression on the Duke's face and the cutting gestures of the bystanders, he let his insolence get the better of him, and turned to me with that most hideous face of his, screaming aloud: 'Oh, hold your tongue, you ugly sodomite!' At these words the Duke frowned, and the others pursed their lips up and looked with knitted brows toward him. The horrible affront half maddened me with fury; but in a moment I recovered presence of mind enough to turn it off with a jest: 'You madman! you exceed the bounds of decency. Yet would to God that I understood so noble an art as you allude to; they say that Jove used it with Ganymede in paradise, and here upon this earth it is practised by some of the greatest emperors and kings. I, however, am but a poor humble creature, who neither have the power nor the intelligence to perplex my wits with anything so admirable.' When I had finished this speech, the Duke and his attendants could control themselves no longer, but broke into such shouts of laughter that one never heard the like. You must know, gentle readers, that though I put on this appearance of pleasantry, my heart was bursting in my body to think that a fellow, the foulest villain who ever breathed, should have dared in the presence of so great a prince to cast an insult of that atrocious nature in my teeth; but you must also know that he insulted the Duke, and not me; for had I not stood in that august presence, I should have felled him dead to earth. When the dirty stupid scoundrel observed that those gentlemen kept on laughing, he tried to change the subject, and divert them from deriding him; so he began as follows: 'This fellow Benvenuto goes about boasting that I have promised him a piece of marble.' I took him up at once. 'What! did you not send to tell me by your journeyman, Francesco, that if I wished to work in marble you would give me a block? I accepted it, and mean to have it.' He retorted: 'Be very well assured that you will never get it.' Still smarting as I was under the calumnious insults he had flung at me, I lost my self-control, forgot I was in the presence of the Duke, and called out in a storm of fury: 'I swear to you that if you do not send the marble to my house, you had better look out for another world, for if you stay upon this earth I will most certainly rip the wind out of your carcass.' Then suddenly awaking to the fact that I was standing in the presence of so great a duke, I turned submissively to his Excellency and said: 'My lord, one fool makes a hundred; the follies of this man have blinded me for a moment to the glory of your most illustrious Excellency and to myself. I humbly crave your pardon.'

372

82 *Apollo and Hyacinth*, marble by Cellini, *c.* 1547.
Florence, Bargello

Then the Duke said to Bandinello: 'Is it true that you promised him the marble?' He replied that it was true. Upon this the Duke addressed me: 'Go to the Opera, and choose a piece according to your taste.' I demurred that the man had promised to send it home to me. The words that passed between us were awful and I refused to take the stone in any other way. Next morning a piece of marble was brought to my house. On asking who had sent it, they told me it was Bandinello, and that this was the very block which he had promised.

I had it brought at once into my studio, and began to chisel it. While I was rough-hewing the block, I made a model. But my eagerness to work in marble was so strong, that I had not patience to finish the model as correctly as this art demands. I soon noticed that the stone rang false beneath my strokes, which made me oftentimes repent commencing on it. Yet I got what I could out of the piece – that is, the Apollo and Hyacinth, which may still be seen unfinished in

my workshop. While I was thus engaged, the Duke came to my house, and often said to me: 'Leave your bronze awhile, and let me watch you working on the marble.' Then I took chisel and mallet, and went at it blithely. He asked about the model I had made for my statue; to which I answered: 'Duke, this marble is all cracked, but I shall carve something from it in spite of that; therefore I have not been able to settle the model, but shall go on doing the best I can.'

His Excellency sent to Rome post-haste for a block of Greek marble, in order that I might restore his antique Ganymede, which was the cause of that dispute with Bandinello. When it arrived, I thought it a sin to cut it up for the head and arms and other bits wanting in the Ganymede; so I provided myself with another piece of stone, and reserved the Greek marble for a Narcissus which I modelled on a small scale in wax. I found that the block had two holes, *374* penetrating to the depth of a quarter of a cubit, and two good inches wide. This led me to choose the attitude which may be noticed in my statue, avoiding the holes and keeping my figure free from them. But rain had fallen scores of years upon the stone, filtering so deeply from the holes into its substance that the marble was decayed. Of this I had full proof at the time of a great inundation of the Arno, when the river rose to the height of more than a cubit and a half in my workshop. Now the Narcissus stood upon a square of wood, and the water *375* overturned it, causing the statue to break in two above the breasts. I had to join the pieces; and in order that the line of breakage might not be observed, I wreathed that garland of flowers round it which may still be seen upon the bosom. I went on working at the surface, employing *376* some hours before sunrise, or now and then on feast-days, so as not to lose the time I needed for my Perseus.

Having succeeded so well with the cast of the Medusa, I had great hope of bringing my Perseus through; for I had laid the wax on, and felt confident that it would come out in bronze as perfectly as the Medusa. The waxen model produced so fine an effect, that when the Duke saw it and was struck with its beauty – whether somebody had persuaded him it could not be carried out with the same finish in metal, or whether he thought so for himself – he came to visit me more frequently than usual, and on one occasion said: 'Benvenuto, this figure cannot succeed in bronze; the laws of art do not admit of it.' These words of his Excellency stung me so sharply that I answered: 'My lord, I know how very little confidence you have in me; and I believe the reason of this is that your most illustrious Excellency lends too ready an ear to my calumniators, or else indeed that you do not understand my art.' He hardly let me close the sentence when he broke in: 'I profess myself a connoisseur, and understand it very well indeed.' I replied: 'Yes, like a prince, not like an artist; for if your Excellency understood my trade as well as you imagine, you would trust me on the proofs I have already given. These are, first, the colossal bronze bust of your Excellency, which is now in Elba; secondly, the restoration of the *377* Ganymede in marble, which offered so many difficulties and cost me so much trouble, that I would rather have made the whole statue new from the beginning; thirdly, the Medusa, cast by me in bronze, here now before your Excellency's eyes, the execution of which was a greater triumph of strength and skill than any of my predecessors in this fiendish art have yet achieved. Look you, my lord! I constructed that furnace anew on principles quite different from those of other founders; in addition to many technical improvements and ingenious devices, I supplied it with two issues for the metal, because this difficult and twisted figure could not otherwise have come out perfect. It is only owing to my intelligent insight into means and appliances that the statue turned out as it did; a triumph judged impossible by all the practitioners of this art.'

With all the forces of my body and my purse, employing what little money still remained to me, I set to work. First I provided myself with several loads of pinewood from the forests of Serristori, in the neighbourhood of Montelupo. While these were on their way, I clothed my *378* Perseus with the clay which I had prepared many months beforehand, in order that it might be

83 *Narcissus*, marble by Cellini, 1548–65. Florence, Bargello

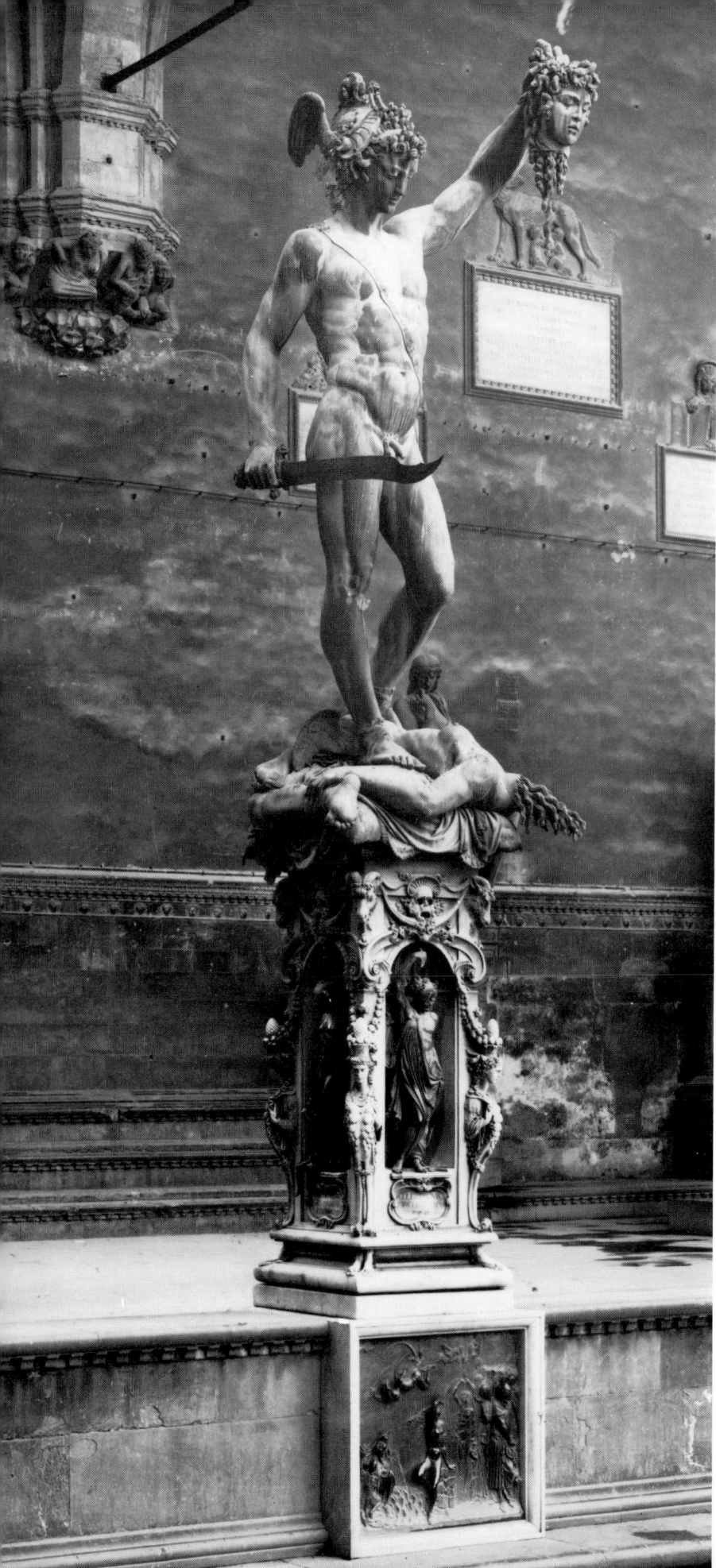

84 *Perseus with the head of Medusa*, bronze by Cellini, 1554. Florence, Loggia dei Lanzi

duly seasoned. After making its clay tunic (for that is the term used in this art) and properly arming it and fencing it with iron girders, I began to draw the wax out by means of a slow fire. This melted and issued through numerous air-vents I had made; for the more there are of these, the better will the mould fill. When I had finished drawing off the wax, I constructed a funnel-shaped furnace all round the model of my Perseus. It was built of bricks, so interlaced, the one above the other, that numerous apertures were left for the fire to exhale at. Then I began to lay on wood by degrees, and kept it burning two whole days and nights. At length, when all the wax was gone, and the mould was well baked, I set to work at digging the pit in which to sink it. This I performed with scrupulous regard to all the rules of art. When I had finished that part of my work, I raised the mould by windlasses and stout ropes to a perpendicular position, and suspending it with the greatest care one cubit above the level of the furnace, so that it hung exactly above the middle of the pit, I next lowered it gently down into the very bottom of the furnace, and had it firmly placed with every possible precaution for its safety. When this delicate operation was accomplished, I began to bank it up with the earth I had excavated; and, ever as the earth grew higher, I introduced its proper air-vents, which were little tubes of earthenware, such as folk use for drains and such-like purposes. At length, I felt sure that it was admirably fixed, and that the filling-in of the pit and the placing of the air-vents had been properly performed. I also could see that my workpeople understood my method, which differed very considerably from that of all the other masters in the trade. Feeling confident, then, that I could rely upon them, I next turned to my furnace, which I had filled with numerous pigs of copper and other bronze stuff. The pieces were piled according to the laws of art, that is to say, so resting one upon the other that the flames could play freely through them, in order that the metal might heat and liquefy the sooner. At last I called out heartily to set the furnace going. The logs of pine were heaped in, and, what with the unctuous resin of the wood and the good draught I had given, my furnace worked so well that I was obliged to rush from side to side to keep it going. The labour was more than I could stand; yet I forced myself to strain every nerve and muscle. To increase my anxieties, the workshop took fire, and we were afraid lest the roof should fall upon our heads; while, from the garden, such a storm of wind and rain kept blowing in, that it perceptibly cooled the furnace.

Battling thus with all these untoward circumstances for several hours, and exerting myself beyond even the measure of my powerful constitution, I could at last bear up no longer, and a sudden fever, of the utmost possible intensity, attacked me. I felt absolutely obliged to go and fling myself upon my bed. Sorely against my will having to drag myself away from the spot, I turned to my assistants, about ten or more in all, what with master-founders, hand-workers, country-fellows, and my own special journeymen, among whom was Bernardino Mannellini of Mugello, my apprentice through several years. To him in particular I spoke: 'Look, my dear Bernardino, that you observe the rules which I have taught you; do your best with all despatch, for the metal will soon be fused. You cannot go wrong; these honest men will get the channels ready; you will easily be able to drive back the two plugs with this pair of iron crooks; and I am sure that my mould will fill miraculously. I feel more ill than I ever did in all my life, and verily believe that it will kill me before a few hours are over.' Thus, with despair at heart, I left them, and betook myself to bed.

No sooner had I got to bed, than I ordered my serving-maids to carry food and wine for all the men into the workshop; at the same time I cried: 'I shall not be alive to-morrow.' They tried to encourage me, arguing that my illness would pass over, since it came from excessive fatigue. In this way I spent two hours battling with the fever, which steadily increased, and calling out continually: 'I feel that I am dying'. My housekeeper, who was named Mona Fiore da Castel del Rio, a very notable manager and no less warmhearted, kept chiding me for my discouragement; but, on the other hand, she paid me every kind attention which was possible. However, the sight of my physical pain and moral dejection so affected her, that, in spite of that brave heart of hers, she could not refrain from shedding tears; and yet, so far as she was able, she took good care I should not see them. While I was thus terribly afflicted, I beheld the figure of a

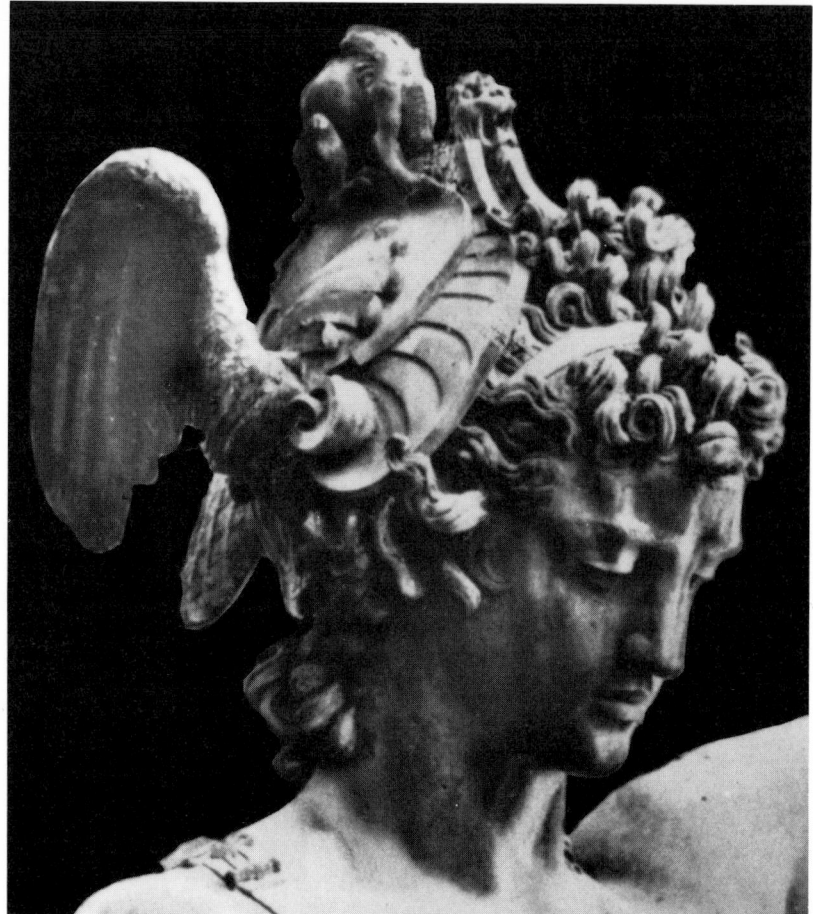

85 Detail of the head of Perseus from plate 84

man enter my chamber, twisted in his body into the form of a capital S. He raised a lamentable, doleful voice, like one who announces their last hour to men condemned to die upon the scaffold, and spoke these words: 'O Benvenuto! your statue is spoiled, and there is no hope whatever of saving it.' No sooner had I heard the shriek of that wretch than I gave a howl which might have been heard from the sphere of flame. Jumping from my bed, I seized my clothes and began to dress. The maids, and my lad, and every one who came around to help me, got kicks or blows of the fist, while I kept crying out in lamentation: 'Ah! traitors! enviers! This is an act of treason, done by malice prepense! But I swear by God that I will sift it to the bottom, and before I die will leave such witness to the world of what I can do as shall make a score of mortals marvel.'

When I had got my clothes on, I strode with soul bent on mischief toward the workshop; there I beheld the men, whom I had left erewhile in such high spirits, standing stupefied and downcast. I began at once and spoke: 'Up with you! Attend to me! Since you have not been able or willing to obey the directions I gave you, obey me now that I am with you to conduct my work in person. Let no one contradict me, for in cases like this we need the aid of hand and hearing, not of advice.' When I had uttered these words, a certain Maestro Alessandro *380* Lastricati broke silence and said: 'Look you, Benvenuto, you are going to attempt an enterprise which the laws of art do not sanction, and which cannot succeed.' I turned upon him with such fury and so full of mischief, that he and all the rest of them exclaimed with one voice: 'On then! Give orders! We will obey your least commands, so long as life is left in us.' I believe they spoke thus feelingly because they thought I must fall shortly dead upon the ground. I went

immediately to inspect the furnace, and found that the metal was all curdled; an accident which we express by 'being caked'. I told two of the hands to cross the road, and fetch from the house of the butcher Capretta a load of young oak-wood, which had lain dry for above a year; this wood had been previously offered me by Madame Ginevra, wife of the said Capretta. So soon as the first armfuls arrived, I began to fill the grate beneath the furnace. Now oak-wood of that kind heats more powerfully than any other sort of tree; and for this reason, where a slow fire is wanted, as in the case of gun-foundry, alder or pine is preferred. Accordingly, when the logs took fire, oh! how the cake began to stir beneath that awful heat, to glow and sparkle in a blaze! At the same time I kept stirring up the channels, and sent men upon the roof to stop the conflagration, which had gathered force from the increased combustion in the furnace; also I caused boards, carpets, and other hangings to be set up against the garden, in order to protect us from the violence of the rain. ₃₈₁

When I had thus provided against these several disasters, I roared out first to one man and then to another: 'Bring this thing here! Take that thing there!' At this crisis, when the whole gang saw the cake was on the point of melting, they did my bidding, each fellow working with the strength of three. I then ordered half a pig of pewter to be brought, which weighed about sixty pounds, and flung it into the middle of the cake inside the furnace. By this means, and by piling on wood and stirring now with pokers and now with iron rods, the curdled mass rapidly began to liquefy. Then, knowing I had brought the dead to life again, against the firm opinion of those ignoramuses, I felt such vigour fill my veins, that all those pains of fever, all those fears of death, were quite forgotten.

All of a sudden an explosion took place attended by a tremendous flash of flame, as though a thunderbolt had formed and been discharged amongst us. Unwonted and appalling terror astonished every one, and me more even than the rest. When the din was over and the dazzling light extinguished, we began to look each other in the face. Then I discovered that the cap of the furnace had blown up, and the bronze was bubbling over from its source beneath. So I had the mouths of my mould immediately opened, and at the same time drove in the two plugs which kept back the molten metal. But I noticed that it did not flow as rapidly as usual, the reason being probably that the fierce heat of the fire we kindled had consumed its base alloy. Accordingly I sent for all my pewter platters, porringers, and dishes, to the number of some two hundred pieces, and had a portion of them cast, one by one, into the channels, the rest into the furnace. This expedient succeeded, and every one could now perceive that my bronze was in most perfect liquefaction, and my mould was filling; whereupon they all with heartiness and happy cheer assisted and obeyed my bidding, while I, now here, now there, gave orders, helped with my own hands, and cried aloud: 'O God! Thou that by Thy immeasurable power didst rise from the dead, and in Thy glory didst ascend to heaven!' . . . even thus in a moment my mould was filled; and seeing my work finished, I fell upon my knees, and with all my heart gave thanks to God.

After all was over, I turned to a plate of salad on a bench there, and ate with hearty appetite, and drank together with the whole crew. Afterwards I retired to bed, healthy and happy, for it was now two hours before morning, and slept as sweetly as though I had never felt a touch of illness. My good housekeeper, without my giving any orders, had prepared a fat capon for my repast. So that, when I rose, about the hour for breaking fast, she presented herself with a smiling countenance, and said: 'Oh! is that the man who felt that he was dying? Upon my word, I think the blows and kicks you dealt us last night, when you were so enraged, and had that demon in your body as it seemed, must have frightened away your mortal fever! The fever feared that it might catch it too, as we did!' All my poor household relieved in like measure from anxiety and overwhelming labour, went at once to buy earthen vessels in order to replace the pewter I had cast away. Then we dined together joyfully; nay, I cannot remember a day in my whole life when I dined with greater gladness or a better appetite.

After I had let my statue cool for two whole days, I began to uncover it by slow degrees. The first thing I found was that the head of Medusa had come out most admirably, thanks to the air-

86–89 The four statues for the base of the *Perseus*: left to right, *Jupiter*, *Minerva*, *Mercury*, and *Danaë with the young Perseus*. Bronze, 1545–50. Florence, Bargello

vents; for, as I had told the Duke, it is the nature of fire to ascend. Upon advancing farther, I discovered that the other head, that, namely, of Perseus, had succeeded no less admirably; and this astonished me far more, because it is at a considerably lower level than that of the Medusa. Now the mouths of the mould were placed above the head of Perseus and behind his shoulders; and I found that all the bronze my furnace contained had been exhausted in the head of this figure. It was a miracle to observe that not one fragment remained in the orifice of the channel, and that nothing was wanting to the statue. In my great astonishment I seemed to see in this the hand of God arranging and controlling all.

I went on uncovering the statue with success, and ascertained that everything had come out in perfect order, until I reached the foot of the right leg on which the statue rests. There the heel itself was formed, and going farther, I found the foot apparently complete. This gave me great joy on the one side, but was half unwelcome to me on the other, merely because I had told the Duke that it could not come out. However, when I reached the end, it appeared that the toes *382* and a little piece above them were unfinished, so that about half the foot was wanting. Although I knew that this would add a trifle to my labour, I was very well pleased because I could now prove to the Duke how well I understood my business. It is true that far more of the foot than I expected had been perfectly formed; the reason of this was that from causes I have recently described, the bronze was hotter than our rules of art prescribe; also that I had been

90 *Perseus freeing Andromeda*, relief from the base of the *Perseus*. Bronze, 1545–50. Florence, Bargello

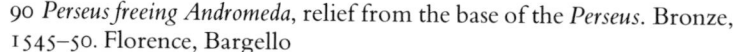

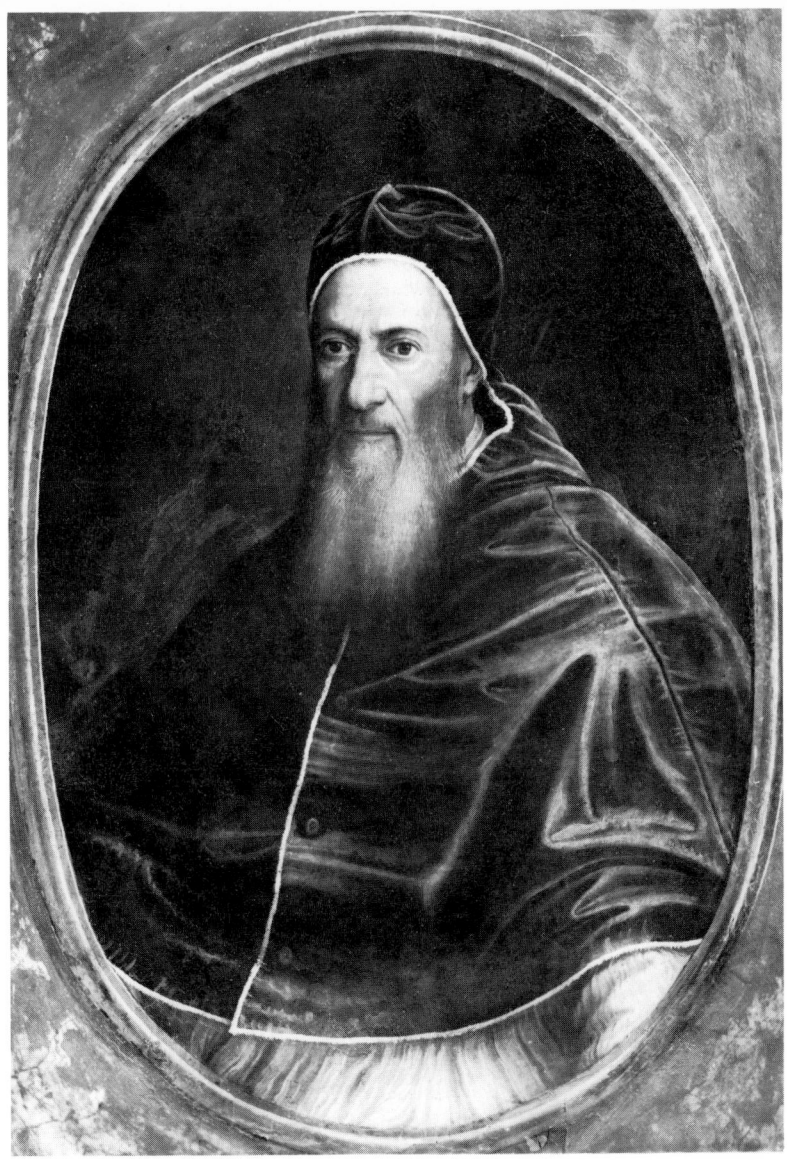

91 *Pope Julius III* by Girolamo Siciolante da Sermoneta. Rome, Galleria di Palazzo Spada (*See note 383*)

obliged to supplement the alloy with my pewter cups and platters, which no one else, I think, had ever done before.

Having now ascertained how successfully my work had been accomplished, I lost no time in hurrying to Pisa, where I found the Duke. He gave me a most gracious reception, as did also the Duchess; and although the majordomo had informed them of the whole proceedings, their Excellencies deemed my performance far more stupendous and astonishing when they heard the tale from my own mouth. When I arrived at the foot of Perseus, and said it had not come out perfect, just as I previously warned his Excellency, I saw an expression of wonder pass over his face, while he related to the Duchess how I had predicted this beforehand. Observing the princes to be so well disposed towards me, I begged leave from the Duke to go to Rome. He granted it in most obliging terms, and bade me return as soon as possible to complete his Perseus; giving me letters of recommendation meanwhile to his ambassador, Averardo Serristori. We were then in the first years of Pope Giulio de Monti. 383

Before leaving home, I directed my workpeople to proceed according to the method I had taught them. The reason of my journey was as follows. I had made a life-sized bust in bronze of

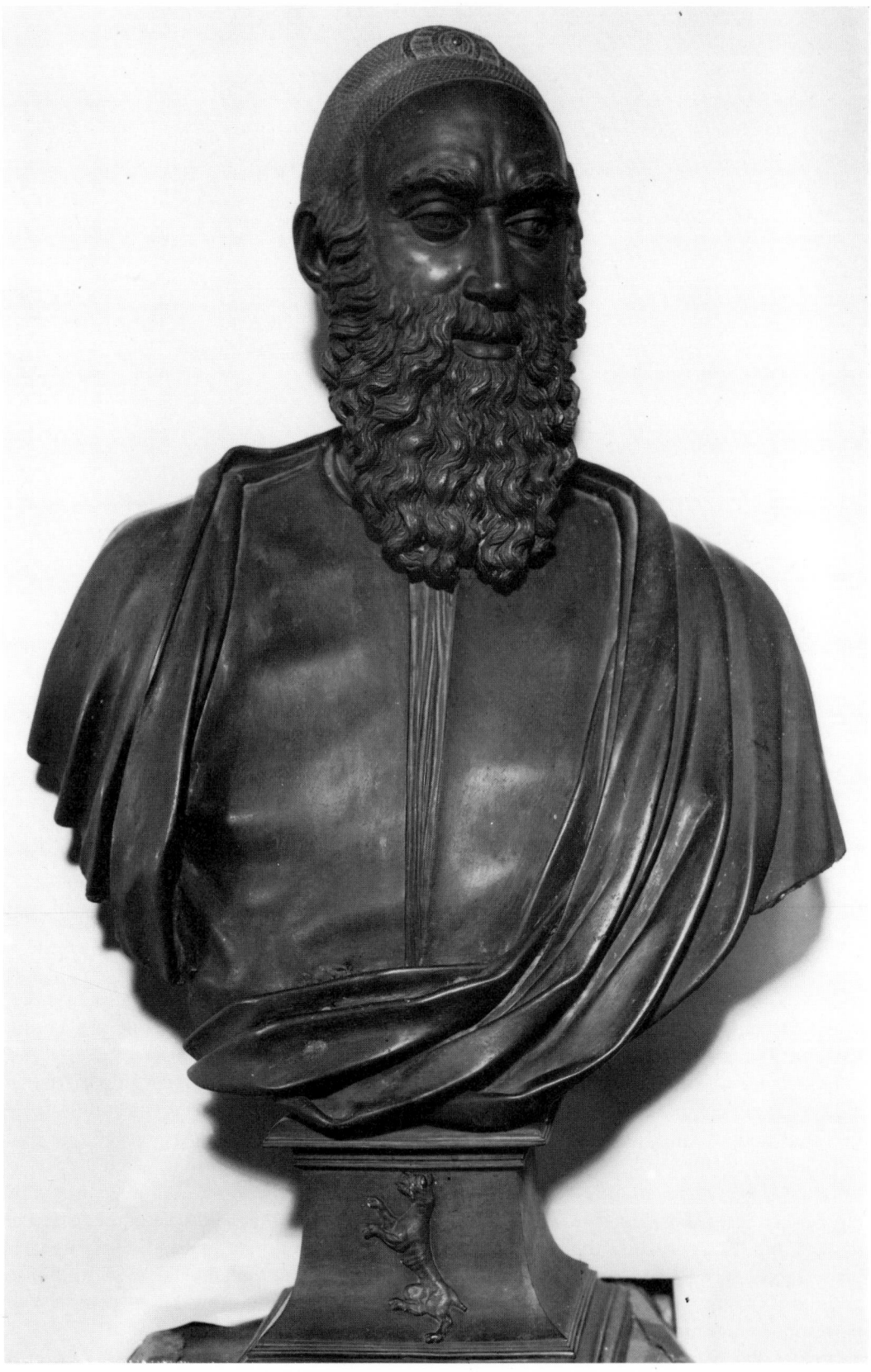

92 Bindo Altoviti, bust by Cellini, *c.*1550. Bronze. Boston, Isabella Stewart
Gardner Museum

Bindo Altoviti, the son of Antonio, and had sent it to him at Rome. He set it up in his study, 384
which was very richly adorned with antiquities and other works of art; but the room was not
designed for statues or for paintings, since the windows were too low, so that the light coming
from beneath spoiled the effect they would have produced under more favourable conditions.
It happened one day that Bindo was standing at his door, when Michel Agnolo Buonarroti, the
sculptor, passed by; so he begged him to come in and see his study. Michel Agnolo followed,
and on entering the room and looking round, he exclaimed: 'Who is the master who made that
good portrait of you in so fine a manner? You must know that that bust pleases me as much, or
even more, than those antiques; and yet there are many fine things to be seen among the latter.
If those windows were above instead of beneath, the whole collection would show to greater
advantage, and your portrait, placed among so many masterpieces, would hold its own with
credit.' No sooner had Michel Agnolo left the house of Bindo than he wrote me a very kind
letter, which ran as follows: 'My dear Benvenuto, I have known you for many years as the
greatest goldsmith of whom we have any information; and henceforward I shall know you for
a sculptor of like quality. I must tell you that Master Bindo Altoviti took me to see his bust in
bronze, and informed me that you had made it. I was greatly pleased with the work; but it
annoyed me to notice that it was placed in a bad light; for if it were suitably illuminated, it
would show itself to be the fine performance that it is.' This letter abounded with the most 385
affectionate and complimentary expressions towards myself; and before I left for Rome, I
showed it to the Duke, who read it with much kindly interest, and said to me: 'Benvenuto, if
you write to him, and can persuade him to return to Florence, I will make him a member of the
Forty-eight.' Accordingly I wrote a letter full of warmth, and offered in the Duke's name a 386
hundred times more than my commission carried; but not wanting to make any mistake, I
showed this to the Duke before I sealed it, saying to his most illustrious Excellency: 'Prince,
perhaps I have made him too many promises.' He replied: 'Michel Agnolo deserves more than
you have promised, and I will bestow on him still greater favours.' To this letter he sent no
answer, and I could see that the Duke was much offended with him.

When I reached Rome, I went to lodge in Bindo Altoviti's house. One of the first things I did
was to go and kiss the Pope's feet; and while I was speaking with his Holiness, Messer Averado
Serristori, our Duke's Envoy, arrived. I had made some proposals to the Pope, which I think he
would have agreed upon, and I should have been very glad to return to Rome on account of the
great difficulties which I had at Florence. But I soon perceived that the ambassador had
countermined me.

Then I went to visit Michel Agnolo Buonarroti, and repeated what I had written from
Florence to him in the Duke's name. He replied that he was engaged upon the fabric of St
Peter's, and that this would prevent him from leaving Rome. I rejoined that, as he had decided 387
on the model of that building, he could leave its execution to his man Urbino, who would 388
carry out his orders to the letter. I added much about future favours, in the form of a message
from the Duke. Upon this he looked me hard in the face, and said with a sarcastic smile: 'And
you! to what extent are you satisfied with him?' Although I replied that I was extremely
contented and was very well treated by his Excellency, he showed that he was acquainted with
the greater part of my annoyances, and gave as his final answer that it would be difficult for him
to leave Rome.

I returned in bad spirits to Florence. I went at once to the palace to pay my respects to the
Duke, whom I found to be at Castello beyond Ponte a Rifredi. In the palace I met Messer Pier 389
Francesco Ricci, the majordomo, and when I drew nigh to pay him the usual compliments, he
exclaimed with measureless astonishment: 'Oh, are you come back?' and with the same air of
surprise, clapping his hands together, he cried: 'The Duke is at Castello!' then turned his back
and left me.

About this time the war of Siena broke out, and the Duke, wishing to fortify Florence,
distributed the gates among his architects and sculptors. I received the Prato gate and 390
the little one of Arno, which is on the way to the mills. The Cavaliere Bandinello 391

93 *Chimera of Arezzo*, Etruscan, restored by Cellini in 1554. Bronze.
Florence, Museo Archeologico

got the gate of San Friano; Pasqualino d'Ancona, the gate at San Pier Gattolini; Giulian
di Baccio d'Agnolo, the wood-carver, had the gate of San Giorgio; Particino, the
wood-carver, had the gate of Santo Niccolo; Francesco da San Gallo, the sculptor,
called Il Margolla, got the gate of Santa Croce; and Giovan Battista, surnamed Il Tasso,
392 the gate Pinti. Other bastions and gates were assigned to divers engineers, whose names I do
not recollect, nor indeed am I concerned with them. The Duke, who certainly was at all
times a man of great ability, went round the city himself upon a tour of inspection, and when
he had made his mind up, he sent for Lattanzio Gorini, one of his paymasters. Now this man
was to some extent an amateur of military architecture; so his Excellency commissioned him
to make designs for the fortifications of the gates, and sent each of us his own gate drawn
according to the plan. After examining the plan for mine, and perceiving that it was very
incorrect in many details, I took it and went immediately to the Duke. When I tried to point
out these defects, the Duke interrupted me and exclaimed with fury: 'Benvenuto, I will give
way to you upon the point of statuary, but in this art of fortification I choose that you should
cede to me. So carry out the design which I have given you.' To these brave words I answered
as gently as I could, and said: 'My lord, your most illustrious Excellency has taught me
something even in my own fine art of statuary, inasmuch as we have always exchanged ideas
upon that subject; I beg you then to deign to listen to me upon this matter of your
fortifications, which is far more important than making statues. If I am permitted to discuss it
also with your Excellency, you will be better able to teach me how I have to serve you.' This
courteous speech of mine induced him to discuss the plans with me; and when I had clearly

94 The *Salone dei Cinquecento*, planned and decorated by Vasari and his assistants. Florence, Palazzo Vecchio

demonstrated that they were not conceived on a right method, he said: 'Go, then, and make a design yourself, and I will see if it satisfies me.' Accordingly, I made two designs according to the right principles for fortifying those two gates, and took them to him; and when he distinguished the true from the false system, he exclaimed good-humouredly: 'Go and do it in your own way, for I am content to have it so.' I set to work then with the greatest diligence. When I had finished my bastions, I touched some score of crowns, which I had not expected, and which were uncommonly welcome. So I returned with a blithe heart to finish my Perseus.

During those days some antiquities had been discovered in the country round Arezzo. Among them was the Chimæra, that bronze lion which is to be seen in the rooms adjacent to the great hall of the palace. Together with the Chimæra a number of little statuettes, likewise *393* in bronze, had been brought to light; they were covered with earth and rust, and each of them lacked either head or hands or feet. The Duke amused his leisure hours by cleaning up these statuettes himself with certain little chisels used by goldsmiths. It happened on one occasion *394* that I had to speak on business to his Excellency; and while we were talking, he reached me a little hammer, with which I struck the chisels the Duke held, and so the figures were disengaged from their earth and rust. In this way we passed several evenings, and then the Duke commissioned me to restore the statuettes. He took so much pleasure in these trifles that he made me work by day also, and if I delayed coming, he used to send for me. *395*

About this time the new apartments were built toward the lions; the Duke then wishing to *396* be able to retire into a less public part of the palace, fitted up for himself a little chamber in these new lodgings, and ordered me to approach it by a private passage. I had to pass through his

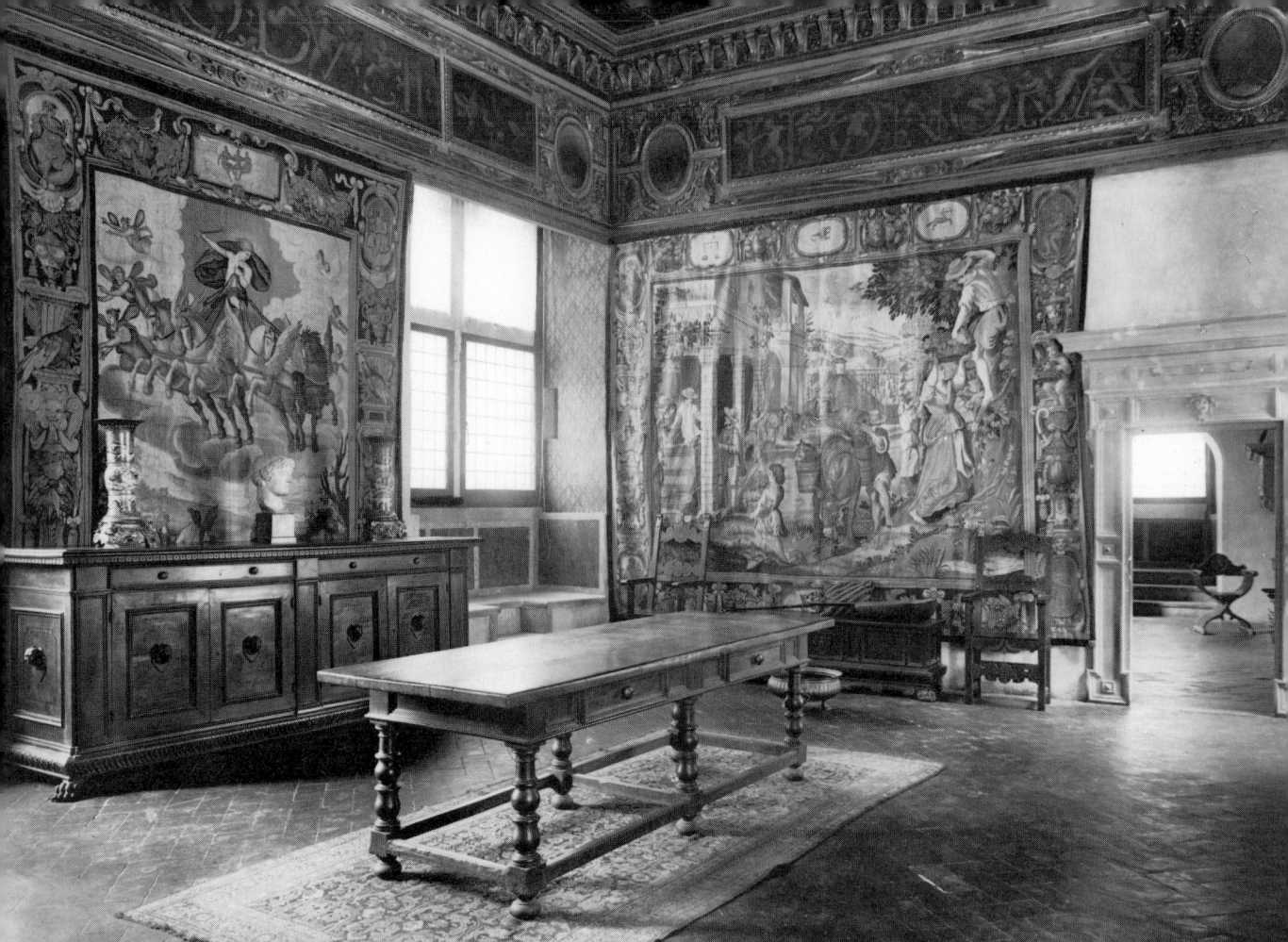

95 The *Sala di Ester*, the Duchess's quarters, decorated by Vasari and Stradano, 1561–2. Florence, Palazzo Vecchio

397 wardrobe, then across the stage of the great hall, and afterwards through certain little dark galleries and cabinets. The Duchess, however, after a few days, deprived me of this means of access by having all the doors upon the path I had to traverse locked up. The consequence was that every evening when I arrived at the palace, I had to wait a long while, because the Duchess occupied the cabinets for her personal necessities. Her habit of body was unhealthy, and so I never came without incommoding her. This and other causes made her hate the very sight of me. However, notwithstanding great discomforts and daily annoyances, I persevered in going. The Duke's orders, meanwhile, were so precise, that no sooner did I knock at those doors, than they were immediately opened, and I was allowed to pass freely where I chose. The consequence was that occasionally, while walking noiselessly and unexpectedly through the private rooms, I came upon the Duchess at a highly inconvenient moment. Bursting then into such a furious storm of rage that I was frightened, she cried out: 'When will you ever finish mending up those statuettes? Upon my word, this perpetual going and coming of yours has grown to be too great a nuisance.' I replied as gently as I could: 'My lady and sole mistress, I have no other desire than to serve you loyally and with the strictest obedience. This work to which the Duke has put me will last several months; so tell me, most illustrious Excellency, whether you wish me not to come here any more. In that case I will not come, whoever calls me; nay, should the Duke himself send for me, I shall reply that I am ill, and by no means will I intrude again.' To this speech she made answer: 'I do not bid you not to come, nor do I bid you to disobey the Duke; but I repeat that your work seems to me as though it would never be finished.'

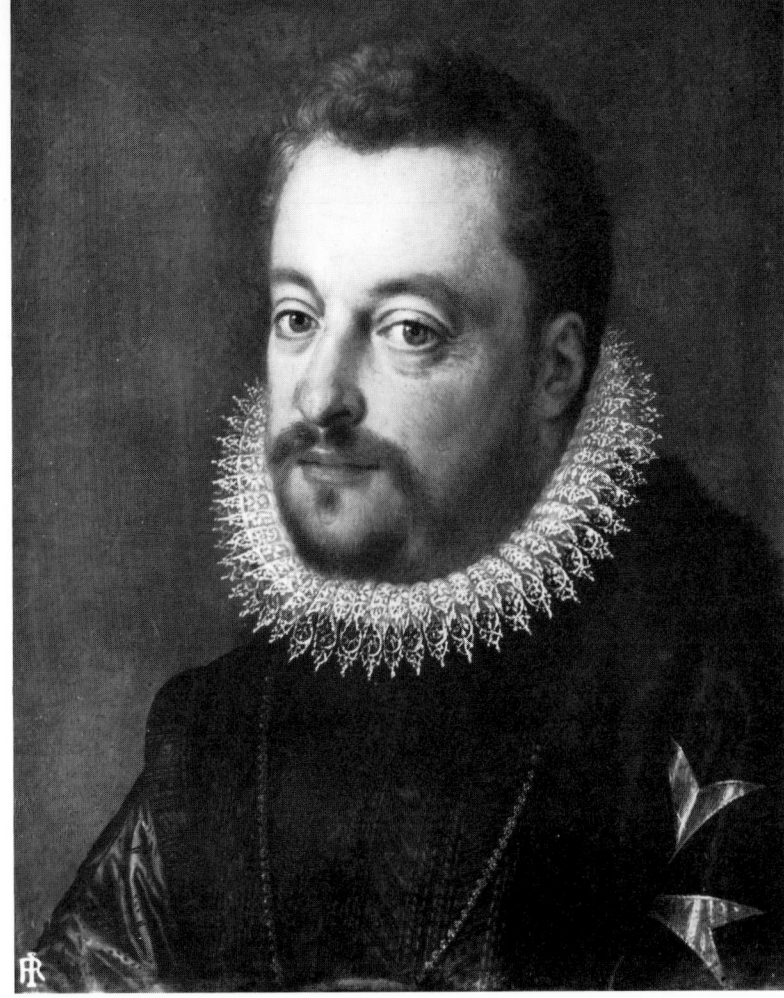

96 *Portrait of Ferdinando I de' Medici* by Scipione Pulzone. Florence, Palazzo Pitti

Whether the Duke heard something of this encounter, or whatever the cause was, he began again as usual. Toward twenty-four o'clock he sent for me; and his messenger always spoke to this effect: 'Take good care, and do not fail to come, for the Duke is waiting for you.' In this way I continued, always with the same inconveniences, to put in an appearance on several successive evenings. Upon one occasion among others, arriving in my customary way, the Duke, who had probably been talking with the Duchess about private matters, turned upon me in a furious anger. I was terrified, and wanted to retire. But he called out: 'Come in, friend Benvenuto; go to your affairs; I will rejoin you in a few moments.'

While I was working at these bagatelles, the Prince, and Don Giovanni, and Don Arnando, and Don Garzia kept always hovering around me, teasing me whenever the Duke's eyes were turned. I begged them for mercy's sake to hold their peace. They answered: 'That we cannot do.' I told them: 'What one cannot is required of no one! So have your will! Along with you!' At this both Duke and Duchess burst out laughing. 398

Another evening, after I had finished the small bronze figures which are wrought into the pedestal of Perseus, that is to say, the Jupiter, Mercury, Minerva, and Danæ, with the little Perseus seated at his mother's feet, I had them carried into the room where I was wont to work, and arranged them in a row, raised somewhat above the line of vision, so that they produced a magnificent effect. The Duke heard of this, and made his entrance sooner than usual. It seems that the person who informed his Excellency praised them above their merit, using terms like 'far superior to the ancients', and so forth; wherefore the Duke came talking pleasantly with the Duchess about my doings. I rose at once and went to meet them. With his fine and truly 399

princely manner he received me, lifting his right hand, in which he held as superb a pear-graft as could possibly be seen. 'Take it, my Benvenuto!' he exclaimed; 'plant this pear in your garden.' To these words I replied with a delighted gesture: 'O my lord, does your most illustrious Excellency really mean that I should plant it in the garden of my house?' 'Yes,' he said, 'in the garden of the house which belongs to you. Have you understood me?' I thanked his Excellency, and the Duchess in like manner, with the best politeness I could use.

After this they both took seats in front of the statues, and for more than two hours went on talking about nothing but the beauties of the work. The Duchess was wrought up to such an enthusiasm that she cried out: 'I do not like to let those exquisite figures be wasted on the pedestal down there in the piazza, where they will run the risk of being injured. I would much rather have you fix them in one of my apartments, where they will be preserved with the respect due to their singular artistic qualities.' I opposed this plan with many forcible arguments; but when I saw that she was determined I should not place them on the pedestal where they now stand, I waited till next day, and went to the palace about twenty-two o'clock. Ascertaining that the Duke and Duchess were out riding, and having already prepared the pedestal, I had the statues carried down, and soldered them with lead into their proper niches. Oh, when the Duchess knew of this, how angry she was! Had it not been for the Duke, who manfully defended me, I should have paid dearly for my daring.

I returned to the Loggia, whither my Perseus had already been brought, and went on putting the last touches to my work, under the old difficulties always; that is to say, lack of money, and a hundred untoward accidents, the half of which would have cowed a man armed with adamant.

However, I pursued my course as usual; and one morning, after I had heard mass at San Piero Scheraggio, that brute Bernardone, broker, worthless goldsmith, and by the Duke's grace purveyor to the mint, passed by me. No sooner had he got outside the church than the dirty pig let fly four cracks which might have been heard from San Miniato. I cried: 'Yah! pig, poltroon, donkey! is that the noise your filthy talents make?' and ran off for a cudgel. He took refuge on the instant in the mint; while I stationed myself inside my house-door, which I left ajar, setting a boy at watch upon the street to warn me when the pig should leave the mint. After waiting some time, I grew tired, and my heat cooled. Reflecting, then, that blows are not dealt by contract, and that some disaster might ensue, I resolved to wreak my vengeance by another method. The incident took place about the feast of our San Giovanni, one or two days before; so I composed four verses, and stuck them up in an angle of the church where people go to ease themselves. The verses ran as follows:

> Here lieth Bernardone, ass and pig,
> Spy, broker, thief, in whom Pandora planted
> All her worst evils, and from thence transplanted
> Into that brute Buaccio's carcass big.

Both the incident and the verses went the round of the palace, giving the Duke and Duchess much amusement. But, before the man himself knew what I had been up to, crowds of people stopped to read the lines and laughed immoderately at them. Since they were looking towards the mint and fixing their eyes on Bernardone, his son, Maestro Baccio, taking notice of their gestures, tore the paper down with fury. The elder bit his thumb, shrieking threats with that hideous voice of his, which comes forth through his nose; indeed he made a brave defiance.

When the Duke was informed that the whole of my work for the Perseus could be exhibited as finished, he came one day to look at it. His manner showed clearly that it gave him great satisfaction; but afterwards he turned to some gentlemen attending him and said: 'Although this statue seems in our eyes a very fine piece, still it has yet to win the favour of the people. Therefore, my Benvenuto, before you put the very last touches on, I should like you, for my sake, to remove a part of the scaffolding on the side of the piazza, some day toward noon, in order that we may learn what folk think of it.'

400
401
402

403

404

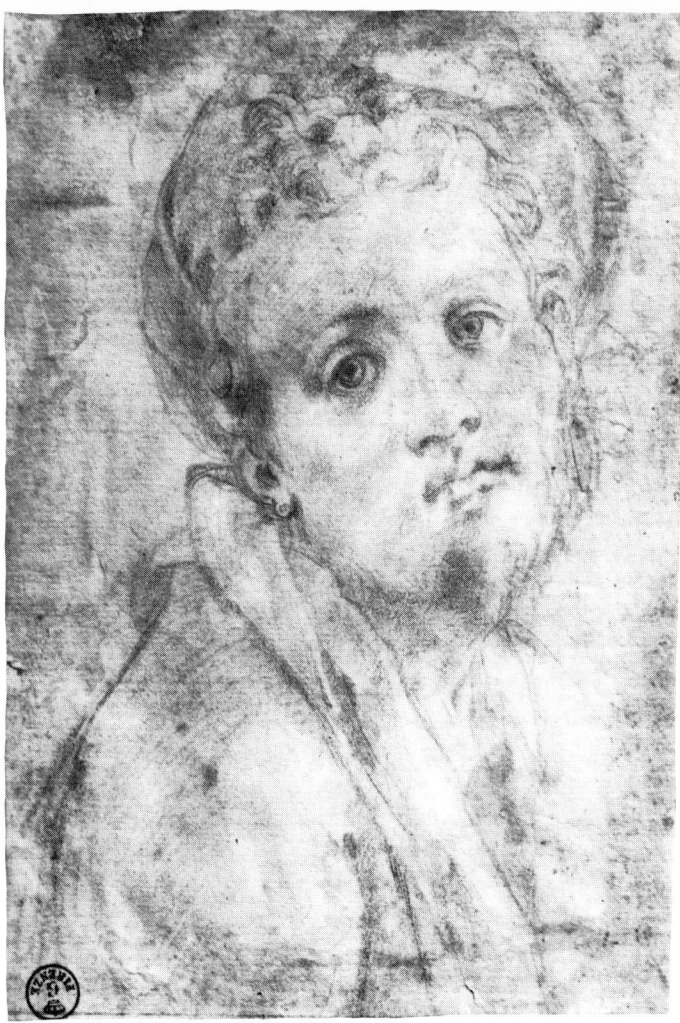

97 *Self-portrait* of Pontormo, *c.* 1528. Florence, Galleria degli Uffizi (Gabinetto dei Disegni)

When the Duke had left, I gave orders to have the screen removed. Yet some trifles of gold, varnish, and various other little finishings were still wanting; wherefore I began to murmur and complain indignantly, cursing the unhappy day which brought me to Florence. Too well I knew already the great and irreparable sacrifice I made when I left France; nor could I discover any reasonable ground for hope that I might prosper in the future with my prince and patron. From the commencement to the middle and the ending, everything that I had done had been performed to my great disadvantage. Therefore, it was with deep ill-humour that I disclosed my statue on the following day.

Now it pleased God that, on the instant of its exposure to view, a shout of boundless enthusiasm went up in commendation of my work, which consoled me not a little. The folk kept on attaching sonnets to the posts of the door, which was protected with a curtain while I gave the last touches to the statue. I believe that on the same day when I opened it a few hours to the public, more than twenty were nailed up, all of them overflowing with the highest panegyrics. Afterwards, when I once more shut it off from view, every day brought sonnets, with Latin and Greek verses; for the University of Pisa was then in vacation, and all the doctors and scholars kept vying with each other who could praise it best. But what gratified me most, and inspired me with most hope of the Duke's support, was that the artists, sculptors and painters alike, entered into the same generous competition. I set the highest value on the eulogies of that excellent painter Jacopo Pontormo, and still more on those of his able pupil

405

406

407

408 Bronzino, who was not satisfied with merely publishing his verses, but sent them by his lad
409 Sandrino's hand to my own house. They spoke so generously of my performance, in that fine
style of his which is most exquisite, that this alone repaid me somewhat for the pain of my long
troubles. So then I closed the screen, and once more set myself to finishing my statue.

The great compliments which this short inspection of my Perseus had elicited from the
noble school of Florence, though they were well known to the Duke, did not prevent him
from saying: 'I am delighted that Benvenuto has had this trifling satisfaction, which will spur
him on to the desired conclusion with more speed and diligence. Do not, however, let him
imagine that, when his Perseus shall be finally exposed to view from all sides, folk in general
will be so lavish of their praises. On the contrary, I am afraid that all its defects will then be
brought home to him, and more will be detected than the statue really has. So let him arm
himself with patience.' These were precisely the words which Bandinello had whispered in the
410 Duke's ears, citing the works of Andrea del Verrocchio, who made that fine bronze of Christ
and St Thomas on the front of Orsanmichele; at the same time he referred to many other
411 statues, and dared even to attack the marvellous David of divine Michel Agnolo Buonarroti,
accusing it of only looking well if seen in front; finally, he touched upon the multitude of
sarcastic sonnets which were called forth by his own Hercules and Cacus, and wound up with
abusing the people of Florence. Now the Duke, who was too much inclined to credit his
assertions, encouraged the fellow to speak thus, and thought in his own heart that things would
go as he had prophesied, because that envious creature Bandinello never ceased insinuating
malice. On one occasion it happened that the gallows bird Bernardone, the broker, was present
at these conversations, and in support of Bandinello's calumnies, he said to the Duke: 'You
must remember, prince, that statues on a large scale are quite a different dish of soup from little
figures. I do not refuse him the credit of being excellent at statuettes in miniature. But you will
soon see that he cannot succeed in that other sphere of art.' To these vile suggestions he added
many others of all sorts, plying his spy's office, and piling up a mountain of lies to boot.

Now it pleased my glorious Lord and immortal God that at last I brought the whole work to
completion: and on a certain Thursday morning I exposed it to the public gaze. Immediately,
before the sun was fully in the heavens, there assembled such a multitude of people that no
words could describe them. All with one voice contended which should praise it most. The
folk kept pointing me out as something marvellous and strange. Among the many who did so,
412 were two gentlemen, deputed by the Viceroy of Sicily to our Duke on public business. Now
these two agreeable persons met me upon the piazza: I had been shown them in passing, and
now they made monstrous haste to catch me up; then, with caps in hand, they uttered an
oration so ceremonious, that it would have been excessive for a Pope. I bowed, with every
protestation of humility. They meanwhile continued loading me with compliments, until at
last I prayed them, for kindness' sake, to leave the piazza in my company, because the folk were
stopping and staring at me more than at my Perseus. In the midst of all these ceremonies, they
went so far as to propose that I should come to Sicily, and offered to make terms which should
413 content me. They told me how Fra Giovan Agnolo de' Servi had constructed a fountain for
them, complete in all its parts, and decorated with a multitude of figures; but it was not in the
same good style they recognized in Perseus, and yet they had heaped riches on the man. I cut
their ceremonies short, thanking them for the high praises they had bestowed upon me, which
were indeed the best reward that artists could receive for their labours. I told them they had
greatly stimulated my zeal, so that I hoped, after a few years were passed, to exhibit another
masterpiece, which I dared believe would yield far truer satisfaction to our noble school of
Florence. The two gentlemen were eager to resume the thread of their complimentary
proposals, whereupon I, lifting my cap and making a profound bow, bade them a polite
farewell.
414 The day after next I betook me to the palace. Messer Giacopo Guidi, secretary to his
Excellency, called me with his wry mouth and haughty voice: 'The Duke says he wants you to
tell him how much you ask for your Perseus.' I exclaimed that if the Duke gave me ten

thousand crowns I should not be paid enough. Upon the following day, when I paid my respects to the Duke, he beckoned to me. I approached, and he exclaimed in anger: 'Cities and great palaces are built with ten thousands of ducats.' I rejoined: 'Your Excellency can find multitudes of men who are able to build you cities and palaces, but you will not, perhaps, find one man in the world who could make a second Perseus.' Then I took my leave without saying or doing anything farther.

About that time I was very intimate with Girolamo degli Albizzi, commissary of the Duke's militia. One day this friend said to me: 'O Benvenuto, it would not be a bad thing to put your little difference of opinion with the Duke to rights; and I assure you that if you repose confidence in me, I feel myself the man to settle matters. I know what I am saying.' Girolamo then composed a letter, with much skill and greatly to my honour, fixing the sum which the Duke would have to pay me at 3500 golden crowns in gold; and this should not be taken as my proper recompense for such a masterpiece, but only as a kind of gratuity; enough to say that I was satisfied; with many other phrases of like tenor, all of which implied the price which I have mentioned. *415*

The Duke signed this agreement as gladly as I took it sadly. When the Duchess heard, she said: 'It would have been better for that poor man if he had placed himself in my hands; I could have got him five thousand crowns in gold.' One day, when I went to the palace, she repeated these same words to me in the presence of Messer Alamanno Salviati, and laughed at me a little, saying that I deserved my bad luck. *416*

I ought to add that a few days before he came to terms with Albizzi, the Duke had shown he was excessively displeased with me. The reason was as follows: I complained of some abominable acts of injustice done to me by Messer Alfonso Quistelli, Messer Jacopo Polverino of the Exchequer, and more than all by Ser Giovanbattista Brandini of Volterra. When, therefore, I set forth my cause with some vehemence, the Duke flew into the greatest rage conceivable. Being thus in anger, he exclaimed: 'This is just the same as with your Perseus, when you asked those ten thousand crowns. You let yourself be blinded by mere cupidity. Therefore I shall have the statue valued, and shall give you what the experts think it worth.' To these words I replied with too much daring and a touch of indignation, which is always out of place in dealing with great princes: 'How is it possible that my work should be valued at its proper worth when there is not a man in Florence capable of performing it?' That increased his irritation; he uttered many furious phrases, and among them said: 'There is in Florence at this day a man well able to make such a statue, and who is therefore highly capable of judging it.' He meant Bandinello, Cavaliere of St Jacopo.

His Excellency sent for the Archbishop of Pisa, named De' Bartolini, and Messer Pandolfo della Stufa, requesting them to order Baccio Bandinelli, in his name, to examine well my Perseus and value it, since he wished to pay its exact price. These excellent men went forthwith and performed their embassy. In reply Bandinello said that he had examined the statue minutely, and knew well enough what it was worth; but having been on bad terms otherwise with me for some time past, he did not care to be entangled anyhow in my affairs. Then they began to put a gentle pressure on him, saying: 'The Duke ordered us to tell you, under pain of his displeasure, that you are to value the statue, and you may have two or three days to consider your estimate. When you have done so, tell us at what price it ought to be paid.' He answered that his judgment was already formed, that he could not disobey the Duke, and that my work was rich and beautiful and excellent in execution; therefore he thought sixteen thousand crowns or more would not be an excessive price for it. Those good and courteous gentlemen reported this to the Duke, who was mightily enraged; they also told the same to me. I replied that nothing in the world would induce me to take praise from Bandinello, 'seeing that this bad man speaks ill of everybody.'

The Duke sent me word by Messer Lelio Torello, his Master of the Rolls, that he wanted me to execute some bas-reliefs in bronze for the choir of St Maria del Fiore. Now the choir was by Bandinello, and I did not choose to enrich his bad work with my labours. He had not indeed *417*
418
419

420 designed it, for he understood nothing whatever about architecture; the design was given by Giuliano, the son of that Baccio d'Agnolo, the wood-carver, who spoiled the cupola. Suffice it to say that it shows no talent. For both reasons I was determined not to undertake the task, although I told the Duke politely that I would do whatever his most illustrious Excellency ordered. Accordingly, he put the matter into the hands of the Board of Works for St Maria del Fiore.

In due course I came before the Board. In the first place, I said that the construction of the choir was altogether incorrect without proportion, art, convenience, grace, or good design. In the next place, the bas-reliefs would have to stand too low, beneath the proper line of vision; they would become a place for dogs to piss at, and be always full of ordure. Consequently, I declined positively to execute them. However, since I did not wish to throw away the best years of my life, and was eager to serve his most illustrious Excellency, whom I had the sincerest desire to gratify and obey, I made the following proposal. Let the Duke, if he wants to employ my talents, give me the middle door of the cathedral to perform in bronze. This would be well seen, and would confer far more glory on his most illustrious Excellency. I would bind myself by contract to receive no remuneration unless I produced something better

421 than the finest of the Baptistery doors. But if I completed it according to my promise, then I was willing to have it valued, and to be paid one thousand crowns less than the estimate made by experts.

422 The members of the Board were well pleased with this suggestion, and went at once to report the matter to the Duke, among them being Piero Salviati. They expected him to be extremely gratified with their communication, but it turned out just the contrary. He replied that I was always wanting to do the exact opposite of what he bade me; and so Piero left him without coming to any conclusion. On hearing this, I went off to the Duke at once, who displayed some irritation when he saw me. However, I begged him to condescend to hear me, and he replied that he was willing. I then began from the beginning, and used such convincing arguments that he saw at last how the matter really stood, since I made it evident that he would only be throwing a large sum of money away. Then I softened his temper by suggesting that if his most illustrious Excellency did not care to have the door begun, two pulpits had anyhow to be made for the choir, and that these would both of them be considerable works, which would confer glory on his reign; for my part, I was ready to execute a great number of bronze bas-reliefs with appropriate decorations. In this way I brought him round, and he gave me orders to construct the models.

423 Accordingly I set to work on several models, and bestowed immense pains on them. Among these there was one with eight panels, carried out with far more science than the rest, and which seemed to me more fitted for the purpose. After I had taken them several times to the palace, his Excellency sent word that he wished me to make the door square, because he liked that form better; and thus he went on conversing for some time very pleasantly. I meanwhile lost no opportunity of saying everything I could in the interests of art. Now whether the Duke knew that I had spoken the truth, or whether he wanted to have his own way, a long time passed before I heard anything more about it.

424 About this time the great block of marble arrived which was intended for the Neptune. It had been brought up the Arno, and then by the Grieve to the road at Poggio a Caiano, in order to be carried to Florence by that level way; and there I went to see it. Now I knew very well that the Duchess by her special influence had managed to have it given to Bandinello. No envy prompted me to dispute his claims, but rather pity for that poor unfortunate piece of marble. Observe, by the way, that everything, whatever it may be, which is subject to an evil destiny, although one tries to save it from some manifest evil, falls at once into far worse plight; as

425 happened to this marble when it came into the hands of Bartolommeo Ammanato, of whom I shall speak the truth in its proper place. After inspecting this most splendid block, I measured it in every direction, and on returning to Florence, made several little models suited to its proportions. Then I went to Poggio a Caiano, where the Duke and Duchess were staying, with

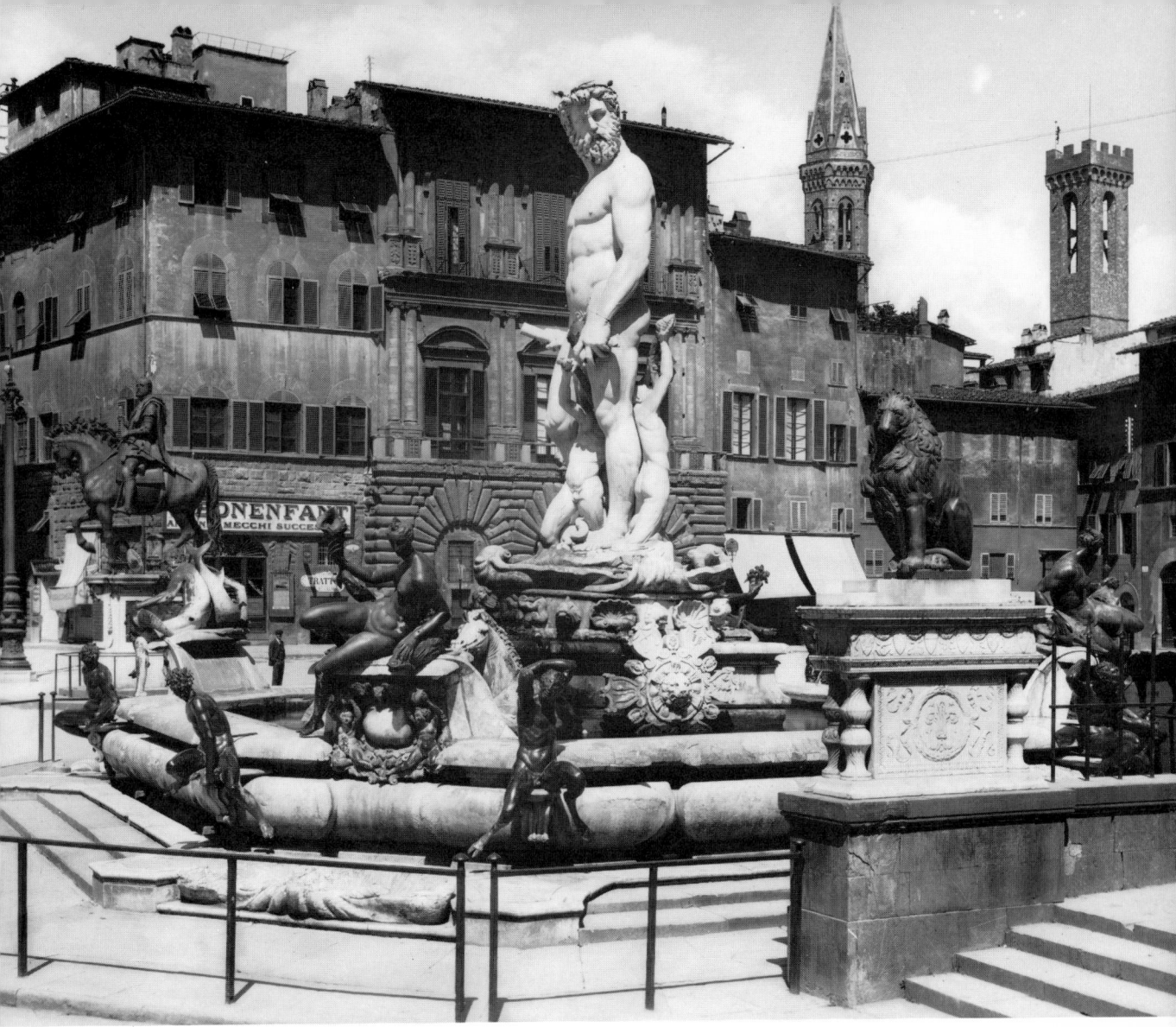

98 *The Fountain of Neptune* by Ammannati, 1576. Florence, Piazza della
Signoria

their son the Prince. I found them all at table, the Duke and Duchess dining in a private
apartment; so I entered into conversation with the Prince. We had been speaking for a long
while, when the Duke, who was in a room adjacent, heard my voice, and condescended very
graciously to send for me. When I presented myself before their Excellencies, the Duchess
addressed me in a very pleasant tone; and having thus opened the conversation, I gradually
introduced the subject of that noble block of marble I had seen. I then proceeded to remark that
their ancestors had brought the magnificent school of Florence to such a pitch of excellence
only by stimulating competition among artists in their several branches. It was thus that the
wonderful cupola and the lovely doors of San Giovanni had been produced, together with
those multitudes of handsome edifices and statues which made a crown of artistic glory for
their city above anything the world had seen since the days of the ancients. Upon this the
Duchess, with some anger, observed that she very well knew what I meant, and bade me never
mention that block of marble in her presence, since she did not like it. In a great rage, she told
me that I tired her patience out; she wanted the marble for Bandinello, adding: 'Ask the Duke;
for his Excellency also means Bandinello to have it.' When the Duchess had spoken, the Duke,
who had kept silence up to this time, said: 'Twenty years ago I had that fine block quarried
especially for Bandinello, and so I mean that Bandinello shall have it to do what he likes with

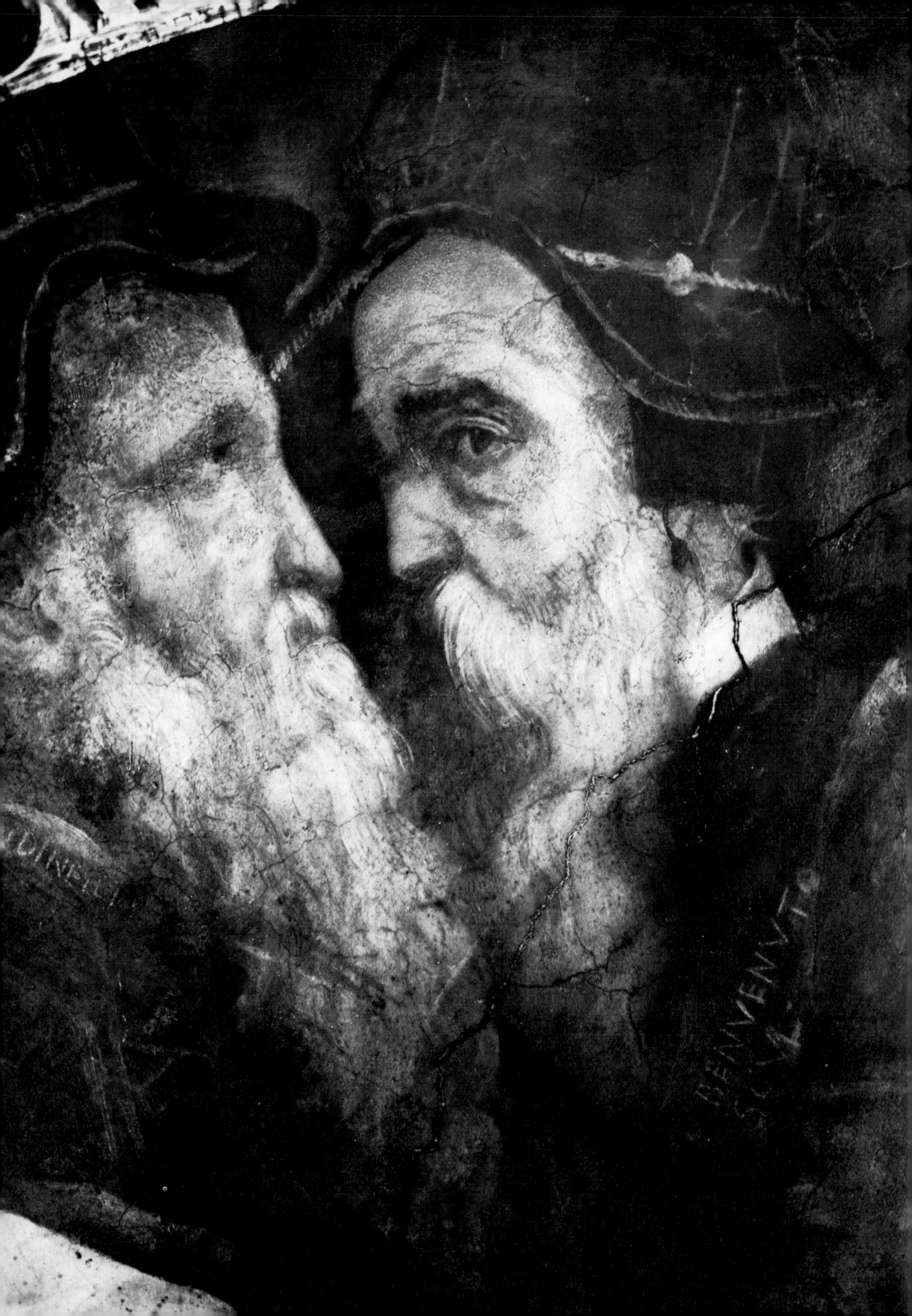

it.' I turned to the Duke and spoke as follows: 'My lord, I entreat your most illustrious Excellency to lend a patient hearing while I speak four words in your service.' He told me to say all I wanted, and that he would listen. Then I began: 'You will remember, my lord, that the marble which Bandinello used for his Hercules and Cacus was quarried for our incomparable Michel Agnolo Buonarroti. He had made the model for a Samson with four figures, which would have been the finest masterpiece in the whole world; but your Bandinello got out of it only two figures, both ill-executed and bungled in the worst manner; wherefore our school still exclaims against the great wrong which was done to that magnificent block. I believe that more than a thousand sonnets were put up in abuse of that detestable performance; and I know that your most illustrious Excellency remembers the fact very well. Therefore, my powerful prince, seeing how the men to whose care that work was entrusted, in their want of taste and wisdom, took Michel Agnolo's marble away from him, and gave it to Bandinello, who spoilt it in the way the whole world knows, oh! will you suffer this far more splendid block, although it belongs to Bandinello, to remain in the hands of that man who cannot help mangling it, instead of giving it to some artist of talent capable of doing it full justice? Arrange, my lord, that every one who likes shall make a model; have them all exhibited to the school; you then will hear what the school thinks; you own good judgment will enable you to select the best; in this way, finally, you will not throw away your money, nor discourage a band of artists the like of whom is not to be found at present in the world, and who form the glory of your most illustrious Excellency.'

The Duke listened with the utmost graciousness; then he rose from table, and turning to me, said: 'Go, my Benvenuto, make a model, and earn that fine marble for yourself; for what you say is the truth, and I acknowledge it.' The Duchess tossed her head defiantly, and muttered I know not what angry sentences.

I made them a respectful bow and returned to Florence, burning with eagerness to set hands upon my model.

When the Duke came to Florence, he sought me at my house without giving me previous notice. I showed him two little models of different design. Though he praised them both, he said that one of them pleased him better than the other; I was to finish the one he liked with care; and this would be to my advantage.

I went to the Duchess, and took her some small bits of goldsmith's work, which greatly pleased her Excellency. Then she asked what I was doing, and I replied: 'My lady, I have taken in hand for my pleasure one of the most laborious pieces which have ever been produced. It is a Christ of the whitest marble set upon a cross of the blackest, exactly of the same size as a tall man.' She immediately inquired what I meant to do with it. I answered: 'You must know, my lady, that I would not sell it for two thousand golden ducats; it is of such difficult execution that I think no man ever attempted the like before; nor would I have undertaken it at the commission of any prince whatever, for fear I might prove inadequate to the task. I bought the marbles with my own money, and have kept a young man some two years as my assistant in the work. What with the stone, the iron frame to hold it up, and the wages, it has cost me above three hundred crowns. Consequently, I would not sell it for two thousand. But if your Excellency deigns to grant me a favour which is wholly blameless, I shall be delighted to make you a present of it. All I ask is that your Excellency will not use your influence either against or for the models which the Duke has ordered to be made of the Neptune for that great block of marble.' She replied with mighty indignation: 'So then you value neither my help nor my opposition?' ' On the contrary, I value them highly, princess; or why am I offering to give you what I value at two thousand ducats? But I have such confidence in my laborious and well-trained studies, that I hope to win the palm, even against the great Michel Agnolo Buonarroti,

99 *Baccio Bandinelli and Cellini*, detail from the fresco by Vasari in the
Palazzo Vecchio (plate 35)

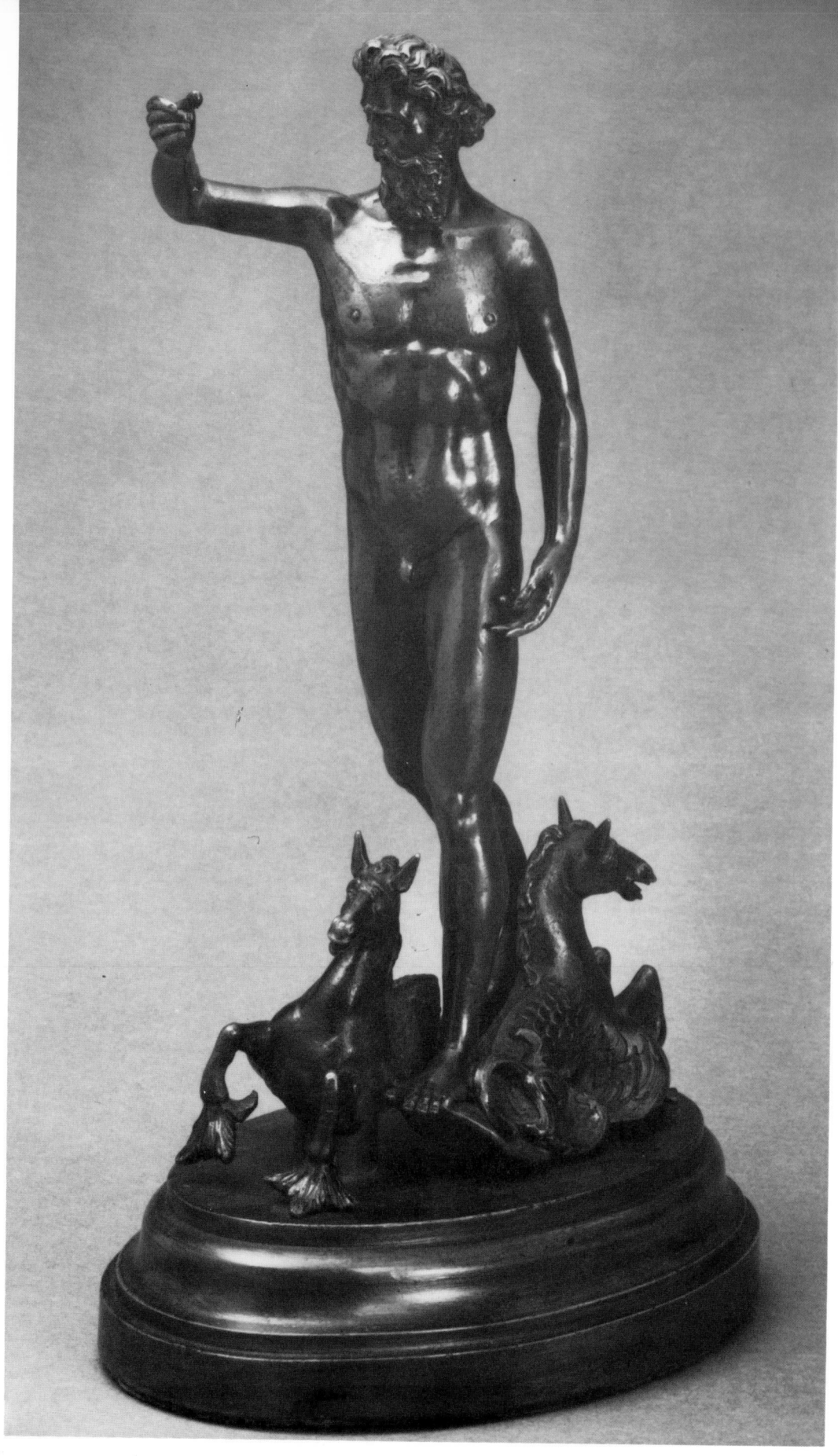

from whom and from no one else I have learned all that I know. Indeed, I should be much better pleased to enter into competition with him who knows so much than with those others who know but little of their art. Contending with my sublime master, I could gain laurels in plenty, whereas there are but few to be reaped in a contest with these men.' After I had spoken, she rose in a half-angry mood, and I returned to work with all the strength I had upon my model.

When it was finished, the Duke came to see it, bringing with him two ambassadors, one from the Duke of Ferrara, the other from the Signory of Lucca. They were delighted, and the Duke said to those two gentlemen: 'Upon my word, Benvenuto deserves to have the marble.' Several months after this date, Bandinello died; and it was thought that, in addition to his intemperate habits of life, the mortification of having probably to lose the marble contributed to his decline. *430*

Bandinello had received information of the crucifix which, as I have said above, I was now engaged upon. Accordingly he laid his hands at once upon a block of marble, and produced the Pietà which may be seen in the church of the Annunziata. Now I had offered my crucifix to St Maria Novella, and had already fixed up the iron clamps whereby I meant to fasten it against the wall. I only asked for permission to construct a little sarcophagus upon the ground beneath the feet of Christ, into which I might creep when I was dead. The friars told me that they could not grant this without the consent of their building committee. I replied: 'Good brethren, why did not you consult your committee before you allowed me to place my crucifix? Without their leave you suffered me to fix my clamps and other necessary fittings.' *431*

On this account I refused to give those fruits of my enormous labours to the church of S. Maria Novella, even though the overseers of the fabric came and begged me for the crucifix. I turned at once to the church of the Annunziata, and when I explained the terms on which I had sought to make a present of it to S. Maria Novella, those virtuous friars of the Nunziata unanimously told me to place it in their church, and let me make my grave according to my will and pleasure. When Bandinello became aware of this, he set to work with great diligence at the completion of his Pietà, and prayed the Duchess to get for him the chapel of the Pazzi for his monument. This he obtained with some difficulty; and on receiving the permission, he erected his Pietà with great haste. It was not altogether completed when he died.

The Duchess then said that, even as she had protected him in life, so would she protect him in the grave, and that albeit he was dead, I need never try to get that block of marble. Apropos of which, the broker Bernardone, meeting me one day in the country, said that the Duchess had assigned the marble. I replied: 'Unhappy piece of stone! In the hands of Bandinello it would certainly have come to grief; but in those of Ammanato its fate is a hundred times worse.' Now I had received orders from the Duke to make a clay model, of the same size as the marble would allow; he also provided me with wood and clay, set up a sort of screen in the Loggia where my Perseus stands, and paid me one workman. I went about my business with all diligence, and constructed the wooden framework according to my excellent system. Then I brought the model successfully to a conclusion, without caring whether I should have to execute it in marble, since I knew the Duchess was resolved I should not get the commission. Consequently I paid no heed to that. Only I felt very glad to undergo this labour, hoping to make the Duchess, who was after all a person of intelligence, as indeed I had the means of observing at a later period, repent of having done so great a wrong both to the marble and herself. Giovanni the Fleming also made a model in the cloister of S. Croce; Vinzenzio Danti of Perugia another in the house of Messer Ottaviano de' Medici; the son of Moschino began a third at Pisa, and Bartolommeo Ammanato a fourth in the Loggia, which we divided between us. *432* *433* *434*

100 *Neptune*, attrib. Cellini, 1559–60. Bronze, 9½ ins (24 cm) high. Raleigh, North Carolina Museum of Art (Gift of Mr and Mrs Arthur Levy Jr.)

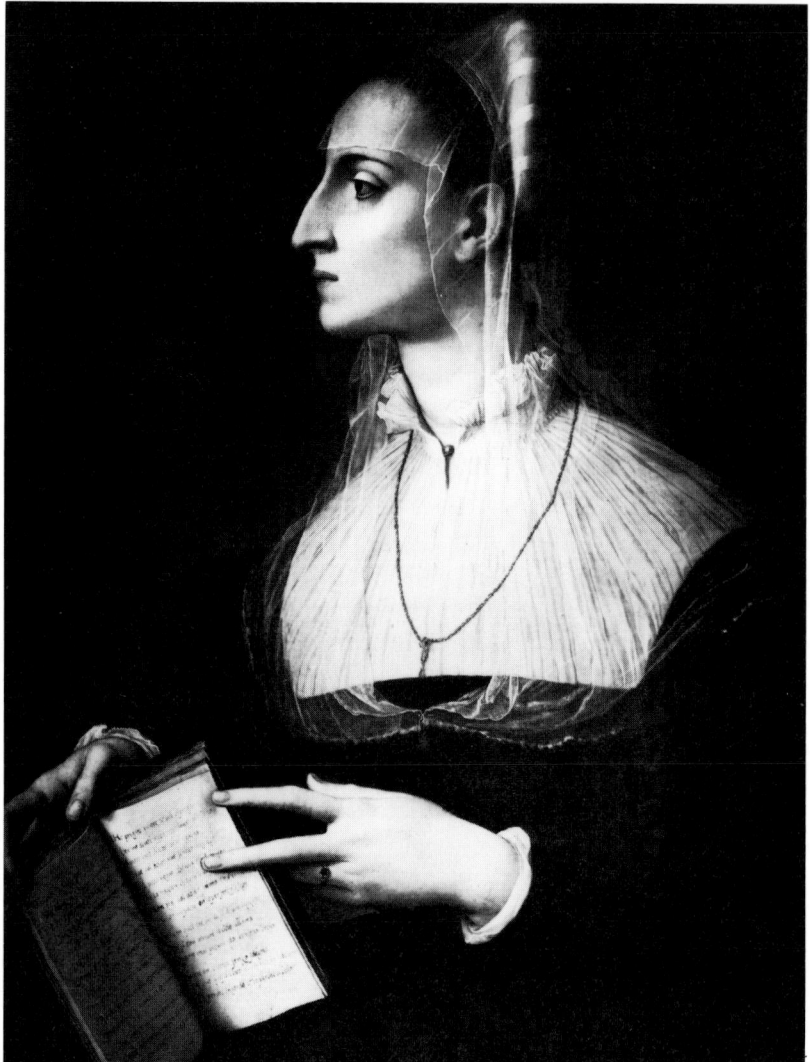

101 ABOVE *Portrait of Laura Battiferri*, wife of Bartolomeo Ammannati, by Bronzino. Florence, Palazzo Vecchio

102 OPPOSITE *Bartolomeo Ammannati*, detail from the fresco by Vasari in the Palazzo Vecchio (plate 35)

When I had blocked the whole of mine out well, and wanted to begin upon the details of the head, which I had already just sketched out in outline, the Duke came down from the palace, and Giorgetto, the painter, took him into Ammanato's workshed. This man had been engaged there with his own hands several days, in company with Ammanato and all his workpeople. While, then, the Duke was inspecting Ammanato's model, I received intelligence that he seemed but little pleased with it. In spite of Giorgetto's trying to dose him with his fluent nonsense, the Duke shook his head, and turning to Messer Gianstefano, exclaimed: 'Go and ask Benvenuto if his colossal statue is far enough forward for him to gratify us with a glance at it.' Messer Gianstefano discharged this embassy with great tact, and in the most courteous terms. He added that if I did not think my work quite ready to be seen yet, I might say so frankly, since the Duke knew well that I had enjoyed but little assistance for so large an undertaking. I replied that I entreated him to do me the favour of coming; for though my model was not far advanced, yet the intelligence of his Excellency would enable him to comprehend perfectly how it was likely to look when finished. This kindly gentleman took back my message to the

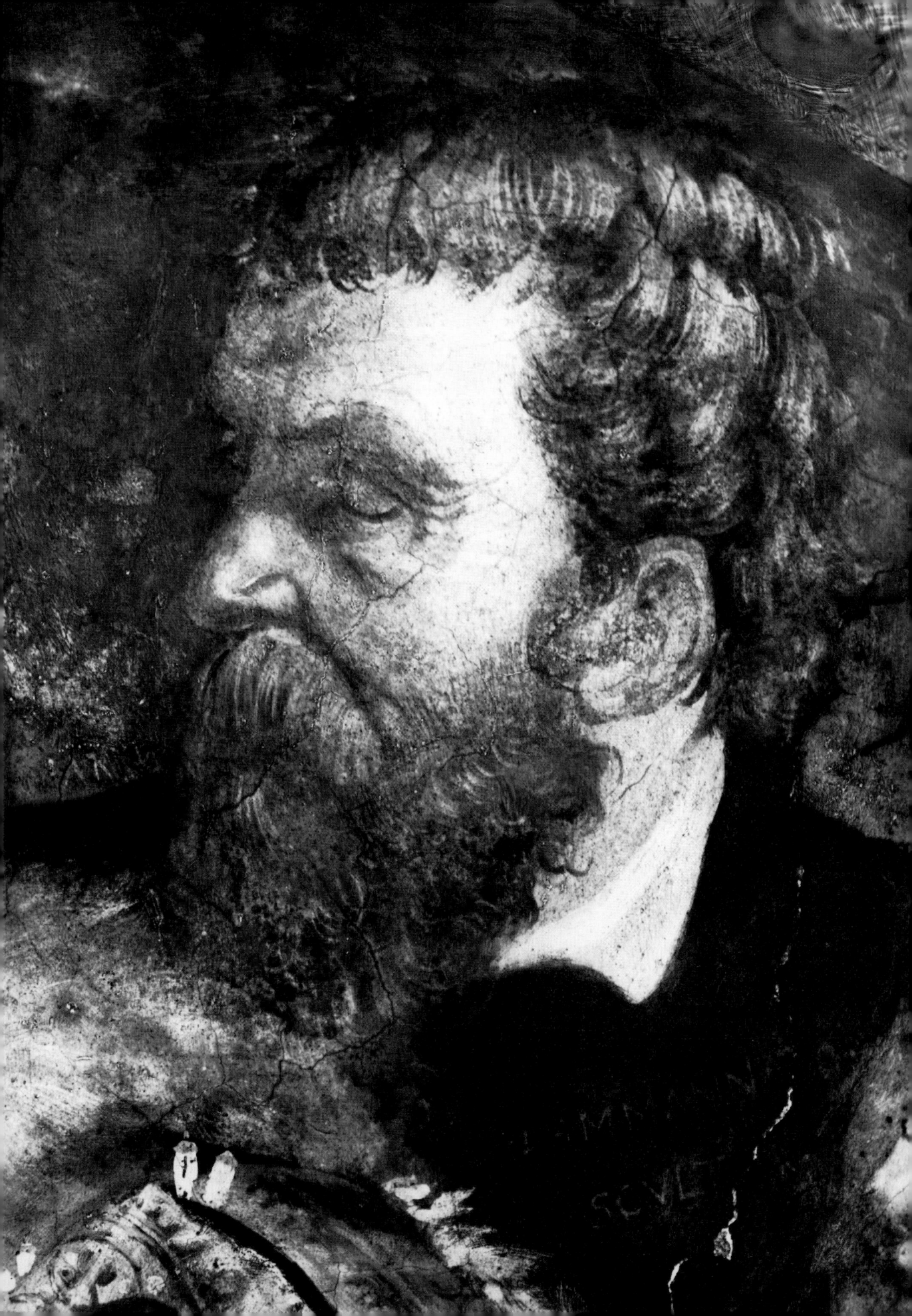

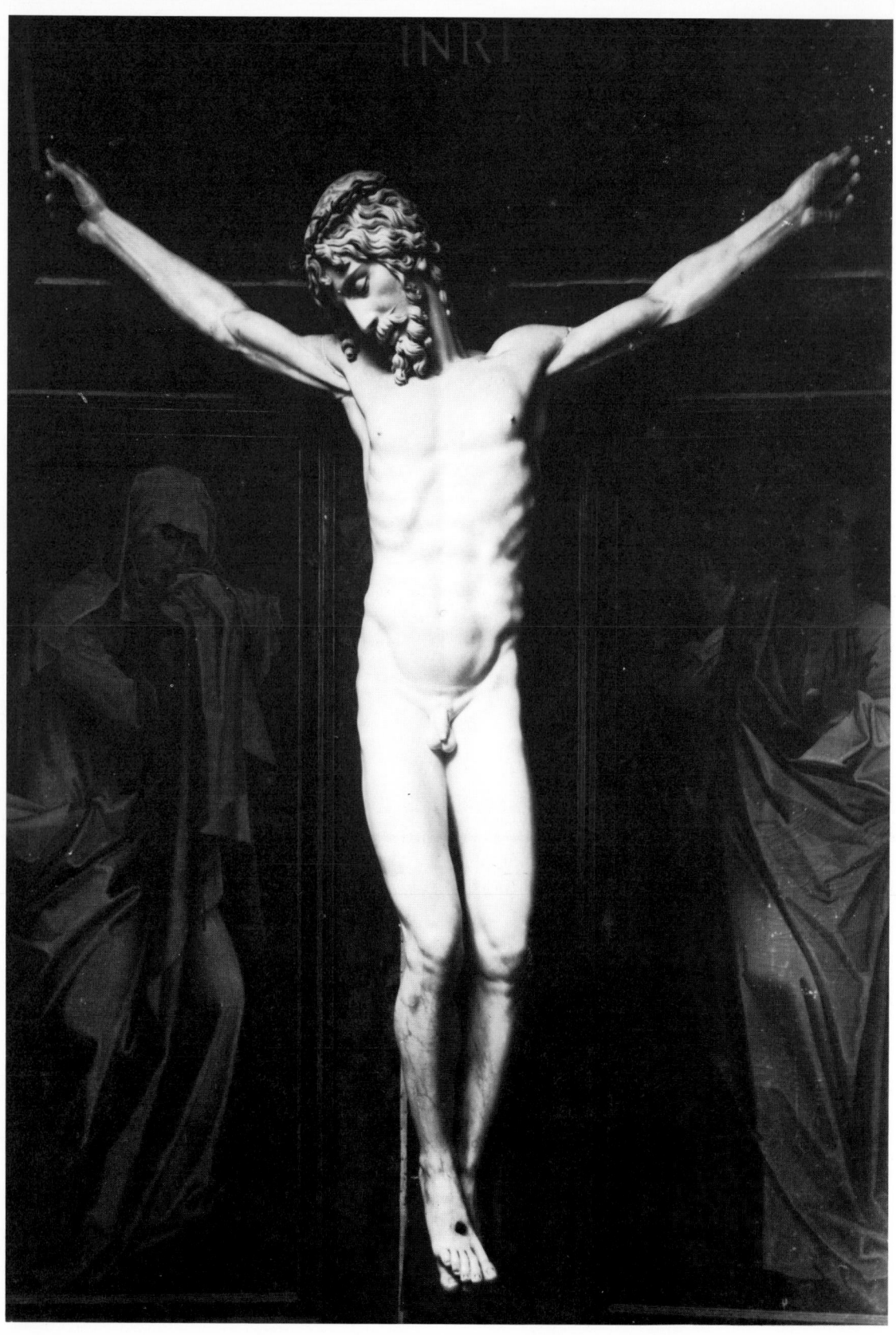

103, 104 *Crucifix* by Cellini, 1556–62. Marble. Escorial, near Madrid
(monastery of S Lorenzo)

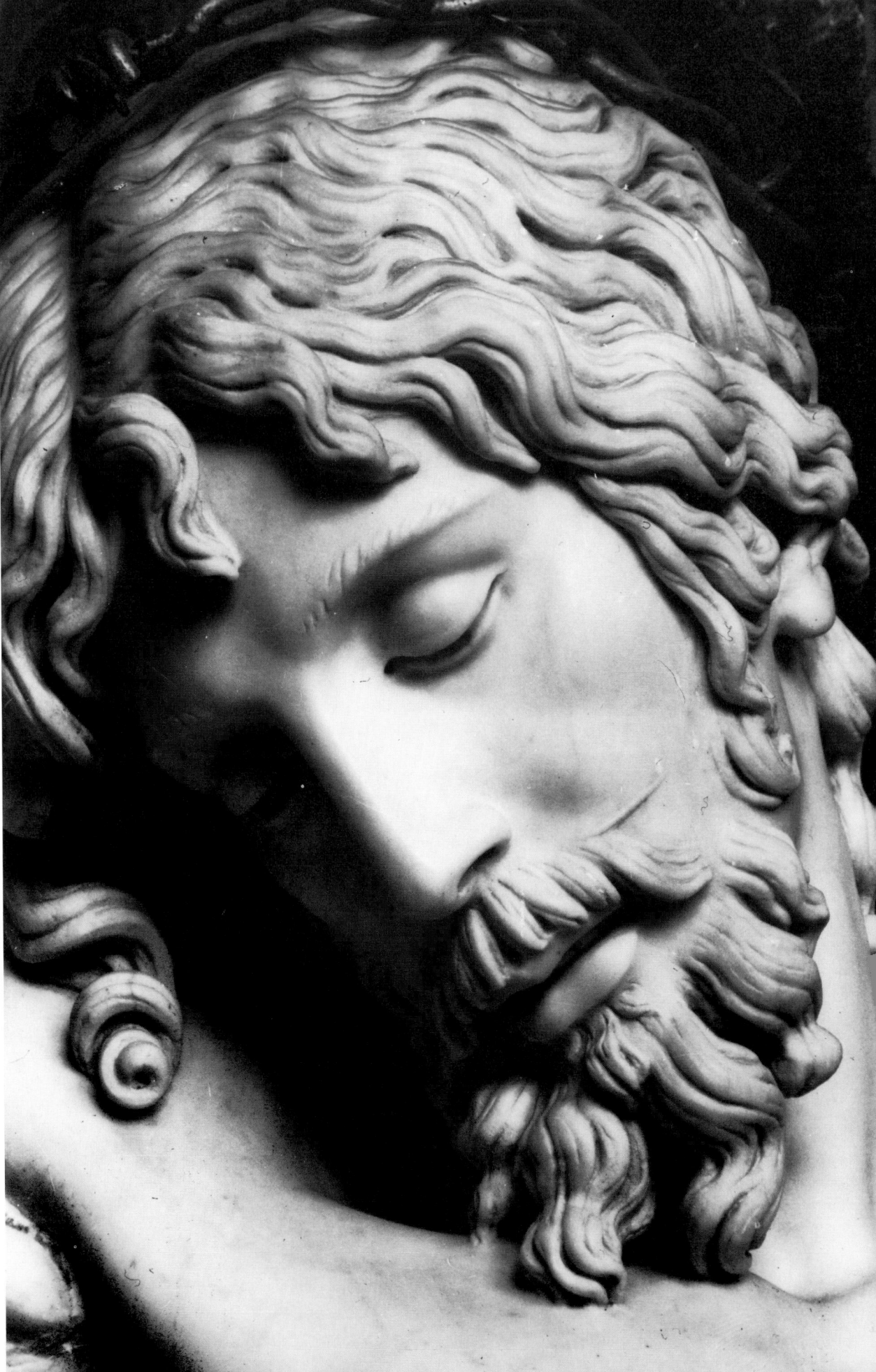

Duke, who came with pleasure. No sooner had he entered the enclosure and cast his eyes upon my work, than he gave signs of being greatly satisfied. Then he walked all round it, stopping at each of the four points of view, exactly as the ripest expert would have done. Afterwards he showed by nods and gestures of approval that it pleased him; but he said no more than this: 'Benvenuto, you have only to give a little surface to your statue.' Then he turned to his attendants, praising my performance.

438 Albeit I was suffering so severely, I forced myself to work upon my Colossus in the Loggia; but after a few days I succumbed to the malady and took to my bed. No sooner did the Duchess hear that I was ill, than she caused the execution of that unlucky marble to be assigned to Bartolommeo Ammanato. He sent word to me through Messer living in Street, that I might now do what I liked with my model since he had won the marble. This Messer was

439 one of the lovers of Bartolommeo Ammanato's wife; and being the most favoured on account of his gentle manners and discretion, Ammanato made things easy for him. There would be much to say upon this topic; however, I do not care to imitate his master, Bandinello, who always wandered from the subject in his talk. Suffice it to say that I told Ammanato's messenger I had always imagined it would turn out thus; let the man strain himself to the utmost in proof of gratitude to Fortune for so great a favour so undeservedly conferred on him by her.

 Having quite completed my crucifix, I thought that if I raised it to some feet above the ground, it would show better than it did upon a lower level. After I had done so, it produced a far finer effect than even it had made before, and I was greatly satisfied. So then I began to exhibit it to every one who had the mind to see it.

 As God willed, the Duke and the Duchess heard about it. On their arrival then from Pisa, both their Excellencies arrived one day quite unexpectedly, attended by all the nobles of their court, with the sole purpose of inspecting my crucifix. They were so much delighted, that each of these princes lavished endless praises on it, and all the lords and gentlefolk of their suites

440 joined in chorus. With these agreeable words they left me, and I remained highly satisfied.

 Many weeks passed, but of me nothing more was spoken. This neglect drove me half mad

441 with despair. Now about that time the Queen of France sent Messer Baccio del Bene to our Duke for a loan of money, which the Duke very graciously supplied, as rumour went. Messer Baccio del Bene and I had been intimate friends in former times; so when we renewed our acquaintance in Florence, we came together with much mutual satisfaction. In course of conversation he related all the favours shown him by his most illustrious Excellency. He told me how her Majesty of France was most eager to complete the monument of her husband

442 Henri II, and how Daniello da Volterra had undertaken a great equestrian statue in bronze, but the time had already elapsed in which he promised to perform it, and that a multitude of the richest ornaments were required for the tomb. If, then, I liked to return to France and occupy my castle, she would supply me with all the conveniences I could ask for, provided only I cared to enter her service. These proposals he made on the part of the Queen. I told Messer Baccio to beg me from the Duke; if his most illustrious Excellency was satisfied, I should very willingly return to France. He answered cheerfully: 'We will travel back together!' and considered the affair settled. Accordingly, next day, in course of conversation with the Duke, he alluded to myself, declaring that if his Excellency had no objection, the Queen would take me into her employ. The Duke replied without a moment's hesitation: 'Benvenuto's ability in his profession is known to the whole world; but at the present time he does not care to go on working.' Then they touched on other topics; and upon the day following I called on Messer Baccio, who reported what had passed between them. Then I lost all patience, and exclaimed: 'Oh, me! His most illustrious Excellency gave me nothing to do, while I was bringing to perfection one of the most difficult masterpieces ever executed in this world; and it stands me in more than two hundred crowns, which I have paid out of my poverty! Oh, what could I not have done if his Excellency had but set me to work! I tell you in pure truth, that they have done me a great wrong!' The good-natured gentleman repeated to the Duke what I had answered.

The Duke told him we were joking, and that he wanted me for his own service. The result was that in my irritation I more than once made up my mind to make off without asking leave. However, the Queen preferred to drop negotiations, in fear of displeasing the Duke; and so I remained here, much to my regret.

About that time the Duke went on a journey, attended by all his court and all his sons, except the prince, who was in Spain. They travelled through the Sienese Maremma, and by this route *443* he reached Pisa. The poison from the bad air of those marshes first attacked the Cardinal, who was taken with a pestilential fever after a few days, and died at the end of a brief illness. He was *444* the Duke's right eye, handsome and good, and his loss was most severely felt. I allowed several days to elapse, until I thought their tears were dried, and then I betook myself to Pisa.

105 *Diana of Ephesos*, drawing by Cellini for the seal of the Academy of Florence, 1563. Chalk, pen and ink, wash, $7 \times 5\frac{1}{2}$ ins (18.4 × 14.2 cm). Munich, Staatliche Graphische Sammlung

NOTES

For Vasari's *Lives* reference is made to the G. Milanesi edition, Florence, 1878–85.

Abbreviations: C. = Cellini autob. = autobiography n. = note

1 C. had already completed the Perseus, and was sculpting the marble Crucifix for his tomb (see n. 429) whilst under house-arrest (see n. 424).

2 The desire to stress their supposed illustrious origins was common to other Renaissance artists.

3 Villani's (d. 1348) *Cronaca* (chronicle) in twelve books, begun *c.* 1308, narrates the history of Florence. C. read it when imprisoned in the Castel Sant'Angelo (see p. 106).

4 The idea of Florence as a new Rome, already established in the time of Dante and Villani, was strengthened under the humanists who governed the Florentine Commune during the last quarter of the 14th cent. In a celebrated letter to Gaspare Squaro de' Broaspini (17 Nov. 1377) Coluccio Salutati wrote: 'This famous city is the flower of Tuscany, the model of all Italy, and the emulator of the most glorious city of Rome, from which it is descended' (Salutati, *Epistolario* (Letters), ed. F. Novati, I, Rome, 1891, p. 277).

5 According to Villani, the legendary Fiorino was a Roman noble. By stating that Fiorino came from Cellino, the artist would have us believe that he was descended from the founder of Florence. Having obtained economic success (a leitmotive of C.'s autob.), 16th-cent. artists sought social prestige, a tendency recorded in Vasari's *Lives*. The play on the names *Fiorino da Cellino* and *Cellini* is, however, rather ingenuous, as the artist declares his middle-class origins a few lines below. Montefiasconi is 10 m. north of Viterbo.

6 Val d'Ambra is the valley surrounded by the territory of Arezzo, the Chianti, and the upper Valdarno.

7 Today no. 22, overlooking the Piazza del Mercato Centrale next to S. Lorenzo.

8 Another attempt to improve his family's social status. Andrea described himself as a bricklayer in his 1487 income-tax declaration.

9 Vitruvius Pollio's (1st cent. BC) treatise *De architectura*, the most important surviving source on classical architecture, was published in numerous editions during the Renaissance. The passage here referred to is in Book I, ch. I.

10 An artistic education was considered incomplete without a knowledge of music, which was directly related to the theory of architectural proportions (see R. Wittkower, *Architectural Principles in the Age of Humanism*, London, 1962).

11 Giovanni C. (1451/53–1528) married Elisabetta Granacci (b. 1464) in 1480.

12 C. was not born on 2 Nov. 1500, but the following day, as shown by the *Libro de' Battezzati* (Baptisms), 1488–1500 (Archive of the Opera del Duomo, Florence).

13 Lorenzo il Magnifico (1449–92); his son Piero (1472–1503).

14 Piero was expelled in 1494. C. probably hoped that the frequent emphasis on his good relationship with the Medici would outweigh his occasionally impertinent criticism of the ducal family and help him publish the autob.

15 P. Soderini (1452–1522) was elected *Gonfaloniere* for life of the Florentine Republic in 1502, remaining in office until the Medici returned in 1512. He commissioned the *Battle of Anghiari* from Leonardo, for which C.'s father erected the scaffolding, and the *Battle of Cáscina* from Michelangelo for the Great Hall in the Palazzo Vecchio.

16 Cardinal Giovanni de' Medici (1475–1521), son of Lorenzo il Magnifico, was elected Pope in 1513. He and his brother Giuliano, Duke of Nemours, regained possession of Florence with the help of the Spanish after the Sack of Prato.

17 The Palazzo Medici in Via Larga (now known as Palazzo Medici-Riccardi, in Via Cavour) was begun in 1444 by Michelozzo for Cosimo de' Medici (1389–1464) the Elder (*Pater Patriae*). Completed in 1467, the exterior loggia was finished by Michelangelo c. 1517–20.

18 Giuliano Della Rovere (1443–1513) became Pope as Julius II in 1503. His powerful personality helped the Papacy regain its lost prestige and authority. He was also a great patron of the arts and commissioned works from Bramante (see n. 140), Raphael, Michelangelo, and many others.

19 Salviati (d. 1533), who married Lucrezia de' Medici (1470–1550), the eldest daughter of Lorenzo il Magnifico, was elected *Gonfaloniere* for the first two months of 1514. He was grandfather of Cosimo I (see n. 207).

20 Michelangelo Brandini, a goldsmith employed by the Medici, was from Gaiole in the Chianti and not Pinzi di Monte, where, however, he owned some properties. He was praised by C. in his *Trattato dell'Oreficeria*. Michelangelo's son, Bartolomeo or Baccio (1488–1560), who changed his family name into Bandinelli, was one of the most talented sculptors of the 16th

cent., and the most formidable of C.'s rivals whilst the latter was dictating the autob.: Benvenuto's negative appraisals of Bandinelli must, therefore, be considered with caution.

21 Giovanfrancesco C. was nicknamed Cecchino del Piffero. For his death, see pp. 57–9.

22 Giovanni dalle Bande Nere (1498–1526), a member of the subsidiary branch of the Medici and a well-known *condottiere*, married Maria Salviati, daughter of Jacopo. For Cosimo see n. 207.

23 The gates were to the north of the city. The San Gallo gate is in the present Piazza della Libertà at the end of Via Cavour, and the Porta a Pinti or Fiesolana was in the present Piazzale Donatello.

24 The Eight – *gli Otto di Guardia* – were magistrates responsible for maintaining law and order in Florence.

25 The goldsmith Castoro worked for Siena Cathedral.

26 Giulio de' Medici (1478–1534), nephew of Lorenzo il Magnifico, became Archbishop of Florence in 1513, was elected Cardinal in 1517, and became Pope Clement VII in Nov. 1523.

27 Cavalletto, son of the more widely known miniaturist Giovanni Battista, worked for Bologna Cathedral 1519–23. The 15th-cent. church of the Madonna del Barracano was altered in the 18th cent.

28 C. resided in Pisa throughout 1517, helping the goldsmith Ulivieri della Chiostra who worked for the Sacristy of the Cathedral. The Fish Stone was near the present Piazza del Mercato.

29 The renaissance of the *studia humanitatis* stimulated a new interest in and admiration for classical art, and a journey to Rome to study the ancient remains became common practice; the many surviving sketchbooks show how this study formed an essential part of an artist's education. The Campo Santo in Pisa was planned by Giovanni di Simone in 1278. Its cloister still houses ancient sarcophagi.

30 Pietro Torrigiano (1472–1528), called Petir Torrysany in English documents, was a member of the so-called 'Scuola di S. Marco', a sort of academy *ante litteram* promoted by Lorenzo il Magnifico. Torrigiano's neglected personality has been investigated in Alan P. Darr's recent monograph on the Henry VII monument in Westminster Abbey, where T. executed (1511–18) the tombs of Lady Margaret Beaufort, Henry VII, and Elizabeth of York. He also worked on a monument to Henry VIII at Windsor. After a brief sojourn in Florence in 1519 when he met C., T. returned to London, moving to Spain in *c.* 1522.

31 C. refers to the cartoon celebrating the *Battle of Cáscina*, which sealed the victory of Florence over Pisa (1364); it was commissioned in 1504 (see n. 15) and is now known only through copies.

32 See n. 15.

33 Michelangelo's cartoon was in the Medici Palace. The *Sala del Papa* is on the first floor of the Great Cloister in the Florentine church of S. Maria Novella.

34 The importance C. attached to the concept of 'school' becomes clear in the second part of the autob.

35 He frescoed the ceiling of the Sistine Chapel for Julius II, 1508–12. C. praises Michelangelo's first studies because they were made in Florence.

36 The frescoes of the Brancacci Chapel in the Carmine were executed by Masaccio and Masolino da Panicale, 1424–28, and completed by Filippino Lippi

c. 1481–82. They represent episodes from the life of St Peter and the famous *Expulsion of Adam and Eve*. Torrigiano's account is confirmed by a Michelangelo drawing (Munich, Graphische Sammlung), a copy of Masaccio's *The Tribute Money*.

37 C. frequently mentions Michelangelo with great respect and admiration, but was only superficially influenced by him. With the publication of Vasari's *Lives*, Michelangelo (the only living artist included in the first edition) had become a legendary figure.

38 Giovan Francesco Lippi was the son of Filippino (*c.* 1457–1504) and grandson of Fra Filippo (*c.* 1406–1469), both among the greatest painters of the Florentine Quattrocento.

39 Although mainly active in Florence, Filippino also frescoed the Carafa Chapel in S. Maria sopra Minerva in Rome.

40 Giovambattista Tasso (1500–55), one of the period's most gifted woodcarvers, executed the ceiling designed by Michelangelo for the Laurentian Library in Florence. He was also an architect and planned the Loggia of the New Market (1547–51) in Florence. T. was among the artists questioned by Varchi (see n. 51) on the famous 'paragone' between painting and sculpture, that is, which of the two was superior (see *Scritti d'Arte del Cinquecento*, ed. P. Barocchi, I, Milan-Naples, 1971, pp. 507–9). See also p. 157.

41 This gate, erected in 1328, is the present Porta Romana, to the southwest of the city. It took its name from the church of the same name nearby.

42 Giovanni de Georgis, called Firenzuola, was the goldsmiths' 'consul' in Rome in 1528. Firenzuola is in Tuscany.

43 Giannotto Giannotti was the brother of the famous historian Donato.

44 The sarcophagus, originally outside the Pantheon, now forms part of the monument to Clement XII in the Lateran.

45 Paolo d'Arzago. Arzago d'Adda is 20 m. east of Milan. Arzago owned a workshop near the church of Sant'Eligio, the patron saint of goldsmiths.

46 Antonio da San Marino (?–1522?) was one of Raphael's heirs.

47 C. praised Salv. Guasconti in his *Trattato dell'Oreficeria*. Michele was his cousin. The fight C. describes took place on 13 Nov. 1523.

48 In fact he wounded the arms and back of Gherardo Guasconti, Michele's son.

49 S. Maria Novella is the impressive Dominican church founded by Fra Sisto and Fra Ristoro in 1246, whose façade (*c.* 1455–60) was designed by Alberti. Alessandro Strozzi betrayed Benedetto da Foiano (see n. 248) after the fall of the second Florentine Republic in 1530.

50 This gate, now dividing the Viale Rosselli in two, is to the northwest of the city.

51 Varchi (1503–65), the celebrated author of the *Storia fiorentina*, was born in Florence, but his family was from Montevarchi.

52 The River Paglia, a tributary of the Tiber, runs near Orvieto. For Clement VII see n. 26.

53 Santo di Cola was the Pope's goldsmith and a mace-bearer.

54 For Luca Agnolo da Iesi see below, pp. 27–8, 29. Iesi is in the Marches.

55 Don Francesco di Andrea di Cabresa went to Rome for the Lateran Council in 1517, remaining there until the Sack of 1527.

56 Gianfrancesco Penni (c. 1488–c. 1528) and Giulio Romano (see n. 82) inherited Raphael's workshop, completing the Sala di Costantino in the Vatican and the *Coronation of the Virgin* for Monteluce (now in the Vatican Gallery). Penni was a rather poor imitator of Raphael; his *Madonna del Divino Amore* (Naples, Capodimonte), however, shows his competent technical ability.

57 The Sistine Chapel. Michelangelo had not yet frescoed the *Last Judgement*.

58 Chigi (c. 1465–1520), the famous and powerful banker, commissioned his 'house' (i.e. the Villa Farnesina, built 1509–11, and purchased by Cardinal Farnese in 1580) from Peruzzi (see n. 81). It contains frescoes by Peruzzi, Sodoma, Sebastiano del Piombo (see n. 119), and Raphael (the *Triumph of Galatea* and, with assistants, the Loggia of Psyche). C.'s great admiration for Peruzzi's architectural works is expressed in his fragmentary *Trattato dell'Architettura*.

59 Sigismondo Chigi was also a patron of Peruzzi, who planned his Villa Le Volte (now Mieli) near Siena.

60 Sulpizia Petrucci, daughter of Pandolfo, ruler of Siena, married Chigi in 1507.

61 These words recall those C. ascribed to Torrigiano (see p. 20). Such remarks, made to emphasize his precocious interest in sculpture, were made retrospectively and directed at the 'noble school of Florence' (see below p. 153).

62 Porzia was in fact the younger sister of Sulpizia.

63 The concept of competition as an important stimulus to improve skill was common in artistic circles during the Renaissance. Begun for practical reasons, such as competitions for prestigious public commissions, the contest was transformed into a sort of intellectual ideal.

64 Giangiacomo de Berardini was also an inlayer.

65 The Duke is Cosimo I (see n. 207).

66 The Belvedere is the villa built by Pope Innocent VIII, 1485–87; later, it was included by Bramante (see n. 140) in his project for the Belvedere Courtyard, an enormous structure on three levels linking the papal palace with the Villa, (J.S. Ackerman, *The Cortile del Belvedere*, Vatican City, 1954). The top level, known as the *Cortile Ottagono* or *Cortile delle Statue*, was built to house Julius II's collection of classical sculptures.

67 Dreams and nightmares play an important part in the autob. See also pp. 68, 85–6, 107, 108–9.

68 A portrait (Naples, Capodimonte) once attributed to Parmigianino, but sometimes ascribed to Gregorio Pagani, shows a medal representing Leda and the swan which, according to the fashion of the time, is placed in the hat of an anonymous sitter (see also n. 153).

69 Lautizio Rotelli (d. 1527), mentioned in C.'s *Trattato dell'Oreficeria* (XIII) as specializing in 'seals for cardinals' bulls', worked for the Mint of Perugia until 1518.

70 Cristoforo Foppa, called Il Caradosso (b. Mondonico, near Pavia, c. 1452–d. 1526/7). C. calls him Milanese because his father Gian Maffeo had been a well-known goldsmith in Milan. Caradosso worked for the most prestigious patrons of his time including Popes Julius II, Leo X, Hadrian VI, and Clement VII. His masterpiece, Julius II's now destroyed tiara (begun 1510), is recorded in the drawings (c. 1725) by Bartoli.

71 During the Middle Ages melancholy was considered an inferior temperament derived from one of the human body's four humours. The neo-platonic philosopher Marsilio Ficino, however, noting that Aristotle had drawn a distinction between naturally melancholic and mad people, believed that the former were prone to depression, but could reach the *furor divinus* (a superior and creative state of mind). A melancholic disposition became synonymous with what we call genius. Vasari's opinion of melancholy, a leitmotive of the *Lives*, was still negative, but to be melancholic became fashionable among 16th-cent. artists.

72 The relationship between Art and Nature was an important aspect of Renaissance art literature. For Leonardo, Art was the means of investigating Nature and the physical world, and the more painting imitated Nature the more it was praiseworthy. During the Renaissance, however, the ideal of an artistic Beauty derived from, but superior to, Nature evolved. In C.'s passage not only can Art equal Nature, but Nature can even surpass Art.

73 Giacomo Berengario, a friend of the Venetian printer Aldo Manuzio, was one of the period's best physicians.

74 Syphilis was supposedly introduced into Italy by the French army of Charles VIII.

75 Cardinal Pompeo Colonna presented him with a St John painted by Raphael (Vasari, VI, 370–1).

76 The Duke of Ferrara, Alfonso I d'Este (1476–1534), was a great patron of Titian. C.'s story resembles Vasari's account of the 'antique' cupid sculpted by Michelangelo (Vasari, VII, 147–8).

77 Alberto Bendidio (c. 1470–1541) was a friend of Lodovico Ariosto and Celio Calcagnini, and the Duke of Ferrara's chancellor.

78 Giovambattista di Iacopo, called Il Rosso Fiorentino (1495–1540), one of the most talented Mannerist artists, worked in Florence, Rome (1524–27), Central Italy, and Fontainebleau (from 1530). See also p. 95.

79 Cervéteri, now famous for its Etruscan remains, is on the coast 25 m. northwest of Rome. The Count is probably Averso dell' Anguillara.

80 The autob. confirms that banditry was a widespread phenomenon (see also F. Braudel, *La Méditerranée et le Monde méditerranéen à l'époque de Philippe II*, 2nd enlarged ed., Paris, 1966).

81 Michelangelo di Bernardino di Michele (c. 1470–1540) was a pupil of the Sienese sculptor Giacomo Cozzarelli. From 1524 he collaborated with Tribolo (see n. 179) on Pope Hadrian VI's tomb (presbytery, S. Maria dell'Anima, Rome), based on designs by the great Sienese architect and painter Baldassare Peruzzi (1481–1536) (see notes 58–9).

82 Giulio Pippi, called Romano (c. 1499–1546), the most talented of Raphael's pupils (see n. 56), became one of the 16th cent.'s greatest architects. He supervised all the Gonzaga family artistic enterprises in Mantua (see pp. 49–50). Gianfrancesco is again Penni.

83 Francesco Ubertini, called Bachiacca (1494–1557), a pupil of Andrea del Sarto, worked for important patrons such as Pier Francesco Borgherini and Cosimo I, and designed cartoons for tapestries.

84 Probably the poet Eurialo d'Ascoli, a friend of Caro (see n. 119), Tolomei, and Aretino.

85 Such gatherings were fairly common during the first half of the 16th cent. Vasari (VI, 609–611) describes the meeting of the Florentine Compagnia del Paiuolo where Andrea del Sarto's model of the Baptistery (made of sausages, parmesan cheese, lasagne, thrushes, marzipan, etc.) was eaten.

86 Romano arrived in Mantua in 1524. Federico II Gonzaga (1500–40) was 5th Marquis and became first Duke in 1530. Like his mother Isabella d'Este, he was a great patron of the arts, and commissioned or acquired some thirty works from Titian.

87 C. refers to the celebrated grotesques in the Domus Aurea, Nero's 'Golden House', by then already well under street level: many graffiti signatures of Renaissance artists have been found in it.

88 The notion of facility played an important rôle in the writings of artists and humanists connected with Cosimo I's court. For example, Giovambattista Adriani (1511–79), in his letter on the artists of antiquity addressed to Vasari and placed before the second edition of the Lives, praised the speed of the painter Nicomachus (Vasari, I, 42).

89 C. alludes to the war between the Emperor Charles V and the King of France, Francis I, begun in 1521. For Giovanni dalle Bande Nere see n. 22.

90 Charles de Bourbon, cousin of Francis I, defected to the Emperor in 1523. He led the Imperial army in the Sack of Rome in May 1527.

91 Piero del Bene was a rich merchant and banker. The Colonna, one of the noblest and most turbulent Roman families, rose against the papal government in 1526.

92 The Campo Santo is the German cemetery near the Vatican.

93 Lorenzo da Ceri (d. 1528) was a mercenary in the service of Francis I; Orazio Baglioni (1493–1528), also a mercenary, belonged to the most powerful family in Perugia.

94 Antonio da Santa Croce had been an artillery captain at least since 1517 (see Scipione Ammirato, Istorie Fiorentine, II, Florence, 1641, 327).

95 Prati is the area extending beyond the Castel Sant'Angelo.

96 Benedetto Accolti the Younger (1497–1549) became Archbishop of Ravenna in 1524; the Florentine Niccolò Gaddi (d. 1552) was an opponent of the Medici. Both were elected Cardinals in 1527, three days before the Sack.

97 Alessandro Farnese (1467–1549), Dean of the Sacred College, became Pope Paul III in 1534. A great patron of the arts (Michelangelo and Titian worked for him) and a cultivated humanist, he should not be confused with his nephew Cardinal Alessandro (see n. 255). For Salviati see n. 19.

98 Cavalierino, one of Clement VII's protégés, is mentioned by Vasari (V, 530) in the Life of Giulio Romano.

99 Filippo Strozzi (1489–1538) had close French contacts. Among the fuorusciti (the opponents of the Medici expelled from Florence), he was an enemy of the first Duke Alessandro, and then of Cosimo I, who defeated him at Montemurlo and ordered his execution.

100 Philibert of Châlons, Prince of Orange (d. 1530), had become the head of the Imperial army after Bourbon's death.

101 Francesco or Franciotto Orsini, member of one of the noblest Roman families, was elected to the purple in 1517.

102 The autob. confirms how peripatetic Renaissance artists were. Even a modest Florentine coppersmith like Bartolomeo Masi travelled extensively, as is shown by his diary (Ricordanze di Bartolomeo Masi, calderaio fiorentino dal 1478 al 1526, ed. G. O. Corazzini, Florence, 1906).

103 Niccolò Milanese had been in the service of Isabella d'Este since 1514.

104 The site of the well-known house of Romano in Via Poma 18 was purchased by the artist in 1538, after C.'s visit.

105 The Palazzo del Te was begun in late 1524 or early 1525 and the decoration was practically completed by the end of 1534. It was altered by the architect Paolo Pozzo in the 18th cent.

106 Ercole Gonzaga (1505–63), Archbishop of Mantua, was made Cardinal in 1527. The original seal is lost, but an impression is reproduced in plate 22.

107 Piero Landi helped C. leave Florence after the artist had wounded Gherardo Guasconti (see n. 48). See also p. 87.

108 The Medici were expelled from the city on 17 May 1527. For Alessandro see n. 122; for Ippolito see n. 155.

109 Giuliano Bugiardini (1475–1554) had been Michelangelo's fellow-pupil of the sculptor Bertoldo and of the painter Ghirlandaio. He is underrated due to Vasari's reserved, even if affectionate appraisal.

110 According to Paolo Giovio's Dialogo dell'imprese militari et amorose (Lyons, 1559, p. 8), the combination of mottoes and images was not supposed to be 'so obscure to be interpretable only by one who knows the Sibylline Mysteries', nor yet 'so clear as to be understood by every plebeian'. In this case the image of Atlas holding up the sky and the words of the motto ('it is pleasant to support sublime things') complement each other.

111 The poet Luigi Alamanni (1495–1556) had conspired against Cardinal Giulio de' Medici (Clement VII) in 1522, and fled to France in 1530. C. met him again at the court of Francis I.

112 The morse made by C. was melted down in 1797. Fortunately three water-colour drawings by F. Bartoli record its appearance (plates 18–20).

113 Florence was besieged Oct. 1529–Aug. 1530.

114 It seems that Micheletto was the son of the Florentine Francesco Nardini (or Naldini).

115 Pompeo De Capitaneis was killed by C. on 26 Sept. 1534 (see pp. 77–8); Traiano Alicorno, a Milanese notary, is mentioned in Giovio's and Bembo's (see n. 214) letters.

116 Tommaso Cortese (1470–1543) was chief secretary of the office for requests, petitions, and letters patent.

117 Two separate coins, described by C. in his Trattato dell'Oreficeria, now survive; the reverse of one and the obverse of the other correspond to C.'s description of this gold doubloon.

118 For Bandinelli see n. 20.

119 The Florentine Monsignor Gaddi (1495–1542): his Roman palace, now known as Palazzo Niccolini-Amici in Via S. Spirito 42, was planned by Sansovino (see n. 180) before the Sack of 1527. Giovanni Greco was perhaps either Vergezio or Lascaris. Da Fano is

mentioned in letters by Beccadelli and Varchi (see n. 51). Allegretti was a Florentine poet who later wrote two sonnets in honour of C.'s Perseus. Caro (1507–66) was Gaddi's secretary 1529–42, and later became secretary to Cardinal Farnese (see n. 255); Caro made a celebrated translation of Virgil's *Aeneid* into Italian, and was one of the most gifted poets of 16th-cent. Italy. Sebastiano Luciani, called del Piombo (*c.* 1485–1547), was one of the most talented Renaissance portrait painters. He became *piombatore* (the lucrative appointment of putting the official seal on papal bulls) in 1531.

120 Executed 1529–30, it is described in C.'s *Trattato dell'Oreficeria* (XIV). The inscription is taken from Matthew, 14, 31.

121 The poet Giambattista Sanga, poisoned in 1532.

122 Alessandro de' Medici (1510–37) became 'head' of Florence in 1531 and Duke in 1532.

123 Alessandro received this Duchy from Charles V in 1532.

124 Bernardo Strozzi, called Cattivanza, was a captain of the Florentine republican army in 1530.

125 This affection is confirmed by Varchi's *Istoria fiorentina* (Book XI).

126 The bridge linking the Banchi with the Castel Sant'Angelo.

127 A certain Maffeo di Giovanni.

128 He was a member of Cardinal Ippolito de' Medici's (see n. 155) retinue.

129 The prison of Torre di Nona was near the church of S. Salvatore in Lauro, behind the Piazza Navona.

130 C. again stresses his loyalty to the Medici.

131 Pope Leo X's competition for the project of S. Giovanni dei Fiorentini in 1518 was won by Sansovino (see n. 180), but his model was never executed. In 1559 Duke Cosimo I commissioned a new project from Michelangelo. The church was finally built under the supervision of Giacomo della Porta who did not follow Michelangelo's centrally planned design. The church is to the northwest of Via Giulia (see n. 168).

132 The Palazzo Medici was called Palazzo Madama after Madama d'Austria (daughter of the Emperor Charles V), who married Duke Alessandro and, after his death, Ottavio Farnese (see n. 236).

133 Francesco del Nero (d. 1563), notorious for his avarice, later became a Florentine senator. Ammannati (see n. 425) designed his tomb (S. Maria sopra Minerva, Rome) *c.* 1549–50, and Giulio Mazzoni (1525?–1618?) sculpted his bust in the oval niche of the monument. The Bishop of Vasona (Vaison) was the Vicentine Girolamo Schio (d. 1533), elected Bishop in 1523; he was Clement VII's personal confessor.

134 Jacopo Balducci, superintendent of the pontifical Mint since 1529, was later imprisoned and tortured under the accusation of having stamped counterfeit money.

135 Cesare Macheroni was tried in April–May 1532; his accomplice was a certain Raffaello di Domenico. The Mint in Via dei Banchi Nuovi was erected by Antonio da Sangallo the Younger (see n. 220) *c.* 1530.

136 This took place on 8/9 Oct. 1530. Floods were common in Renaissance Rome: the Tiber embankments were only built in the 19th cent. An area of Rome is still called Arenula from the sand deposited by floods (*rena* = sand).

137 Monte Cavallo was the Renaissance name for the Quirinal.

138 It was left unfinished by C.: Cosimo I later commissioned the goldsmith Niccolò Santini to complete the chalice; Cosimo gave it to Pope Pius V in 1569 when elected Grand-Duke of Tuscany. It is mentioned by Vasari, VII, 621–2.

139 This passage is important for the artist-patron relationship on iconographical matters. As in the commission of a medal representing *Moses striking the Rock* (see p. 76), it was the Pope himself who prescribed the iconography, but on other occasions such as the fountain of Mars for Francis I (see pp. 132–3) the subject-matter was left to the artist.

140 The celebrated architect and painter Donato Bramante (1444–1514). His activity in Rome after 1499 had a fundamental influence on 16th cent. architecture.

141 Bartolomeo (or Baccio) Valori, first governor of Florence after the fall of the Republic in 1530, was beheaded in 1537 for conspiracy against the Medici. As shown by Howard Burns, drawings by Michelangelo for Valori's palace survive.

142 Roberto Pucci (1463–1547) became Cardinal in 1542.

143 Clement left Rome in Nov. 1532 to meet Charles V in Bologna, where in 1530 he had crowned him Emperor.

144 Giovanni Salviati (1490–1553), son of Jacopo (see n. 19), was a nephew of Leo X. C. called him 'Cardinal beast', probably for his ugly face, which Sebastiano del Piombo depicted (see n. 119). He was elected Cardinal in 1517.

145 Clement returned in March 1533.

146 He was legate of Parma and Piacenza 1533–37.

147 Tobbia was from Camerino in the Marches. Documents record him working for the Vatican 1537–46.

148 Pier Giovanni Aliotti was Master of the Wardrobe. He later became the accountant of the pontifical *fabbriche* (buildings).

149 See n. 115.

150 Tommaso d'Antonio Perugino was appointed to the papal Mint jointly with G. Bernardi da Castelbolognese (see n. 153) in 1534.

151 Felice Guadagni was C.'s faithful assistant for many years.

152 Vincenzo Romoli, another example of Florentine preferment at the court of the Medici Popes, was an intermediary at the Mint.

153 Giovanni Desiderio Bernardi da Castelbolognese (1469–1553) was a goldsmith, medallist (see n. 150), and crystal and gem engraver; the six crystals of the so-called Cassetta Farnese (Naples, Capodimonte), executed from drawings by Perino del Vaga, are his masterpiece. He is traditionally identified as the sitter in a portrait in Capodimonte (see n. 68).

154 This is the third time that Gaddi is recorded as a clerk of the Camera in a few pages (p. 56 and p. 61). These repetitions suggest that C. dictated his memoirs at long intervals.

155 Cardinal Ippolito de' Medici (1511–35), son of Giuliano (see n. 16), was made Cardinal in 1529. He was a cultivated and intelligent patron of the arts. An opponent of his tyrannous cousin Duke Alessandro, he frequented the *fuorusciti*.

156 Ponte Sisto is at the southeast end of Via Giulia (see n. 168) near Palazzo Farnese.

157 Giovambattista Savelli was a cavalry captain in the service of Clement VII and, from 1540, of Cosimo I. Palombara Sabina is north of Tivoli.

158 S. Germano is near Sulmona in Abruzzo. The Abbey of Montecassino, in southern Lazio, was founded by St Benedict in 529; it was rebuilt after World War II. For Piero de' Medici see notes 13 and 14. The painter and sculptor Antonio di Giovanni da Settignano, called Solosmeo (active 1525–36), a pupil of Andrea del Sarto and Sansovino (see n. 180), worked 1531–33 with other artists on the monument to Piero designed by Antonio da Sangallo the Younger (see n. 220) in 1531. Only fragments of it survive.

159 Carlo Ginori, Gonfaloniere of Florence in the first two months of 1527, was a friend of Vasari and patron of artists.

160 Pietro Alvarez of Toledo (d. 1553) became Viceroy in 1532. His daughter Eleonora married Cosimo I in 1539.

161 Pecci was later in the service of Catherine de' Medici (see n. 281).

162 The medal, finished by C. in 1534, represents Peace beside the temple of Janus, whose doors were closed during periods of peace in ancient Rome. The inscription means: 'The doors of War are closed'.

163 The Florentine Pietro Carnesecchi (1508–67), secretary to Clement VII, later adhered to the heretical doctrines of Juan de Valdès and Melanchthon: for this he was tried, beheaded, and burnt at the stake.

164 The Pope, or rather C., expresses an idea common to Vasari's Lives: that modern artists (above all Michelangelo), who took classical art as their model, have not only equalled, but even surpassed it. See also the words of Francis I below (p. 120 and p. 144).

165 This medal, made in 1534, alludes to the Well of S. Patrizio in Orvieto commissioned by Clement from Antonio da Sangallo the Younger (see n. 220). The inscription is: 'That the people may drink' (Exodus, 17, 6).

166 Each new pope freed a few criminals after his election as a sign of magnanimity. Therefore, as C. and Pompeo were well aware, when a pope fell seriously ill, it was a good occasion to settle old scores by drastic solutions, relying on the new pontiff's pardon. Hence Pompeo hired an assassin 'to do to me what he was dreading I might do to him'.

167 Clement died on 25 Sept. 1534.

168 Via Giulia is the splendid street forming part of Bramante's town-planning scheme designed for Pope Julius II. The surrounding area was much frequented by artists: C. (see p. 85), Raphael, Antonio da Sangallo the Younger, Salviati and others had properties there.

169 Piloto, the Florentine goldsmith and sculptor Giovanni di Baldassarre (d. 1536), was a friend of the painter Perino del Vaga, whose celebrated cartoon of Moses crossing the Red Sea he owned. He accompanied Michelangelo in his flight to Venice during the siege of Florence and executed the polygonal ball designed by Michelangelo for the top of the New Sacristy of S. Lorenzo (see n. 371).

170 Francesco Cornaro (d. 1543), elected Cardinal in 1528.

171 Bernardo Michelozzi, Bishop of Forlì, had also been a member of Leo X's retinue.

172 See n. 97.

173 The poet Latino Giovenale Manetti (1486–1553) was nominated commissario (person responsible) for Rome's antique monuments and owned an impressive collection of antiquities, described by U. Aldrovandi in his Delle statue antiche (Venice, 1556; written in 1550).

174 Ambrogio Recalcati was Paul III's chancellor and chief secretary.

175 This sentence attributed to the Pope well exemplifies the artists' newly won social prestige. For a similar comment from Sansovino, see p. 82.

176 Designed in 1534, the coin shows on the obverse the Farnese arms, and on the reverse St Paul. 'Vas electionis' derives from the Acts of the Apostles (9, 15; the Conversion of St Paul).

177 The Feast of the Assumption (15 Aug.).

178 An interesting patron, Pier Luigi Farnese's (1503–47) relationships with artists were stormy: besides C., he also had the painter Francesco Salviati imprisoned. See also notes 230 and 328.

179 Niccolò di Raffaello called Tribolo (1500–50). A pupil of Sansovino, he was a Florentine sculptor and architect. The fountain he designed for the Medici villa at Castello (see n. 389) is his best-known work. Tribolo was among the artists questioned by Varchi (see n. 40; ed. Barocchi, pp. 518–19).

180 Jacopo Tatti (1486–1570), called Sansovino because his first master Andrea Contucci was from Monte Sansavino, was one of the most distinguished artists of the Italian Cinquecento. After the Sack of Rome, he moved to Venice where he became the Republic's official architect.

181 The Palazzo Pazzi in Via del Proconsolo was built by Giuliano da Maiano 1460–72. Purchased by Franceschetto Cybo, it was occupied by Lorenzo's wife, Ricciarda Malaspina, from whom he was separated. Lorenzo himself (1500–49) was Pope Innocent VIII's nephew, and in 1530 Clement VII made him head of the papal army. Lorenzo's magnificent portrait by Parmigianino is now in Copenhagen (Statens Museum for Kunst).

182 Niccolò da Monte Aguto was a friend of C. (see p. 87).

183 Ser Maurizio da Milano was the cruel and authoritarian Chancellor of the Eight (see n. 24).

184 Executed in 1535, this is C.'s finest coin for the Duke. St Cosmas and St Damian were the patron saints of the Medici because they were physicians (medici in Italian). Such puns were common to the culture of the time.

185 All these coins were executed in 1535.

186 Margaret of Austria married Alessandro in Naples in Feb. 1536.

187 Pietro Paolo Galeotti later helped C. cast the Perseus.

188 Bernardo Baldini (d. 1573) was purveyor to the Mint and, as Cosimo's favourite goldsmith from 1545, he was hated by C. Until a few years ago Baldini was a well-known 'name without works', but M. Collareta has recently discovered some documents which allow two reliquaries of the treasure of S. Lorenzo in Florence to be attributed to him: a crystal glass containing the Rib of St Roch, and a bottle containing the bones and ashes of various saints ('Una traccia per "Bernardone orefice"', Prospettiva, July 1976, pp. 57–59).

189 Lorenzino (1513–48) de' Medici murdered his cousin

on 5/6 Jan. 1537. Having fled to Venice (where eventually Cosimo's agents killed him), he commissioned a medal, whose reverse is borrowed from a denarius of Brutus celebrating the murder of Julius Caesar.

190 Ottaviano married Francesca Salviati, sister of Maria (the mother of Cosimo I). Vasari painted for him a *Venus* and a *Leda* based on Michelangelo's cartoons (Vasari, VII, 669).

191 The goldsmith Cennini (1481–1535) is praised with due reservation in C.'s *Trattato dell'Oreficeria*.

192 See notes 168 and 119.

193 The Capitol, once ancient Rome's religious focus, became the medieval and Renaissance administrative centre. C. was freed by the Butchers' confraternity.

194 Francesco Fusconi, who cured C. from this attack of malaria, was physician to Popes Hadrian VI, Clement VII, and Paul III. His collection of antiquities is described by Aldrovandi (see n. 173).

195 The Florentine Mattio Franzesi, a well-known burlesque poet, later became secretary to Cardinal Niccolò Ardinghelli.

196 The old man is Charon. Many Florentine artists, including C. (see p. 137), were acquainted with Dante's *Divine Comedy*.

197 For Landi see n. 107.

198 C. disparagingly gives this name to the painter and architect Giorgio Vasari (1511–74). While he was dictating these pages, Vasari was Cosimo's court artist. As usual, C.'s words must be regarded with caution.

199 Manno Sbarri (active 1548–61), a friend of Vasari and Salviati, is mentioned by Caro (see n. 119) in a letter to the well-known medallist Alessandro Cesati. Sbarri executed the silver structure of the famous Cassetta Farnese (see n. 153).

200 Vasari did not need C.'s recommendation since, when still a boy, he had been introduced to Alessandro and Ippolito de' Medici by Cardinal Silvio Passerini.

201 Francesco Catani was a friend of Varchi.

202 Luca Martini was also a friend of the painter Bronzino (see n. 408). According to R. Borghini's *Il Riposo* (1584), M. was a connoisseur, and Varchi dedicated to him his *Lezione della scultura e della pittura*.

203 Abbot Francesco Soderini (d. 1551), not to be confused with Cardinal Francesco Soderini, had been exiled from Florence in 1530, and his sister Nannina married Agostino del Nero, brother of Francesco (see n. 133).

204 The Magliana was a papal villa on the banks of the Tiber 7 m. outside Rome. Embellished by Innocent VIII, it was further transformed by Giuliano da Sangallo during the reign of Julius II. Leo X was very fond of this villa, the present state of which is rather neglected.

205 It was common belief that great and fatal deeds were accompanied or preceded by astonishing natural events, as shown by Luca Landucci's diary (*Diario fiorentino dal 1450 al 1516*, ed. I. del Badia, Florence, 1883).

206 Bettini, another Florentine exile, was a friend of Michelangelo, who drew for him the cartoon of *Venus kissed by Cupid* (1532–3), later painted by Pontormo.

207 Cosimo I (1519–74) became Duke on 9 Jan. 1537. He abdicated in favour of his son Francesco in 1564, and was elected Grand-Duke in 1569.

208 Charles V conquered Tunis in 1535.

209 Charles V made his entry into Rome on 5 April 1536. The *apparatus* was organized by Antonio da Sangallo the Younger (see n. 220).

210 Durante Duranti later became Cardinal, and Bishop of Brescia.

211 The greatest master to whom C. alludes is Don Giulio Clovio (1498–1578), the 16th cent.'s most celebrated miniaturist. Influenced by Michelangelo, he worked for Cardinal Grimani and illuminated a Book of Offices of Our Lady for Cardinal Alessandro Farnese (see n. 255). His remarkable life is narrated by Vasari, VII, 557 ff.

212 Sforza Sforza (d. 1575), son of Bosio (Count of Santa Fiora) and of Costanza Farnese (Paul III's natural daughter).

213 A gifted writer and a friend of Cardinal Bembo. For his father Piero see n. 91.

214 Pietro Bembo (1470–1547), the celebrated author of the *Asolani* and *Prose della volgar lingua*, was elected *in pectore* in 1538 and proclaimed Cardinal in 1539.

215 G. F. Hill in the *Burlington Magazine*, 1910, pp. 13 ff., maintained that Bembo's medal in the V & A is that described by C., but it was probably executed by C. on a later occasion.

216 C. was accompanied by two assistants: Ascanio de' Mari from Tagliacozzo, later in Henry II's service; and Girolamo Pascucci, who later accused C. of having stolen Clement VII's gems during the Sack.

217 The war in Piedmont between the Imperial and French armies.

218 C. had met Busbacca on his way to France.

219 See n. 78.

220 The Florentine Antonio da Sangallo the Younger (1484–1546) was nephew of the architects Giuliano (see n. 330) and Antonio the Elder. The foremost building expert of his epoch, he worked for Clement VII, Paul III, and numerous other patrons (see also notes 135, 158, 165, 209, 228).

221 Agnolo Cesi was a close friend of Agostino Chigi (see n. 58).

222 It seems that the Florentine merchant Ricciardo del Bene, who lived in Paris (see p. 142), was a relative of Piero (see n. 91).

223 Andrea Sguazzella followed his master Andrea del Sarto to France, and remained there in Francis I's service. He is mentioned in Vasari's *Lives*, V, p. 29 and p. 57.

224 The Florentine Giuliano Buonaccorsi (?–1563) became treasurer in 1523. Michelangelo presented his faithful assistant Antonio Mini with the *Leda*, a painting originally intended for Alfonso d'Este (see n. 76). Mini went to France in 1532, and there left the painting with Buonaccorsi. When Mini died in 1533, B. did not restore it to his heirs and the painting is now lost.

225 Francis I transformed the medieval castle into the splendid Château of Fontainebleau from 1528. It was erected by the master mason Gilles Le Breton, who planned the *Porte Dorée*, the north side of the *Cour du Cheval Blanc*, and the portico and staircase of the *Cour de l'Ovale* (the last only partly preserved). It was embellished by Primaticcio's (see n. 300) architectural additions (*Aile de la Belle Cheminée*, 1568; *Grotte des Pins*, c. 1543), and by Rosso's (see n. 78) and

Primaticcio's stuccoes and frescoes (*Galerie François Premier*, c. 1533–45; *Chambre de la Duchesse d'Etampes*, c. 1541–45; the *Salle de Bal*, 1552–56; *Galerie d'Ulysse*, 1550s).

226 Francis I (reigned 1515–47) introduced the Italian Renaissance into France and was a great patron of the arts. During this visit to Fontainebleau C. began a signed medal of Francis I which is not mentioned in the autob.

227 Ippolito II d'Este (d. 1572), son of Duke Alfonso (see n. 76), was made Cardinal in 1539. He commissioned the celebrated Villa d'Este at Tivoli designed by Pirro Ligorio.

228 The Duke was Ercole II d'Este (1508–59), son of Alfonso. The sanctuary of Loreto in the Marches was planned by Giuliano da Maiano, Giuliano da Sangallo (see n. 330), and Bramante (see n. 140); it was restored by Antonio da Sangallo the Younger (see n. 220) in 1536. It houses the Santa Casa, which, according to legend, is the house of the Virgin Mary moved by angels from Nazareth to Loreto in 1294: its exterior, designed by Bramante, is covered with sculptures and reliefs executed under Andrea Sansovino's (see n. 180) supervision.

229 G. Pascucci, mentioned in n. 216.

230 Duke of Castro from 1537.

231 Crespino de' Boni, the Bargello or Chief Constable.

232 Giorgio Ugolini is mentioned by Varchi in his *Storia fiorentina* (Cologne (Naples), 1721, Book XII, 458) and in papal account books.

233 Caro mentions in a letter to Giovanni Guidiccioni, Bishop of Fossombrone, that the heretic preacher Frate Pallavicino was again imprisoned in June 1540.

234 Girolamo Savonarola (1452–98), the Dominican friar who gained great authority in Florence after the fall of the Medici in 1494. Even the young Michelangelo felt the forcefulness of his sermons, but S.'s vehement criticism of the Church's corruption provoked Pope Alexander VI's reprisals and S. was burnt at the stake. S.'s followers, the so-called *Piagnoni*, continued to play an important rôle in Florentine politics.

235 The *acquaruoli* (who sold drinking water) were common figures in Renaissance Rome.

236 See n. 186. Margaret of Austria entered Rome on 3 Nov. 1538 where she was forced to marry Ottavio Farnese. Refusing to share her life with Ottavio (she was 16; he was 13 and had syphilis), Margaret lived in Cardinal Cesi's palace in the present Via della Conciliazione. The palace was reshaped by Martino Longhi the Elder in 1575.

237 The Borgo Vecchio was destroyed in the 1930s when Mussolini opened the Via della Conciliazione.

238 Not the palace of Cardinal Cesi, but the Vatican palace.

239 Giacomo Rastelli was in the service of Paul III and other popes until his death in 1566.

240 See n. 142.

241 Guido Ascanio Sforza (1519–64), brother of Sforza Sforza (see n. 212), was elected Cardinal in 1534. He commissioned his family chapel in S. Maria Maggiore in Rome from Michelangelo, who entrusted Tiberio Calcagni with its realization. It was carried out, possibly by Giacomo della Porta, after Michelangelo's and the patron's deaths.

242 The Palazzo Sforza-Cesarini, erected by Cardinal Rodrigo Borgia (Alexander VI) and almost completely rebuilt by Pio Piacentini in 1888, overlooks Via dei Banchi Vecchi, where C. had opened his workshop (see p. 60).

243 Francesco Cornaro (see n. 170).

244 10 June 1539.

245 See n. 129.

246 For Villani's *Cronaca* see n. 3. If it was the printed edition, it contained only the first ten books of the chronicle published for the first time in Venice in 1537.

247 Sandrino Monaldi had commanded the Republican army during the siege of Florence in 1530.

248 Fra Benedetto Tiezzi from Foiano, 18 m. south of Arezzo, was a Dominican friar of S. Maria Novella in Florence. A close follower of Savonarola (see n. 234), he preached against the Medici. Betrayed by Alessandro Strozzi (see n. 49), he was imprisoned in the Castle in 1530 where Clement VII had him starved to death.

249 See n. 12.

250 Antonio Ugolini replaced his brother on 1 Dec. 1539.

251 The soldier was a certain Giovanni, nicknamed Pedignone.

252 The goldsmith, medallist, and sculptor Leone Leoni (c. 1509–90) worked for many prestigious patrons such as Charles V, Ferrante Gonzaga, and the Milanese Medici. He became very rich, owned an impressive collection of works of art and plaster casts of classical statues, and built his elegant house in Milan to his own drawings. In 1537 he had started working for the Roman Mint. See also n. 428.

253 Giovan Gerolamo de' Rossi (d. 1564) became Bishop of Pavia in 1530. Involved in the conspiracy and murder of Count Alessandro Langosco in 1538, he was imprisoned and deposed. C. met him again in France (see pp. 134, 149) in 1544, and the Bishop later praised C.'s Perseus in a sonnet. His brother Pier Maria de' Rossi was Count of San Secondo, 15 m. north of Parma.

254 Jean de Monluc (d. 1579), French ambassador to the Pope, was elected Bishop of Valence in 1533.

255 Alessandro Farnese (1521–89), son of Pier Luigi, was elected Cardinal in 1534. He was probably the most powerful cardinal of the 16th cent. and his court was frequented by the most distinguished Italian poets, humanists, and artists: he commissioned the impressive Palazzo Farnese at Caprarola and the Gesù (the Roman mother-church of the Jesuit Order) from his favourite architect Vignola; and also patronized Titian, Vasari (see n. 198), F. Salviati, Giulio Clovio (see n. 211), Taddeo and Federico Zuccaro, Bartholomeus Spranger, and many others.

256 24 Nov. 1539. C. had been imprisoned for over a year (from 23 Oct. 1538).

257 Ippolito II d'Este lived in Cardinal Gonzaga's palace.

258 For Alamanni see n. 111. The well-known lawyer and philosopher Gabriele Maria Cesano (1490–1568) was a friend of Caro, Varchi, and of Tolomei who wrote a dialogue on the Italian language, *Il Cesano de la lingua toscana*, in 1525 (first printed ed. 1555). Cesano's only known work is the *Ethica secondo la dottrina d'Aristotele*, a manuscript in the Vatican Library (Codex Urb. Lat. 1347) dedicated to Cardinal Ippolito II d'Este.

259 The original seal has disappeared. C.'s description in his *Trattato dell'Oreficeria* (XIII) adds that he was paid 300 ducats. St Ambrose, patron saint of Milan, is represented because the Cardinal was Archbishop of that city. For Lautizio see n. 69.

260 This is the model of the celebrated salt-cellar which C. later executed for Francis I (see pp. 125–6 and 141).

261 C. describes a common difficulty arising from the relationship between artists and artistic advisers: for example, Caro's scheme for the medal of Bishop Guidiccioni was so elaborate that the painter Perino del Vaga had to simplify it and provide the medallist Alessandro Cesati with a more feasible, even if still detailed, design. It is true, however, that in the same letter Caro gave the artist freedom to do this.

262 François de Tournon (d. 1562), one of Francis I's most powerful political advisers and a patron of poets and writers, was elected Cardinal in 1530.

263 The humanist Cyriacus of Ancona recorded that the Sienese Angelo Parrasio was active at the Este court in Ferrara where he painted the Muses in this palace (Vasari, III, 90, note 1). Belfiore no longer exists.

264 Ercole II and Paul III signed a treaty in 1539.

265 It amounted to one hundred and eighty thousand ducats.

266 This work is lost. Its reverse was similar to one of C.'s medals for Clement VII (see p. 75).

267 See n. 77.

268 He had been an excellent administrator for Alfonso I (see n. 76).

269 See n. 73.

270 Salviati (see n. 144) was Archbishop of Ferrara 1520–50; after having been imprisoned by Paul III, Accolti (see n. 96) left Rome in 1535 and went to Ferrara, where he was Abbot of S. Bartolomeo. The Este court was renowned for its musicians and theatrical performances.

271 The Abbey of Ainay (in those days Esnay).

272 C. arrived at Fontainebleau in mid-September 1540.

273 C. wishes the Florentine School (see n. 333) to understand that the King regarded him as highly as the greatest Florentine artist who had lived at the French court.

274 According to C.'s own account, he completed only the Jupiter, now lost, probably melted down.

275 The treasurer was Guillaume Proudhomme, Lord of Fontenay-en-Brie.

276 The castle of Nesle stood on the left bank of the Seine, on the site of the present Palais de l'Institut at the end of the Pont-des-Arts. Originally owned by Amaury, Lord of Nesle (Picardy), it was sold to Philip IV in 1308. Le Petit Nesle was a small part of the castle (on the site of the Bibliothèque Mazarine). The Provost of Paris, who administered civil and criminal justice, was Jean d'Estouteville, Lord of Villebon.

277 Nicolas de Neufville, Lord of Villerois. He married a daughter of G. Proudhomme (see n. 275) in 1532, and inherited his father's position as Chief Secretary in 1539.

278 Jean Lallemant, Lord of Marmaignes, became Royal Secretary in 1551 under Henry II.

279 Orbec is in Normandy. The name of the Viscount is unknown.

280 Ippolito II d'Este paid C. on 12 Dec. 1540 and gave the vase and bowl to Francis I on 16 March 1541.

281 Anne de Pisseleu (1508–c. 1580), Francis I's mistress 1526–47, married Jean de Brosse (first Duke d'Étampes) in 1536. Primaticcio decorated her room at Fontainebleau. Jean de Lorraine (d. 1550), son of Duke René II, was made Cardinal in 1518 and was also Archbishop of Lyons. Henry II d'Albret, King of Navarre, was Count of Béarn and Foix; his wife Marguerite de Valois (1492–1549) was a poetess, and patron of artists and men of letters. The Dauphin was the future Henry II (reigned 1547–59); he married Catherine de' Medici (1519–89), daughter of Lorenzo, Duke of Urbino, in 1533.

282 The making of the Jupiter is narrated in great detail in C.'s *Trattato dell' Oreficeria* (XXV).

283 Le Petit Nesle faced the Louvre, Francis I's residence, but the Pont-des-Arts did not then exist.

284 The two heads are lost. This passage reflects the common Renaissance idea that both antique examples and nature were artistic ideals to be followed.

285 Piero Strozzi (1500–58), a son of Filippo (see n. 99), was a *condottiere* and became Lord of Belleville and Epernay. He also published some verses under the name of Sciarra Fiorentino.

286 Antoine le Maçon, secretary of Marguerite de Valois; she encouraged him to translate Boccaccio's *Decameron*, published in Paris in 1545.

287 They are in the Biblioteca Nazionale in Florence.

288 The two scenes were iconographically related to the statue, since they illustrated the loves of Jupiter, and were certainly in keeping with the erotic taste of the Fontainebleau School.

289 The Juno was never executed. A drawing in the Louvre published by Popp in *Zeitschrift für bildende Kunst*, 1927–8, p. 11, relates to this work (plate 52).

290 The Count of Anguillara was perhaps Averso Anguillara da Stabbia (see n. 79) who was then in the service of Piero Strozzi. The Count of Pitigliano was Giovan Francesco Orsini, but here C. probably refers to his son Nicola, who served P. Strozzi. Galeotto Pico (d. 1550) lost his title to Mirandola in 1536 and took refuge in France.

291 The Château of St-Germain-en-Laye, 12 m. outside Paris, was built by the master mason Pierre Chambiges from 1539 and continued by Guillaume and Jean Langeois 1544–9. According to the 17th-cent. art critic Félibien, Sebastiano Serlio (1475–1554), the celebrated Italian writer on architecture, was partly responsible for some of it. Altered by Louis XIV, it was 'restored' in the 19th cent.

292 The satyrs were to have been cast in bronze and would have been c. 355 cm high. Either they are lost or were never cast. The satyr holding a club, which was to be placed on the left of the doorway, is recorded by a C. autograph drawing once owned by John Barnard, later by Sir Thomas Lawrence, and now in the Woodner Family Collection, New York (plate 64; first published in the catalogue *The Newark Museum, Old Master Drawings*, 17–22 May 1960, no. 25). Sir John Pope-Hennessy has recently published a bronzette by C. derived from the model and representing the same satyr ('A bronze satyr by Cellini', *Burlington Magazine*, 1982, pp. 406–12).

293 The famous Nymph of Fontainebleau (in the Louvre since the French Revolution) was cast before 2 March 1543. Never installed over the *Porte Dorée*, it was

later given by Henry II to his mistress Diane de Poitiers, who placed it over the entrance door of her castle at Anet. The casting of the relief is described in C.'s *Trattato della Scultura* (1).

294 Only two plaster casts (Paris, Louvre) are known. The bronze Victories were moved to Anet with the Nymph and placed in the Museum of the Petits-Augustins during the French Revolution. Later transferred to Neuilly, they were destroyed in 1848.

295 The device was a salamander amidst flames; the motto was 'Nutrisco et extinguo'.

296 Guido Guidi (d. 1569) was the son of Giuliano and of Costanza Bigordi, a daughter of the Florentine painter Domenico Ghirlandaio. He became Francis I's personal physician in 1542. After he returned to Florence in 1547, Cosimo I appointed him professor of medicine and philosophy of the famous *Studio* in Pisa. See also n. 299.

297 See n. 253. De' Rossi dedicated poems to Francis I, the Queen of Navarre, and Antoine le Maçon (see n. 286).

298 See n. 111.

299 Pierre Gauthier printed Guidi's *Chirurgia è Graeco in Latinum conversa* (Paris, 1544), a translation of the books by Hippocrates, Galen, and Oribasius, and dedicated to Francis I. Francesco Salviati and assistants provided the splendid illustrations, now in two manuscripts in the Bibliothèque National, Paris (see M. Hirst's definitive article, 'Salviati Illustrateur de Vidus Vidius', *Revue de l'Art*, 1969, no. 6, pp. 19–28). It is not unlikely that C.'s frequent remarks on medicine and physicians were the result of his long friendship with Guidi.

300 The Bolognese painter, architect, stuccoist, and sculptor Primaticcio (1504/5–70) helped Giulio Romano (see n. 82) to decorate the Palazzo del Te (see n. 105); in France from 1532, he became the leading figure of the School of Fontainebleau after Rosso's death (see n. 78). Francis I made him Abbot of St Martin of Troyes and Canon of the Sainte-Chapelle in Paris. See also n. 225.

301 C.'s unfair judgement betrays his pride in belonging to the Florentine School.

302 C. alludes to the first line of *Canto* VII of the *Inferno*.

303 For Giotto's undocumented trip to France, see Vasari, I, 387.

304 The Florentine Guadagni lived in Lyons. He commissioned a *Doubting St Thomas* from Salviati for the Guadagni Chapel in the church of the Jacobins in Lyons *c.* 1547; this has recently been restored (see *Le XVIe siècle florentin au Louvre*, Exh. catalogue, Paris, 1982, pp. 39–41).

305 The Veronese Matteo del Nassaro was a goldsmith, die-caster, and musician (he was a pupil of Tromboncino at the Gonzaga Court in Mantua); he also made drawings for tapestries. Matteo entered the service of Francis I *c.* 1517 and became master of the Mint (see Vasari, V, 375–379).

306 C. refers to the second story of the second day of Boccaccio's *Decameron*. In it Rinaldo d'Asti attributes his success in love to his habit of saying an Our Father and a Hail Mary for the souls of St Julian's father and mother after each night's lodging.

307 Many preachers were alarmed by the wide diffusion of the 'eros socraticus' in Tuscany. C. was no exception to the practice, and was imprisoned for sodomy in

1557. Artists also used their *garzoni* as models for female figures (see, for example, Michelangelo's well-known drawing (New York, Metropolitan Museum) for the Libyan Sibyl on the vault of the Sistine Chapel).

308 From 1541 Jacques de la Fa (d. 1545) was entrusted by Francis I with the accounts of the works executed in the Petit Nesle.

309 Primaticcio received payments for this fountain 1541–50. As shown by V. Bush (*The Colossal Sculpture of the Cinquecento*, New York and London, 1976), at least fifty colossal statues were made in Italy (where Michelangelo's David had been a crucial example) during the 16th cent.; such *colossi* were a conscious antique revival. C.'s *Trattato della Scultura* discusses colossal sculpture; his stone and plaster model remained in the Petit Nesle after his departure for Florence.

310 When Charles IX married Elizabeth of Austria (1570) he gave the salt-cellar, begun in Rome in 1540, to Archduke Ferdinand. Formerly in the Schloss Ambras, it is now in the Kunsthistorisches Museum, Vienna. On the base the figures of Night, Day, Twilight, and Dawn are clearly inspired by Michelangelo's Medici Tombs (see n. 371); in his *Trattato dell'Oreficeria*, C. wrongly states that the Four Winds are the Four Seasons.

311 In 1540, Primaticcio made plaster casts of the Marcus Aurelius, recently (1538) moved to the Capitol; of the reliefs of the Trajan Column; and of the Laocoon, the Cleopatra (now known as Ariadne), the Venus, the Commodus, the Zingara, the Apollo, the Nile, and the Tiber, then all in the Vatican (see n. 66 and H. H. Brummer, *The Statue Court in the Vatican Belvedere*, Stockholm, 1970).

312 *Scorzone* means *rozzone*, that is rustic country girl.

313 Maddalena Bonaiuti.

314 For Ricciardo del Bene see n. 222. His wife was Jeanne Louan (or Lovau).

315 Charles V entered Paris on 1 Jan. 1540. The *apparatus* designed by Rosso and Primaticcio for his entry into Fontainebleau is partly described by Vasari, V, 170–1.

316 The Hercules was perhaps designed by Rosso and executed by a certain Cherrier. It stood between two columns representing Charles V's device and sustaining the Emperor's motto: 'Plus ultra'. Another motto ('Altera alterius robor') was inscribed on the base of the statue.

317 The Gallery of Francis I (see n. 225).

318 It seems that C. dictated his autob. up to this point between 3 November 1558 and 14 June 1559 when Henry II died.

319 Margaret of Valois (1523–74) was the niece of Marguerite of Navarre (see n. 281) and of Francis I.

320 See n. 164.

321 Le Petit Nesle acquired a notoriety from the murders said to have been committed there by Philip V's wife Joan in the 14th cent. It has been suggested that *Lemmonio Boreò* is either a corruption of *Le démon bourreau* (the devil executioner), or of *Le moine bourreau* (the monk executioner); or that C. meant *Le moine bourru*, the grumpy monk, or the ghost of a monk dressed in drugget (*bure*).

322 Following Charles V's defeat in Algiers in 1542, Francis I had attacked the Emperor the next year. In

August 1544, however, the Imperial army advanced to Épernay, within twenty leagues of Paris. The Treaty of d'Crépy was signed on 18 Sept. 1544.

323 Claude d'Annebaut (d. 1552) was made Admiral of France in 1543. Girolamo Bellarmati (1493–after 1554) had been banished from Siena for political motives. A learned mathematician, he became Francis I's military architect and designed the harbour of Le Havre. His *Chorographia Thusciae*, dedicated to Valerio Orsini, was published in 1536.

324 Argentan was in the Duchy of Alençon, and is *c.* 90 m. west of Paris.

325 Ippolito, who seems to have been one of the Gonzaga of Sabbioneta and Bozzolo, governed Mirandola 1537–8 (for Galeotto see n. 290). Lionardo Tedaldi is unknown.

326 C. left Paris in June–July 1545.

327 A letter of Battista Alamanni, son of the poet Luigi, to B. Varchi informs us that C. was in Lyons on 7 July 1545.

328 Pier Luigi Farnese (see n. 178) became Duke of Parma and Piacenza on 26 Aug. 1545.

329 The murder (10 Sept. 1547) was organized by the Imperial governor of Milan, Don Ferrante Gonzaga, a brother of Federico II and the most implacable of Pier Luigi's enemies. Count Agostino Landi was among the conspirators.

330 For Cosimo I see n. 207. The splendid villa of Poggio a Caiano, 16 m. northwest of Florence, was rebuilt by Giuliano da Sangallo (1445–1516) in the early 1480s for Lorenzo il Magnifico. A glazed terracotta frieze attributed to Andrea Sansovino (see notes 180 and 228) adorns the exterior, while the interior houses a magnificent *salone* frescoed by Andrea del Sarto, Franciabigio, Pontormo (see n. 407) and A. Allori (see n. 409).

331 See n. 14.

332 The Duchess was Eleonora of Toledo (1522–62). See n. 160.

333 The mid-16th cent. consciousness of an independent Florentine School, whose works were superior to and distinct from those produced in other Italian centres, was endorsed by the foundation in Florence of the first art academy: C., a member of the *Accademia del Disegno*, designed its seal (see C. Davis, 'Benvenuto Cellini and the Scuola Fiorentina', *North Carolina Museum of Art Bulletin*, 1976, no. 4, pp. 1–70). The concept of School as a language common to artists of the same area and respecting local characteristics was revived by the 18th-cent. connoisseur Abbot Lanzi, and it became an important, even if now rather obsolete, instrument of art criticism.

334 The wax model, now in the Bargello, is also mentioned in C.'s *Trattato dell'Oreficeria* (XII) and *Trattato della Scultura* (VIII), where he informs us that it was executed in two months.

335 The Piazza della Signoria.

336 C. refers to Donatello's *Judith* and Michelangelo's *David*.

337 It is clear that by now C. had given up the idea of publishing his autob.

338 Riccio (*c.* 1490–1564) had been Cosimo's tutor, and became Provost of Prato Cathedral. Vasari mentions him in the Lives of Francesco Salviati and Giovanangelo Montorsoli.

339 Gorini is recorded in the court's account books 1543–5.

340 See n. 40.

341 The bronze model of Medusa was purchased by the V&A in 1965 (see Sir John Pope-Hennessy, 'A sketch model by Benvenuto Cellini', *Victoria and Albert Museum Bulletin*, 1965).

342 His name was Cencio (see p. 163).

343 See n. 20.

344 The Opera del Duomo was a permanent institution for maintaining the fabric of Florence Cathedral.

345 C.'s sister Liperata married a certain Bartolomeo (d. 1528). Here C. refers to her second husband Raffaello Tassi who died in that year, 1545. Liperata then married the goldsmith Pagolo Pagolini (or Paolo Paolini) who helped C. cast the Perseus.

346 In C.'s days, the wardrobe also housed a small goldsmith's workshop. The *Guardaroba* of Cosimo I was redesigned by Vasari (see n. 198).

347 Giampaolo (1518–*c.* 1582) and Domenico (1520–90) were sons of the gem-engraver Michele Poggini. G. was a goldsmith and carver in hard stones (*pietre dure*), and later a rival of Pompeo Leoni (Leone's son, see n. 252) at the court of Philip II of Spain. D. was a goldsmith, medallist (he executed the medals of B. Varchi and of Cosimo I), sculptor, and poet (he wrote a sonnet in honour of C.'s Perseus). Also active in Rome, he became Sixtus V's master of the Mint.

348 This clay model (late 1545/early 1546) is lost. On 25 Aug. 1545 C. had been paid for an oval bronze relief representing a greyhound (now in the recently reorganized *Sala dei Bronzetti* in the Bargello), a test for the casting of the Perseus. Since C. was still in France on 7 July (see n. 327), the artist's account of an immediate commission of the Perseus from the Duke (see p. 153) is confirmed.

349 See n. 188.

350 Landi lectured to the Florentine Academy and wrote the comedy *Il Commodo* for Cosimo I's wedding with Eleonora of Toledo in 1539. He was probably a merchant in precious stones: according to a note of C., dated 16 Nov. 1555, the artist also sold a diamond to Landi.

351 The Loggia of the New Market in the Via Calimala, near the Palazzo Vecchio, was erected by Tasso (see n. 40).

352 Antonio Ubertini (1499–1572) was a brother of Francesco (see n. 83) and like him was called Bachiacca. Antonio was praised in a sonnet by Varchi for his mastery of embroidery.

353 Pierfrancesco Riccio (see n. 338).

354 C.'s reference to sodomy is here apparent. Although he defends sodomy as 'practised by some of the greatest emperors and kings' (see p. 174), it was severely punished in Cosimo I's Florence and the artist preferred to leave for Venice.

355 His name was Bernardo Mannellini (see p. 179).

356 Here Michele di Goro's handwriting stops. Three pages written by another hand follow, and then C. himself completed the autob.

357 For Lorenzo de' Medici see n. 189; for Buonaccorsi see n. 224.

358 Leone Strozzi (1515–54), Prior of Capua, was in the service of Francis I and Henry II. For Piero see n. 285.

359 The over life-size bronze *all'antica* bust, now in the

Bargello, was completed by 17 Feb. 1547 when C. was paid 500 gold *scudi* for it. Its armour was originally enriched by touches of gold (see also n. 377). The inventory of C.'s workshop made in 1571 (hereafter, *the 1571 inventory*) after his death lists an unfinished marble bust of Cosimo, which reappeared in 1958 (San Francisco, De Young Museum): even if probably executed by an assistant, it was certainly made under the artist's supervision.

360 Zanobi Portigiani from Fiesole helped Giambologna (see n. 432) to cast part of the Neptune Fountain in Bologna.

361 The most important Florentine town-planning feature promoted by Cosimo, the Via de' Servi links the Cathedral and city centre with SS. Annunziata, the church protected by the Medici.

362 This farm, called lo Spinello, was on the Fiesole hillside. S. Domenico is a 15th-cent. church 2 m. from Florence on the road to Fiesole.

363 Cosimo Bartoli mentions Francesco di Matteo in his *Ragionamenti Accademici*, pp. 19b–20a (see C. Davis op. cit. in n. 333, pp. 37–9).

364 Sforza Almeni from Perugia was arbiter of the court's taste. In 1554 Cristofano Gherardi frescoed his palace façade (in Via de' Servi) following Vasari's drawings: the paintings are lost, but its iconographical scheme has been discussed by C. and G. Thiem. C. Davis discovered an unpublished fresco cycle painted by Vasari and Gherardi inside the palace ('Frescoes by Vasari for Sforza Almeni, "Coppiere" to Duke Cosimo I', *Mitteilungen des Kunsthistorischen Instituts in Florenz*, 1980, pp. 127–202). Almeni was killed by Cosimo in mysterious circumstances in 1566.

365 Philip II, King of Spain from 1556.

366 The Clock Hall, the Sala dell'Oriolo (or dei Gigli), created by Giuliano da Maiano 1472–76 from part of a pre-existing 'Great Hall', has a magnificent wooden ceiling by Benedetto and Giuliano da Maiano; Domenico Ghirlandaio frescoed the east wall with a St Zenobius (patron saint of Florence) and other figures 1482–85; and Bernardo Rosselli decorated the others with golden lilies (*gigli*) on a blue ground. The name *Oriolo* comes from a cosmographical clock built before 1484 by Lorenzo della Volpaia for Lorenzo il Magnifico.

367 Stefano Colonna (d. 1548) became lieutenant-general of Cosimo's army in 1542.

368 C.'s additions to the Ganymede (Bargello) are clearly visible. Such practice was common during the Renaissance, and some sculptors such as Sormano and Vacca made it their profession.

369 Together with the study of Antiquity and Nature, Anatomy was the third fundamental aspect of Cinquecento art training.

370 In 1508 Soderini (see n. 15) ordered a huge block of marble for Michelangelo to sculpt a Hercules as a companion piece to the David. In 1525 Clement VII gave the commission to Bandinelli, preferring Michelangelo to concentrate on the Medici Tombs (see n. 371). Michelangelo was recommissioned after the Medici's expulsion (1527) in Aug. 1528; this time he decided to carve a *Samson and a Philistine* from the half-begun block: it was, therefore, a group of two (or three; Vasari, VI, 155) figures, and not four as C. claims (see p. 199). Following the fall of the Florentine

Republic, Bandinelli completed the marble 1530–4. The 'wretched' sonnets were indeed written, as reported by Vasari (VI, 159), who informs us that Duke Alessandro arrested some of their authors.

371 The Medici funerary Chapel (or the New Sacristy) in S. Lorenzo, executed 1520–34 and left unfinished by Michelangelo. The tombs were assembled by his followers and opened to the public in 1545.

372 Despite C.'s harsh criticism, Bandinelli's drawings and designs are among the finest examples of Florentine draughtsmanship (see R. Ward's 'Some Late Drawings by Baccio Bandinelli', *Master Drawings*, 1981, pp. 3–14). Vasari's fresco in the Palazzo Vecchio of Cosimo I surrounded by his artists represents C. and B. as two old and fierce figures reflecting each other like a mirror image. The allusion to their antagonism is clearly intentional.

373 Executed *c.* 1547, the group is now in the Bargello. It was listed together with a clay model for an Hyacinth in the 1571 inventory. Some time between 1757 and 1779, it was placed in the Bóboli Gardens where it was later identified by F. Kriegbaum, 'Marmi di Benvenuto Cellini ritrovati', *L'Arte*, 1940, pp. 5–25. The defective marble and certain unfinished details corroborate C.'s account.

374 Listed in the 1571 inventory, the model is now lost.

375 The flood of 1557, not that of Aug. 1548, since the marble for the statue arrived in Florence in Nov. 1548.

376 Also listed in the 1571 inventory, it is in the Bargello. Executed some time between 1548 and 1565, it was installed in the garden of the Medici Villa at Pratolino as early as 1596, and moved to the Bóboli Gardens some time between 1789 and 1819. The crack is still visible, but the (probably bronze) garland is lost.

377 The bust was installed above the entrance to the fortress at Portoferraio (in those days called Cosmopoli) on the Isle of Elba on 15 Nov. 1557, and returned to Florence in 1781.

378 Montelupo Fiorentino is on the Arno 15 m. west of Florence.

379 C., however, dismissed her in 1556; he re-employed her in 1560, but in 1562 accused her of theft.

380 The brother of the sculptor and foundryman Zanobi Lastricati (1508–90). Both helped C. cast the Medusa (the first part of the Perseus group to be executed). Zanobi also cast Tribolo's fountain for the Villa Medici at Castello (see n. 389).

381 Capretta was a faithful supporter of the Medici.

382 C. worked on the Perseus Aug. 1545–April 1554. It still stands in the Loggia dei Lanzi. The marble for the base, probably executed by Francesco del Tadda following a wooden model recorded in C.'s workshop in 1571, was delivered in Nov. 1548. The main bronze figure was realized from two separate castings: the Medusa (see p. 166) was paid for in 1548; and the Perseus, signed on the baldric BENVENVTVS CELLINVS CIVIS FLOR. FACIEBAT MDLIII, between Jan. and May 1553. R. Borghini's *Il Riposo* (1584) mentions C.'s lost drawing for the model; also lost is the large-scale plaster or stucco model recorded in the 1571 inventory. The small bronze Perseus (Bargello) is an autograph work based on the main statue.

383 Serristori was Cosimo's ambassador in Rome until 1564. His palace is now on Via della Conciliazione.

Giovanni Maria de Monte (1487–1555), elected Julius III in Feb. 1550, was a political ally of Cosimo I. A great patron of the arts, he commissioned from Vasari (a distant relative), Ammannati (see n. 425), and Vignola the splendid Villa Giulia in Rome, erected 1551–55 under Michelangelo's supervision.

384 B. Altoviti (1491–1557) was one of the period's richest bankers, a patron of the arts, and an anti-Medicean. His palace on the Tiber, whose loggia was frescoed by his protégé Vasari, was destroyed in 1888 (the frescoes are now in the Palazzo Venezia in Rome). C.'s bust of him was purchased by Bernard Berenson in 1898 for the Isabella Stewart Gardner Museum in Boston (see C. Avery, 'Benvenuto Cellini's bronze bust of Bindo Altoviti', *Connoisseur*, May 1978, pp. 62–72). For the Altoviti collection, see U. Aldrovandi, op. cit., in n. 173.

385 The original letter is lost.

386 One of the three Councils instituted by Clement VII in 1532 to govern Florence.

387 Michelangelo assumed the task of building the new St Peter's in 1546. He radically changed its plan, exterior, and dome; the last was later modified by Giacomo della Porta who built it in 1588–90.

388 Francesco di Bernardino d'Amadore (or Amatori) (d. 1555) from Castel Durante (now Urbania near Urbino) was Michelangelo's faithful servant for over twenty years.

389 Lorenzo (1463–1503) and Giovanni (1467–98; Cosimo's grandfather) di Pierfrancesco Medici purchased this villa 4 m. northwest of Florence in 1478. The villa was rebuilt by Vasari for Cosimo I, but its interior decoration by Volterrano dates from the 17th cent. Tribolo (see n. 179), Ammannati (see n. 425), and Buontalenti designed its splendid garden.

390 Begun in 1553, the war ended on 12 April 1555 with Cosimo's annexation of Siena.

391 See n. 50.

392 The San Frediano gate, erected by Andrea Pisano (1332), is beyond the Arno at the top of Borgo San Frediano, near S. Maria del Carmine. Pasqualino d'Ancona is P. Boni; for the gate see n. 41. The architect and wood-carver Giuliano Baglioni (1491–1555) (see also notes 397 and 419), son of Baccio d'Agnolo (see n. 420), replaced his father as architect of the Opera del Duomo (see n. 344). The San Giorgio gate, erected in 1224, is near the Belvedere fortress. Antonio Particini worked on the *apparati* for the entry of Charles V into Florence in 1536, and for the wedding of Francesco de' Medici (see n. 398) with Giovanna d'Austria in 1565. The destroyed gate of S. Niccolò was in the present Piazza Francesco Ferrucci. The sculptor and architect F. da Sangallo (1494–1576), son of Giuliano (see n. 330), specialized in military architecture. In 1543 he succeeded Baccio d'Agnolo (see n. 420) as *capomaestro* of Florence Cathedral. The gate *alla Croce* (or of St. Ambrose) is in Piazza Beccaria. For Giovambattista Tasso see n. 40; for the Pinti gate see n. 23.

393 Vasari, I, 220–1, informs us that this Etruscan bronze (Florence, Museo Archeologico) was discovered in 1554 and that Cosimo placed it in the *Quartiere* of Leo X in the Palazzo Vecchio.

394 Cosimo encouraged an Etruscan revival, which added to the myth of a renewed Tuscan *imperium*. He favoured the Tuscan Order in architecture, and commissioned Pierfrancesco Giambullari to investigate the supposed Etruscan origins of the Tuscan language.

395 C.'s Perseus closely corresponds to an Etruscan bronze statuette (ht. 18 cm) in the Museum für Kunst und Gewerbe in Hamburg (see W. Braunfels, *Perseus und Medusa von Benvenuto Cellini*, Berlin, 1948, pp. 7–8; 2nd ed., Stuttgart, 1961, pp. 8–10).

396 C. refers to the rear of the palace. Tasso erected the entrance door 1550–2. This block was reshaped by Vasari who designed and painted the *Quartiere* of Leo X on the first floor in 1555–62, and that of the Elements on the second floor in 1555–66; the exterior façade, however, was designed by Ammannati (see n. 425) in 1588 and completed by Bernardo Buontalenti by 1596 following Ammannati's wooden model.

397 The Great Hall of the Florentine Republican Government (see n. 15) was transformed by Vasari into the *Salone dei 500*. This enterprise had been begun (1542–3?) by Giuliano di Baccio d'Agnolo (see n. 392), and Bandinelli, who executed some marble statues of members of the Medici family for it. Vasari completed it in 1565: he removed the low ceiling thus creating an impressive space for the wedding of Francesco I, and decorated the walls and ceiling with historical events and allegorical subjects concerning the history of Florence and Cosimo I.

398 The Prince was Francesco de' Medici (1541–87) who became Duke in 1564. Giovanni (1543–62) became Cardinal in 1560. Ferdinando (1549–1609) became Cardinal in 1563 and Grand-Duke of Florence in 1587; he resigned his cardinalate in 1588 and married Christine of Lorraine in 1589. Garzia lived 1547–62.

399 They stood in the niches of the base, with the relief of *Perseus freeing Andromeda* (for which a wax model was recorded in the 1571 inventory) beneath. They have been replaced by copies and are now in the Bargello. In 1552 N. Santini (see n. 138) was paid for helping C. polish the Mercury.

400 The remains of the Romanesque church of S. Piero Scheraggio, incorporated by Vasari while building the Uffizi in 1561, are now beyond the Gallery's ticket-office.

401 The Mint was behind the Loggia dei Lanzi.

402 S. Miniato al Monte, the masterpiece of Florentine Romanesque architecture, is beyond the Arno.

403 24th June.

404 Baccio Baldini, a physician and lecturer at the *Studio* in Pisa, was the Laurentian Library's first librarian and author of a biography of Cosimo I.

405 The finishing touches, which reveal C.'s goldsmith's taste for precious details, are now lost.

406 The celebrated *Studio* founded by Cosimo. After the Perseus success, C. was admitted to the Florentine nobility in 1554.

407 Iacopo Carucci from Pontormo (1494–1556/7) was a pupil of Andrea del Sarto. His melancholic and hypochondriac character is revealed by his diary begun in 1554. See also n. 330.

408 Agnolo di Cosimo called Bronzino (1503–72) was a pupil of Pontormo. One of the greatest Renaissance portrait painters, he served the Medici 1538–65. Also a talented poet, he wrote two sonnets praising the Perseus.

409 Alessandro Allori (1535–1607) closely followed his

master Bronzino's late style. His masterpiece is the recently restored *Deposition* (Florence, Museo di Santa Croce). See also n. 330.

410 The Florentine sculptor, painter, and goldsmith Andrea del Verrocchio (1435–88) was Leonardo's teacher. His best-known work is the monument to Bartolomeo Colleoni in Venice. C. refers to the *Incredulity of St Thomas* (1466–83) for the Magistracy of the Mercanzia (or Mercatanzia). The gothic S. Michele in Orto in Via de' Calzaiuoli is the church whose external tabernacle holds statues commissioned by the local guilds from the leading Florentine sculptors.

411 Executed 1501–4, it was installed in the Piazza on 8 June 1504. The original was moved to the Accademia in 1873.

412 The Spanish Don Giovanni de Vega was Viceroy 1547–57.

413 Giovanni Angelo Montorsoli (1507?–63), one of the period's most gifted sculptors, is not yet fully appreciated because his work is dispersed about Italy. In Messina (1547–57), he completed the Orion Fountain in 1550, and the Neptune Fountain (restored; fragments in the Museo Nazionale in Messina) in 1557.

414 Iacopo Guidi (d. 1587) from Volterra, Bishop of Penna in Abruzzo from 1561, took part in the Council of Trent.

415 A cousin of Maria Salviati (Cosimo's mother), Albizi (d. 1555) was a member of the Forty-Eight (see n. 386) during the reign of Duke Alessandro. Vasari, VII, 202–3, informs us that C. returned from France with four cartoons for the ceiling of the Sistine Chapel, which Michelangelo had given to his assistant Antonio Mini (see n. 224), and that they were owned by Girolamo's heirs.

416 Salviati was the brother of Cardinal Giovanni and of Maria, Cosimo's mother. Francesco Salviati painted a *Madonna* for him (Vasari, VII, 21).

417 L. Torelli (1489–1576) from Fano was a man of law and a poet. He entered the service of Cosimo in 1539, became his chief secretary in 1546, and was elected senator by Francesco de' Medici in 1571. C. praised him in a sonnet.

418 S. Maria del Fiore is Florence Cathedral.

419 Bandinelli asked Giuliano di Baccio d'Agnolo (see n. 392) to draw the plan and execute the wooden model of the choir under the dome of the Cathedral. Some of Bandinelli's marble reliefs (the series was completed by his pupil Giovanni Bandini) are still *in situ* (some signed B.B.F. 1555); Bandinelli's larger statues have been dispersed, however.

420 The architect and wood-carver Baccio Baglioni (1462–1543), called Baccio d'Agnolo. His best work is the elegant Palazzo Bartolini in Piazza S. Trinita in Florence. As architect of the Opera del Duomo (see n. 344) he began the much criticized gallery, judged by Michelangelo as a caprice ('una gabbia da grilli'), around the top part of the drum of Florence Cathedral.

421 C. refers to the Baptistery's so-called 'Gates of Paradise' executed by L. Ghiberti 1424/5–52.

422 Salviati (1504–64), son of Alamanno, was elected to the Forty-Eight (see n. 386) in 1553.

423 These projects, however, were never realized. A wax relief of Adam and Eve (probably for the choir) and 'two or three' models for the pulpits of S. Maria del Fiore are listed in the 1571 inventory.

424 In C.'s account there is a gap of four years between the events of 1555/56 narrated up to p. 196 and the arrival of the marble in 1559. C. was imprisoned in Aug. 1556 for having beaten the goldsmith Giovanni di Lorenzo. Freed in Oct., in early 1557 he was given a four-year sentence for sodomy which was commuted to house-arrest for the same period.

425 The architect and sculptor Ammannati (1511–92), active in Venice, Padua, and Rome (see n. 383), returned to Florence in 1555. His Neptune was placed in the Piazza in Oct. 1565 as part of the decorations for the wedding of Francesco de' Medici. C. praised Ammannati and his wife in a sonnet, but after the Neptune *affaire* C. became hostile to him. For Ammannati see also notes 389, 396, and 436.

426 C. flatteringly ascribes the commission of the most important artistic achievements of Quattrocento Florence to the Medici.

427 See n. 370.

428 These models, recorded in the 1571 inventory, are lost. The large model (see below, p. 201), later given to Francesco de' Medici and criticized by C.'s rival Leone Leoni (see n. 252) in a letter of 1560 to Michelangelo, is also lost. A bronze statuette (plate 100) can however be related to C.'s model.

429 The terracotta, wax (recorded in C.'s will of 1555), and plaster models for this work are lost. In a letter to Cosimo, dated 3 March 1557, C. wrote that he had completed the Crucifix. C. bought the black marble for the cross on 27 Nov. 1557, but, as his *Trattato della Scultura* (VI) says, it was hard to work and brittle, and he completed it only in 1562. The life-size Crucifix is signed and dated: BENVEN/VTVS. CEL/LINVS. FLORE/NT. FACIEB/AT. MDLXII. The statue, originally intended for his tomb, was purchased by Cosimo I in 1565 for the Pitti Palace (Vasari, VII, 623); in 1576, Francesco de' Medici presented it to Philip II of Spain. Now covered by a clumsy loin-cloth, it is in the monastery of S. Lorenzo, El Escorial.

430 A certain Ser Conegrano, and Girolamo Lucchesini.

431 Bandinelli's *Dead Christ supported by Nicodemus* (1554–60) is on the right of the tribune of SS. Annunziata (see n. 361). The head of Nicodemus is a self-portrait. According to Vasari, the work was begun by Clemente Bandinelli, Baccio's son.

432 Giovanni Bologna (or Giambologna) (1529–1608) arrived in Florence *c.* 1556 and became the favourite sculptor of the Grand-Dukes. His first monumental work, the Neptune Fountain (Bologna, 1563–6), was probably based on his model for the Florentine competition (see also n. 360). (See the Exh. catalogue *Giambologna Sculptor to the Medici*, London, 5 Oct.–16 Nov. 1978). Santa Croce is the huge Franciscan church planned by Arnolfo di Cambio in 1294 and reshaped by Vasari following the precepts of the Council of Trent.

433 The sculptor and goldsmith Danti (1530–76) and his father Giulio executed the bronze statue of Julius III (see n. 383) outside Perugia Cathedral, 1553–55. D. entered the service of Cosimo in 1557 and wrote the *Primo libro del trattato delle perfette proporzioni* (Florence, 1567), inspired by the work of Michelangelo.

434 Francesco (d. 1578), son of Simone Mosca, worked for Cosimo in Pisa Cathedral in the 1560s (Vasari, VI, 310).

435 In contemporary documents Vasari is sometimes mentioned as Giorgino, but C.'s Giorgetto is intentionally disparaging.

436 Vasari and Ammannati had been associates in Rome when the latter was sculpting the statues for the De Monte Chapel in S. Pietro in Montorio planned by the former and commissioned by Julius III. Their collaboration was so close that Vasari (a painter) was paid for the marble balustrade, and Ammannati (a sculptor) received some payments for painting.

437 Gianstefano Alli was one of Cosimo's *camerieri*. He was frequently sent to Rome to buy medals and cameos.

438 C. had been poisoned by a sheep-farmer called Piermaria d'Anterigoli, nicknamed Sbietta.

439 In a sonnet C. compared the poetess Laura Battiferri (1523–89) to Petrarch's Laura. Her friends included Varchi, Caro, and Tasso. Her works were published in Florence (Giunti) in 1560.

440 In the original text C.'s word 'conseguentemente' (consequently) before the phrase 'all the lords' is essential for appreciating his acute description of court behaviour.

441 Catherine de' Medici (see n. 281) ruled France after Henry II's death in 1559. Baccio del Bene was probably a member of the same family as Albertaccio (see n. 213) and Ricciardo (see n. 222).

442 The tomb of Henry II in St-Denis, commissioned by Catherine in 1563 as a mausoleum for herself, the King, and their sons, was designed by Primaticcio (see n. 300). The marble and bronze sculptures are by Germain Pilon (*c.* 1530–83). The painter D. Ricciarelli da Volterra (1509–66) was a pupil of Perino del Vaga and one of Michelangelo's closest followers. Towards the end of his life he turned his attention to sculpture and thanks to Michelangelo's recommendation obtained the commission of the bronze horse for the equestrian monument to Henry II: it was re-used for the monument to Louis XIII, and melted down in 1792. Ricciarelli's slowness in completing his commissions is confirmed by Vasari's *Life of Daniele*.

443 Francesco de' Medici left for Spain on 23 May 1562.

444 Cardinal Giovanni died at Rosignano on 21 November 1562.